Aber

D1142357

5

Essential

ART

The History of Western Art

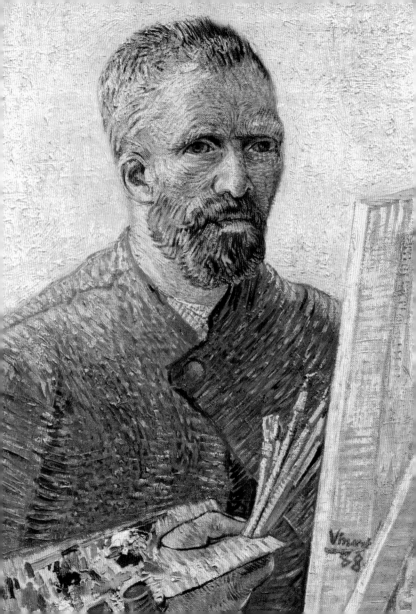

Essential ART

The History of Western Art

Elke Linda Buchholz, Gerhard Bühler,
Karoline Hille, Susanne Kaeppele,
and Irina Stotland

HERBERT PRESS · LONDON
an imprint of A&C Black

Contents

Akhenaten, page 27

Discus Thrower, page 53

Art: A World History

Contents

Sandro Botticelli: The Birth of Venus,
page 136

Albrecht Dürer: Self-Portrait, page 194

208 Baroque

Peter Paul Rubens: The Rape of the Daughters of Leucippus, page 238

Contents

**Paul Cézanne: La Montagne
Sainte-Victoire**, page 383

**Auguste Rodin:
The Thinker**, page 364

412 20th Century before 1945

Gustav Klimt: The Kiss, page 400

6

**Nam June Paik:
Andy Warhol Robot**,
page 492

Pre- and Early History

40,000–500 BCE

Gold Funerary Mask of Psusennes I, ca. 990 BCE, gold, height 48 cm, Egyptian Museum, Cairo

Pre- and Early

Egypt

3000 Founding of Egypt; wall paintings in tombs

2800 Painted reliefs

2700 Stylistic proportions develop; first seated and freestanding statues

2600 Seated statue of King Djoser; standing statues of King Menkaure and his queen

p. 35

The Aegean

3000 Minoan civilization begins in Crete

2600 Cycladic figurines

2000 Old Minoan Palaces in Crete; Kamares ceramics

1600 Serpent goddess; frescoes in Akrotiri, Santorini

1500 Mural painting in Knossos; shaft graves in Mycenae

1300 Objects found in Mycenaean cupola graves

1200 The Dark Ages begin; decline of the Mycenaean civilization

Central Europe

40,000 Homo Sapiens

25,000 Venus figurines

21,000 Cave paintings at Altamira and Lascaux, small sculptures

10,000 End of hunter-gatherer culture and cave painting

8000 Sun deities in different cultures; abstract golden cones

3000 Neolithic period

3000 Linear B and pottery culture

2500 Bronze Age begins; Stonehenge

1000 Iron Age begins

500 Greek imports in Hallstatt

300 La Tène style developed—combines Celtic designs with Greek styles

100 Styles develop outside the Roman sphere of influence

p. 19

40000 10000 5000 4000

History

Mesopotamia

3000
Sumerian reliefs on vases

2700
Man and woman, praying statues from Tell Asmar with large eyes

2300
Victory Stele of Naram-Sin

2150
Seated and standing statues of King Gudea; large sculptures of figures

1750
Stele of Hammurabi

700
Lamassu in Sargon II's palace in

Khorsabad; monumental sculptures

600
Ishtar Gate in Babylon; depictions with blue glazed tiles

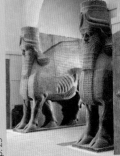

p. 23

13

| 3000 | 2000 | 1000 | 500 |

2500
Seated scribe from Sakkara

2400
Tomb paintings, height of relief art

1850
Middle Kingdom;

praying and kneeling statues; cube stool

1350
New Kingdom, Akhenaten and Nefertiti reign; artistic revolution of the Amarna period

900
Small sculptures made of bronze

500
Egyptian Classicism, harkens back to the style of the Old and Middle Kingdoms

China

33,000
Ceramics with geometric motifs

1500
Ritual bronzes of the Shang Dynasty

1000
Zhou Dynasty; bronze animal statues and small jade sculptures are created

200
Qin Dynasty; terracotta army

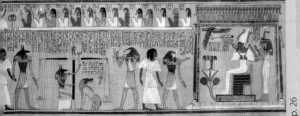

p. 26

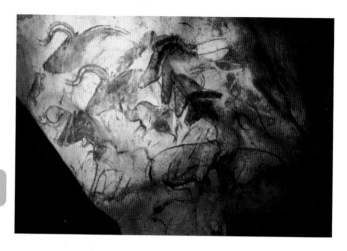

Pre- and Early History

Art first manifested itself in Europe with the appear-
ance of humans during the Upper Paleolithic Age
(40,000–10,000 BCE). Motifs found in cave paintings
and small sculptures from this time used the animal
world for inspiration and are often interpreted as
charms used to assist the hunt. Numerous female fer-
tility objects that have been retrieved suggest that
reproduction was accompanied by metaphysical
ideas. The end of the Ice Age, with the rapid change
in climate and culture, also brought an end to the
hunter-gatherer society in Europe. The Middle East
came into focus with the onset of the Neolithic peri-
od (ca. 9000 BCE). Peoples living in the Euphrates and
Tigris river basins found wild cereals and grasses as
well as undomesticated sheep and goats—a discov-
ery that facilitated a transformation in lifestyle as
they settled down and became farmers. The first

■ **Cave Painting**,
ca. 18–16th century
BCE, Chauvet Cave,
near Vallon-Pont-
d'Arc

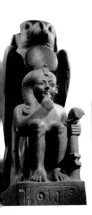

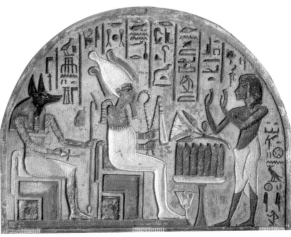

■ **Stele of Nanai**, Egyptian, ca. 1400–1350 BCE, painted wood, Museo Egizio, Turin

■ **Ramses II as a Child with Huron**, Egyptian, ca. 1250 BCE, granite and limestone, height 231 cm, Egyptian Museum, Cairo

cities and sanctuaries developed in southern Mesopotamia (present-day Iraq) around 4500 BCE, and the Sumer civilization evolved around 3500 BCE. As in the cultures of ancient Egypt and ancient China, the rich marshes located between the Euphrates and Tigris rivers yielded rich harvests. The design and construction of canals and dikes were important in the process of securing the developing civilizations from flooding. In order to oversee these measures, administrative organizations were developed, forming the roots of larger state structures. Temples in Mesopotamia became the religious, industrial, political, and cultural centers of the cities. The Sumerians can be considered the inventors of the potter's wheel, the plow, the wheel, the wagon, and writing itself. Praying statues and steles depicting figurative scenes and stories had already appeared around 3000 BCE.

Introduction

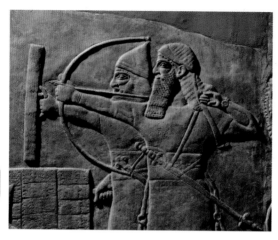

Statues depicting kings as the messengers of the gods were created during this time. The cultures of the Arcadian, Assyrian, and Babylonian civilizations became tightly bound together in Mesopotamia. The palace complexes of the Assyrian and Babylonian rulers were equipped with monumental reliefs and sculptures.

China, during the Shang Dynasty, experienced its first cultural heyday in the 2nd century BCE. Isolated from outside influences, Chinese art developed its own unique style for almost 4000 years. Aside from ornate bronze vessels, lacquerware, and silk works, the discovery of thousands of sculptures of warriors and horses, commissioned by the first Qin emperor, is distinctive testimony to the quality of Chinese art.

The life-size statue of the Emperor Djoser indicates the beginning of sculpture in the Old Kingdom of ancient Egypt in ca. 2600 BCE. The tombs of the pharaohs, who were regarded as gods, were deco-

■ **Archers**, Assyrian, 9th century BCE, detail of a stone relief, British Museum, London

■ **The Prince**, Minoan, ca. 17th–14th century BCE, stucco relief, painted, Archaeological Museum, Heraklion

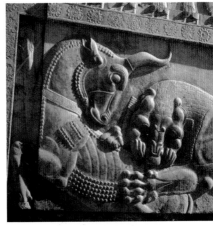

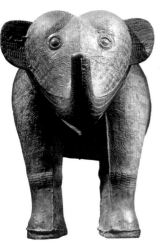

■ **Elephant**, Chinese, Shang Dynasty, 12th–11th century BCE, bronze, height 64 cm, Musée Guimet, Paris

■ **Lion Attacking a Bull**, Persian, first half of the 5th century BCE, relief, Persepolis, Iran

■ **Warrior of Hirschlanden**, Celtic, 6th century BCE, sandstone figure, height 150 cm, Württembergisches Landesmuseum, Stuttgart

rated in immeasurable luxury. The belief in an afterlife helped foster the development of art forms aimed at preserving the deceased's lifestyle, and surviving works are extremely rich. Over the centuries, the Egyptian dynasties of the Old, Middle, and New Kingdoms fostered innumerable precious sculptures, wall paintings, and reliefs.

Despite economic contact with the Minoan island of Crete, the first European civilization possessed an entirely different character than Egyptian culture and art. Mycenaean princes from the Aegean who settled on the Greek mainland were the political and cultural heirs of the Minoans, who abruptly disappeared around 1500 BCE. A time of cultural decline began in Greece around 1200 BCE. Mycenaean culture sharply declined into what is commonly refered to as the Dark Ages after the burning of the palaces of the urban elite.

Introduction

Stone Age Sculpture

ca. 38,000 BCE–ca. 10,000 BCE

■ Homo Sapiens (Cro-Magnon Man) begins to settle in Europe during the Late Paleolithic ■ Numbers of small sculptures made of stone, bone, or ivory appear for the first time ■ Next to the figures of wild horses and mammoths appear human figures, such as the fertility idols called Venus statuettes

■ **ca. 38,000–28,000 BCE** Aurignacia culture, from the Aurignac region, France, creates bone weapons and ivory statuettes found in southern Germany

27,000–20,000 BCE Gravettia culture, discovered in La Gravette, France, makes weapon points, statuettes, and relief depictions

16,000–10,000 BCE Magdalenia culture from Dordogne; France, cave paintings and decorated objects such as weapons, pendants, and amulets from animal teeth, bones, or ivory

Figures found in Aurignac, France, are among the oldest hitherto discovered sculptures in the world. These sculptures were carved out of mammoth ivory. Hunters preferred to depict the animals from their immediate environment. Sculptures of wild horses only 5 cm high, as well as carvings of mammoths, bears, and bison in mammoth ivory, were found in several places in Germany's Swabian Alps. Flutes made of bird bones and mammoth ivory found in the cave of Geissenklösterle are considered to be the oldest musical instruments in the world. An upright human figure with a lion's head, 28 cm high, carved of mammoth ivory, was discovered nearby in a cave in Hohlenstein-Stadel, Lonetal (Lone Valley). Robust, mostly faceless figurines of female fertility idols, called Venus figures, are common artifacts recovered from the Gravettia culture. These fertility idols were depicted even more abstractly in the Magdalenia culture.

■ **Figure of a Bison**, Magdalenia culture, ca. 12,000 BCE, height 10 cm, discovered in La Madeleine, Dordogne. Musée d'Antiquités, Saint-Germain-en-Laye, France

This figure, carved of deer horn, shows a bison licking its side. It reveals how intimately acquainted humans were with animals, how they observed them, and how accurately they noted their movements. Horses, mammoths and bison were the most commonly depicted animals. This figure was an ornament at the end of a staff for hurling spears.

Head of a Woman, Paleolithic Age, ca. 20,000 BCE, height 3.65 cm, Musée d'Antiquités, Saint-Germain-en-Laye, France

The head of a woman is all that remains of a mammoth-ivory statuette found in Brassempouy, Landes, France. It appears to be a Venus figure, although the statue's head and face are executed in great detail. Venus statuettes, or fertility idols, were often roughly worked, accentuating the feminine physique rather than precise details. This piece has a finely reproduced hairstyle including braids. An interpretation of the figurine as a portrait has not been verified by research.

Venus of Willendorf, Gravettia culture, ca. 24,000–22,000 BCE, height 11 cm, Naturhistorisches Museum, Vienna

This statuette, made of soft limestone, was found in 1908 in Willendorf, southern Austria. Traces of coloring indicate that it was originally painted red. Round feminine breasts, back, stomach, and thighs are amply illustrated, but the figure has neither arms nor face. The head is covered by stylized hair. The figure has been interpreted as a fertility idol and is one of the best known Venus statuettes of prehistory.

Thinker from Cernavoda, Neolithic period, 6th century BCE, height 11.5 cm, Institute for Archeology, Bucharest

This male figurine was found in the lower Danube in Cernavoda, Romania. The end of the Ice Age at around 10,000 BCE and the warmer climate that followed brought about the end of the highly developed hunting culture. In its wake followed a farming culture, which reached Europe from the Middle East by way of the Balkans. In the 6th century BCE, vessels and clay figures were already being produced in the Danube region, and represent both depictions of animals and humans. Here, the male figure, seated on a bench, supports his head with his hands. Deep in thought, the *Thinker* is unique in that it does not appear to be a hunting or fertility idol, but rather a reflection of human introspection.

Stone Age Sculpture

Stone Age Painting

40,000–4,000 BCE

■ In the late Stone Age, about 30,000 years ago, cave paintings of great artistic merit were created ■ Paintings have been found in the cave systems of southwestern Europe, in Africa, Australia, and in other parts of the world
■ *left:* **Aborigine Art**, rock painting, Kakadu National Park, Arnhemland, Australia

40,000–10,000 BCE Paleolithic period; hunter cultures

10,000 BCE Waning of the Ice Age in Europe, with great climatic changes

10,000–4,000 BCE Neolithic Revolution— agriculture and animal domestication spreads from the Middle East to Central Europe; hunter cultures persist in Africa and Australia until colonial times

As "the art of the hunter," the Stone Age cave painters depicted mainly animals of the hunt, but also natural enemies such as bears and lions. According to a cultic-religious interpretation, these paintings served as a sort of "hunter's magic," a means of assuring a good hunt. But other interpretations are possible. Few human figures are depicted in the European wall paintings that were discovered, but contemporaneous sculptures often had human subject matter. Next to amazingly naturalistic depictions of animals, abstract signs and lines were drawn over and into the animals, perhaps signifying spears from the hunt.

■ **Bison**, between 21,000 and 13,000 BCE, cave painting from Altamira, Spain

This master painting has a gradation of its brown, black, and ocher tones. The composition as a whole, as well as the accurate detailing, is impressive.

■ **Running Deer**, between 21,000 and 13,000 BCE, cave painting from Altamira, Spain

The cave of Altamira houses over 100 charcoal drawings and colored depictions of animals including bison, deer, horses, and boar. Red, yellow, and brown tones came from ocher and hematite, while black came from charcoal. Green, blue, and white pigments are absent.

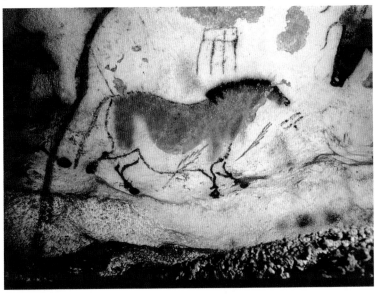

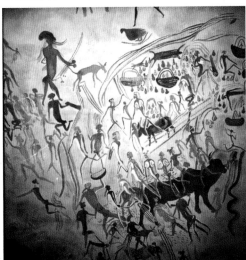

■ **Wild horse**, between 17,000 and 15,000 BCE, cave painting from Lascaux, Dordogne, France

Wild horses in flight are followed by arrows, depicted, as usual, in profile. Colors were applied with fur, feathers, wood brushes, or fingers, or as powdered pigment that was blown through hollow bones.

■ **African Picture of the Hottentots (Khoi)**, CA. 2500 BCE, Diana's Vow Farm, Rusape, Zimbabwe

This painting depicts the preparations for the burial of a chief. His riches—cattle, sheep, and hunting dogs—are shown. Human figures, in Mesolithic "silhouette style," are shown in various movements and poses.

Stone Age Painting

Mesopotamia: Sumer, Akkad, Babylon, Assyria

3500 BCE–539 BCE

■ Located between the Euphrates and Tigris rivers ■ Mesopotamia developed around 3000 BCE ■ Called the cradle of civilization

From 3500 BCE Sumerian civilization develops

3000–2700 BCE Uruk and other Sumerian cities grow

2350 BCE Akkadian Empire; conquest of Uruk by Sargon II

2100–1955 BCE The rebirth of Sumeria under Emperor Gudea

1792 BCE Old Babylonian Empire under Hammurabi

ca. 17th century BCE Old Assyrian Empire

ca. 1600 BCE The sacking of Babylon by the Hittites

ca. 850 BCE New Assyrian Empire under Assurnaspiral II

ca. 600 BCE New Babylonian Empire

539 BCE The seizure of Babylon by the Persians

Mesopotamian Works

Gudea of Lagash, 2141–22 BCE, Detroit Institute of Art

Head of a Roaring Lion, 9th–8th century BCE, Metropolitan Museum of Art, New York

The Black Obelisk of Shalmaneser III, 858–824 BCE, British Museum, London

The art of Mesopotamia, from the region known today as Iraq, comprises that of the cultures of Sumeria, Akkad, Babylon, and Assyria until the 6th century BCE. Although they possessed societal differences, these civilizations established their cultures and artistic forms in succession from one another. As a result, their traditions can be regarded as tightly intertwined. Reliefs and clay steles, used by the ruling class to narrate stories, were the preferred art forms in Sumeria. Sculptures often depicted cubical or cylindrical forms, and the detail of the eyes is quite impressive. The art of stone carving, or glyphs, began with the advent of the cylinder seal. The claim to power by the Assyrian kings was demonstrated by the construction of their palaces, which were equipped with monumental reliefs and sculptures.

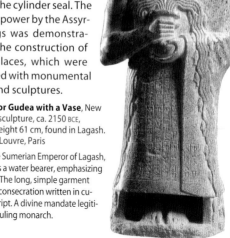

■ **Emperor Gudea with a Vase**, New Sumerian sculpture, ca. 2150 BCE, calcium, height 61 cm, found in Lagash. Musée du Louvre, Paris

Gudea, the Sumerian Emperor of Lagash, is shown as a water bearer, emphasizing his power. The long, simple garment includes a consecration written in cuneiform script. A divine mandate legitimizes the ruling monarch.

Winged Bull, ca. 720 BCE, limestone, height 400 cm, found in Khorsabad at the Palace of Sargon II. Musée du Louvre, Paris

The monumental figure of the winged bull with a human head symbolized the union of the bull's physical strength with human reason. The figures have five legs, appearing from the front, the side, and the rear in good condition. During the reign of Sargon II (722–705 BCE), the New Assyrian Empire reached the height of its power. The doors of the Khorsabad Palace were watched over by these chimera. Visitors to the emperor had to proceed through the door according to a prescribed method. A sequence of reliefs glorifying the emperor's deeds and military victories was located on the nearby walls. These scenes were carefully composed in order to influence the visitor.

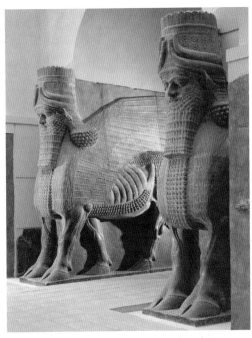

The Code of Hammurabi, Old Babylonian, ca. 1750 BCE, height 225 cm, black basalt, found at Susa. Musée du Louvre, Paris

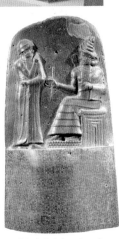

Hammurabi ruled and carried out justice in accordance with the approval of the gods. The law is written below this relief and can be called one of the first examples of political propaganda in art.

Bull from the Ishtar Gate of Babylon, 604–561 BCE, tile relief, Pergamon Museum, Berlin

The Processional Way to the ziggurat of the god Marduk and the Palace of Nebuchadnezzar II traveled through this 14-meter-high gate entrance. Bulls, dragons, and lions were depicted.

Mesopotamia: Sumer, Akkad, Babylon, Assyria

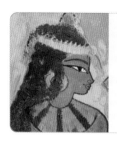

Early High Culture of Egypt

ca. 3100 BCE–395 CE

■ Along with the pyramids, over 3000 memorials dedicated to the afterlife remain in Egypt ■ The tombs of the godlike pharaohs were also outfitted with artwork of immeasurable wealth ■ The art of the dynasties of the Old, Middle, and New Kingdoms brought forth many precious works

ca. 3100 BCE Unification of Upper and Lower Egypt by King Menes, founder of the First Dynasty; early Dynastic Period; development of hieroglyphics

2700 BCE Beginning of the Old Kingdom, the Third to Sixth Dynasties

2650 BCE Building of the Great Pyramid of Chephren (Khafre)

2134–1785 BCE Middle Kingdom, 11th and 12th Dynasties

1550–1070 BCE New Kingdom, 18th (Amarna Period) to 20th Dynasty

750–332 BCE Late Period, 25th to 30th Dynasties

332 BCE–395 CE Greco-Roman Period

Unlike Mesopotamia, the community that developed in Egypt along the Nile had no centralized power controlled by a single ruler. The pharaoh (originally meaning "palace") stood at the head of a strict bureaucratic hierarchy and ruled as the incarnation of the god Horus. The Nile and the sun determined their fundamental religious beliefs. The river was worshiped as the god Hapy and the sun as the god Ra. The physical isolation created by the surrounding desert prompted independent characteristics in Egyptian art, such as a resistance toward outside influences as well as a continuous and conservative adherence to tradition. The art that was created was mostly court art and followed strict conventions, which explains the absence of stylistic anomalies. The representation of human figures was determined by a ⟳

■ **Sitting Scribe**, Old Kingdom, ca. 2500 BCE, height 53.7 cm, Musée du Louvre, Paris

The naturally posed limestone figure was painted, and the eyes were outlined in copper and inlaid with alabaster and quartz. Mastery of the ideograms and phonograms in Egyptian hieroglyphics ensured scribes a high social status. They recorded all important business, administrative dates, and transactions.

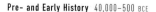

■ **Hunting Scene**, ca. 1429–1375 BCE, fresco, Grave of Nebamon, Thebes. British Museum, London

This work depicts a bird hunt in the papyrus thicket. In this fresco we can see the canon of proportions—important figures are largest. The depiction does not follow natural perspective, but instead shows all important details and viewpoints based on a standardized schematic design. Size, clothing, makeup, and hairstyle identify the status of the figure, creating an easy-to-understand hierarchy. Animals are represented with more realism than humans.

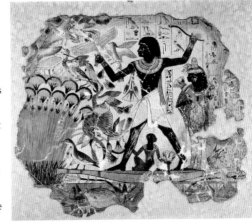

■ **Menkaure and His Queen**, 4th Dynasty, ca. 2470 BCE, slate, height 139 cm, Museum of Fine Arts, Boston

With one leg extended forward, Menkaure demonstrates the pose of highly placed persons. Only traces of the original paint remain. The sculpture, from the processional road in Giza, is unfinished.

■ **Cow Milking**, Old Kingdom, early 6th Dynasty, after 2347 BCE, limestone relief

The relief sculpture from the *mastaba*, or grave site, of the vizier Kagemni shows scenes of offerings being performed and everyday life, including the milking of a cow with its rear legs bound. The relief works from this time show an appreciation for genre scenes.

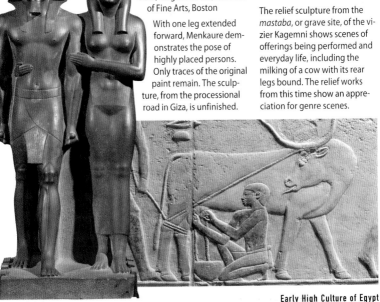

Early High Culture of Egypt

canon of proportions, organized geometrically. The same formula for the human figure was used over hundreds of years: head and legs in profile, and eyes and upper body viewed from the front. The sizes of figures were determined by their social status. A large influence on art was belief in the afterlife. Pharaohs were gods, but their physical bodies were human, so mummification immortalized them. Art was often created to accompany people in their graves. Statues served to house their spirits and, along with paintings and relief sculptures, were meant to preserve their lives for them.

■ **Book of the Dead of Hunefer**, New Kingdom, 19th Dynasty, ca. 1285 BCE, height 39 cm, British Museum, London

The *Book of the Dead* contains a description of the trial that Osiris holds over the dead. The dead must answer, before the 42 gods, to all the misdeeds he is said to have committed. The jackal-headed god Anubis places the heart of the deceased on a scale, weighing it against an ostrich feather, the symbol of Ma'at, the goddess of truth and justice. Thot, god of scribes, reports the results to the enthroned god Osiris.

■ **Tutankhamun Canopic Jar**, Pharaoh of the 18th Dynasty, ca. 1346–37 BCE, 39.5 x 11.5 x 12.5 cm

The gold- and jewel-inlaid canopic jar held the mummified liver of the pharaoh and is emblematic of the power and wealth of the king. Several sarcophagi held the ruler's mummy, while his internal organs were removed and preserved in canopic jars like this one. Thanks to a well-hidden entrance, the treasures in Tutankhamun's burial chambers remained safe from grave robbers.

Other Works

Statue of Karomama, the Divine Adoratrice of Amun, 22nd Dynasty, 945–715 BCE, Musée du Louvre, Paris

Lid of the Coffin of Maakare, 21st Dynasty, Egyptian Museum, Cairo

Papyrus Collections, Ägyptisches Museum, Berlin

Roman Period Portrait of a Boy, 2nd century CE, Metropolitan Museum of Art, New York

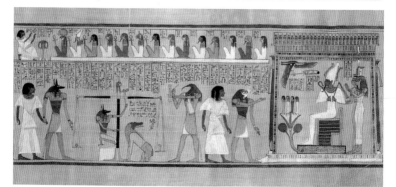

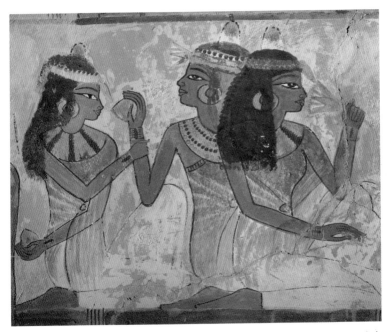

Ladies Preparing Before the Funerary Banquet, 18th Dynasty, ca. 1500 BCE, wall paintings from the grave of Nakht, scribe and priest under Tuthmosis

In Egypt, the belief was held that the dead would be reunited with their families in the afterlife and a feast would be held in celebration. In addition to the celebration itself, the ladies' preparation for the event was shown in grave paintings. In this scene from the grave of Nakht, a woman hands another a mandrake root, while a third reaches for a lotus blossom.

Akhenaten, Amarna period, stone, ca. 1355 BCE, height 25 cm, Ägyptisches Museum, Berlin

Pharaoh Amenhotep IV (1364–47 BCE), a member of the cult of Aten, changed his name to "Akhenaten." Central to the cult of Aten was the worship of the sun as the giver of light, warmth, and life. Akhenaten forbade the worship of the old gods. Through his support, the latent tendencies in Egyptian art toward naturalism went into full swing and brought about a radical break with artistic tradition. The portraits from this time show no idealization, but instead denote a figure's characteristic attributes.

Early High Culture of Egypt

Nefertiti

As Egyptian sculpture reached its apex during the 18th Dynasty, so did relief sculpture. During the New Kingdom, the Pharaoh Akhenaten (ca. 1364–47 BCE) provided measures for a fundamental change in Egyptian art. By turning away from the traditional modes of representation, a stronger trend toward naturalism ensued. This development caused the idealized treatment of the ruling classes to come to a halt, and the new trend would actually grotesquely exaggerate their worst features. Even the Pharaoh Akhenaten himself was often portrayed in an unfavorable manner. However, the portrayal of his wife, Nefertiti—whose name means "the beauty that has come"—was the direct opposite. The exquisitely vivid image of the queen attests to a great empathy for her by artists. The subtle paint on her bust (opposite) is original and has never needed to be restored. Both eyes were originally inlaid with crystals.

■ **Daughter of Akhenaten**, New Kingdom, ca. 1375 BCE, brown quartz, 24.8 x 12.3 x 16.5 cm, Egyptian Museum, Cairo

This portrait is believed to be Princess Meritaten. Typical of art from the New Kingdom, the back of the head is elongated, which is emphasized here by the lack of hair. This type of head is obscured by the royal crown in the bust of Nefertiti.

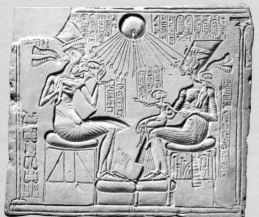

■ **Relief of Akhenaten and Nefertiti**, New Kingdom, ca. 1350 BCE, limestone, height 32 cm, Ägyptisches Museum, Berlin

This unusually private scene shows Akhenaten and Nefertiti together with their three children. Located above them, the god Aten, depicted here as a radiating sun, transmits his rays, a sign of life, down to the ends of the royal couple's hands. Instead of the customary schematic gestures, the portrayal of the royal couple with their children is full of powerful emotion.

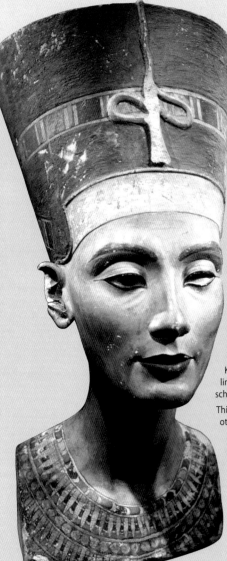

■ **Bust of Nefertiti**, by the workshop of Thutmose, New Kingdom, ca. 1350 BCE, painted limestone, height 50 cm, Ägyptisches Museum, Berlin

This bust of Nefertiti was found near other ceramic sculptures of the royal family in Thutmose's studio in the capital city Amarna. Research suggests that this piece was probably intended as a test or model, because the throat, for instance, has been proven to be too thin to carry the weight of the crown. Traces of plaster indicate that the artist used it to rework the sculpture.

Nefertiti

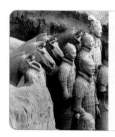

China—Art of the Early Empire

1550 BCE–220 CE

■ Developed independently from other civilizations ■ Strong influence of philosophy on art ■ Lacquer and silk work are characteristically Chinese

1550–1030 BCE Shang Dynasty; first characters of proto-Chinese writing are developed and recorded in abundance

1027–256 BCE Zhou Dynasty; iron is widely used

551–479 BCE Confucius's life and works

475–221 BCE The Warring States period and the Golden Age of Chinese philosophy

221–207 BCE Qin Dynasty; Qin Shi Huang, founder of the dynasty, builds the first Chinese capital and begins the construction of the Great Wall of China

206 BCE–220 CE Han Dynasty; expansion westward; Silk Road

■ Three-Footed Vessel, Shang Dynasty, bronze, height 21.6 cm, National Museum, Beijing

This vessel, designed to warm wine, was used in ritual offerings of food and drink in ancestor worship. Bronze casting allowed for more slender forms than those made of clay.

Chinese art preserved its characteristic values without any notable outside influences for almost 4000 years. China experienced its first cultural Golden Age with the Shang Dynasty around 1550 BCE, during which time a large number of artistic bronze vessels for religious activities and ancestor worship were made. There were over thirty types of vessels, each with a specific task, used to make food and wine offerings to the spirits of ancestors. As a general rule, the entire surface of a vessel was covered in decoration. Rounded ornamentation and figural forms, despite their repetitive nature, grew to be more organic over time and possess a more intrinsic tension and dynamism. Common motifs included animals and mythical creatures. During the Zhou Dynasty, silk work and lacquer work such as dishware, furniture, and musical instruments developed. The primary patrons of Chinese art were the royal court and wealthy nobles. Later, during the Han Dynasty, the Silk Road opened trade westward.

Other Important Works from China

Female Dancer, Han Dynasty, 2nd century BCE, Metropolitan Museum of Art, New York	**Wooden Phoenix,** Zhou Dynasty, 770–256 BCE, Musée Guimet, Paris
Tomb Jar, Han Dynasty, 1st–3rd century, Smithsonian Institution, Freer and Sackler Galleries, Washington, DC	**Ritual Wine Vessel,** Shang Dynasty, ca. 1500 BCE, National Museum, Beijing

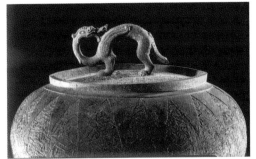

■ **War Drum**, Zhou Dynasty, 770–481 BCE, bronze, height 69.6 cm, Municipal Museum, Xianyang

The depiction of dragons, as well as other mythical creatures composed of different animal parts, is characteristic of Chinese art. The dragon, seen here functioning as handle, symbolized luck and was also a mark of the emperor.

■ **Dog**, Han Dynasty, ca. 141 BCE, terracotta, length 30.5 cm, weight 2.5 kg, Archeological Museum, Shaanxi

The production of animal sculptures in a simple, yet natural style was popular during the Han Dynasty. The posture of the animal was rendered exactly. The works which have survived from this era, such as this terracotta piece, come from excavated graves and consist of terracotta, bronze, and lacquer work. Sculptures depict musicians, warriors, and horses, as well as remarkably constructed miniatures of houses, ships, and carriages. Because of their religious beliefs, these objects were re-created for use by their departed ancestors.

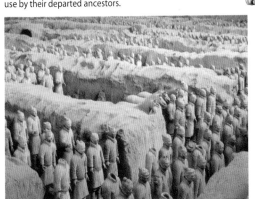

■ **Emperor's Army**, Qin Dynasty, ca. 221–207 BCE, terracotta, Mausoleum of Emperor Qin, Shaanxi Province

Grave number one, with 6000 life-size statues of warriors and horses, was discovered in 1974. Every one of the terracotta warriors possesses an original face. The grand expanse and power of the Chinese Empire is reflected in the different races featured. As seen with these sculptures, the art of the Qin Dynasty had a naturalized style.

China—Art of the Early Empire

Cycladic and Minoan Sculpture

3100 BCE–2000 BCE

■ One of the earliest civilizations in Europe ■ Produced works as early as 2700–2200 BCE ■ Named after the Cyclades Islands off Greece

3100 BCE Begining of the first phase of the early Bronze Age in Crete, the Cycladic Islands, and the Greek mainland, with copper used in weapons and tools

2700–2200 BCE Second phase of the Bronze Age sees a trade in metals, the formation of a hierarchical society, and the spread of Cycladic marble idols through Greece, Crete, and the western coast of the Middle East

2200 BCE Widespread destruction on the Cyclades and the mainland by invaders from the Balkans

2000 BCE Building of the old palaces in Crete

■ **Snake Goddess**, ca. 1600 BCE, faience, height 29.5 cm, from the Palace of Knossos. Archeological Museum, Heraklion, Crete

The goddess is wearing a long skirt and a bodice open in the front, revealing her breasts. She holds a twisting snake in each hand, while on her

The Bronze Age culture of Crete is named after the mythic King Minos. City centers developed in Crete, alongside societies with hierarchical structures. The Minoan culture most likely grew from the maritime trade in metals. The first palaces arose in Knossos, Malia, Phaistos, Galatas, and Kato Zakros around 2000 BCE, where the ruling elite performed priestly and administrative functions. More than 400 large clay vessels with linear A script were found in the Knossos palace. Crete spread its influence over the Aegean Sea and expanded its trade relations with the Middle East and Egypt during the New Palace epoch, beginning around 1700 BCE.

Archeological discoveries show that the Cyclad Islands had an independent culture as early as 4000 BCE, producing high-quality sculptures carved from local marble. Human figures were depicted according to geometric forms such as triangles and ovals.

head sits a crouching panther. These attributes distinguish her as *Potnia Theron*, goddess of animals. She exhibits features that are unmistakably similar to those of Oriental fertility goddesses. Goddesses or priestesses in this type of outfit also appear in murals, such as *Ladies in Blue* from the Palace of Knossos, but it is not clear if these figures represent the clothing that was actually worn by aristocratic ladies at that time.

Pre- and Early History 40,000–500 BCE

■ **Female Idol**, Cycladic, ca. 2400–2300 BCE, marble, height 46 cm, discovered on Chalandriani, Island of Syros

Small sculptures of high quality were being created from local marble in the Cyclades around 2700–2200 BCE. Unfortunately, most objects were obtained from grave robberies, so little is known about their discovery.

It is certain, however, that they served some sort of religious purpose, because for the most part, they were grave offerings. Whether they were images of divinities or depictions of the dead themselves is unknown.

■ **Bullfight Rhyton**, New Palace Era, ca. 1500 BCE, soapstone, shell, jasper, and rock crystal, height 26 cm, discovered at the Small Palace of Knossos. Archeological Museum, Heraklion, Crete

Rhytons, or stylized drinking vessels in the form of bulls' heads or created from bull horns, contained sacrificial drinks for the dead or the gods. The bull was one of the favorite animal motifs in Minoan paintings and sculptures. Its cultic importance has not been fully clarified. This example of a *rhyton* is particularly beautiful. The variety of colors, from the use of different materials, is striking in comparison with other monochrome relics dating from the same time.

■ **Harp Player,** Cycladic, ca. 2800–2200 BCE, marble from the isle Paros, found in Keros, near Amorgos. Metropolitan Museum of Art, New York

The abstract Cycladic idols fascinate viewers because they appear virtually modern in style. The figures have their own system of proportions. They were carved out of marble blocks with blades of obsidian and their surfaces were polished with emery. Frequently portrayed figures are women with arms resting on their stomachs or male musicians, such as flute and harp players. In the royal graves of Ur, however, musicians themselves were placed in the graves of their deceased kings, showing us how important music was during this period.

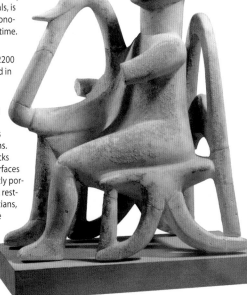

Cycladic and Minoan Sculpture

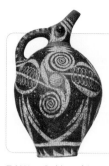

Minoan Ceramics and Murals

2000 BCE–1500 BCE

■ ca. 1700 BCE Crete's influence in the Aegean grew ■ Palaces were destroyed ca. 1500 BCE ■ *left:* **Minoan Ceramic**, Palace of Phaistos

2000 BCE Building of the old palaces in Crete and the introduction of the potter's wheel

1700 BCE Destruction of the old palaces, building of new ones

ca. 1630 BCE Eruption of the volcano near Santorini (ancient Thera)

1600–1500 BCE Shaft graves in Mycenae and the end of Minoan hegemony over the Aegean Islands

ca. 1500 BCE Destruction of all palaces on Crete, except for the Palace of Knossos

■ **Bull Hurdler**, 16th century BCE, fresco, height 86 cm, Palace of Knossos, Crete

A pale woman holds the horns of the steer while a dark-skinned male acrobat either flips over its back or tries to ride it. This athletic ritual was probably performed by a bull cult. The fresco was discovered by British archeologists in 1900 and about half of it has been restored.

Unlike the Egyptians, Minoan artists did not depict their rulers. The themes that decorate their painted ceramics, palace murals, and small sculptures were taken mainly from nature. Next to flowers and landscapes, scenes of people, ships, and animals were also particularly popular. They also showed events or happenings. This distinguishes Minoan artists from their contemporaries in Egypt and in Mesopotamia. An excellent example of this is the *Bull Hurdler* fresco from Knossos, which depicts a person hurdling a bull. Like the Egyptians, the Minoans portrayed women with fair skin, whereas men were depicted with darker skin. Minoan figures were often much more fluid than their Egyptian counterparts and portrayed a greater sense of movement through their rounded shapes. Murals with human figures were painted in bewitching colors in the palaces of Knossos and in Akrotiri, as well as in other places.

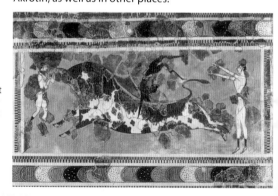

Pre- and Early History 40,000–500 BCE

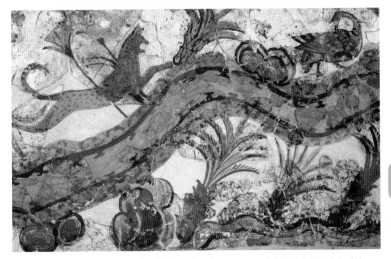

Riverscape, Late Minoan, 16th century BCE, fresco, detail of a mural, Akrotiri on Santorini

This is the earliest known pure landscape fresco—with hills, flora, birds, and predatory cats. These frescoes were discovered in the 1930s by archeologists while they were unearthing a Minoan settlement on Santo-rini. The inhabitants had abandoned it prior to a volcanic eruption around 1625 BCE. Ash covered the city, preserving the wall paintings.

Boxing Boys, Late Minoan, ca. 1500 BCE, width 92.5 cm, partly restored, Akrotiri on Santorini

This Minoan fresco, from the island of Santorini, exceeds even the ones in the palaces of Crete. It shows two aristocratic youths engaged in the sport of boxing. The fighters are nude except for loincloths. They wear earrings and jewelry of lapis lazuli, which point to their aristocratic background. They each wear a glove on the right hand for striking, while the left hand is apparently meant to ward off blows. They are depicted using a side profile, while their eyes are shown from a frontal view.

Other Minoan Works

Fisherman with Fish, pre-1600 BCE, fresco, Akrotiri on Santorini

Lilly Prince, New Palace epoch, ca. 1600 BCE, fresco, Palace of Knossos, Crete

Ladies in Blue, New Palace epoch, ca. 1600 BCE, fresco, Palace of Knossos, Crete

Ceramic Vessel in the Maritime Style, New Palace epoch ca. 1650–1500 BCE

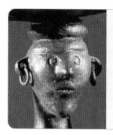

Bronze and Iron Ages in Central Europe

2000 BCE–450 BCE

■ An independent culture develops in central Europe with the onset of the early Bronze age ■ Art preserved from this time is greatly influenced by early religions ■ Mediterranean and European trade spreads artistic impulse

ca. 2000 BCE The early Bronze Age begins in central Europe

ca. 2000 BCE Usage of chariots; the metal trade begins

ca. 1000 BCE Iron production begins

ca. 800 BCE The Hallstatt era begins; local princes extend the iron ore and salt trades to compete with imports of Greek luxury items

ca. 480 BCE The La Tène era begins; Greek lotus and pattern motifs are adopted into Celtic ornamentation

from 3rd century BCE Roman influence increases with widespread pillaging across Western Europe

The successful recovery of artistic works from this period in central Europe is very rare. For example, the *Sun Chariot of Trundholm* was found broken, and the later recovered *Gundestrup Cauldron* was found sunk in a swamp. Both these pieces, along with the *Golden Hat of Schifferstadt*, which was found encased in gold sheet metal, came from tribes who deliberately hid artifacts. The work from this period originated from early religions. The burial of these items could signify past offerings to their gods. Ornamentation in the form of punched rows of pearls, beads, and circles is a common way of identifying metal work from the Bronze Age. The gold helmets are believed to have been worn by priests in cult ceremonies, and a calendar function was presumably contained within their system of ornamentation. The use of chariots became ever more important in central Europe at the beginning of the first century. The importance of vehicles is attested to by the many chariots found buried next to princes' tombs.

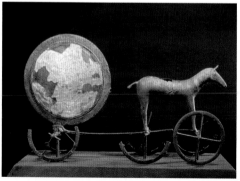

■ **The Sun Chariot of Trundholm**, 14th century BCE, bronze with gold sheet metal, Denmark National Museum, Copenhagen

Spirals and circles, symbols used throughout the Bronze Age to symbolize the sun and its divine power, are seen here embellishing the golden disc. It was likely that cultic processions existed in which a horse-driven chariot carried a model of the sun.

■ Cult Chariot from Strettweg, ca. 7th century BCE, bronze, height 33 cm, length 48 cm, Strettweg, Austria

The large, nearly nude, female figure is raising her hands to lift up a plate that was probably used to hold a vase. Because of her large, towering size, she is believed to represent a goddess or shaman. The other figures in the piece are warriors and horses, placed in a symmetrical arrangement. The wagon's construction alludes to a symbolic meaning rather than a practical one of transport. Additionally, the human and animal figures display parallels to the geometric sculpture of ancient Greece.

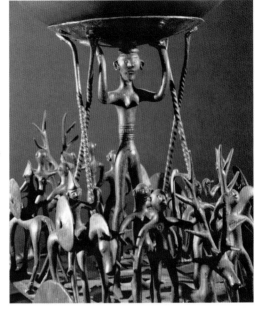

■ Gundestrup Cauldron, ca. 100 BCE, silver, gilt in parts, diameter 65 cm, weight 8.8 kg, Denmark National Museum, Copenhagen

Adorned with depictions of gods, animals, and other attributes, this work illustrates ancient Celtic-German rituals. The piece was constructed in the Donau River region in southern Germany.

■ Golden Hat of Schifferstadt, Middle Bronze period, ca. 1400–1300 BCE, gold sheet metal, 0.1–0.2 mm thick, height 29.6 cm, found in Schifferstadt, Germany

This hat is just one of four found in central Europe that were fashioned out of one thin piece of seamless gold sheet metal. That three other hats were found attests to the widespread, high level of metal craftsmanship that existed throughout central Europe during the Bronze Age.

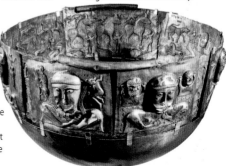

Bronze and Iron Ages in Central Europe

Antiquity

900 BCE–300 CE

Venus de Milo, ca. 130–120 BCE, marble, height 202 cm,
Musée du Louvre, Paris

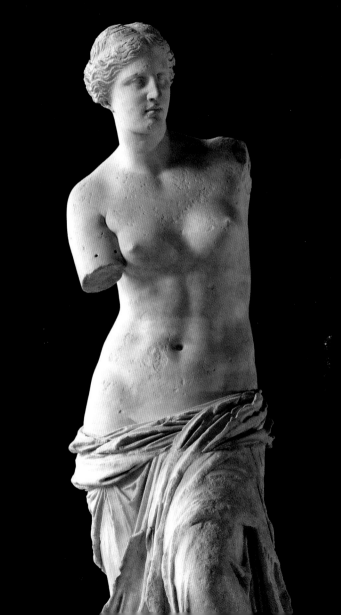

Antiquity

Greece

900

Beginning of ceramic work with geometric patterns

800

Vase paintings with figurative scenes

776

First Olympic games are held in honor of Zeus

700

Orientalizing era; Homeric epics

600

Early Archaic male and female freestanding statues

480

Beginning of the Severe Style in sculpture; *Kritios Kouros*

450

The High Classical era; the Rich Style comes into fashion; *Doryphoros* statue by the

p. 51

Greek sculptor Polykleitos; pediment figures of Zeus's temple

350

The Late Classical period; the Attic sculptor Praxiteles creates his *Aphrodite of Knidos* and *Hermes;* Lysippus sculpts *Apoxyomenos*

900 800 700 600 500 400

Etruria

900

Etruscan civilization in Italy begins

650

Greek colonies in Southern Italy influence Etruria

500

Etruscan tombs with murals

400

Capitoline Wolf and

the *Chimera of Arezzo* p. 59
are created

300

Rome comes to power

Rome

750

Rome founded

600

Etruscan kings rule in Rome

500

Rome develops into the Roman Republic

300

Ideals of Hellenistic art and culture spread throughout Rome

250

Busts from the Republican era in naturalist style

p. 52

330
Apollo Belvedere; the Greek sculptor Leochares is active; rise of the Hellenistic period; Alexander the Great reigns and expands his empire

280
Bust of Demosthenes

190
Statue of Nike Samothrace

170
Pergamon Altar; dramatic expressiveness in sculpture

150
Venus de Milo is created by Alexandros of Antioch

50
Laocoön and His Sons sculpture group; the myth of Laocoön was a popular theme in ancient Greek writing

30
Roman province establishes rule

| 200 | 100 | 1 | 100 | 200 | 300 |

200
Hellenistic Classicism and Eclecticism

100
Roman *Venus de Milo*; Hellenistic marble sculpture copy after the original by Alexandros of Antioch

50
Villa of the Mysteries, Pompeii

1 CE
Court style of Augustus; *Augustus of Prima Porta* armor statue; frieze with figures; *Ara Pacis* is commissioned by Augustus

81
Arch of Titus

110
Column of Trajan

170
Equestrian statue of Marcus Aurelius

200
Christian mural paintings in the catacombs of Rome

300
Sculpture of the Tetrarchs

330
Colossal Constantine

p. 66

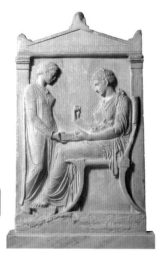

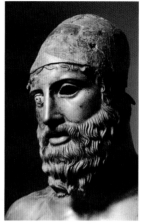

Antiquity

After the collapse of Mycenaean civilization in the 12th century BCE and the ensuing Dark Ages in Greece, development of new societies and culture began slowly in the Greek-speaking world. In the 9th and 8th centuries BCE, the increasing growth of trade led to the first encounters with civilizations of the Middle East and Egypt, which provided crucial stimuli for the continuation of an independent Greek style of art and architecture. Access to such rich cultures inspired the Greek style and promoted their understanding of the artistic and architectural innovations. Major Panhellenic sanctuaries such as Olympia, Delphi, Delos and Samos, which developed at

■ **Funeral Stele of Hegeso**, Attic, ca. 410–400 BCE, marble, height 158 cm, National Archeological Museum, Athens

■ **Riace Warrior**, Greek, ca. 430 BCE, bronze, height 197 cm, Museo Nazionale, Reggio di Calabria

■ **Dying Gaul**, Roman copy of a Greek sculpture, ca. 220 BCE, marble, height 93 cm, Musei Capitolini, Rome

Antiquity 900 BCE–300 CE

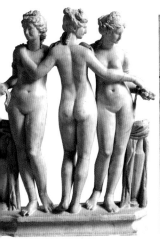

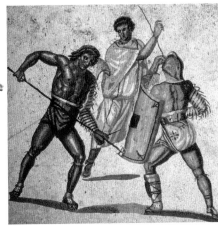

The Three Graces, Roman, 2nd century CE, marble, height 40 cm, Musée du Louvre, Paris

Gladiator Fight, Roman mosaic, 2nd century CE, 16 x 10 m, floor of the Roman villa in Nennig

this time, emerged as cultural centers, characterized by their temple architecture and numerous precious votive offerings.

Literacy had been lost and the Mycenaean script was forgotten, but after the adoption of script from the literate civilizations of the Near East, the epics of Hesiod and Homer, especially the *Odyssey* and the *Iliad*, helped create a common cultural identity among the Greek people. Centuries later, these mythological themes serve art as an inexhaustible source of topics and motifs. Ceramics of the Geometric Period were strictly patterned, with the first figurative depictions added in the 8th century BCE. From the 7th century BCE onward, Greek city states were ruled, both politically and culturally, by the aristocracy, whose preference dictated the themes and ideals portrayed in

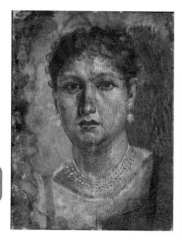

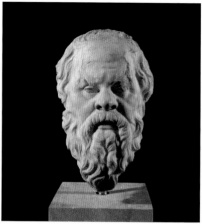

sculptures and vase paintings. Influenced by Egyptian examples, the first life-size statues of male (Kouros) and female (Kore) figures emerged during the Orientalizing era.

The human body began to be understood anatomically with the transition to a strict style known as the Classical era, which started around 480 BCE. Movement extended to the limbs and all parts of the body. The High Classical period of the 5th century BCE perfected three-dimensional renderings of the human figure, which have been preserved by a few original bronze statues and many Roman copies. Figurative sculpture reached its zenith with the Temple of Zeus and the Parthenon of the Acropolis in Athens. The Classical period in Greece has been esteemed as the high point of ancient art.

The sculpture of the following Hellenistic period, the last pre-Christian centuries, is characterized by

■ **Mummy Portrait**, ca. 150–200 CE, fresco, Ägyptisches Museum, Berlin

■ **Socrates**, ca. 340 BCE, marble, height 35.5 cm, Roman copy of Attic bronze original, Museo Nazionale Romano, Rome

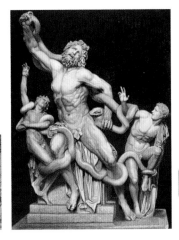

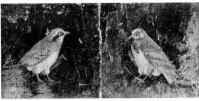

Birds, Roman, 1st century CE, mural painting, Museo Nazionale Archeologico, Naples

Laocoön and His Sons, Greek sculpture, ca. 50 BCE, marble, height 184 cm, Vatican Museum, Rome

the combination of an expressive pathos with classic forms from the 5th century. In addition, hitherto unknown topics and functions developed.

In the 2nd century BCE, Rome, having become a Hellenistic cultural province, achieved a grandeur befitting the capital of an empire and became the chief power in the area of the Mediterranean. The Roman upper classes adopted the culture of the Greeks, and gathered and copied many Greek works, most often from the Classical period. The Romans' repeated usage of Greek stylistic elements makes it difficult to define an independent style of Roman art . With their naturalist and artistic qualities, portrait busts are the most important contribution of the Romans to sculpture. Next to busts, the historic reliefs of the state are the greatest Roman genre. These pieces are excellent examples of how art served the ruling government and a higher agenda than mere decoration.

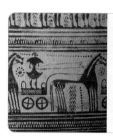

Mycenaean to Geometric Styles in Greece

ca. 1650 BCE–ca. 400 BCE

■ Mycenaean culture is considered the first high culture of the European mainland ■ Geometric era has a Greek cultural revival after the Dark Ages

■ **1650–1500 BCE** Shaft graves from Grave Circles A and B

1400 BCE First Mycenaean palace complexes and copula graves

1200 BCE Destruction of the Mycenae centers of power and their settlements; beginning of the Dark Ages

ca. 1000 BCE Beginning of the proto-Geometric era

ca. 900 BCE Beginning of the early Geometric era

850–800 BCE The time of Homer

750–700 BCE Late Geometric era

ca. 400 BCE Greek colonies in southern Italy

The beginning of the Mycenaean era is marked by the shaft graves of Grave Circles A and B (1650–1500 BCE), discovered by Heinrich Schliemann in 1876. Relics found in the Mycenaean shaft graves are thought to be status symbols of an aristocratic elite.

Mycenaean culture was heavily influenced by the Minoan culture, which had dominated the Aegean area for several centuries. The first Mycenaean palace complexes were erected around 1400 BCE. Murals played an especially important role in these palaces. The Mycenaeans also developed Linear Script B from Linear Script A. Linear Script B, a forerunner of Greek, has been decoded, while Linear Script A has not yet been deciphered. The destruction of the Mycenaean princedoms in 1200 BCE was followed by a period known as the Dark Ages. The Dark Ages were plagued with economic and cultural impoverishment, which did not end until the Geometric era.

■ **Warrior Vase**, 12th century BCE, Mycenaean ceramic, height 43 cm, National Archaeological Museum, Athens

Despite some damage, the figures on the vase are easily discernable. On this *krater*, or vase, the depiction of the deployment of the warriors offers an idea of the equipment and mode of warfare in the last phase of the Mycenaean Bronze Age. The bearded warriors wear helmets with horns, breast armor to the waist, and shin guards, and carry lances and shields. This indicates a new method of warfare involving mobile infantry. The Mycenaean aristocracy generally used two-wheeled war chariots.

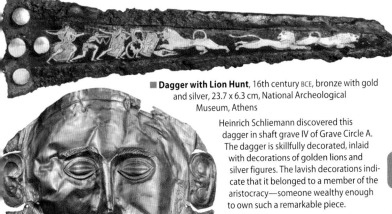

■ **Dagger with Lion Hunt**, 16th century BCE, bronze with gold and silver, 23.7 x 6.3 cm, National Archeological Museum, Athens

Heinrich Schliemann discovered this dagger in shaft grave IV of Grave Circle A. The dagger is skillfully decorated, inlaid with decorations of golden lions and silver figures. The lavish decorations indicate that it belonged to a member of the aristocracy—someone wealthy enough to own such a remarkable piece.

■ **The Mask of Agamemnon**, ca. 1500 BCE, gold, height 35 cm, National Archaeological Museum, Athens

Heinrich Schliemann thought he recognized the features of the legendary King Agamemnon in this golden mask. However, today it is known that this never could have been a representation of Agamemnon because the piece is about 300 years too old.

■ **Geometric Krater (Vase)**, ca. 740 BCE, pottery, National Archeological Museum, Athens

From Kerameikos, this vase was found in the potters' quarter and cemetery of ancient Athens. Ceramics from this period are decorated with regular geometrical lines, which is why this period is called the Geometric era. Vessels are decorated with horizontal bands, rows of meandering lines, triangles, diamonds, circles, and swastikas. As the Geometric period progressed, entire vessels were covered with these forms. At first, during the early development of the Geometric style, only animals were depicted. Human figures began to be depicted after 800 BCE. These figures are shown in silhouette—the upper body is pictured from the front while the hips and legs are shown in profile. The cult of the dead is a favorite motif of the large grave vases. On this *krater*, the dead, lying in state, the mourners, and the funeral procession are depicted in frieze form. The geometric forms that are shown on ceramics were also depicted on small sculptures.

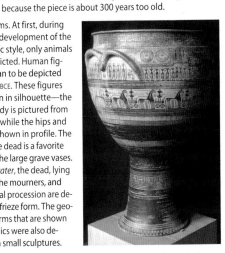

Mycenaean to Geometric Styles in Greece

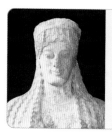

Archaic Period: Sculpture and Architectural Sculpture

700–480 BCE

■ In the *polis*, or Greek city-state, political and cultural life developed under the direction of the aristocracy ■ Greek art was influenced by Egypt and the Orient

8th century BCE A time of great sea voyages; the Greeks establish "colonies" as independent city-states in southern Italy; trade burgeons in the Mediterranean, and Corinth becomes the leading merchant power in the region

from 620 BCE Athens assumes the leading role in the export of vases to the colonial Greek cities of Italy

549 BCE Sparta unites the cities of southern Greece in the Peloponnesian Union

561–510 BCE Tyranny of Pisistratus established in Athens

508–507 BCE Reforms of Cleisthenes and the introduction of democracy into Greece

490 BCE First victory over the Persian King Darius in the Battle of Marathon

480 BCE Destruction of Athens by the Persians but the Greeks achieve a victory in the naval battle of Salamis

479 BCE Final victory by Athens and Sparta over the Persian king Xerxes in the battle of Plataea

Antiquity 900 BCE–300 CE

Art in the early Archaic period of the 7th century BCE was heavily influenced in subject matter and form by the styles of Egypt and the Middle East. These techniques were, however, reinterpreted in a Greek sense and further developed. Typical of the sculpted art of the time were male (Kouros) and female (Kore) figures. These sculptures were either used as votive offerings to gods in temples or placed on graves. These Greek statues were freestanding and do not appear to have been attached to columns as their Egyptian prototypes were. The aristocratic society, which dictated the styles and forms of art, had a preference for beauty which is expressed in the nude, athletically trained body of the Kouros. The Kouros statues were fashioned after young men of the nobility, whose education included athletic training and competition (*agone*) in the nude. However, Kore sculptures always appear clothed.

■ **Lady from Auxerre**, ca. 640 BCE, limestone, height 65 cm, Musée du Louvre, Paris

This statuette wears a cloak over the shoulders in accordance with Cretan custom. The influence of Oriental fertility goddesses is apparent in the clearly delineated breasts and the hand gesture. The stylistic development of the Kore in Archaic times is apparent in the treatment of the clothes. The folds were initially simply incised into the surface, but they eventually became more involved, developing into three-dimensional creases.

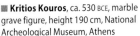

Kritios Kouros, ca. 530 BCE, marble grave figure, height 190 cm, National Archeological Museum, Athens

Until the end of the Archaic period and the beginning of the early Classical era, the Kouros figure underwent a definite change in style. In the seventh century BCE, details such as ears, hair, muscles, and knees were strongly stylized and almost ornamental in appearance. Over time, these details, and therefore the body as well, became less stylized and more naturalistic.

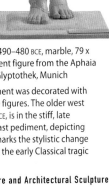

49

Other Archaic Works

Statue of a Kouros (Youth), ca. 590–580 BCE, Metropolitan Museum of Art, New York

Berlin Goddess, ca. 570 BCE, Antikensammlung, Berlin

Rampin Rider, ca. 550 BCE, head and upper torso in the Musée du Louvre, Paris, the rest in the Acropolis Museum, Athens

Apollo from Piraeus, ca. 520 BCE, National Archaeological Museum, Athens

Kritios Boy, ca. 480 BCE, Acropolis Museum, Athens

The Battle Between the Gods and the Giants, ca. 530 BCE, Museum Delphi, Athens

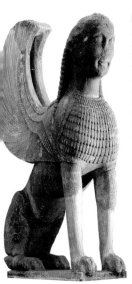

Sphinx of Naxos, ca. 560–570 BCE, marble, height 10m (incl. column), Delphi Museum

The sphinx is a mythical monster with a woman's head, the chest and wings of a bird, and the body of a lion. A popular theme in Archaic art, sphinxes can be found in Egyptian and Oriental art as well, often as guards. This example was found perched atop an Ionic column.

Fallen Warrior, 490–480 BCE, marble, 79 x 183 cm, east pediment figure from the Aphaia Temple on Ägina. Glyptothek, Munich

This temple's pediment was decorated with marble battle scene figures. The older west pediment, ca. 500 BCE, is in the stiff, late Archaic style. The east pediment, depicting the battle of Troy, marks the stylistic change from late Archaic to the early Classical tragic liveliness.

Archaic Period: Sculpture and Architectural Sculpture

Black- and Red-Figure Pottery

early 7th century BCE—late 4th century BCE

■ Surviving works reveal great painting talent ■ The pottery gives insight into the styles of wall and panel paintings, of which almost none remain

early 7th century BCE Oriental Period—Black-figure vase painting originates in Corinth and speads to Attica

ca. 590–580 BCE The great vase painter Sophilos is active

ca. 530 BCE The Andokides Painter develops the red-figure technique

ca. 550 BCE–525 BCE Exekias is active creating pottery with battle scenes

mid 6th century BCE Athenian vase painters develop narratives in their work

late 4th century BCE Black and red-figure vase painting ends

■ **Fighting Warriors**, by Kleimachos, ca. 560–550 BCE, black-figure, fragment of a *hydria* (water vessel), Musée du Louvre, Paris

Two soldiers face each other in battle. A dead or wounded man lies on the ground. In the black-figure technique, first the outline of the figure is blocked out, then the interior details are glazed. When fired, the glaze becomes a gleaming black, while the background remains pale.

During the Early Archaic period, 7th century BCE, vase designs reflected oriental influences. The most common design was the animal frieze, which often included mythic creatures from the East. Corinthian workshops first introduced the black-figure technique at the beginning of the 7th century BCE. In the 6th century, Athenian craftsmen from the area of Kerameikos took the lead in the export of Greek ceramic and perfected the technique. In black-figure, detailed interior modeling of the figures is achieved through etching, which allows for a complex figural composition. Women are always depicted in white and men in black. The red-figure technique was developed around 530 BCE and came to replace the black-figure technique. The quality of craftsmanship in figural vase paintings began to decline throughout the 5th century, and in the 4th century it was given up entirely.

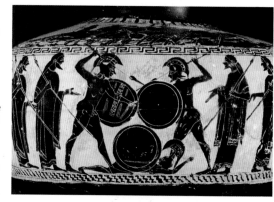

■ François Vase,
ca. 570 BCE, black-figure, 66 x 181 cm, Museo Archeologico, Florence

The vase is named for its discoverer Alessandro François. Signatures cite Klitias as the painter and Ergotimos as the potter. The scenes, rendered in the black-figure style, depict the heroic adventures of Theseus and Achilles.

■ Adventures of Theseus,
by Kodros, ca. 440 BCE, red-figure bowl, diameter 33 cm, British Museum, London

Depicted are the heroic adventures of Theseus. In the middle, Theseus drags the dead Minotaur from the Labyrinth. Vase-paintings depicted themes preferred by the ruling aristocrats, such as war, sports, and social events .

51

Black- and Red-Figure Pottery

Other Black- and Red-Figure Works

Achilles and Ajax Playing a Dice Game, by Exekias, ca. 540–530 BCE, black-figure, Vatican Museums, Rome

Column Krater, by Lydosea, 550 BCE, black-figure, Metropolitan Museum of Art, New York

Herakles Wrestling Antaios, by Euphronios, ca. 510 BCE, red-figure *krater*, Musée du Louvre, Paris

Satyr and Maenad, ca. 500–490 BCE, red-figure, Getty Museum, Los Angeles

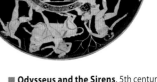

■ Odysseus and the Sirens, 5th century BCE, red-figure *stamnos*, height 36 cm, British Museum, London

Changes in vase painting techniques meant that instead of first tracing the black figures, the entire surface of the pot was covered in glaze, leaving only the figures bare. The interior details were no longer etched in glaze, but could be painted in, which allowed for a more fluid style. Signatures appear on the more beautiful vessels, naming both the painter and potter. This *stamnos* (wine vessel) by the Siren Painter shows Odysseus and the sirens, a scene from Homer's *Odyssey* about his journey home after the Trojan War.

Black- and Red-Figure Pottery

Classical Antiquity

508–404 BCE

■ After the Greek victory over the Persians in the 5th century, Athens became the fifth power in Greece ■ Literature and art reached their peak at the beginning of High Classicism ■ Sculptures created during the Classical period became models for European carvings throughout Antiquity and the Renaissance

■ **508–507 BCE** The fall of the tyrants and institution of democracy in Athens

480 BCE Destruction of the Athenian Acropolis by the Persians

480–479 BCE Victory of the Greeks over the Persians at Plataea and Salamis; Athens becomes the cultural center of Greece; renaissance of art, literature such as tragedies and comedies, and philosophy

431–404 BCE Peloponnesian War, defeat of Athens by Sparta

■ **Poseidon**, ca. 460 BCE, bronze, height 209 cm, from Cape Artemision. National Museum, Athens

A most arresting bronze sculpture, the *Poseidon's* gesture makes one physically sense the movement of the missing trident.

Early Classicism, with its strict style, overcame the rigidity of the Archaic period and brought a fresh sense of movement and corporeality to the figure, as expressed in the pediments and metopes of the Temple of Zeus in Olympia. During the Classical period, individual artists became distinguishable for the first time. Polykleitos, Myron, and Phidias number among the masters of High Classicism. Under the direction of Phidias, the monumental idol statues of *Zeus* in Olympia and *Athena* in the Parthenon temple on the Athenian Acropolis were constructed, of which small replicas can give only an approximation of their greatness. The Late Classical period expanded on these freedoms of technique and execution, as can be seen in the works of Lysippos, Praxiteles, and Skopas, the most important sculptors.

Other Important Classical Works

Head of a Blond Youth, ca. 485 BCE, Acropolis Museum, Athens	Classical Antiquity, Sparta
Venus Genitrix, Roman copy, ca. 480 BCE, Musée du Louvre, Paris	Harmodios and Aristogeiton (The Tyrant Murderers), ca. 477 BCE, National Museum, Naples
Leonidas, King of Sparta, ca. 480 BCE, Museum of	Charioteer of Delphi, ca. 470 BCE, bronze original, Delphi Museum, Greece

Antiquity 900 BCE–300 CE

Colonna Venus, ca. 180 CE, slightly adapted Roman copy of the *Aphrodite of Knidos* by Praxiteles, ca. 350–340 BCE, marble, 209 x 83 x 73 cm, Museo Pio-Clementino, Rome

Already in antiquity, Praxiteles provoked a sensation with his sculpture *Aphrodite*, which stood in the shrine at Knidos. In Early Classicism, still fully covered by drapery, the sculptures of the "wet style" began to show details of the female form. With his unclothed *Aphrodite*, Praxiteles created the first female nude in art history. This sculpture, one of several Roman copies, is here identified as Venus. It approximates the quality of the original, even though some of the Roman copies changed the hand positioning to a protective gesture of embarrassment. The sculptures are ideals of feminine beauty.

Discus Thrower, Roman copy of bronze original by Myron, ca. 450 BCE, marble, height 170 cm, British Museum, London

Found 1781 on the Esquilin in Rome, the *Discus Thrower* stands in transition between the "strict style" and the High Classical style of the 5th century BCE. The artist succeeded in capturing the entire dynamic movement leading to the release of the discus into one concentrated moment. Despite the inner tension, the composition exhibits a balance in direction and movement that supplies a proverbial "classic" sense of calm and equilibrium. The anatomical details and musculature of the athlete are reproduced in perfect realism.

Seer, ca. 470 BCE, marble, height 138 cm, from the east pediment, Temple of Zeus at Olympia. Archeological Museum, Olympia

The east pediment's sculptures depict the chariot race between King Oenomaus and Pelops, who vied for the hand of the king's daughter. The realistically depicted *Seer* knows the tragic outcome of the race.

Doryphorus

Polykleitos of Argos (ca. 450–420 BCE) was one of Antiquity's most famous and heavily imitated sculptors. Though now lost, Polykleitos's work exhibits his *Canon of Proportions*, which sought to describe the ideal body proportions based on mathematical ratios. Polykleitos also appears to have co-developed the contrapposto stance, in which the figure's body weight is shifted onto one foot, leaving the other slightly bent. This stance was much more natural than earlier poses and created a greater sense of realism. Contrapposto was the first pose to allow the influence of gravity to affect the relationship between the figures' muscles and limbs. His representation of human anatomy became a foundation and standard for European carving and sculpture up until modern art in the 20th century.

■ **Diadumenos**, Argivian, antique copy from the 1st century BCE, marble, height 195 cm, National Archaeological Museum, Athens

Found in Delos, this marble copy of *Diadumenos* shows a young athlete tying on a diadem, the ribbon band used in ancient Greece to identify the winner. The athlete is shown as though he is in mid-step, evoking a great sense of dynamism and life throughout the entire posture. Although his arms are broken off at the wrist, it is apparent that he is focused on his action. The bronze original, from around 420 BCE, is attributed to Polykleitos because stylistically, the sculpture parallels his other works.

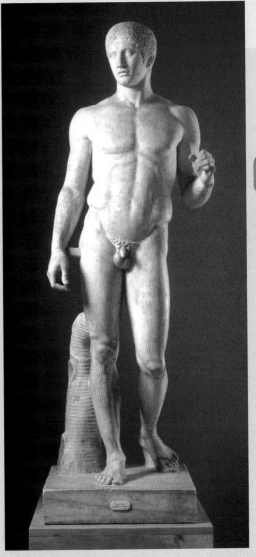

■ **Doryphorus**, Roman copy of the bronze original from 440 BCE, marble, height 212 cm, Museo Nazionale, Naples

Doryphorus, the spear bearer, is known only through a collection of Roman marble copies. It is assumed that the figure of *Doryphorus* was used by Polykleitos as a practical example and demonstration of his "canon" theories. The unweighted leg is pulled back even further compared to *Kritios Kouros*. Due to the figure's shifted center axis, the body forms a soft S-curve. The contrapposto stance creates tense and relaxed regions of the body on opposite sides. Polykleitos created the ideal build of an athlete.

■ **Kritios Kouros**, late Archaic/ Early Classical, ca. 490–480 BCE, highest fragment 86 cm, original figure 117 cm, Acropolis Museum, Athens

Kouroi began to distribute their weight between a weighted and an unweighted leg for the first time. The tension and repose that settles into the slightly tilted hips is revealed in the musculature of the upper body. Because this sculpture was found in the rubble of the Athenian Acropolis, and was clearly created only shortly before the city was destroyed in 480 BCE, the date is accurate.

Doryphorus

Hellenistic Art

404–31 BCE

■ The influence of Greek culture spreads across the world with the empire of Alexander the Great (356–323 BCE) ■ Rome was also a Hellenistic cultural center ■ There is a plurality of themes and diverging styles ■ The influence of both late antiquity and Lysippus introduces an expressive pathos into art

Other Hellenistic Works

Drunken Old Man, 3rd century BCE, Glyptothek, Munich

Barberini Faun, ca. 220 BCE, Glyptothek, Munich

Laocoön and His Sons, 1st century BCE, Vatican Museum, Rome

Nike of Samothrace, ca. 190 BCE, Musée du Louvre, Paris

The influence of the sculptor Lysippus and his school remained prominent within the sculpture of early Hellenism. The classical realism of Late Antiquity grew to a solemn, almost baroque dramatization by the middle of the 2nd century BCE. The sculpture of the *Dying Gaul*, the large votive offering of the Attalians from around 220 BCE, or the subsequent *Winged Victory of Samothrace* were examples of this trend. Retrospective tendencies, as well as a greater tendency toward expressiveness, greatly shaped the art during the late Hellenistic period, leading to an unprecedented number of styles.

■ **Venus de Milo**, end of the 2nd century BCE, marble, height 202 cm, Musée du Louvre, Paris

The *Venus de Milo*, also known as the *Aphrodite de Milo*, is an example of the Classical current within Hellenism, or the return to the model of Late Antiquity. Despite the missing arms, a pronounced allusion to the *Aphrodite from Capua* from the late 4th century BCE can be made. The latter sculpture holds within her outstretched arms the shield of her beloved Ares, in which she regards her own reflection.

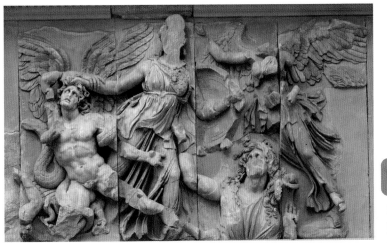

■ **Pergamon Altar**,
ca. 180 BCE, east frieze of the Zeus Pergamon Altar, Pergamon Museum, Berlin

Athena is depicted in the war between the Olympian gods and the Titans, which symbolizes the victory of Pergamon over the Celts. The Late Classical sculptures have a great sense of pathos and realism.

■ **Aphrodite, Pan, and Eros**,
ca. 100 BCE, marble, height 130 cm, excavated at Delos. National Archeological Museum, Athens

The lustful Pan, god of the woods, grabs Aphrodite by the arm, pulling her close. She laughingly defends herself with her sandal. Even Eros, the winged god of love, admonishes Pan with force. This portrayal has strong sexual references and is borrowed from the myth of Dionysus, the god of wine, which deals with intoxication and sensuality. In this time, patrons were able to commission new themes, and their own personal preferences, such as eroticism, can be found in art from the private realm. These examples served as a prototype for much of the later Baroque period in Europe. Aphrodite is realistically modeled and the dynamism of the interaction between the figures is intense.

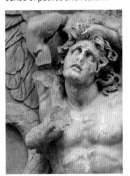

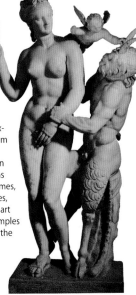

The Etruscans

ca. 700–90 BCE

■ Etruscans origins are disputed ■ Trade relationships throughout the Mediterranean brought influences from the Orient, but the dominant influences were from Greece ■ Masterpieces in bronze work ■ Innumerable wall paintings and art objects from the necropolises of Tarquinia and Cerveteris

■ **ca. 700 BCE** Graves, rich in grave goods and grave paintings

620–509 BCE Etruscan kings in Rome

550 BCE Alliance with Carthage against the Greek city-states

474 BCE Defeat of the Etruscan fleet by Syracuse near Cumae; end of the Etruscan naval power

396–262 BCE The individual city-states are successively captured by Rome and dissolve into the Roman Empire

90 BCE Granting of Roman civil rights

As in Greece, beginning in the 8th century BCE, the Etruscans developed city-states under the leadership of an aristocracy. In the 7th and 6th centuries BCE, the Etruscan city-states controlled central Italy. The growing trade relationship with the Greek city-states of Italy led to the adoption of Greek culture and practices. Despite this, the Etruscans also maintained their own cultural traditions from the Iron Age. Etruscan cemeteries have revealed a lot about their culture. In contrast to the Greeks, but like the Egyptians, the Etruscans believed in an afterlife. This belief influenced the richly painted tombs of the nobility. Already prized during antiquity were Etruscan tools and artwork made from bronze like the *Capitoline Wolf*, the symbol of Rome, or the *Chimera of Arezzo*. The independent Etruscan character disappeared in later times under the dominance of the Greeks.

■ **Etruscan wall painting**, first half of the 5th century BCE, Tomb of the Leopards, Tarquinia

The burial chamber, richly outfitted with wall paintings, depicts a Greek-style banquet scene. The participants lounge in pairs on sofas and are served by slaves, while being entertained with music and dancing. In contrast to Greece, Etruscan women were allowed to join such events.

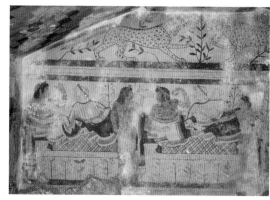

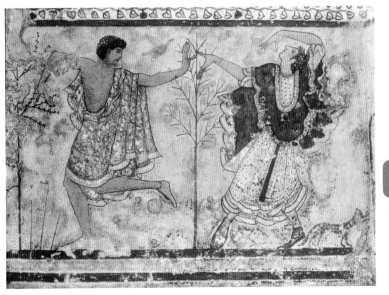

Other Important Etruscan Works

Chariot, ca. 550–525 BCE, bronze, 130.9 cm, Metropolitan Museum of Art, New York

Apollo of Veio, ca. 500 BCE, terracotta, height 175 cm, Museo Villa Giulia, Rome

Capitoline Wolf, ca. 500 BCE, bronze, height 85 cm, Museo Capitolino, Rome

Chimera, 5th century BCE, bronze, height 80 cm, Archeological Museum, Florence

■ **Sarcophagus of a Married Couple**, end of the 6th century BCE, terracotta, 220 x 141 cm, Museo Nazionale di Villa Giulia, Rome

The couple is depicted atop the sarcophagus in a relaxed pose, as if they were guests at a banquet. The influence of Archaic Greek sculpture is evident in the formation of the faces and hair. The rounded figures' sarcophagus is shaped like a sofa, thus showing Oriental, not Greek, influences.

■ **Dancing Couple**, ca. 470 BCE, wall painting, National Archaeological Museum, Tarquinia

The dancing couple conveys a sense of sensuality and joy in life, which is completely typical of Etruscan art. Also common in Etruscan painting is the portrayal of men with a darker skin tone than women.

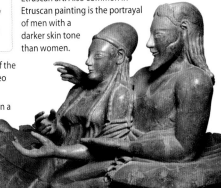

The Etruscans

Roman Portrait Busts

Although influenced by Greek models, portrait busts are deemed the most important Roman contribution to the sculpture of antiquity. Tributes and effigies were erected in public plazas since the Republican period. They sought to disseminate core values and principles through an appreciation of the subject and his accomplishments. In the later empire, which encompassed numerous provinces, representations of the emperor served an important function. Even when far away from Rome they symbolically expressed the presence and power of the sovereign. To that end, selected imperial effigies from Rome were copied and disseminated en masse.

■ **Bust of Caesar**, ca. 50 BCE, marble, Kunsthistorisches Museum, Vienna

The bust of Caesar, Roman statesman and general, with vigorous features, depicts the successful general, who embodied an ideal military aptitude—*virtus*. Instead of conforming to classical Greek idealization, the Roman tradition of naturalistic depictions during the Republican era reveals itself in the realistic representation of facial features and wrinkles. The origins of the effigies were wax masks prepared at the deathbed.

■ **Octavian**, ca. 39 BCE, marble, portion of a life-size statue, portrait bust from the Forum Arles. Musée Lapidaire Paien, Arles

Octavian is shown with a short beard, a sign of mourning after the murder of his adoptive father, Julius Caesar. The idealistic depiction follows the widely disseminated images of Alexander the Great as a youthful hero. The typical *anastolé*, or backswept curls, are only implied.

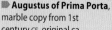

▶ **Augustus of Prima Porta**, marble copy from 1st century CE, original ca. 20–17 BCE, height 204 cm, Vatican Museum, Rome

Roughly 250 busts of Augustus have survived. This statue is the main prototype for them. With regal lines, the facial forms absorbed Classical Greek modes of representation. The idealized appearance expresses the majesty (*auctoritas*) and dignity (*dignitas*) of the sovereign.

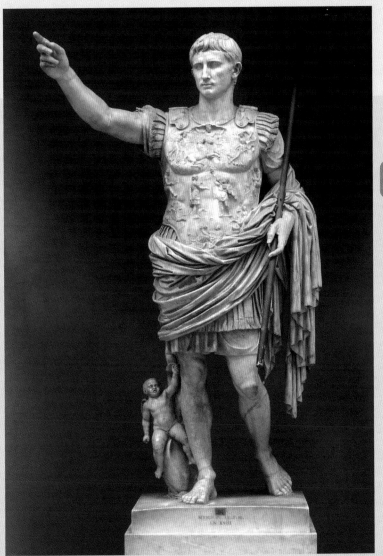

The Augustinian Period

202 BCE–96 CE

- The Roman upper classes of the Late Republic adopted Hellenistic culture
- Greek artworks came in great numbers to Rome ■ Artists and workshops copied Classical models ■ Busts of the emperor and reliefs depicting political scenes in the Classical style appeared throughout the entire empire

202–31 BCE Late Roman Republic, predominance in the Mediterranean area

31 BCE Triumph of Octavian over Antony and Cleopatra at Actium, Roman Republic becomes the Roman Empire

31 BCE–14 CE Augustus's Reign; beginning of the Roman Empire

14–37 CE Reign of Tiberius

41–54 CE Reign of Claudius

54–68 CE Reign of Nero

69–96 CE Flavian Dynasty

79–81 CE Titus's reign; Mt. Vesuvius erupts in 79 CE

81–96 CE Domitian's rule

After the murder of Caesar and the triumph of Octavian, who later became Augustus (27 BCE–14 CE), the Roman Republic transformed itself into an empire. During the first one-and-a-half centuries, the Empire underwent a time of peace, *Pax Romana*, and flourished culturally. To avoid the image that he was creating a new monarchy, and in order not to suffer the same fate as Caesar, Augustus solidified his political position by retaining certain aspects of republican government, such as the Senate and other government offices. Augustus propagated a style of Classicism that followed Classical Greek. His successors, the Julio-Claudian and Flavian dynasties (69–96 CE), expanded the empire's borders and sought to extend the stylistic continuation of Augustinian Classicism throughout the Empire with state monuments and reliefs.

■ **Large Parisian Cameo**, ca. 40 CE, sardonyx, 31 x 26.5 cm, Cabinet des Medailles, Musée du Louvre, Paris

The Roman Empire had high standards of carving, and most artists utilized different colored layers of stone. Here, the Emperor Tiberius and his wife, Livia, are shown; underneath them appear the personifications of conquered lands, followed by a sphere of gods.

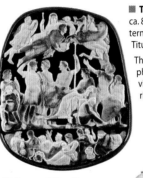

■ **The Spoils of Jerusalem** ca. 81 CE, section of the left internal relief from the the Arch of Titus, Forum Romanum, Rome

This relief decorates a triumphal arch, celebrating Titus's victory. The procession carries the spoils from the Temple of Solomon in Jerusalem.

■ **Statue of Claudius as Jupiter**, ca. 50 CE, marble, Vatican Museum, Rome

This statue depicts Claudius, the Roman emperor from 41–54 CE, as Jupiter with a *corona civica*—wreath of leaves—and an eagle. It should be noted that this depiction does not equate the emperor with a god, but rather symbolizes the idea that the emperor possesses the same amount of power on Earth that Jupiter, father of the gods, possesses in the cosmos.

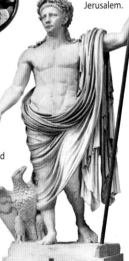

■ **Ara Pacis**, 9 BCE, detail of north frieze, marble, length 10.5 m, Ara Pacis Museum, Rome

This "Altar of Majestic Peace," commissioned by Augustus, was consecrated in the 9th century BCE on the occasion of his return from the battlefields of Gaul and Spain. The iconography depicts the inaugural procession, with Augustus, his successor Tiberius, consuls, lictors, priests, and the royal family hierarchically organized by familial rank. Later reliefs depicted the Julian dynasty genealogy according to Aeneas.

The Roman Empire

96–337 CE

- Culturally, Rome remained part of the Hellenistic world ■ Borrowed freely from Greek styles ■ Some distinctly Roman genres of art, such as portrait busts, historic reliefs, and relief-sarcophagi, develop ■ Roman sculpture develops few new techniques

96 CE Five Good Emperors

98–117 CE Trajan Empire grows to its largest size

117–138 CE Hadrian

138–161 CE Antoninus Pius

161–180 CE Marcus Aurelius

193–284 CE Late Empire and soldier-emperors

250 CE Persecution of Christians

284–324 CE Tetrarchs: four-part division of the empire

306–337 CE Constantine the Great ends the persecution of the Christians

■ **Ludovisi Battle Sarcophagus**, 251 CE, marble, 273 x 153 x 137 cm, Museo Nazionale Palazzo Altemps, Rome

Crowded together, the ceramic figures emerge from the sarcophagus and are almost fully three-dimensional. By the 2nd century CE, marble sarcophagi were the most important genre of Roman sculpture, with a succession into early Christian art. Later, during the Renaissance, they became important artistic inspirations.

The 2nd century CE was a period of political stability, and Rome was at its economic as well as cultural height. During the time of "The Five Good Emperors," competent leadership abounded, and the emperors Trajan and Hadrian, from a province in Spain, ascended to the throne for the first time. Theaters, amphitheaters, circuses, and thermal baths provided the basis for the people's education and entertainment. In the 3rd century, the rule of the soldier-emperors created political crises. In historical reliefs, funded by the government, art continued to serve political purposes and developed in the relief-sarcophagi. The theme of a sculpture and its intended function determined which of the older Greek styles would be used.

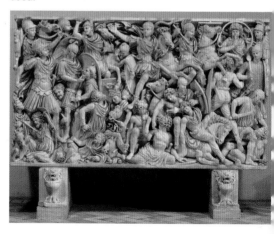

Antiquity 900 BCE–300 CE

■ **Flavian Woman**, 80–90 CE, marble head on modern bust, Museo Nazionale Romano delle Terme, Rome

This bust of Julia, daughter of Titus, was fashioned using the Classicist simplicity of the Augustan period. The curled hair, achieved by drilling deeply into the marble, demonstrates the sculptor's mastery of the medium.

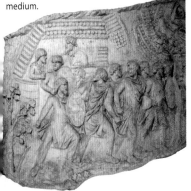

■ **Relief from the Column of Trajan**, 113 CE, plaster cast of the marble original of the *Column of Trajan* in Rome, height 90–125 cm, Muzeul Naţional de Istorie a României, Bucharest

Trajan's victory in the Dacian War is one of the images shown on *Column of Trajan*, which narrates two victorious military campaigns against the Dacians in over 100 continuous scenes.

■ **Emperor Marcus Aurelius**, 161–180 CE, marble, Museo Capitolino, Rome

This portrait of Marcus Aurelius follows the rule of ideals that Emperor Hadrian (117–138 CE) introduced. Typical of this style, Aurelius is shown with a beard and long, curly hair. Instead of following the Classicist example of the leader as athletic warrior and commander, as was common during Augustus's rule and that of his successors, this novel portrayal of the ruler orients itself toward the portraits of philosophers and the erudite. By using the ideals associated with education, the emperor shows himself to be part of the Hellenistic cultural tradition. The ringlets of hair result in a delightful play of light and shadow.

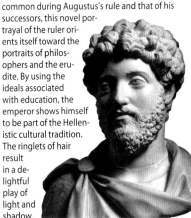

Roman Painting

after 600 BCE–200 CE

■ As early as Greek Antiquity, painting reached a standard that European art would not again match until the 16th century ■ Nothing has survived of painting on natural materials such as wood panels ■ Murals and reflections of painting in other genres provide clues to other lost art

■ **6th and 5th centuries BCE** Etruscan tomb painting

ca. 460–447 BCE Polygnotus is active; tiered grading in composition

ca. 435–390 BCE The painter Zeuxis is active in southern Italy; light and shadow painting

ca. 370–320 BCE The artist Apelles creates portraits, including some of Alexander the Great

2nd century–79 CE Four styles of Pompeii mural painting

1st–3rd century CE Roman-Egyptian mummy portraits

■ **Battle of Alexander**, ca. 390 BCE, mosaic, 12 x 2.71 m, Museo Nazionale Archeologico, Naples

The picture of the unhelmeted, forward-surging Alexander against the fearfully retreating Persian emperor glorifies Alexander's victory over Darius III in the Battle of Issus in 333 BCE. The mosaic was unearthed in Pompeii's Casa del Fauno and is thought to be modeled after a 4th century Greek painting by Philoxenos.

As represented in Classical sources such as Pliny the Elder's *Naturalis Historia*, painting in Greece enjoyed an equally important status as sculpture. Sadly only a few works survive, notably mural painting (*al fresco*, which means that paint was applied to wet plaster, or *al secco*, in which paint was applied to dry walls), which allows the quality of masterpieces passed down through literary sources only to be surmised. Etruscan murals, vase painting, mosaics, and the adoption of Greek models in Roman mural painting beginning in the 1st century BCE all provide clues. These were found in the cities buried by Mt. Vesuvius' eruption. Like sculpture, Greek painting was held as the basic model in Roman times. Portrait painting played an important role in Roman ancestor worship. The mummy portraits from Imperial Egypt are an example of this.

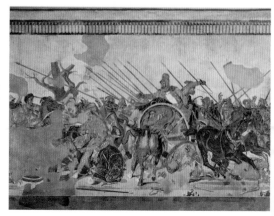

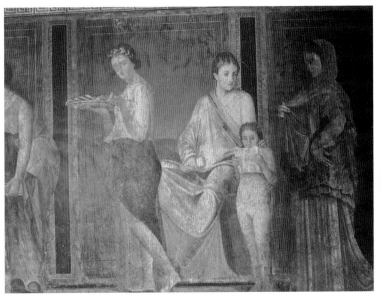

■ **Pompeii Mural Painting**, mid 1st century BCE, detail of a wall painting, Villa dei Misteri, Pompeii

The fresco presumably depicts a scene from an initiation ritual by women in the cult of Dionysus. The high artistic standard of the picture demonstrates the status of the cities of Pompeii and Herculaneum, which were buried by Mt. Vesuvius.

■ **Herculaneum Painting**, ca. 70 CE, mural, 218 x 182 cm, Museo Nazionale, Naples

The mythological scene depicts the finding of Telephos by his father, Hercules.

Other Roman Works

Grave of the Tuffatore, ca. 480 BCE, Archeological Museum, Paestum

Cubiculum (bedroom) from the Villa of P. Fannius Synistor, ca. 40–30 BCE, Metropolitan Museum of Art, New York

Fragment of Wall Painting from a Villa in Pompeii, ca. 70–79 CE, Musée du Louvre, Paris

Late Antiquity and the Middle Ages

300–1450

God the Father as the Creator, from *Bible Moralisée*, first half of the 13th century, opaque colors and gold on parchment, Österreichische Nationalbibliothek, Vienna

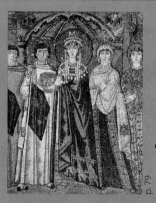

650–800
Irish and Anglo-Saxon Illuminated Manuscripts

Irish monasteries create ornate monograms at the beginning of illuminated texts

p. 79

780–900
Carolingian Illumination

During the Carolingian Renaissance, Christian themes from the West combine with Classical design elements

300 400 500 600 700 800

330–850
Early Christian Mosaics and Painting

Mosaics combine Christian subject matter with classical design elements

p. 86

632–1850
Islamic Painting

Image avoidance occupies the center of the Islamic conception of art, leading to the dominance of calligraphy and arabesque ornamentation

850–1453
Byzantine Medieval Period

Religious icons emerge as a new pictorial form

the Middle Ages

p. 112

1150–1450
Gothic Art

Stained glass windows in the French Gothic cathedrals and a courtly style in illuminated manuscripts

1250–1370
Trecento Painting

Giotto

1267–1337

Duccio di Buoninsegna
ca. 1250–1318/19
Simone Martini
1284–1344

| 900 | 1000 | 1100 | 1200 | 1300 | 1450 |

900–1050
Illuminated Manuscripts, and Murals

Stylization and simplification take effect on illumination, murals, and stained glass

1050–1150
Romanesque Art

Little influence of Antiquity can be found in the art of Germany, England, and Spain

ca. 1400
International Gothic style

Throughout Europe, the High Gothic courtly style combines with Italian influences and realistic characterizations

p. 108

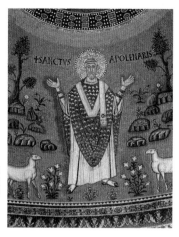

An Illuminated Era

God the Father as the Creator from the *Bible Moralisée*
—a Bible with a theological-moral exegesis from
Champagne, ca. 1325—vividly symbolizes the art of
European medieval Christianity. The illumination typ-
ifies the Middle Ages as a period of important me-
chanical inventions, advancing technology, and
scientific discoveries. This period begins with the
victory of Constantine the Great under the sign of the
cross at the Milvian Bridge in 312. In the Byzantine
world, Greek was spoken, people were closer to An-
tiquity, and the styles of that era remained present,
despite being forgotten in the West for several centu-
ries. The mosaic was the most defining medium of
pictorial exposition for the Eastern world, while in the
West, besides mural painting, the manuscript took
center stage. The codex, which consisted of folded
and stitched-together sets of 24 vellum pages, was

■ **St. Apollinare**,
ca. 549, mosaic,
Basilica di Sant'
Apollinare en
Classe, Ravenna

■ **Illuminated
Page**, ca. 680–720,
opaque paint on
parchment, *Lindis-
farne Gospels*.
British Library,
London

Late Antiquity and the Middle Ages 300–1450

■ **St. Luke the Evangelist**, ca. 816–45, opaque paint on parchment, Evangéliaire d'Ebbon. Bibliothèque Municipale, Espernay

■ **The Triumph of the Archangel Michael over the Dragon**, ca. 975, opaque paint on parchment, Apocalypsin Commentarius. Museo Capitular de la Catedral, Gerona

embellished with extravagant illuminations and gold-leaf ornamentation. These manuscripts shaped Western art prior to the advent of panel painting in about 1200. While Irish monks in the 7th century primarily adorned the initials of the text or even entire pages with pure ornamentation, figurative illustrations appeared in the Court School of Charlemagne, especially in depictions of the evangelists. The French sovereign, who was crowned in Rome in 800, was the first emperor of the re-created Roman Empire, and he heralded the Carolingian Renaissance. A crucial element when analyzing art from this period is that images can only be extrapolated to a limit, because so much knowledge pertaining to them has been lost. However, it is known that every element of the images carried a meaning or symbolism that, in its time, was easily understood by the populace.

Introduction

From Romanesque to Gothic

Romanesque art was influenced by the founding of new religious orders. Following the Benedictines, the Cluniacs (Cluny) and Cistercians (Cîteaux), who first and foremost shaped the genres of architecture and sculpture, influenced the entire epoch. Starting in the 11th century, illustrated narratives appeared in increasing numbers on church walls, functioning as pictorial sermons for the mostly illiterate faithful. Romanesque Europe, composed of small feudal states stretching from Scandinavia to Sicily and from Spain to Italy, was united by the Christian faith and the cultural and literary language of Latin. As a result of the Crusades and pilgrimages, even laymen became mobile, and art began to travel across the continent. Byzantium and Islam also impacted artistic development. The Gothic period, with the construction of elaborate cathedrals, constituted the golden age of stained glass. Architectural advances meant the walls

Initial I, ca. 1111, opaque paint on parchment, *Moralia in Job*, manuscript 173, f. 41. Bibliothèque Municiple, Dijon

Master Bertram: The Creation of the Animals, 1379–83, tempera on wood, 80 x 51 cm, Petrikirche, Hamburg. Hamburger Kunsthalle

Late Antiquity and the Middle Ages 300–1450

■ **Simone Martini: The Miracle of the Child Falling from the Balcony**, ca. 1324, tempera on wood, Pinacoteca Nazionale, Siena

■ **A Doctor Lets the Blood of a Patient**, ca. 1240, opaque paint on parchment, 26.5 x 21.5 cm, Makamat, Abu Muhammed al-Kasim Hariri, Ms. C23, vol. 12a. Institute for Oriental Studies, St. Petersburg

could now be opened up, and light poured in through windows as an expression of the divine. Simultaneously, in Italy, owing to the close association with the Byzantine Empire and the architectural and sculptural carryovers from Antiquity, an entirely different style developed in painting that was oriented more toward the naturalism of Antiquity than the art north of the Alps. For the first time, painters' names and biographies became important, in a way giving birth to the "modern" artist. Although still very dependent on patronage, be it the court or the church, artists and their workshops became famous and highly lauded. It is noteworthy that all of these periods featured iconoclastic controversy—Byzantium as well as the West and Islam asked themselves whether it was admissible to portray God and the saints. This commonality across all periods and religions stands in contrast to repeated reemergences of the naturalistic pictorial idiom of Antiquity.

Introduction

Early Christian Art

313–843

■ Started in the city of Byzantium (today Istanbul) ■ Additional centers of art developed in the Eastern Roman Empire ■ In the city of Ravenna, mosaics, illuminations, murals, and icons using antique forms became infused with a Christian context

■ **313** Constantine I issues the Edict of Milan

324–330 Constantinople is founded

402–476 Ravenna is the Eastern Roman Empire's capital

527–565 Tenure of Emperor Justinian I; the revival of antiquity in art

532–751 Ravenna becomes the center of administrative activity for the Byzantine Empire

726–843 The Iconoclastic Controversy between Iconoclasts and Iconodules

When Constantine the Great won the Battle of the Milvian Bridge in 312, his Late Antiquity military victory had a decisive influence upon the history of European art. With his Roman adversaries defeated, Constantine was able to enforce Christianity as a religion. Byzantium, later renamed Constantinople, became his new capital city, a development that eventually led to the foundation of the Eastern Roman Empire in 395. Further cultural centers developed subsequently in the cities of Ravenna and Thessaloniki, where Greek traditions had a stronger cultural influence than Roman heritage. Here Byzantine art expressed the combination of new Christian themes with antique art forms in murals and patterned mosaics. Because many mural paintings were chipped away and painted over, it is unfortunately difficult to study them. However, the décor of many churches, above all in ⟳

■ **Vienna Genesis**, 550, purple parchment, script in silver ink, 31.8 x 25.8 cm, National Library of Austria, Vienna

This famous image belongs to the oldest surviving illuminated manuscripts from the eastern realm of the Byzantine Empire (probably Syria). The book of Genesis is related here upon purple-colored parchment. Depicted is Jacob's first encounter with his future wife Rachel, along with that of his second wife, Leah.

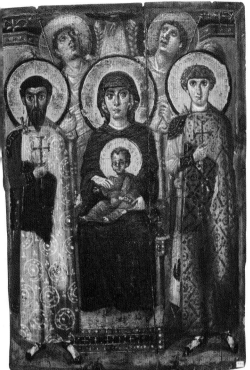

The Byzantine Empire

■ **Throned Madonna with Child, the Saints Theodore and George, and Two Angels**, 6th–7th centuries, encaustic on wood, 66.5 x 48 cm, Saint Catherine's Monastery, Mount Sinai

The worship of icons began during early Christianity. From the very beginning an icon (Greek *eikon*, image) was not for artistic enjoyment, but for the practical realization of the saints on Earth—as a saint was believed to be present in reality through the icon. Icons became the preferred image form of the Greek Orthodox Church and later the Russian Orthodox Church. This exceptional work, most likely completed in Constantinople, has a delicate, decorative style. The robes and throne, along with the naturalness of the angel's faces, is amazing. The similarities between this work and artworks from ancient Rome are evident. The large eyes and the frontal posture of the figures became typical of all subsequent icons.

■ **Christ on the Throne**, 390, mosaic, Santa Pudenziana, Rome

This is the oldest of early Christian mosaics in which many elements of Christian art appear for the first time. A man, lion, bull, and eagle float in heaven as the four evangelistic symbols, whereas the buildings in the background symbolize heavenly Jerusalem. Christ sits upon the king's throne, clearly making his claim to heavenly power. Here he is portrayed in the antique tradition as a conversing philosopher standing before the apostles.

Early Christian Art

Ravenna, provide us with a visual documentation of the mosaic art. These newer mosaics used glass and gold tesserae (mosaic pieces). These light-reflecting materials gave the churches a ceremonial glow. The book also progressed as an art form during this time from the scroll to the codex—a bound, handwritten manuscript—of which the *Vienna Genesis*, a Byzantine-era illumination, is a stunning example. The icon, an important artistic invention, appeared in the 6th century, and would eventually serve as an important model in the development of 13th-century panel paintings.

The "Iconoclastic Controversy" was a strict ban based on the first two Commandments. All icon production and other artistic activities halted from 726–843.

■ **Christ as the Good Shepherd**, 450, mosaic, Mausoleum of Galla Palcidia, Ravenna

The Roman Empress Galla Placidia decided to construct her own mausoleum during her lifetime, although she was not buried there after her death in 450. Christ is portrayed as the Good Shepherd who allows his sheep to graze in this mosaic found above the mausoleum's entrance. This motif, from the Gospel of John, was used prevalently in the early days of Christianity in burial places as a means of expressing the request for salvation.

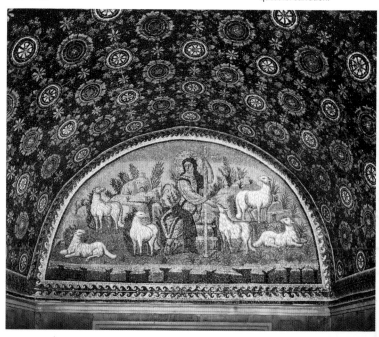

■ **Baptism of Christ**, 5th–6th century, mosaic, Arian Baptistery, Ravenna

During the 5th and 6th centuries, Ravenna was ruled by the Ostrogothic King Theodoric the Great, who associated himself with the Arian direction of Christianity. In this mosaic, from the Arian Baptistry, Christ is depicted totally nude as he is baptized by John the Baptist. The dove above Christ symbolizes the Holy Ghost. A new effect found in this mosaic is the usage of gold leaf, which had never been used in the mosaics of Antiquity. The figure to the left of Christ symbolizes the Jordan River.

■ **Queen Theodora**, 547, mosaic, San Vitale, Ravenna

The portrayal of the East Roman Emperor Justinian I, his wife, Theodora, and their entourage is the most magnificent aspect of the mosaics found in the Basilica in San Vitale.

■ **Christ before Pontius Pilate**, 550, Sant'Apollinare Nuovo, Ravenna

This mosaic, from the palace of Theodoric the Great, shows the biblical passage in which Pontius Pilate "washed his hands clean of it." (Matt. 27: 24).

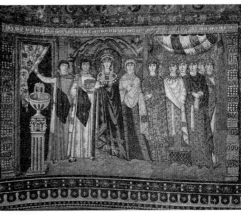

Other Works of Early Christian Art

Santa Constanza, 350, mosaics, Rome	Sant'Apollinare in Classe, 549, mosaics, Ravenna
Santa Maria Maggiore, 432–440, mosaics, Rome	Rabula-Evangelical from Zagba, 586, Florence
Burial Chamber, 450–500, mural, Nicaea (Iznik)	Florence Codex Rossanensis, 6th century, Rossano
Imperial Palace, 400–550, floor mosaic, Istanbul	Hagios Demetrios, 650, mosaics, Saloníki

Early Christian Art

Byzantine Medieval Period

1057–1453

■ Constantinople remained the center of Byzantine art ■ Smaller centers developed at monsasteries in Greece and on the Empire's edges ■ 12th century contact with Italy gave some centers a Western influence ■ The production of murals, mosaics, illuminated manuscripts, and religious icons continued

1057–1185 Komnenian dynasty reigns over the Byzantine Empire
1096–97 First Crusade, at the command of the Byzantine Emperor Alexios I Komnenos, against the Seljuks in Asia Minor
1202–04 Fourth Crusade, which intensifies the separation of the Orthodox East and Catholic West
1204 Constantinople, conquered by Crusaders, comes under the influence of Venice
1259–1453 Palaiologan dynasty reigns over the Byzantine Empire
1453 Constantinople conquered by the Ottomans

■ **Theotokos of Vladimir**, 12th century, icon, tempera on wood, 113.6 x 68 cm, from Constantinople. Tretyakov Gallery, Moscow

This icon depicts Mary and Christ in an intimate embrace. Mary was always depicted in Byzantine art as *Eleousa*, "the Merciful." Her left hand touches the spot on Christ's torso where his side-wound will be, and her sad gaze foresees his future.

Byzantine art evolved under the Komnenian dynasty, and developed more fully in the following centuries. Works such as the *Theotokos of Vladimir* icon or the *Weeping Christ* in Nerezi display a previously unknown expression of feelings. The Byzantine style arrived in Russia with the construction of the St. Sofia Cathedral in Kiev in 1037. Constantinople's conquest and plunder by Venice proved a harsh blow from which the Empire never fully recovered. Serbian monasteries and churches such as those at Ohrid and Studenica bear witness to the style of the Palaiologan period, which was adopted in the West as *maniera greca*, the Greek style. The iconostasis, the wall of icons and religious paintings in a church that separates the choir from the worshippers, was refined in the 14th century.

■ **The Dormition of Mary**, 1310, mosaic, Kariye Camii, former church of the Chora Monastery, Istanbul

The dormition of Mary, or the "falling asleep in death," was an important motif in Byzantine art. Like other feast-day art, it followed a strict pattern. The apostles Peter and Paul carry out the death rites, while the golden Christ in the mandorla (large halo) holds a small child in his veiled hands —the soul of Mary.

■ **Crucifixion**, 1209, mural, Church of St. Joachim and St. Anna (also called King's Church), Studenica, Serbia

Delicate limbs, elongated figures, linear and calligraphic shaping of garments, and the allusion to feelings determined the expression of these murals. Christ's head, with its closed, pain-filled eyes, was accurately adapted for the Italian painting of the 14th century.

Other Works

Menelogion of Basielos II, ca. 985, illuminated manuscript

Icon with the Archangel Gabriel, ca. 1250, Monastery of Saint Catherine, Egypt

Hagia Sophia, ca. 1260, mosaic, South Gallery, Istanbul

Annunciation to Mary, ca. 1320, icon, Ohrid

■ **The Weeping Christ**, 1164, mural, Church of St. Panteleimon, Nerezi near Skopje, Macedonia

These murals, donated by Emperor Manuel I Komnenos and created by Greek artisans, show pain and sympathy. Beginning in the 12th century, this linear style was adopted by the West, both in French illuminated manuscripts and Italian Trecento painting, and became known and influential as *maniera greca*.

Irish and Anglo-Saxon Illuminations

650–800

■ From Irish monasteries, the art of illuminating manuscripts spread to Scotland and England ■ Ornate initials developed into full-page decorations

from the 3rd century A form of Celtic Christianity developed in Ireland, which had been Christian since Antiquity, even though it was never part of the Roman Empire

5th century The foundation of monasteries in Ireland by St. Patrick, the Irish apostle, and other missionaries

6th century St. Columba founds the following monasteries: Bangor, Derry, and Kells in Ireland, as well as Iona and Durrow in Scotland

late 6th century The Irish-Scottish mission encounters the mainland

590 Saint Columanus travels to France, where he founds the Annegray monastery, just as he founds the Luxeuil monastery in the Vogses, and the Bobbio monastery in Lombardy. St. Gallus, the founder of St. Gallen in Switzerland, was one of his traveling companions

7th century Irish monasteries build a close-knit network on the European mainland

8th century The Lindisfarne monastery in Northumbria, England becomes more well-known

In Ireland, monasteries began concentrating on the careful copying of Christian works such as the Gospels, embellishing them with fantasy-filled ornamentation. Most of the abstract forms that can be found in these decorations were derived from metal work, such as brooches and buckles. The tradition of spiral marking is among the oldest forms of decoration in the history of mankind, whereas knot weaving ornamentation derives from Celtic traditions. Tracery—the delicate lacing of lines to form a design—is a Germanic tradition. Forms of ornamentation such as the adornment of entire book pages, large decorated initials at the beginning of a page, and pictures of the Evangelists expanded during this time. This would later influence the illuminations that developed in Scotland and England.

■ **Book of Kells**, ca. 800, illuminated page with symbols of the four Evangelists, Trinity College Library, Dublin

The *Book of Kells* originates from a monastery located on the island of Iona near Scotland. Such depictions of the Evangelists with their symbols developed around the end of the period of Irish and Anglo-Saxon illuminations. This codex in particular is rich in terms of its usage of color and fantasy-filled ornamentation, which is more meticulously carried out than similar works that preceded it.

Lindisfarne Gospels,
ca. 698–700, illuminated page depicting the Gospel of John, British Museum, London

The Bishop Eadfrith was appointed to copy and illuminate the *Lindisfarne Gospels*. This image comes from the colophon, or the end of the book. Scottish monks, led by the Abbot Aidan, founded a monastery on the island of Lindisfarne, off the northeast coast of England. The principles of the Irish and Anglo-Saxons in formulating ornamental initials are easy to see in this illumination. The beginning of the Gospel of John (*In principio erat verbum*, or *In the beginning was the Word*) was embellished with tracery, rhombuses, crosses, and other forms. Animal and human heads, plants, and birds, all artistically decorated, add further life to the pages already bursting with an intricate, vibrant display of colors.

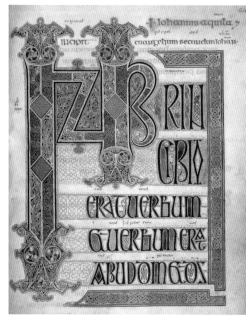

Book of Durrow,
7th century, ornamental page, Jona monastery. Trinity College Library, Dublin

The *Book of Durrow* is one of the oldest known books still in existence. Styles of ornamentation employed here include spirals, tracery, and trumpet-ornaments. The spherical forms were not used merely as a form of embellishment, but were interpreted in general as being symbols of the world because of the movement they illustrated.

Other Important Works

Echternach Gospels, ca. 690, Bibliothèque Nationale, Paris	Stockholm Codex Aureus, mid-8th century, Royal Library, Stockholm
Cathach of St. Columba, early 7th century, Royal Irish Academy, Dublin	Book of Dimma, 8th century, Trinity College Library, Dublin
Codex Amiatinus, early 8th century, Biblioteca Medicea Laurenziana, Florence	Book of Nunnaminster, 9th century, British Library, London

quibodiernati e
peruniceni tutui

Carolingian Illuminated Manuscripts

783–900

■ Began at the Court School of Charlemagne ■ Many academies in France
■ Exclusively religious subjects ■ The Carolingian Renaissance

783–814 The Court School at Aachen

ca. 816–845 The School of Rheims makes manuscripts under the patronage of Archbishop Ebo of Rheims

ca. 826–855 The School of Metz produces manuscripts funded by Archbishop Drogo

ca. 835–853 Large Bible manuscripts are created in the monastery of St. Martin in Tours, which had been founded in the 8th century by Alkuin

Beginning in 783, scholars and theologians gathered in the court of Charlemagne in Aachen began creating valuable manuscripts in scriptoriums, or calligraphy workshops. Portraits of the Evangelists came into vogue, and texts of the four Gospels of the New Testament were embellished with likenesses and symbols of the four Evangelists. At this time, manuscripts such as the *Godescalc Evangelistary*, the *Lorsch Gospels*, and the *Gospels of St. Médard of Soissons* were created. These books were influenced by the Late Antiquity and Byzantine era and demonstrate why scholars speak of a Carolingian Renaissance, or rebirth. The political basis for Charlemagne's rule was the Christian religion, which is why these magnificent manuscripts consist of liturgical texts. Each book of the Gospels has a similar format—four text columns embellished with ornamentation, con- ▭

■ **John the Evangelist**, beginning of 9th century, pigment on parchment, 36.2 x 26.7 cm, from the *Gospel of St. Médard of Soissons*, Court School of Charlemagne. Bibliothèque Nationale, Paris

The Evangelist sits on a throne composed of classical elements such as Corinthian columns. Above the throne hovers an eagle, John's evangelical symbol.

Other Important Works

Godescalc Evangelistary, ca. 781–783, Court School of Charlemagne. Paris

The Golden Psalter (Dagulf Psalter), ca. 783–789, Court School of Charlemagne. Vienna

Utrecht Psalter, ca. 830, School of Rheims. Utrecht

Ebo Gospels, ca. 835, School of Rheims. Epernay

Grandval Bible, ca. 840, London

Vivian Bible, ca. 845, Paris

John the Evangelist, 9th century, pigment on parchment, 37.4 x 27.1 cm, from *The Lorsch Gospels*, Court School of Charlemagne. Biblioteca Apostolica Vaticana, Rome

The *Lorsch Gospels*, also known as the *Codex Aureus of Lorsch*, were written in gold ink. With its sides covered by purple cloth and its lids carved of ivory, it is one of the most valuable products of the Aachen Carolingian School. The illustrations of this manuscript exhibit important characteristics of the Carolingian Renaissance, including Corinthian columns, the Apostle's classical robes, and a triumphal arch, under which the Evangelist transcribes the word of God. Paradise may be glimpsed behind a curtain. The harmonious color scheme and twining tendrils further mark the style of this Court School.

The Fountain of Life, beginning of the 9th century, pigment on parchment, 36.2 x 26.7 cm, from the *Gospel of St. Médard of Soissons*, Court School of Charlemagne. Bibliothèque Nationale, Paris

The fountain of life symbolizes both baptism and Paradise. The four columns in the foreground represent the four Evangelists, from whom God's word flows forth, and the four streams of Paradise. The rivers run from a single spring, which signifies the redeeming grace of Christ flowing to all the nations of the world.

Illuminated Manuscripts in Germany and France

Carolingian Illuminated Manuscripts

Illuminated Manuscripts in Germany and France

cluding with a portrait of its Evangelist. After the death of Charlemagne in 814, the Court School migrated west to Fulda and Rheims, where the *Utrecht Psalter* and the *Ebo Gospels* were produced under Archbishop Ebo. Under Charlemagne's son Drogo, Archbishop of Metz, Rheims became a center of manuscript illumination. Around the middle of the 9th century, the subject matter for illustrations expanded to include themes from the entire Bible. The monastery of St. Martin in Tours, site of the creation of the *Grandval Bible,* was especially noted for this type of work.

■ **Initial D**, ca. 850, pigment on parchment, 26.5 x 14.5 cm, from the *Drogo Sacramentary*. Bibliothèque Nationale, Paris

The mass for Easter Sunday begins with this initial, explaining why it is beautifully decorated here with a scene from the Bible. Decorated letters mark the beginning of manuscript illumination, because the written word of God, rather than images, was initially deemed most important.

■ **John the Evangelist**, ca. 800, pigment on parchment, 32 x 24.9 cm, from the *Viennese Coronation Evangelistary*, Court School of Charlemagne. Kunsthistorisches Museum, Vienna

This depiction of John the Evangelist owes much to earlier Byzantine models. The background landscape is rendered in a dynamic, loose manner and lends a naturalism to the architectural elements of the throne.

Late Antiquity and the Middle Ages 300–1450

■ **Moses Receives the Ten Commandments**, ca. 840, pigment on parchment, 51 x 37.5 cm, from the *Grandval Bible*. British Library, London

The unusually large *Grandval Bible* features whole-page illustrations of the book of Genesis, as well as scenes from the book of Exodus, such as this image here. From the clouds above, the hand of God the Father passes the Commandments from heaven to Moses on Earth. In turn, Moses expounds them to the people, as can be seen in the lower register. The *Grandval Bible* was also famous for a series of pictures depicting Adam and Eve. This series follows the story from their creation to their expulsion from the Garden of Eden. This sort of storytelling, through a series or sequence of pictures, was a popular convention until the Romanesque period.

Carolingian Illuminated Manuscripts

Painting between 900–1050

Illuminated Manuscripts and Murals

■ Illuminated manuscripts under the Holy Roman Emperors Otto I–III emerged around 970 in Reichenau Island, Trier, Echternach (all in Germany) ■ Manuscripts with botanical ornamentation were made in Winchester (England) beginning in 970 ■ Apocalyptic illuminations developed in northern Spain

970–1010/20 Manuscripts on Reichenau Island

970–1100 Winchester School

from 975 Scriptorium in Trier

1000–1100 Illuminations from northern Spain, San Salvador de Tábara monastery as the center

ca. 1050 Echternach produces manuscripts

Under the Holy Roman Emperors Otto I, II, and III, art production shifted from the royal courts to the monasteries. Through the Byzantine wives of Otto II and Otto III, an Eastern influence entered into Western art. The scribes on Reichenau Island and in the monasteries of Trier, Cologne, Regensburg, and Echternach worked with recourse to Carolingian models. Around the year 1000, naturalistic scenes were increasingly negated by gold leaf. This method enabled the images to achieve visionary heights, which were intended to indicate a proximity to God. The glow that radiates from the pictures symbolizes the 🔲

■ **Raising of Jairus' Daughter and Healing of the Hemorrhaging Woman**, late 10th century, mural, Collegiate Church of St. George in upper panel, Reichenau

Scenes from the life of Christ determine the singularity of the murals at the Church of St. George. Christ's fluttering garments show how hastily he carried out miracles.

■ **The Announcement to the Shepherds**, ca. 1007–1012, opaque paint on parchment, from the *Perikpenbuch of Heinrich II*, Reichenau. Bayerische Staatsbibliothek, Munich

Henry II, the last Ottonian Holy Roman Emperor, was the founder of the Bamberg Cathedral, where this work originated. The scene depicted here is remarkable for the liberal application of gold leaf, which demonstrates wealth, the holiness of the image, and also the deep faith of the commissioner. Henry II, canonized in 1146, was the only sainted Holy Roman Emperor. Because of the style of script and illumination, we can gather that this work originates from the Reichenau Island school. The elongated figures, the scenic staging with gestures, and the delineation of corporeality under the figures' attire is typical of this style ca. 1000.

■ **Otto II with the Vassal States Germania, Francia, Italia, and Alemania**, ca. 985, opaque paint on vellum, Trier. Musée Condé, Chantilly

This single folio with the likeness of Emperor Otto II, from the collection of the Pope's letters (*Registrum Gregorii*) from Trier, was made by the unidentified "Master of the *Registrum Gregorii*." The canopy under which Otto II sits is associated with the Carolingian Renaissance.

Works of the Ottoman Empire	
Benedictional of St. Æthelwold, ca. 971–984, Winchester. London	Codex Aureus Epternacensis, ca. 1053–56, Echternach. Nuremberg
Bamberg Apocalypse, ca. 1020, Reichenau. Bamberg	Hitda-Codex, ca. 1025, Cologne. Darmstadt

light of God. Figures' sizes denote their importance. Impressive manuscripts emerged in England at Winchester, such as the *Benedictional of St. Æthelwold*, which is notable for its soft, rounded, botanical ornamentation. The apocalyptic images from northern Spain are significant. They were influenced by Islamic trends and used exotic, multicolored hues.

■ **The Fifth Angel of the Apocalypse: The Swarm of Locusts (Revelations 9:3)**, ca. 1050, illumination accompanying the *Commentary of Beatus of Liébana*, Gascony. Bibliothèque Nationale, Paris

This apocalyptic French piece is presumably a copy of the lost Spanish *Beatus Apocalypse*. The angel commands an army of human-headed locusts. The colors and simple modeling of bizarre figures is typical of these manuscripts.

■ **Noah's Ark**, 975, from the *Gerona Beatus*, opaque paint on vellum, 40 x 26 cm, San Salvador de Tábara Monastery. Museo Capitular de la Catedral, Gerona

This apocalyptic illumination comes from the center of Spanish illumination. Noah had released a dove to investigate whether the floodwaters had abated; here, the moment of its return.

Late Antiquity and the Middle Ages

▶ **Otto III, Surrounded by Evangelist Symbols and Representations of Worldly and Spiritual Power**, 980–1002, from the *Gospel Book of Otto III*, facsimile, Domschatz, Aachen

The Emperor enthroned, Christ-like in the mandorla, sits upon a throne bearing the crouching Terra—personification of Earth. Bowing kings, two warriors, and clergymen stand witness. The hand of God comes from the clouds and crowns the emperor. The throne connects heaven and Earth; avoiding a natural pictorial space so as to assert divinity.

Painting between 900–1050

Romanesque Illuminations

1050–1150

■ Important centers of art included Burgundy, England, Helmarshausen (Lower Saxony), and the Meuse River area ■ While Byzantine influence remained, the painting style was simplified ■ Depth perspective was abandoned in favor of indeterminate figure orientation

■ **11th century** Pilgrimages to Santiago de Compostela begin

1095 Pope Urban II starts the first crusade

after 1108 Cîteaux's monastery produces many manuscripts

ca. 1130 Bury St. Edmunds abbey is England's illustration center

after 1150 Helmarshausen monastery is the illustrations and goldsmithing center in Germany

ca. 1140–70 The Meuse river area produces many manuscripts

after 1150 The Salzburg Painting School

Romanesque illuminations developed alongside murals. Rome, Cluny, Salzburg, and Canterbury were important centers of Romanesque art. These schools adopted many artistic traditions from Late Antiquity and Byzantine art, although these traditions were modified to fit the newer, simpler, more spiritual Romanesque style. Romanesque art sought to illustrate the divine realm of God himself, abandoning nature-oriented illustrations. Figures' hands and eyes were heavily emphasized, imparting a greater significance to their expressions. New religious orders, such as the Cluniac and Cistercian orders from Burgundy, had a strong need for books and Bibles, the numbers of which expanded notably during this time. Other forms of ethically oriented literature were also produced, including bestiaries, or stories featuring animals and a moral lesson, and texts of moral instruction.

■ **The Coronation of King Henry the Lion and His Wife Mathilda**, ca. 1173, opaque colors on parchment, from the *Gospel Book of Henry the Lion*, Helmarshausen. Herzog August Bibliothek, Wolfenbüttel

The chief 12th-century German work shows the hand of God crowning King Henry and Mathilda.

■ **Initial Q**, ca. 1111, opaque colors on parchment, from the *Moralia Manuscript*, Cîteaux.

■ **The Mouth of Hell**, ca. 1140–60, opaque colors on parchment, from the *Psalter of Henry de Blois*, Winchester. British Library, London

Henry of Blois, the bishop of Winchester and brother of King Stephen, was educated in Cluny after the Cluniac Reforms. This depiction of the mouth of hell, taken from the book of Job, is influenced by Byzantine art, as can be seen in the archangel Michael's garment folds.

◀ **Henry IV in front of Mathilde at Canossa**, pre-1115, opaque colors on parchment, from the *Vita Mathildis* of Donizo. Biblioteca Vaticana, Rome

The depiction of the excommunicated Holy Roman Emperor Henry IV, kneeling before Mathilde of Tuscany and Abbot Hugo from Cluny as he begs for assistance in regaining favor with the Pope, pays little attention to perspective or to how the figures relate in space.

Bibliotèque Publique, Dijon

Cîteaux, the first Cistercian monastery, was influenced by St. Benedict's Rule, especially the precept "ora et labora," or "pray and work." The initials depicted in the *Moralia Manuscript* demonstrate the multifaceted nature of the monks' daily work.

Romanesque Illuminations

Romanesque Mural Paintings

1050–1150

■ French, Italian, and Spanish church paintings were ubiquitous, in part due to the large-scale promotion of copies of the Old and New Testaments ■ Byzantine and Mozarabic influences were active ■ Great tendency toward abstraction
■ *left*: **Christ with the four Evangelists**, ca.1250, vault fresco, S. Isidoro, Léon, Spain

before 1100 Romanesque mural paintings in Northern Italy

11th–12th century Elaborate mural paintings in the monastery of Cluny, France

after 1100 Cologne and Bonn create a comprehensive center of artistic activities

1100–1300 Mural paintings in Northern Spain, some with Islamic influence

Church walls and ceilings were painted extensively, to guide the predominantly illiterate churchgoers and serve as a form of devotion. Burgundy's large, reformed Cluniac monastery served as the starting point for this artistic evolution. Unfortunately none of its artwork survived, but other early French churches suggest how it may have looked—abstract, dynamic, and animated. Spanish monasteries, with Mozarabic influences, presented another type of mural painting that mixed Islamic and Spanish art, creating more colorful, simpler, and more linear works. Italy retained the greatest Byzantine influence. In Germany, artistic centers developed in the Rhine area.

■ **Tower of Babel and the Division of Languages**, ca. 1090, fresco in nave, St.-Savin-sur-Gartempe

The church of St.-Savin-sur-Gartempe has the best preserved Romanesque fresco of its size in France. Scenes from the Old Testament are painted on the vaulted walls. Byzantine influences are evident and the dynamic between the figures demonstrates the great dedication and thoughtful handwork behind its creation.

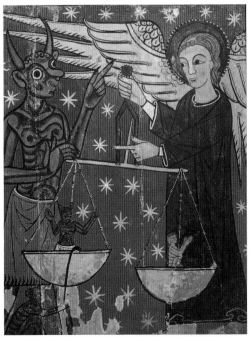

■ **The Archangel Michael as the Weigher of Souls**, 1150, fresco, Museu Episcopal, Barcelona

Spain is particularly rich in Romanesque murals and frescoes, where Mozarabic elements were often mixed into the artwork. The Mozarabic influence is clear in this example, where we see an undefined background, full-bodied color, laminar figures, and, in part, in the distorted, imprecise gestures of the caricatures.

Other Important Works

St. Angelo in Formis, ca. 1080, near Capua

Civate, ca. 1090, San Pietro al Monte, Lake Como

San Clemente de Tahull, ca. 1123, Barcelona

Schwarzrheindorf, ca. 1180, St. Maria and St. Klemens, near Bonn

Tombs of the Saints, ca. 1180, Winchester Cathedral

■ **The Stoning of St. Stephen**, ca. 1170, southern apse of St. John's Monastery, Müstair

It was through a large donation from Bishop Egino of Chur that the nunnery of St. John's Monastery aquired newly painted murals in the 12th century. Carolingian themes were retained, and similarities can be established with the wall paintings in St.-Savin-sur-Gartempe, (opposite) when comparing the dynamically presented figures and their clothing. The tree also demonstrates the Romanesque tendency toward abstraction.

Romanesque Mural Paintings

Romanesque Stained Glass

1050–1150

■ Glass began to be framed by lead ■ Strong color contrasts (red, blue, yellow) dominated the depictions ■ Artistic centers located in the Rhineland and in France (Île de France, Poitiers) ■ The practice of having static faces on figures arose ■ Created a divine light within the cathedrals and churches

ca. 1130 The Augsburg Cathedral acquires 22 glass windows, of which only those featuring the prophets Hosea, David, Daniel, and Jonah survive today

ca. 1150–75 School for the glass arts in western France; unpainted windows depicting biblical stories with a variety of styles appear in Le Mans, Vendôme, Angers, and Poitiers

ca. 1190 The Cathedral of Chartres acquires Romanesque-style windows

■ **The Prophet Hosea**, ca. 1130, glass window located on the southern wall, Augsburg Cathedral

The windows of the Augsburg Cathedral retain several images of prophets carrying Psalm banners. The frontal poses of the prophets have a stark and solemn effect upon the viewer, a distinguishing characteristic of early Romanesque glass work.

The most important centers for stained glass during the Romanesque era were located in the Rhineland and in France, in Île de France and Poitiers. In these centers, colorful glass panels were shaped on boards after preparatory drawings. These panels were held together on the interior with binders, whereupon hands and vestments were applied with enamel fused to the glass by heat. The glass would be framed by soldered lead. This last part of the process was important to the Romanesque stained glass aesthetic because it created the strong, dominant black lines and prominent contours that are characteristic of this style. Romanesque glass is also renowned for its intense, deep reds, blues, and yellows. The colored light that filtered in through the windows created an ethereal, spiritual feeling.

Romanesque Glass Works

Christ's Head, ca. 1140, from Weissenburg Alsace. Strasbourg

Christ's Family Tree, ca. 1150–60, from the Church of Amstein an der Lahn. Cappenberg Castle

Window Featuring the Crucifixion of Christ, ca. 1165, Poitiers Cathedral

Samson with the Gates of Gaza, ca. 1160–70, from the Alpirsbach Abbey. Stuttgart

■ **Knights**, ca. 1160, Cathedral of St. Patroklus, Soest

Great attention was paid to light and shadow in the composition of these intense three-dimensional glass windows. The knights' shields, spears, and helmets make them appear real and animate. The rich ornamentation of the armor and the plant motifs is akin to Romanesque illuminations and murals, which also use linear abstraction.

Romanesque Stained Glass

Bayeux Tapestry

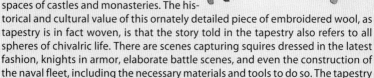

The *Bayeux Tapestry* is a significant piece for many reasons. In one regard, it is an extraordinary and incredibly rare secular, or nonreligious, work of medieval art. In another regard, it represents an exceptional specimen in the realm of textile art. Every king and noble had tapestries; even members of the clergy kept tapestries to adorn the cold and bare living spaces of castles and monasteries. The historical and cultural value of this ornately detailed piece of embroidered wool, as tapestry is in fact woven, is that the story told in the tapestry also refers to all spheres of chivalric life. There are scenes capturing squires dressed in the latest fashion, knights in armor, elaborate battle scenes, and even the construction of the naval fleet, including the necessary materials and tools to do so. The tapestry also included important geographic places like Mt. St. Michel in Normandy, and makes reference to Halley's Comet, which could have been seen in 1066. Although its origins cannot be definitely determined, the lively details in the tapestry point to its construction in England, possibly in Canterbury.

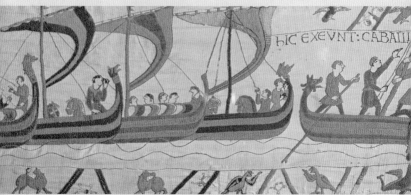

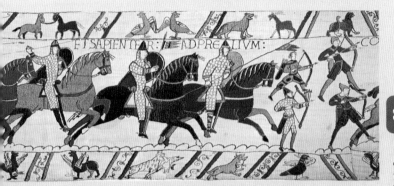

■ **Bayeux Tapestry**, ca. 1080, embroidery on wool cloth, 50 cm x 70 m, Museum of the Bayeux Tapestry, Normandy

Probably commissioned by Odo of Bayeux, the bishop of the local cathedral and William the Conqueror's half-brother, the tapestry narrates many individual scenes of the conquest of England by William I, William the Conqueror, in 1066. The history and progression of the famous Battle of Hastings are consecutively told, where ultimately King Harold, the last Anglo-Saxon king, is defeated. The borders are ornately decorated and each event is labeled in Latin. The tapestry assuredly did not hang in the cathedral, but rather in the hall of an aristocratic estate. The landing of the Norman ships after their Channel crossing and a battle scene on horse and on foot can be seen in the piece.

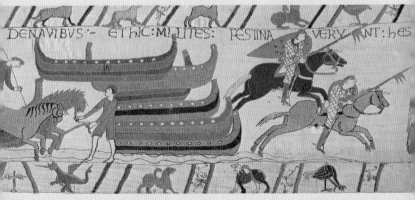

Gothic Stained Glass

12th–14th century

■ Made possible by Gothic cathedral architecture ■ Blue, red, and yellow tones dominated ■ Large stained-glass workshops developed alongside the cathedrals ■ Île de France became the center, then northern France and Alsace ■ Stained glass windows also appeared in English cathedrals

■ **1122** Suger becomes Abbot of St. Denis

1137 Reconstruction of St. Denis under Suger, with first Gothic glass windows

1163 Construction begins on Notre Dame, Paris

from 1184 Construction begins on Notre Dame, Chartres

1190–1250 Gothic architecture and stained glass proliferate in Normandy and England

ca. 1200 Stained glass in Canterbury Cathedral

The buttresses and arches of Gothic architecture allowed opening up the walls of a cathedral as never before for large windows. The Gothic period became the era of stained glass. For Abbot Suger, who built the first Gothic choir in St. Denis in 1137, these colorful, translucent walls, which prompted comparison with gemstones, had above all a theological meaning: They were bearers of sacred images while at the same time appearing as an otherworldly mystery themselves, since they glowed without the aid of fire. Unlike illuminated manuscripts, which were only accessible to a few, stained glass windows were a public religious primer. Furthermore, the windows, with their luminous radiance, far surpassed murals.

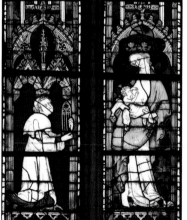

■ **Raoul de Ferrière in Adoration before the Madonna**, 1325, stained glass, Cathedral of Notre Dame, Évreux

The benefactor Raoul de Ferrière prays on his knees to the Madonna, who breast-feeds Christ. This glass panel is typical of the 14th-century French style, which was characterized by courtly refinement and fluid lines. The stained glass also features architectural designs such as the ornamented pointed arch. Also, the bodies are naturalistic, following a relaxed S-curve.

Other Gothic Stained Glass	
Ausburg Cathedral, ca. 1200	Cathedral of St. Étienne, ca. 1220, Sens
Cathedral of St. Étienne, ca. 1210, Bourges	Sainte-Chapelle, ca. 1240–50, Paris
Cathedral of Notre Dame, ca. 1215, Laon	Canterbury Cathedral, ca. 1250, Canterbury

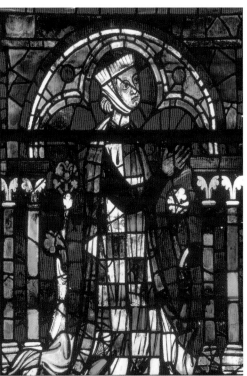

■ **Alix de Thouars (Benefactor Portrait)**, 1221–30, stained glass, detail from beneath the south nave's rose window, Cathedral of Notre Dame, Chartres

Alix de Thouars, daughter of Duke Guy de Thouars and wife of Pierre I of Dreux, Duke of Brittany, wears the latest fashions, as befits an aristocratic benefactress. On her head is a typical headdress—a band that wraps under the chin, a folded band around the forehead, and a flat headpiece. Her dress pays homage to the Dreux coat of arms with yellow and blue quadrants surrounded by the red border. The 176 windows in Chartres Cathedral, begun in 1194, are a source of information about this period. Between 1200 and 1240, ornamental forms developed from simple decorative panels into complex configurations. Rhombuses and quatrefoils increasingly overlap in a kaleidoscopic manner, creating an ethereal effect throughout the interior.

■ **A Furrier Displays His Wares to a Customer**, 1210–25, stained glass, 8.98 x 2.2 m, detail from window in the choir chapel, Cathedral of Notre Dame, Chartres

The lower-left corner of the large window in the choir features a portrait of the benefactor: the Guild of Furriers. Here a furrier shows a customer a mantle of ermine. Such depictions, which have survived in other forms, reveal details of everyday life in the past.

Gothic Stained Glass

Gothic Illuminations and Panel Paintings

12th–14th century

■ Emergence of new manuscript genres ■ Artists recognized with names and dates ■ *left:* Rudolf IV, Duke of Austria, ca. 1365, Dom Museum, Vienna

■ **before 1318** Master Honoré dies. He is documented in Paris multiple times at the end of the 13th century

1334 Jean Pucelle, apprentice of Master Honoré, dies

ca. 1350 Master of Hohenfurth is active in Bohemia

ca. 1380–90 Master of Wittingau in Bohemia

ca. 1340 (Minden)–1414 (Hamburg) Master Bertram

Gothic illuminated manuscripts developed in Paris, the epicenter of the Gothic style, with the work of many artists whose names were now finally noted. Illumination grew to be the most sought-after art of its day and began to triumphantly spread across Europe. Narrative cycles, many with secular themes, dominated from the early 13th century onward. At the end of the 14th century, paper began to be made from rags. The first block-books, which were printed with colorful drawings, appeared in the mid-15th century.

At the end of the 12th century, a completely new artistic medium began to develop—the painted panel. A less

Other Important Manuscripts and Panels

Bible Moralisé (Moralized Bible), ca. 1250, Bibliothèque Nationale, Paris	Manesse Codex, ca. 1310–20, University of Heidelberg Library, Heidelberg
Breviary of Philip the Fair, late 13th century, Bibliothèque Nationale, Paris	Psalter of Bonne of Luxembourg, ca. 1345–49, Cloisters Collection, New York

■ **Harvest Painting from a Speculum Virginum**, ca. 1190, mid-Rhine region, opaque paint on vellum, height about 20 cm, Rheinisches Landesmuseum, Bonn

A *speculum virginum* (mirror for virgins) was a religious instruction book for nuns in the later Middle Ages. The garment styles here are typically Gothic. A woman's age can be discerned from her headdress—young women covered their hair before marriage.

■ **Master Honoré: Humilitas and Superbia, the Sinner and the Hypocrite**, ca. 1290–1300, opaque paint on vellum, 23.5 x 12.7 cm, from *La Somme le Roi* by Laurent de Bois, Paris. British Library, London

La Somme le Roi was written in 1279 for Philip the Bold of France by his confessor Friar Laurent. It emphasized virtues and vices, and was popular among laymen. The Gothic S-curve can be seen above left on Humilitas (Humility).

Gothic Illuminations and Panel Paintings

expensive alternative to the earlier gold work on altar-pieces, tempera painting on wood increased in popularity. Cologne, in Germany, was an important center for painting, but it was superseded by Prague after 1350. Under Emperor Charles IV many important Gothic panels appeared in Bohemia. One example of note is the very first portrait painting: Rudolf IV, Archduke of Austria, was depicted as a dreamy and meditative figure in half-profile by an anonymous painter. The *Manesse Codex*, which appeared around 1310 in Zurich, is a prominent example of illumination from the Upper Rhine region. It contains 138 miniatures of Minnesang poets. The poets are idealized and are shown engaging in courtly activities.

■ **Madonna and Child**, Westphalian, 1260, tempera on wood, Museo Nazionale del Bargello, Florence

This is an early example of panel painting in Germany. The so-called *Zackstil* (jagged style) spread widely through Germany between 1210 and 1280 and developed from Byzantine models into intense expressiveness.

■ **Gideon and His Men Tear Down Baal's Altar, Gideon Sacrifices a Bull (Judges 6:25–27)**, ca. 1253–70, opaque paint on vellum, 21 x 14.5 cm, from the *Psalter of St. Louis*. Bibliothèque Nationale, Paris

This opulent Psalter with 78 illustrations from the Old Testament was intended for liturgical use in the Sainte-Chapelle. The delicate, elongated style of French High Gothic was in demand across Europe.

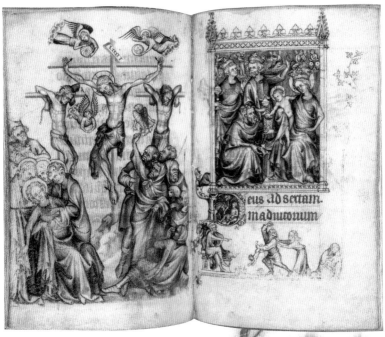

■ **Jean Pucelle**: **Crucifixion of Christ, Adoration of the Magi**, ca. 1325–28, opaque paint on vellum, 9 x 6 cm, from the *Heures de Jeanne d'Evreux*, Paris. Metropolitan Museum of Art, New York

Books of Hours— treasured books of worship and devotion—rose to prominence in the 13th century. Jean Pucelle created this one for Jeanne d'Evreux, the wife of the French King Charles IV. It features 25 miniatures rendered in gray color tones. The artist's masterful use of the small space is striking, especially the *drôle* (French for "comical") around the margins: The jocular, seemingly incoherent drawings depict children's games or fantastical creatures. In contrast, the faces of the figures under the cross differ and appear more naturalistic, presumably due to an Italian influence.

Pre-Renaissance Painting

13th–14th century ("Trecento")

■ Strong Byzantine influence ■ Giotto's work was concerned with malleability, spatial proportion, and realism ■ Duccio di Buoninsegna, influential painter of the Sienese school, painted in the Byzantine tradition ■ Simone Martini united Byzantine and northern Gothic styles

■ **1255–1318/19** Duccio di Buoninsegna, perhaps the student of Cimabue

1272–1302 Cimabue works in Florence

1267–1337 Giotto di Bondone

1284–1344 Simone Martini

1295–1348 Sculptor Andrea Pisano

1300–66 Taddeo Gaddi

ca. 1336 Maso di Banco is active in Florence

ca. 1348 Pietro and Ambrogio Lorenzetti both die, most likely from the plague

Italian art had a unique style during the Gothic era: What is called the *maniera greca*—the Greek style—developed under the influence of Byzantine art at the beginning of the 13th century; the center of this development was Pisa. The *maniera greca* features bold, linear compositions that express powerful feelings, especially in the depictions of the Passion of Christ. However, in the years around 1300, an important development came to pass in Florence, as Giotto di Bondone went beyond mere linear designs in favor of a more adaptable style—a fundamental step toward bridging the gap between Gothic art and the Renaissance. Realism was an important aspect in Giotto's art; his rounded, strong figures seem to stand and act in the real world. A good example of the similar ▭

■ **Duccio di Buoninsegna: Christ Entering Jerusalem**, ca. 1308–11, tempera and gold leaf on panel, 100 x 57 cm, reverse side of the *Maestà* from the Siena Cathedral. Museo dell' Opera del Duomo, Siena

The enormous altarpiece depicting the enthroned Virgin (*Maestà*) on the front side was created by Duccio for the Siena Cathedral. The reverse side of the piece features many small individual panels with scenes from the lives of Christ and Mary. Duccio broke from the conventions of the Byzantine school by giving his figures more volume, an epic sense of scale, and a bold simplicity.

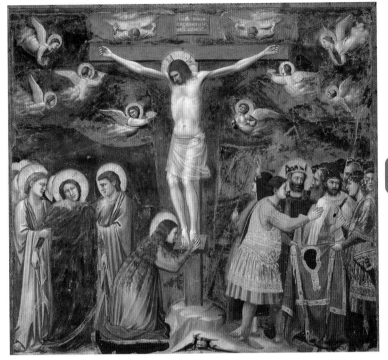

■ **Giunta Pisano: Crucifix**, ca. 1240, tempera on wood, 174 x 131 cm, San Maria degli Angeli, Assisi

A new wave of Byzantine influence in the West was effected by the conquest of Constantinople by the crusaders in 1204. Pisa was one of the first cities in which new artists, such as Giunta Pisano, were embraced. Elements of emotion, or *pathos*, which were familiar in Byzantine art from burial places or crucifixions, can be seen in this painted wood crucifix.

Other Trecento Works

Crucifix, by Cimabue, ca. 1260, San Domenico, Arezzo

Scenes from the Life of St. Francis, by Giotto di Bondone, ca. 1296, San Francesco, Assisi

Scenes from the Passion of Christ, by Pietro Lorenzetti, ca. 1326–29, San Francesco, Assisi

The Triumph of Death, by Buonamico Buffalmacco, 1336–41, Camposanto, Pisa

■ **Giotto: The Crucifixion of Christ**, 1303, fresco, Cappella dell' Arena, Padua

Giotto's frescoes of scenes from the life of Christ became instantly famous in his time for their realness—as demonstrated by the soldiers fighting over Christ's garment—along with the natural portrayal of figures within a space. Although Giotto is said to have transcended *maniera greca*, the influence of this earlier style in the expression of emotions is seen here.

Pre-Renaissance Painting

■ Ambrogio Lorenzetti: Allegory of Good Government, 1337, fresco, partial view with city gate, Palazzo Pubblico, Sala della Pace, Siena

This allegory of good and bad governments was created by Ambriogio Lorenzetti from Siena. The three-wall fresco for the city's town hall is one of the few secular works of its time period. It glorifies the wisdom of the new regime under the Guelphs, the pope's supporters. The buildings and figures are magnificently captured. The peaceful background is a survey of nearby landscapes.

■ Simone Martini: Investiture of St. Martin, ca. 1320–22, fresco, San Francesco, Lower Church, St. Martin's Chapel, Assisi

Although the saint lived during the fourth century, this scene presents him within a courtly 14th-century setting. The dress and hairstyles shown here are contemporary.

approach of the most reputable Italian artists of this era (and also of the stylistic differences between them) can be found in the famous fresco paintings of San Francesco in Assisi near Florence: Cimabue, the Lorenzetti brothers, and Duccio di Buoninsegna of Siena all developed distinguished styles—supple and still strongly influenced by Byzantine art, yet dealing with nature in a manner similar to Giotto. The work of Simone Martini, another artist from the Sienese school, displays a mix of the two main artistic traditions of his time, Gothic and Byzantine. His frescoes in St. Martin's Chapel in San Francesco and also his panels, such as the *Annunciation* from 1333, demonstrate the influence of northern Gothic styles. As the court artist of the Anjou family in France, Martini's works are elegantly sophisticated and introduce the International Gothic style (p. 112).

■ Giotto di Bondone: Maestà, ca. 1310, tempera on wood, 325 x 204 cm, Galleria degli Uffizi, Florence

This grand altarpiece depicts Mary enthroned, holding the Holy Child, surrounded by saints and angels. Giotto's fig-

ures come alive in a realistic space: Although drawing on traditional *Maestà* representations the artist created the impression of deep space by placing Mary and the child on a three-dimensional throne and letting figures overlap each other.

The Lamentation of

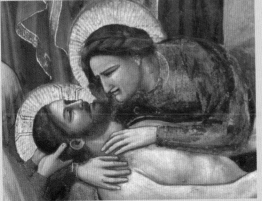

The subject of mourning for Christ was quite unusual in the West up until the 14th century. In the Byzantine world, however, from which Italian art drew its inspiration in this era, the topic was quite common. Giotto's interpretation of this theme can be seen in this fresco from the Arena Chapel in Padua. His translation of the Eastern influence into his own idiom became an example that would go on to influence other artists. The monumental bodies of his figures are plump, dynamic, and sensational. The depiction of grief is realistic in its varying manifestations— the angels tear at their hair, scratch their faces, wring their hands in despair, or scream and cry aloud. These motifs also first appeared in Byzantine art. The idea that a cherub would appear so upset in heaven would have been unthinkable in Gothic art north of the Alps, and the motif is Giotto's addition. The landscape behind Nicodemus and Joseph of Arimathea is rooted in Eastern models, as can be seen in the rocks, but it nevertheless manages a naturalistic and spacious effect. The diagonal of the rock wall creates depth and leads the viewer's attention to the body of Christ. Giotto achieved a magnificent amalgamation of Byzantine models with innovative, realistic features.

Giotto's major innovations are easily recognizable in this detail. The dead Christ's body is masterfully rendered, as well as the grief of the Holy Mother Mary, in whose lap the corpse is traditionally situated. The delicate features of the dead are slightly idealized, but still the body is very realistically depicted with an open mouth. The Virgin's anguish is very human; she is shown as a contemporary mother, thus connecting the modern viewer with the biblical scene.

Christt

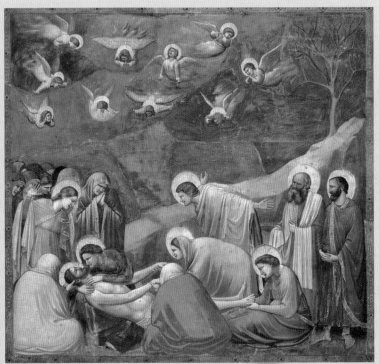

■ **Giotto: The Lamentation of Christ**,
1303–05, fresco, Cappella dell'Arena, Padua

In 1300, the financier and merchant Enrico Scrovegni
bought a derelict Roman amphitheater in Padua
in order to erect a family palace and chapel in
memory of his father. He enlisted the most re-
nowned artists of the time to decorate the com-
plex. Giotto's frescoes in the small chapel consist of 100
scenes from the life of Christ, Mary, Joachim, and Anne,
and depictions of the cardinal virtues and mortal sins.

Giotto: The Lamentation of Christ

International Gothic

1380–1430

■ Around 1400, paintings, illuminations, and sculptures emerged throughout Europe ■ International exchange of artists and their work ■ The High Gothic, courtly style was associated with Italian-influenced, realistic depiction ■ Illuminated manuscripts continued, but panel painting became more prevalent

■ **1370–1422** Conrad von Soest
1384–1409 Jacquemart de Hesdin, illuminator in the service of Duc de Berry
ca. 1400–51 Stefan Lochner is active
1416 The Limbourg brothers and their patron, Duc Jean de Berry, die of the plague

The International Gothic style, also known as the Beautiful Style or the Soft Style, can be observed in European painting and sculpture from around 1380–1430. Religious themes were presented through the manifestation of emotion, and the celestial realm was integrated into daily life. Gothic painting north of the Alps gained a realistic conception of space and figure through the Italian Trecento painters (p. 106). Franco-Flemish illumination also played an important role—its masters, such as Jacquemart de Hesdin and the Limbourg brothers, accounted for this naturalistic yet refined style.

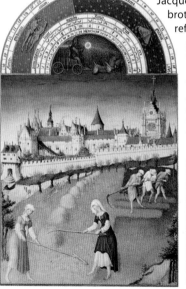

■ **The Month of June**, ca. 1416, 13.5 x 15.5 cm, from the *Très Riches Heures du Duc de Berry*. Musée Condé, Chantilly

This celebrated Book of Hours, by the brothers Jean, Paul, and Hermann of Limbourg, combines an exact topographical rendering of Paris (Palais de la Cité and Sainte-Chapelle) with spatial, concrete depictions of the architecture, as well as figures within the countryside.

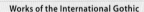

Works of the International Gothic	
Wilton Diptych, ca. 1390, National Gallery, London	The Presentation in the Temple, by Melchior Broederlam, ca. 1399, Musée des Beaux-Arts, Dijon
Crucifixion with a Carthusian Monk, by Jean Beaumetz, ca. 1390–95, Museum of Art, Cleveland	The Annunciation, by Jacquemart de Hesdin, ca. 1400, Bibliothèque Nationale, Paris

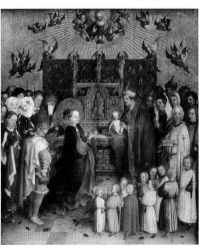

■ **Upper Rhine Master: Little Garden of Paradise**, ca. 1420, tempera on wood, 26.3 x 33.4 cm, Städel-Museum, Frankfurt

This painting allegorizes a *hortus conclusus* (closed-off garden), which alludes to Mary's virginity. Many High Gothic elements catch the eye, yet the natural inclusion of the body indicates an acquaintance with Italian art (Giotto, p. 110). The flowers, associated with Mary, are rendered naturalistically.

■ **Stefan Lochner: The Presentation in the Temple**, 1447, tempera on wood, 139 x 126 cm, Hessisches Landesmuseum, Darmstadt

Stefan Lochner couples several themes together: Joseph's sacrifice after the birth of his son, to exempt him from service to the temple; the purification of Mary, who holds a dove; and the celebration of Candlemas, with children holding candles before the altar.

International Gothic

Islamic Art

661–1923

■ Calligraphy and arabesque ornamentation dominated due to a strict regulation of images ■ Mosaics, book illuminations, and stucco decoration ■ Large style differences based on geography

■ *left:* **God is Great**, Turkish ceramic, ca. 1850

● **661–750** The Umayyad dynasty in Syria, Lebanon, and Jordan; first mosques and mosaics

750–1258 The Abbasid dynasty in Iraq; stucco wall decoration develops

909–1171 The Fatimid dynasty in Egypt; handicrafts with ceramic and other materials

ca. 1100–1300s Moors in Spain; stucco ornamentation

1250–1500 Mongolian-Persian style in Iran; book illumination

1501–1722 The Safavid dynasty in Iran; heyday of book illumination

1520–1800 Mughal style in India; realistic minature paintings

1365–1923 Ottoman style

Other Important Works

Dome of the Rock, ca. 690, Jerusalem

Great Mosque, Cordoba, 965, Creation of Hakam II, mosaic

Dioscorides de Materia Medica, 1229, manuscript, Österreichischen Nationalbibliothek, Vienna

Kalila wa Dimna, ca.1350, manuscript of fables, Istanbul

Islamic art has been shaped by a strict restriction on images. This ban, while not expressly apparent in the *Koran*, is suggested within the other writings of the prophet Mohammed as a guard against idolatry. The style of art has therefore concentrated itself from its very beginnings on ornamental forms, such as calligraphy, decorated ceramics, or stucco decorations found on the walls of mosques and palaces. The style of calligraphy that is used for copying the *Koran*, the word of God, enjoys the highest level of appreciation, and is often made illegible through the extent of ornamentation. At first, art in the Muslim world was dominated by ancient Greco-Roman and Byzantine influences. The first truly Islamic art flourished for the first time under the Abbasid dynasty in the 8th century. Other influences from neighboring China, India, and the Central Asian Steppe, can be seen from the 11th century.

■ **Detail of Stucco Ornamentation**, end of 9th century, Qasr al-Ashiq, Samarra, Iraq

This fine example of stucco ornamentation comes from the Abbasid palace in Baghdad. The style was also used to decorate other palaces and mosques inside and out. Influenced by Antiquity, wine leaves, grapes, and other plant forms are connected in endless chains within a geometric framework distinctive of the arabesque style.

■ **A Doctor Venesects a Patient**, illustration from the *Maqama of Abu Mohammed al-Kasim Hariri*, ca. 1240, painting on paper, 26.5 x 21.5 cm, Institute for Asian Studies, St. Petersburg

The fifty *Maqama* (lit. "assemblies," or pieces of rhymed prose) of the poet Hariri (1054–1121) describe the escapades of the rogue beggar Abu Said, who was famous for his rhetorical abilities. The illustrations provide a multifaceted account of daily life in ancient Iraq. This particular image portrays a venesection, or blood-letting, a common folk remedy during the Middle Ages. Islamic medicine was ahead of its time, due to the *Koran's* promotion of scientific research. Figures such as Rhazes or Avicenna (who died in 1037) are representative of Islamic medicine.

■ **Malik Bakhshi of Heart: Mohammed's Voyage through the Earthly Paradise**, 1436, painting on paper, from a manuscript concerning the *Ascension and Descent of the Prophet*, Afghanistan. Bibliothèque Nationale, Paris

Guided by the archangel Gabriel, the prophet Mohammed rides atop the Burak, the holy mare with human skin, in this magnificent miniature from Afghanistan. The Chinese influence comes from the Mongolian heritage that is found in the region.

Renaissance

1420–1610

Leonardo da Vinci: Lady with Ermine, ca. 1490, oil on
wood, 54.8 x 40.3 cm, Muzeum Czartoryski, Cracow

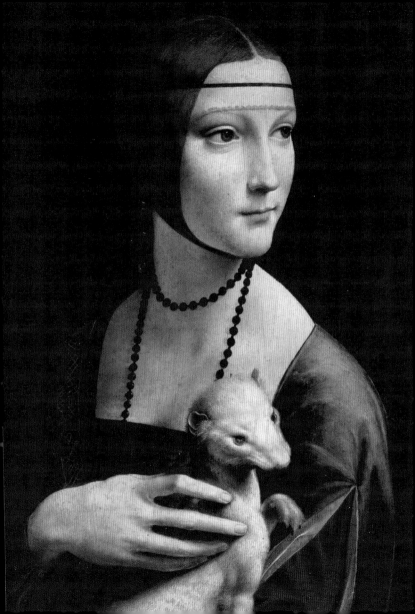

Renaissance

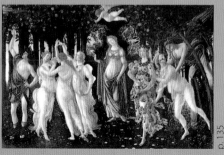
p. 135

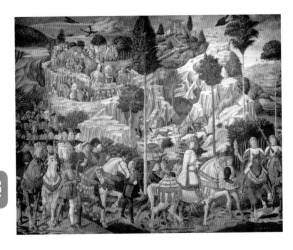

The Dawn of a New Age

The term *renaissance* is a French word that means "rebirth" and describes a cultural movement that began in the 15th century. The Renaissance was driven by a newly awakened desire to revive the art of Classical Antiquity. Consciously turning away from Gothic ideas, artists and distinguished scholars used the literature and statues of the ancient world as models. The movement initiated a far-reaching change in religious ideas—the center of artistic interest was no longer God, the omnipresent being, but rather humanity. Underlying these changes was an intense striving for a closeness to nature and a renewed desire to depict the beauty of the human figure. During the Renaissance, artists no longer thought of themselves as anonymous craftsmen providing a labor, but began both being identified and identifying themselves as creative intellectuals.

Renaissance 1420–1610

■ **Benozzo Gozzoli: Procession of the Magi,** 1459–61, fresco, Palazzo Medici-Riccardi, Florence

▶ **Piero della Francesca: Ideal City,** ca.1470, oil on wood, 60 x 200 cm, Galleria Nazionale delle Marche, Urbino

■ **Pollaiuolo: Hercules and the Hydra**, ca. 1475, 17 x 12 cm, tempera on wood, Galleria degli Uffizi, Florence

■ **Masolino: Two Noble Youths**, ca. 1425, (detail), S. Maria del Carmine, Cappella Brancacci, Florence

Enthusiasm for the Ancient World and a Sense of Reality
In the lively climate of economically prospering Florence, Urbina, and Mantua, rich citizens, such as the Medici family, became patrons of artists and stimulated their growth. The invention of the linear perspective, which has been attributed to the Florentine architect Filippo Brunelleschi, had a revolutionary impact on painting. Enthusiasm for the ideals of classical Antiquity was not only reflected in architecture, but also in the new mythological themes and the re-

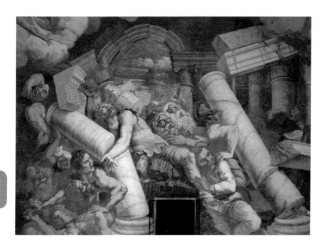

turn to the nude. Inspired by antique sculptures, artists studied living models and investigated the ideal beauty in studies of proportion.

High Renaissance in Rome

Leonardo da Vinci exemplifies the High Renaissance after 1500. Leonardo, Michelangelo, and Raphael defined the Classicist art movement and personified the Renaissance ideal of the *Uomo Universale*—the universal or Renaissance man who strove to embrace all areas of knowledge and to develop his capacities as fully as possible. By creating artwork of staggering beauty, strength, and balance, they became recognized as the model for many generations

■ **Hall of the Giants**, Palazzo del Te, built 1525–35 after designs by Giulio Romano

■ **Perugino: The Marriage of the Virgin**, ca.1500, oil on wood, 236 x 186 cm, Musée des Beaux-Arts, Caen

Renaissance 1420–1610

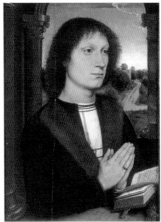

■ **Jacopo da Pontormo: Deposition from the Cross**, ca. 1528, oil on wood, 313 x 192 cm, Santa Felicità, Cappella Barbadori, Florence

■ **Hans Memling: Portrait of Benedetto di Tommaso Portinari**, 1487, oil on wood, 45 x 34 cm, Galleria degli Uffizi, Florence

to come. Rome, under the rule of the popes, emerged as the leading center of art in the Renaissance. Decadent projects, such as the construction of St. Peter's Cathedral—which was financed through the indulgence system in Roman Catholic dogma—engendered criticism, and prompted the German reformer Martin Luther into action. In the art of Michelangelo and the Venetian painter Titian, the dissonance, anxiety, and chaos ripping at the Church's foundations and the widespread tensions of the time are reflected. Through these works, these artists paved the way for a new art movement—Mannerism. From around 1520 onward, the new tendencies of the Mannerist style went beyond the ideals of balance, geometric order, and harmony associated with the Renaissance. Giulio Romano's exaggerated, dramatic art and Bronzino's icy, rigid style are excellent examples of art from this new age.

Introduction

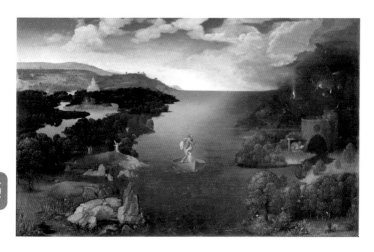

Dutch Naturalism

North of the Alps, the Renaissance developed under different auspices, leading to a style that incorporates Renaissance elements, yet remains far from the elegant lightness of Italian art. Here, the ideals and themes of the mythologies of the ancient world played a minor role. In Flanders, the decline of Gothic styles brought a brilliant naturalism of luminescent colors and meticulous attention to detail, developing under the Dukes of Burgundy. In their religious works, both Jan van Eyck and Hans Memling brought biblical scenes closer to viewers with striking illusionism. In the 15th century, landscapes, still lifes, and portrait painting, in which patrons commissioned artworks of themselves, developed as new artistic genres. Jan van Eyck's perfection of oil painting techniques allowed for new possibilities in art and was later adopted by Italian artists.

■ **Joachim Patinir: Landscape with Charon's Boat**, ca. 1510, oil on wood, 64 x 103 cm, Museo del Prado, Madrid

Renaissance 1420–1610

■ **School of Fontainebleau: Gabrielle d'Estrees and One of Her Sisters**, ca.1592, oil on wood, 96 x 125 cm, Musée du Louvre, Paris

■ **Quentin Massys: Mary and Child**, 1529, oil on wood, 68 x 51 cm, Musée du Louvre, Paris

Manifold Developments in Germany

In Germany, Martin Schongauer advanced graphics to its height, Matthias Grünewald increased the expressiveness of religious painting, and Lucas Cranach discovered the eroticism of the female nude. Albrecht Dürer, an intermediary between Gothic styles and the Renaissance, became well-known in both Italy and Germany for blending German and Italian styles. Protestant iconoclasm during the Reformation induced Hans Holbein to immigrate to England, where he became one of the greatest portrait artists of his time.

Elegance and Eroticism in France

Under King Francis I, an independent artistic milieu developed in France. Francis I invited Italian artists such as Leonardo, Cellini, and Primaticcio to France. They greatly influenced the first School of Fontainebleau, which extended beyond the end of the 16th century.

Masaccio

Tommaso di Giovanni di Simone Cassai
1401, San Giovanni–1428, Rome

■ One of the founders of the early Renaissance in Florence, with sculptor Donatello and architect Brunelleschi ■ First to use central perspective consistently ■ In contact with Giotto ■ Created altarpieces and frescoes

■ **1401** Born Tommaso di Giovanni di Simone Cassai, the son of a notary, in the village of San Giovanni Valdarno near Arezzo

1406 Father dies

1422 Enrolls in the Florentine guild of doctors and apothecaries, which included painters

1422 Paints a triptych, or three-paneled altarpiece, for the church of San Giovenale in Cascia di Reggello

1423 Goes to Rome, most likely in the company of Filippo Brunelleschi

1424 Joins the St. Luke Guild of Painters in Florence

1425 Decorates the Brancacci Chapel of Santa Maria del Carmine together with Masolino da Panicale

1426 Paints a large polyptych in Pisa for the church of Santa Maria del Carmine

1428 Dies in Rome at the age of 27

Although Masaccio lived only to the age of 27, he was a key figure in the history of European art. In Florence, he met two leading men of his time: sculptor Donatello (p. 128) and architect Filippo Brunelleschi. Masaccio took hold of the newly discovered central perspective and used it to lend an entirely new spatial effect to his paintings. He also mastered the human form: Shaped by light and shade, his figures move freely in space, exuding dignity and self-assurance. Masaccio's most extensive work is the fresco cycle in the Brancacci Chapel of the church of Santa Maria del Carmine in Florence, undertaken with Masolino da Panicale. Masaccio was an observer of life, lending biblical scenes an entirely new look as characters express their feelings with gestures and facial expressions. With the cycle still unfinished, he left for Rome, where he later died under unknown circumstances. His few works are considered milestones in art history, studied by his contemporaries and successors.

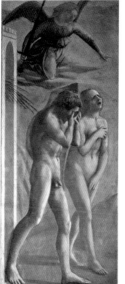

■ **The Expulsion of Adam and Eve from Paradise**, ca. 1426, fresco, 208 x 88 cm, Santa Maria del Carmine, Brancacci Chapel, Florence

Early Renaissance in Italy

Other Works by Masaccio

Madonna with Child and Saints, 1422, Pieve di San Pietro, Cascia di Reggello

The Madonna and Child with St. Anne, ca. 1424, Galleria degli Uffizi, Florence

Madonna Enthroned, 1426, National Gallery, London

The Adoration of the Magi, 1426, Gemäldegalerie, Berlin

■ The Tribute Money,

ca. 1425–27, fresco, height 255 cm, Santa Maria del Carmine, Brancacci Chapel, Florence

The fresco shows Christ in the midst of his apostles in front of a wide landscape. They are depicted as neoclassical archetypes. Masaccio's figures are so lifelike that they appear almost real to the touch.

■ The Holy Trinity,

ca. 1425–28, fresco, 667 x 317 cm, Santa Maria Novella, Florence

Masaccio masterfully demonstrated here what can be achieved through the use of central perspective. He was one of the first painters to employ this technique. The simulated architecture, with its antique forms, creates the illusion of an actual space occupied by the crucified Christ, God the Father, and the dove of the Holy Ghost, flanked by Mary and John. The central point on which all lines converge is at the foot of the cross, at the eye level of the viewer. The space appears so real that the eye is fooled into thinking that it is looking through a hole in the wall into another room. Masaccio deliberately placed the donors at the bottom left and right in front of the niche to show that they are on a different level of reality to the Holy Trinity. This painting was rediscovered in 1861 after being hidden since the 16th century within a Vesari altarpiece and a stone altar.

Masaccio

Donatello

Donato di Niccolò di Betto Bardi
1386, Florence–1466, Florence

■ Most important sculptor of the early Renaissance ■ Concerned intensively with the art of Antiquity ■ Created various works and mastered all techniques of sculpture ■ Each of his creations broke new artistic ground

■ **1386** Born Donato di Niccolò di Betto Bardi

1404 Joins the workshop of sculptor Lorenzo Ghiberti, a sculptor in bronze, as a coworker

1408–1409 His first known work, the marble *David*

1416 Starts a series of monumental marble statues for niches in the dome of the Florentine cathedral

1432/1433 Travels to Rome to study Roman antiquities

1434–37 Creates large roundels out of stucco depicting the life of St. John the Evangelist that are installed under the dome of the old sacristy of San Lorenzo in Florence

1446/1447 Settles down in Padua, where he works in subsequent years on an equestrian statue of the commander of mercenaries Erasmo da Narni, named *Gattamelata*

1453 Returns to Florence and develops a late style that is expressive and restless

1466 Dies in Florence

■ **Equestrian Statue of "Gattamelata" (Erasmo da Narni)**, 1444–53, bronze, height 340 cm, Piazza del Santo, Padua

Renaissance 1420–1610

Donatello was undoubtedly the most influential sculptor of the Early Renaissance. He learned his craft in the workshop of Lorenzo Ghiberti, the most important bronze sculptor of his time. Donatello based his work consciously on Classical models and he was a great influence on subsequent generations, including Michelangelo (p. 150), because of his innovative work. He freed sculpture from its subordination to architecture and dared to create life-size nude figures. With his equestrian sculpture *Gattamelata* in Padua, he created the prototype for countless equestrian monuments executed until the Baroque period. By creating an equestrian statue that did not portray a ruler, he changed artistic tradition.

Donatello worked with marble and bronze as well as wood. His low reliefs are as finely executed as paintings, while his freestanding statues exhibit a dignity and realism that had not been seen since Antiquity. His works embodied the new ideal man of the Renaissance and showed people as self-determined individuals, powerful and intellectually alive.

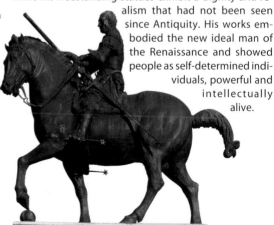

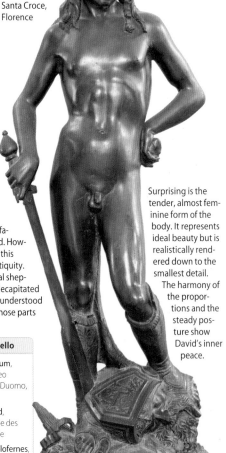

■ **The Annunciation of Mary**, ca. 1435, limestone, 420 x 248 cm, Santa Croce, Florence

■ **David**, ca. 1444–46, bronze, height 158 cm, Museo Nazionale del Bargello, Florence

The date in which Donatello created his famous bronze *David* is still being disputed. However, no one disputes the importance of this figure, as the first life-size nude since Antiquity. Wearing only a hat and boots, the biblical shepherd boy sets his foot carelessly on the decapitated head of the defeated Goliath. Donatello understood the human body as a living organism, whose parts form a harmonious whole.

Surprising is the tender, almost feminine form of the body. It represents ideal beauty but is realistically rendered down to the smallest detail.

The harmony of the proportions and the steady posture show David's inner peace.

Other Important Works by Donatello

St. George, 1416–17, Museo dell'Opera del Duomo, Florence	**Singer's Rostrum**, 1433–38, Museo dell'Opera del Duomo, Florence
Pazzi-Madonna, ca. 1420, Bode Museum, Berlin	**Feast of Herod**, ca. 1439, Musée des Beaux-Arts, Lille
Prophet Habakkuk (Il Zuccone), 1423–26, Museo dell'Opera del Duomo, Florence	**Judith and Holofernes**, ca. 1456–57, Palazzo Vecchio, Florence

Donatello

Paolo Uccello

Paolo di Dono
1397, Florence—1475, Florence

■ Master of representation of perspective ■ Gave his figures new elasticity and monumentality ■ Enthusiastic about geometrical math problems ■ Preferred everyday subject matter ■ Despite his long life, only a few works are known

■ **1397** Born Paolo di Dono
1407 Assistant and student of sculptor Leorenzo Ghiberti, works on the bronze door of the Florentine Baptistry
1415 Enrolls in the official painters' guild
1425 Moves to Venice, works on mosaics of San Marco cathedral
1436 Creates mural of the mercenary commander John Hawkwood
1443–45 Designs glass windows for the Florentine cathedral
1475 Dies in Florence

Florentine native Paolo Uccello was a multidimensional painter who loved to experiment. He was influenced by Donatello (p. 128) and his short-lived contemporary Masaccio (p. 126). He enjoyed applying mathematics to problems of perspective as well as reproducing complicated geometrical figures in exact perspective. Uccello was famous above all for his depiction of big battle scenes and commanders. He painted a life-size, equestrian John Hawkwood, known to Italians as Giovanni Acuto, on a mural of the cathedral of Florence. Hawkwood had commanded mercenaries in the service of Florence. Uccello's contemporaries were astounded by the convincing form in which he painted rider and horse. Influenced by the equestrian monuments of Antiquity, his painting served as an antecedent of the first bronze equestrian statues of the Early Renaissance that were created a short time later by sculptors Donatello and Andrea del Verrocchio.

■ **Equestian Statue of John Hawkwood**, 1436, fresco, 820 x 514 cm, S. Maria del Fiore, Florence

Other Important Works by Uccello	
Scenes From the Story of Creation, ca. 1439, Santa Maria Novella, Florence	Galleria Nazionale, Urbino
The Flood, ca. 1439, Santa Maria Novella, Florence	Five Famous Men, ca. 1450, Musée du Louvre, Paris
The Miracle of the Host, ca. 1467, Museo del	The Hunt by Night, ca. 1467, Ashmolean Museum, Oxford

■ **St. George and the Dragon**, ca. 1456, tempera on canvas, 57 x 74 cm, National Gallery, London

Uccello depicted the dramatic battle of St. George with the dragon in the form of a fairytale scene. The tender figure of the king's daughter is painted according to ideals of elegant beauty of the International Gothic style (which was also valued in Florence). The horse carrying St. George, which gallops diagonally into the picture, is painted with the newly discovered central perspective.

■ **The Battle of San Romano**, ca. 1438–40, tempera on wood, 182 x 320 cm, National Gallery, London

This is one of three tablets on which Uccello depicts the battle of the Florentine mercenary army against the Italian cities of

Siena and Lucca in 1432. Riders and horses appear as if they are carved from wood; lances are laid out in geometric form.

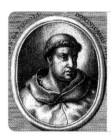

Fra Angelico

Guido da Pietro
ca. 1387, Mugello–1455, Rome

■ Artist-monk ■ Attached to the International Gothic and Masaccio movements ■ Treated religious subjects exclusively ■ Worked with blue, gold, and red tones

ca. 1387 Born Guido da Pietro near Vicchio in Mugello, north of Florence

1417 First documented activity as a painter

ca. 1419–22 Enters the Dominican priory, San Domenico in Fiesole, which strictly observed the rule of the Order of St. Dominic

1436 Moves with his community into the priory of San Marco in Florence, which was being remodeled by the Renaissance architect Michelozzo by order of the Medici

1445 Pope Eugene IV calls him to Rome, where he carries out extensive work for the Vatican

1450 Becomes prior of the priory of San Domenico in Fiesole

1453/1454 Moves again to Rome

1455 Dies in Rome

■ **The Last Judgment**, ca. 1432–35, tempera on wood, 105 x 210 cm, Museo di San Marco, Florence

The Judgment Day was a frequently depicted subject of Christian art. This piece reflects Angelico's palette of gold and blue.

The works of the painter-monk Fra Angelico reflect an unshakable confidence in the divine order of the universe. His Madonnas are filled with extraordinary grace and purity. He clearly articulates with his compositions an expression of faith in a heavenly harmony beyond human passions and worldly problems. However, Fra Angelico presented the traditional medieval belief system in the most advanced artistic form of his time. Therefore, he became one of the most outstanding artists of the early Renaissance in Florence and Rome.

Angelico's personality was molded by his seclusion from the world and his strict submission to the rules of his order—poverty, chastity, and humility. After his death, he was referred to as *pictor angelicus*, the angelic painter. Nearly 530 years after his death, in 1984, he was beatified by the sitting pope, John Paul II.

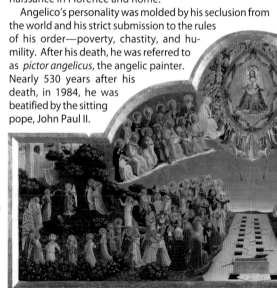

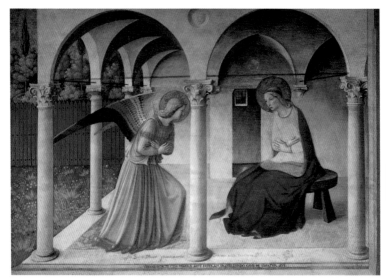

■ **The Annunciation**, ca. 1450, fresco, 216 x 321 cm, San Marco, Florence

Fra Angelico created exclusively religious works, including numerous altar pictures. The frescoes with which he covered the walls of his convent, San Marco, are among the most famous of his works. He kept them deliberately simple in order to promote meditation and prayer. *The Annunciation* (where Mary is told by an angel that she will give birth to Jesus) exudes peace and grace. The finely wrought architecture is constructed according to the rules of central perspective, while mirroring the actual architecture of his priory. The enclosed garden pictured on the left of the painting is emblematic of Mary's virginity.

Other Works by Fra Angelico

Life of St. Dominic, ca. 1423–24, National Gallery, London

The Coronation of the Virgin, ca. 1430–32, Musée du Louvre, Paris

Linaiuoli Tabernacle, 1433, Museo di San Marco, Florence

Altar Piece d'Annalena, ca. 1434–38, Museo di San Marco, Florence

Deposition from the Cross, ca. 1437–40, Museo di San Marco, Florence

Life of St. Stephen and St. Lawrence, ca. 1447–55, Vatican Museum, Rome

Fra Angelico

Sandro Botticelli

Alessandro di Mariano Filipepi
1445, Florence–1510, Florence

■ Favorite painter of the Medici of Florence ■ Mastered all forms of painting
■ Created significant altarpieces and frescoes as well as portraits and mythological scenes

1445 Born in Florence as Alessandro di Mariano Filipepi

1470 Works as an independent painter in Florence

1481 Called to Rome by Pope Sixtus IV, where he works with other Florentines to decorate the walls of the Sistine Chapel

1482 Returns to Florence and works under the patronage of the Medici

1495 Illustrates Dante's *Divine Comedy*

1510 Dies in Florence

After an apprenticeship as a goldsmith, Botticelli learned the craft of painting from Fra Filippo Lippi. Then he probably worked in the workshop of Andrea del Verrocchio, where the young Leonardo (p. 144) was also employed. He developed a very personal style, which relied greatly on moving or swinging lines. Imaginatively moving garments, hair, and contours give his paintings an elegant and highly decorative note. These found great favor with wealthy patrons like the Medici. In his paintings of the Madonna, he created an unmistakable feminine ideal— slender, blonde, maidenly, and slightly melancholy. His depiction of personalities from antique mythology paved the way for other artists by opening up new themes for art. His paintings have come to represent the Florentine style.

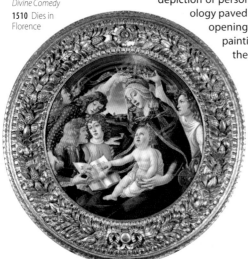

■ **Madonna del Magnificat**, ca. 1482, tempera on wood, diameter 115 cm, Galleria degli Uffizi, Florence

This round picture (*tondo*) belongs to the most significant and beautiful of Botticelli's numerous Madonna portraits. The magnificently carved frame was favored by Florentine painters. Botticelli here composed a group of figures who appear to be moving harmoniously. Madonna is writing down the *Magnificat*, an old Christian song of praise.

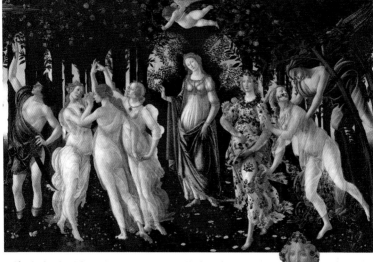

■ **The Spring (La Primavera)**, ca. 1477–82, tempera on wood, 203 x 314 cm, Galleria degli Uffizi, Florence

Botticelli was one of the first Renaissance painters to make the gods of Classical mythology the subject of grandiose paintings. Humanist scholars around the Medici advised Botticelli with his conceptions. In the center of the allegory of *Spring*, Venus, goddess of love, welcomes the viewer into an orange grove. On the right dances Flora, goddess of flowers, accompanied by a nymph and Zephyr, god of wind, while on the left, the three charming Graces appear. On the far left, Mercury, the messenger of the gods, disperses the clouds with his staff. This poetic picture lends itself to several interpretations; however it probably symbolizes sensual and spiritual love.

Other Important Works by Botticelli	
The Return of Judith to Bethulia, ca. 1472, Galleria degli Uffizi, Florence	Moses as a Youth, 1482, Sistine Chapel, Rome
Venus and the Three Graces Presenting Gifts to a Young Woman, ca.1483-85, Musée du Louvre, Paris	Portrait of a Youth, ca. 1483, National Gallery of Art, Washington, DC
	Venus and Mars, ca. 1485, National Gallery, London

Sandro Botticelli

The Birth of Venus

Botticelli's masterwork embodies, more than any other, the culture of the Florentine early Renaissance under the influence of the Classical style. Commissioned by the Medici, this work shows the standing figure of nude Venus, the ideal beauty, on a giant seashell in its center. Two wind gods blow her toward the shore, where a nymph receives her with a cloak embroidered with flowers. This motif is based on *Venus Anadyomene*, a tale from Antiquity. The Florentine poet Angelo Poliziano described the foam-born goddess of love in a 1475 poem that borrowed from Homer. Botticelli's contemporary, the philosopher Marsilio Ficino, interpreted this mythological tale as symbolizing the joining together of spirit and matter. Botticelli was acquainted with such scholarly ideas and utilized them in his paintings. His Venus is as flawless as a marble statue. Her figure follows the shape of a large S. Her windblown hair continues this elegant use of line, and the streaming hems of the garments of the secondary figures answer back. Botticelli strove less for naturalism than for an ideal harmony of all the elements in his paintings. In this way, he created a composition that embodies both extraordinary clarity and beauty. As a result, this painting is, even today, often reproduced.

■ **The Birth of Venus**, ca. 1485, tempera on canvas, 172.5 x 278 cm, Galleria degli Uffizi, Florence

This group of two closely entwined wind gods blow at Venus from the left. They are thrust like a wedge into the composition. They add dynamism to the picture while simultaneously acting as counterweights to the figure of the nymph standing on the right. Anatomical correctness was of less interest to Botticelli here.

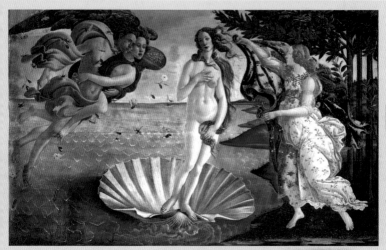

In creating his figure of Venus, Botticelli oriented himself on an archetype of Antiquity, the so-called "Venus Pudica," who modestly covers her breasts and genitals with her hands. Botticelli's beautiful goddess is elegantly balanced on one foot. In this way she exemplifies the Classical concept of *contrapposto*, standing so that her shoulders and arms twist from her hips and legs. Thus she has a more relaxed appearance. However, completely un-Classical is her narrow face and melancholic and musing expression. Venus may mirror the features of Simonetta Vespucci, a Florentine beauty admired by many, including Lorenzo de' Medici; she died at a very young age in 1476.

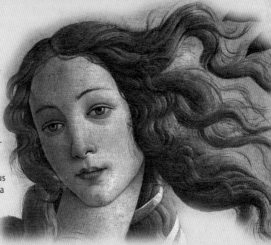

Sandro Botticelli

Piero della Francesca

ca. 1415/20–1492, Borgo San Sepolcro

- Aimed to achieve mathematical exactness in his paintings and frescoes
- Combined central perspective with a realistic and clear treatment of light
- His work is characterized by foreshortening and geometric shapes ■ His murals contain narratives that span the wall and tell a complete story

ca. 1415–20 Born Piero di Benedetto dei Franceschi in Borgo San Sepolcro in the province of Arezzo

1439 Student of Domenico Veneziano in Florence; works on frescoes for the hospital of Santa Maria Nuova

1442 Returns to Borgo San Sepolcro to work and live

1451 Meets the architect and theoretician Leon Battista Alberti in Rimini; paints a fresco for Sigismondo Malatesta as his votive offering

1452 Moves to Arezzo, where he decorates the main choir chapel in San Francesco until 1466

1458–59 Lives in Rome

ca. 1460 In contact with the court of Federico da Montefeltre in Urbino, an important art center

ca. 1480 Gives up painting and devotes himself to the study of perspectives; publishes a tract on the use of perspectives in painting. Much of his research work is later absorbed into the writing of others

1492 Dies in Borgo San Sepolcro

Piero della Francesca did not work in Florence, which was the chief center of early Renaissance culture, but rather for courts and churches in the provinces. Here he developed an unmistakable style, with great clarity of form and festive sublimity. The proportion and rhythm of his works are based on a profound study of geometry and perspective. His paintings were also outstanding because of his natural treatment of light. He treated the area covered by his painting as a unified space

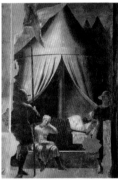

■ **The Dream of Emperor Constantine**, ca. 1458, 329 x 190 cm, fresco, San Francesco, Arezzo

flooded with light. With his fresco *The Dream of Emperor Constantine*, Francesca managed to create one of the earliest painted night scenes. His works are characterized by foreshortened figures and geometric shapes.

Other Important Works by Piero della Francesca	
Madonna del Parto (Madonna of Maternity), ca. 1450, Museo della Madonna del Parto, Monterchi	The Flagellation of Christ, ca. 1455, Galleria Nazionale, Urbino
The Baptism of Christ, ca. 1450, National Gallery, London	The Resurrection of Christ, ca. 1463, Museo Civico, Borgo San Sepolcro
The Meeting of the Queen of Sheba and Solomon, after 1458, San Francesco, Arezzo	Madonna with Child, Saints, and Donor, ca. 1472–74, Pinacoteca di Brera, Milan

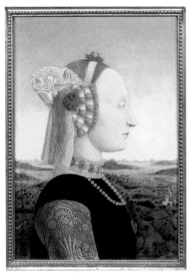
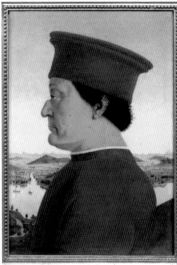

■ **Duke Federico da Monte-feltro and His Spouse Battista Sforza**, ca. 1466, oil on wood, each panel 47 x 33 cm, Galleria degli Uffizi, Florence

These portraits, painted on two wooden panels, bear witness to the influence of northern European painting on Italian art. Piero della Francesco learned the technique of painting in oil (instead of the usual tempera) from Flemish painters, whom he observed at the court of the Duke of Montefeltre. He also owed to them his fine rendition of landscapes, which reflected magnificent depth.

■ **The Story of the True Cross** (detail), after 1458, fresco, San Francesco, Arezzo

This is part of an extensive series of frescoes depicting the legend of the Holy Cross. It shows St. Helena, accompanied by court ladies, kneeling before the re-discovered cross of Christ that is lying on the ground. Characteristic of Piero della Francesca is the definite rhythm he uses to tell the story, as well as the strong, statuesque depiction of people. The scene is spanned by a sky with light clouds.

Piero della Francesca

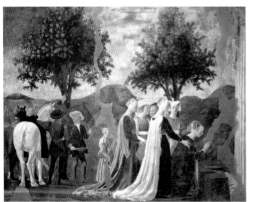

Andrea Mantegna

1431, Isola di Carturo—1506, Mantua

■ Most important painter of the Quattrocento (early Renaissance) in northern Italy ■ Experimented with extreme effects of perspective ■ His illusionistic frescoes inspired Baroque ceiling painting ■ He was one of the first Italian painters to paint on canvas ■ He also did copper engravings

1431 Born in Isola di Carturo, a small village between Vicenza and Padua

1441 Begins to learn art from his adoptive father, Francesco Squarcione, a painter

1448 Paints his first large altarpiece at the age of 17

1449 Along with Niccolò Pizzolo, he starts to paint frescoes in the Ovetari Chapel of the Eremitani Church in Padua; continues this work until 1459

1452 Works on a fresco in the church of Sant'Antonio in Padua

1453 Marries Nicolosa, daughter of the Venitian painter Jacopo Bellini

1460 Becomes court painter of Lodovico Gonzaga in Mantua; works in the castle, where he finishes his masterpiece in the Camera degli Sposi (bridal chamber) in 1474

1466 Travels to Florence

1488 Pope Innocence VIII calls him to Rome to decorate the private chapel Belvedere in the Vatican (not preserved)

1497 Begins a series of mythological paintings for Isabella d'Este

1506 Dies in Mantua

The highly gifted Andrea Mantegna received early recognition in the university town of Padua. Here he communed with cultivated humanists who shared his interest in Roman Antiquity, an interest that was reflected in the architecture he painted, which resembles the Classical Roman style. Mythological themes played an important role in his work.

He depicted human forms and objects with sharp outlines, as if cut out or sculpted. Mantegna was greatly influenced by the Florentine sculptor Donatello (p.128), who was also active in Padua.

■ **The Gonzaga Family**, 1474, fresco, Palazzo Ducale, Mantua

As the court painter of the Gonzaga family in Mantua, Mantegna created these famous frescoes for the Camera degli Sposi (bridal chamber) of the palace. He positioned the lively portraits of his sponsor family before painted imitations of Classical architecture, thus creating an illusion of greater space.

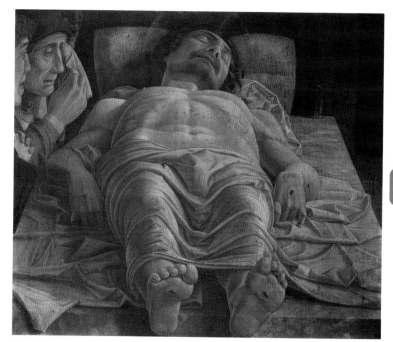

■ **Ceiling Frescoes in the Camera degli Sposi**, 1474, Palazzo Ducale, Mantua

Mantegna attempted daring experiments with perspective. The round ceiling fresco in the Camera degli Sposi appears to offer a glimpse into an open heaven. Angels and other figures bending over a painted sill look down upon the viewer. This concept was a milestone in the development of illusionistic ceiling painting, which reached its zenith in the Baroque period. Another example is found in the drastically foreshortened figure of the dead Christ (above).

■ **The Lamentation Over the Dead Christ**, ca. 1490, tempera on wood, 66 x 81.3 cm, Pinacoteca di Brera, Milan

Other Works by Mantegna

The Adoration of the Shepherds, ca. 1451–53, Metropolitan Museum of Art, New York

The Altar of St. Zeno, 1457–60, Church of St. Zeno, Verona

St. Sebastian, ca. 1458, Kunsthistorisches Museum, Vienna

The Triumph of Caesar, ca. 1486, Hampton Court Palace, London

Andrea Mantegna

Giovanni Bellini

ca. 1430, Venice–1516, Venice

■ Leading painter of the Venetian School in transition from Early Renaissance to High Renaissance ■ Founder of the great Venetian tradition that led, by way of Giorgione, to Titian and Paolo Veronese ■ Created mainly religious paintings but also outstanding portraits, allegories, and mythological scenes

ca. 1430 Born in Venice as son of the painter Jacopo Bellini

1453 His sister marries the painter Andrea Mantegna

1459 Works for some time in Padua alongside his father and his brother Gentile, also a painter

1475 Meets Sicilian painter Antonella da Messina in Venice and learns from him the technique of painting in oil

1479 Receives a commission for a grand picture cycle for the Sala del Maggior Consiglio (great council hall) in the Palace of the Doges in Venice; it takes more than a decade to complete (destroyed in a fire in 1577)

1488 On commission from the Pesaro family, paints a large triptych for the Frari Church in Venice

1506 Meets the German painter Albrecht Dürer, who was visiting Venice during his Italian tour

1516 Dies in Venice

Giovanni Bellini turned Venice into a center of Renaissance painting comparable to Florence or Rome. He created monumental altarpieces and many pictures for private devotion. He was initially influenced by his brother-in-law Andrea Mantegna (p. 140). While oil painting was still a new technique in Italy, he used oils to produce shining colors and lights. With its soft transitions from color to color and its deeply brilliant tones, his paintings formed an opposite pole to the illustrative clarity of the Florentine Renaissance. Bellini's most important pupils were Giorgione (p. 162) and Titian (p. 164).

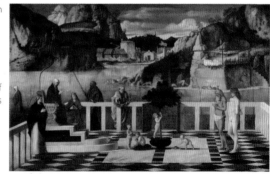

■ **Sacred Allegory**, ca. 1490, oil on canvas, 73 x 119 cm, Galleria degli Uffizi, Florence

The meaning of this mysterious picture has not been completely clarified to this day. It combines various saintly figures and other individuals in one symbolic portrait. The landscape in the background takes on new meaning as a stimulator of mood, and it becomes as important an element of the picture as the figures themselves.

■ **Madonna with Child and Saints Peter, Catharine, Lucia and Jerome (Pala di San Zaccaria)** (altarpiece for the church of St. Zaccaria), 1505, oil on canvas (transferred from wood), 500 x 235 cm, San Zaccaria, Venice

Bellini created this large altarpiece by using the new Renaissance technique known as *Sacra Conversazione*. During the Middle Ages, several saints were each allotted a separate panel. Bellini combined the enthroned Madonna with figures of different saints in a single unit, both spatially and scenically. The architecture Bellini has reproduced illusionistically underscores the clear, symmetrical build-up of the picture. His virtuoso art lends the figures extraordinary precision and dignity.

■ **Young Woman with Mirror**, 1515, oil on canvas, 62 x 79 cm, Kunsthistorisches Museum, Vienna

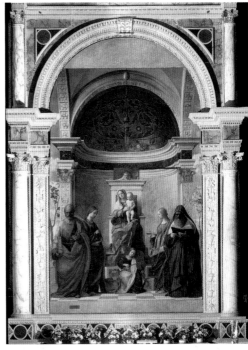

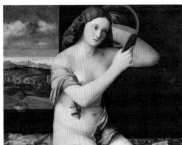

In this late work, Giovanni Bellini created an idealized harmony between landscape and figure, what is close and what is distant. Luminous coloration and clear composition define this picture.

Other Important Works by Bellini

Agony in the Garden, ca. 1459, National Gallery, London

Polyptych of St. Vincent Ferrer, ca. 1464, St. John and St. Paul's Basilica, Venice

Madonna with Saints (Pala di San Giobbe), ca. 1480, Galleria dell' Accademia, Venice

Madonna with Child, ca. 1485–90, Metropolitan Museum, New York

Madonna with Saints (Frari triptych), 1488, Santa Maria dei Frari, Venice

Portrait of a Young Man, ca. 1500, National Gallery of Art, Washington, DC

Portrait of the Doge Leonardo Loredan, before 1501, National Gallery, London

Feast of the Gods, 1514, National Gallery of Art, Washington, DC

Giovanni Bellini

Leonardo da Vinci

1452, Anchiano, near Vinci–1519, Cloux (France)

■ One of the most important masters of the High Renaissance ■ Primarily a painter and draftsman, he also designed sculptures and architecture ■ Besides art, he was involved with science and technology ■ Completed few paintings

1452 Born in the village of Anchiano near Vinci, close to Florence, as the illegitimate child of a notary

1472 Enrolls in the St. Luke Guild of Painters in Florence

1482 Moves to Milan, where he works for Ludovico Sforza

1493 Works on a monumental equestrian statue for Francesco Sforza

1495 Begins his *Last Supper*

1499 After the overthrow of Ludovico Sforza, moves to Florence by way of Mantua and Venice

1502 Becomes the military engineer of General Cesare Borgia

1503 Paints the fresco *The Battle of Anghiari* in the Palazzo Vecchio in Florence (not preserved)

1508 Returns to Milan

1510 Begins intensive study of human anatomy

1513 Travels to Rome

1516 French king Francis I invites him to Castle Cloux near Amboise

1519 Dies in Castle Cloux on the Loire

More than any other personality of the Renaissance, Leonardo da Vinci embodied the humanistic ideal of an all-round cultivated person. Born as the out-of-wedlock child of a maid, Leonardo rose to become one of the most influential artists of all time. He completed only 17 paintings that are undoubtedly his; however he invented solutions to all categories of artistic problems. Generations of artists who came after him benefited from these innovations.

His compositions produce an extraordinarily lively effect and appear harmonic and flowing. Typically, Leonardo created very fine modulations of light and shadow, especially with faces and background landscapes. His human beings express finely differentiated feelings. ▱

■ **Vitruvian Man**, ca. 1490, pen or pencil on paper, 34.3 x 24.5 cm, Gallerie dell'Accademia, Venice

Other Important Works by Leonardo

The Annunciation, ca. 1472–77, Galleria degli Uffizi, Florence	**St. Jerome**, ca. 1480, Pinacoteca Vaticana, Rome
Madonna Carnation, ca. 1474, Alte Pinakothek, Munich	**Adoration of the Magi**, ca. 1482 (incomplete), Galleria degli Uffizi, Florence
Portrait of Ginevra de' Benci, ca. 1475–78, National Gallery of Art, Washington, DC	**Virgin of the Rocks**, ca. 1483–85, Musée du Louvre, Paris
Benois Madonna, ca. 1478–1500, Hermitage, St. Petersburg	**Portrait of a Musician**, ca. 1490, Pinacoteca Ambrosiana, Milan

The lady in the painting is believed to have been the lover of Duke Ludovico il Moro, at whose court Leonardo was active for many years as painter, sculptor, and engineer. It is said that she was a gifted musician and spoke Latin fluently, and frequently attended philosophical meetings with scholars. This portrait appears very life-like not only because of the extremely fine details, but also because of the posture of the beautiful young woman, which appears spontaneous. While she has turned her upper body to the left, she turns her head to the right as if something in that direction has caught her attention. In this way, Leonardo avoided the rigid profile or frontal view customary in portraiture at the time. The ermine is depicted very naturalistically; it appears even more real because she touches it with her hand.

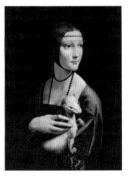

■ **Lady with Ermine ("Cecilia Gallerani")**, ca. 1490, oil on wood, 55 x 40 cm, Muzeum Czartoryski, Cracow

■ **Virgin and Child with St. Anne**, ca. 1501–12, oil on wood, 168 x 130 cm, Musée du Louvre, Paris

As with many of his works, Leonardo left this painting unfinished. St. Anne smiles tenderly upon her daughter, the Virgin Mary, who is sitting upon her lap. She, in turn, bends down with a hint of refrained anxiety toward her son Jesus, who is playing with a lamb. This scene foreshadows his future role as the crucified Lamb of God. Leonardo has composed here a complicated group of people who seem to be in motion, and yet remain closely entwined. By arranging this composition in the Classical form of a pyramid, he lent the picture tranquility and harmonic compactness. The wide, rocky landscape with mountains disappearing behind the blue fog reflect Leonardo's close observation of nature.

Leonardo da Vinci

In creating these figures, he always strove for ideal beauty.

Leonardo's power of innovation was not limited to painting. He was driven relentlessly to discover how things worked. Always trying to go to the heart of things, he studied medicine, optics, anatomy, geology, cartography, and biology. He left behind sketches and notebooks with thousands of closely written pages, which show his deep insights into natural phenomena and made him a founder of scientific illustrations.

Art was a science to Leonardo, one that he believed required the highest attention to detail and that was reflected entirely in the cosmos.

■ Anatomical Study: Embryo in the Womb, ca. 1509–14, chalk, red pencil, pen, and ink on paper, 30.4 x 22 cm, Royal Library, Windsor

Leonardo was not satisfied with the drawing of nudes, which had become commonplace by the 15th century. In order to better understand how the body functioned, he dissected cadavers with highly regarded anatomists. He apparently planned to publish an illustrated handbook on anatomy, which, however, was never completed (just as his theses on the art of painting and engineering were not).

■ Head of Girl, undated drawing

Leonardo was a genius sketcher and drawer. He left innumerable sketches in notebooks as well as studies on sheets of paper—more than any other Renaissance artist. He regarded drawing as a means of research. For him it was a process of spiritual understanding and formal experimentation. Many of his

sketches were drawn hastily; others he worked out with the finest detail. Most of his artistic projects are known to us only as drawings on paper, such as the painting of Leda and the swan. Nothing exists from this project except preliminary studies and copies from his pupils. The decorated hair reminds us of Botticelli's female figures and reveals Leonardo's affinity for curves.

■ **The Last Supper**, 1495–97, dry fresco, 422 x 904 cm, Church of Santa Maria delle Grazie, Milan

The 12 disciples have gathered around Christ for the last Passover meal before his crucifixion. Leonardo depicts the moment of greatest emotional tension, when Christ says, "One of you will betray me." The apostles' dramatic agitation travels like a wave down the table. To the left of Christ, Judas, the betrayer, pulls back in fear. Christ remains steadfast in the center and gestures with outstretched hands at the bread and wine, references to the Eucharist. Here, Leonardo combines various individual reactions, gestures, and temperaments into a single, unified composition. The central perspective in which the room is depicted focuses the viewer's attention on the figure of Christ. Never before had the Last Supper been presented so dramatically. Leonardo painted with tempera and oil on dry wall, an experimental technique that did not endure. Despite many restoration attempts, only remnants of the original are preserved. Nevertheless, this composition has inspired artists from Rembrandt to Warhol.

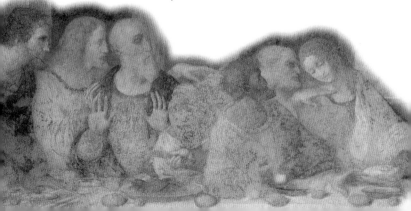

Mona Lisa

The *Mona Lisa* is one of the world's most famous portraits and, at the same time, one of the its most mysterious paintings. It is not even certain that it really depicts the wife of the Florentine citizen Francesco del Giocondo,

who was named Mona Lisa. The unique magic of the painting is perhaps created by the utilization of the style called sfumato: a fine, almost unnoticeable blur found especially over facial features, but also over landscapes. In this way, Leonardo avoided the over-sharp precision and stiffness of earlier portraiture. Tones blend into one another, and the landscape melds with the human figure, the cosmos with humanity.

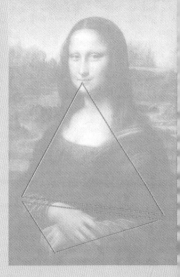

Mona Lisa's Smile It has made her famous, but is she really smiling or not? Leonardo created this mystery by using a virtuoso technique. He left the facial expression of *Mona Lisa* deliberately vague. A fine shadow over the corners of the mouth and the eyes keeps the viewer guessing. He left it to the viewer to interpret her expression.

■ **Mona Lisa (La Gioconda)**, ca. 1503–06, oil on wood, 77 x 53 cm, Musée du Louvre, Paris

Mona Lisa's form appears simple, but her pose is highly calculated. Leonardo uses geometry to make the sitting figure seem realistic. He turns the torso slightly to the left, while her eyes look directly at us. This brings life into the composition.

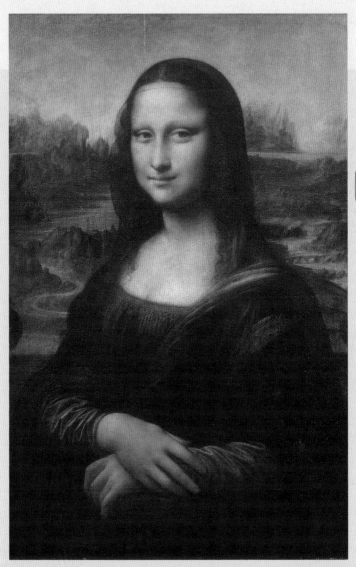

Leonardo da Vinci

Michelangelo Buonarroti

1475, Caprese—1564, Rome

- One of the most illustrious sculptors of all time ■ Leading artistic personality of the High Renaissance and a trailblazer of Mannerism ■ Regarded foremost as a sculptor, but also created outstanding frescoes, architectural designs, and poems ■ Worked for the popes in Rome and the Medici in Florence

1475 Born in the village of Caprese in Tuscany

1488 Apprenticed to the Florentine painter Domenico Ghirlandaio

1490–92 Invited to live in the palace of Lorenzo de' Medici in Florence

1496 Moves to Rome, where he creates his first *Pietà*

1501 Returns to Florence and begins the statue of *David*

1504 Receives a commission for a huge battle fresco in the Palazzo Vecchio in Florence, which he never completes

1505 Called to Rome by Pope Julius II to design his monumental tomb

1508 Begins the ceiling frescoes in the Sistine Chapel

1520 Works on the Medici interment chapel in the church of San Lorenzo in Florence

1534 Moves to Rome and begins the *Last Judgment*

1546 Takes over the supervision of the construction of St. Peter's and designs the dome

1564 Dies in Rome

Michelangelo, who came from the lower nobility, learned painting as a youth from Domenico Ghirlandaio. Then he learned sculpture from Donatello's (p. 128) understudy Bertoldo di Giovanni. He studied models of Classical sculptures in the collection of the Medici, and came into contact with Neoplatonic philosophers. This formed his self-conception as an artist. He perceived Indian beauties as mirrors of the divine. Art was for him not a craft, but an intellectual challenge. Michelangelo was the first artist who was venerated even in his own time as a divine genius. He mastered immense formats and lent his compositions grandiose power and clarity hitherto unseen. ▱

■ **Pietà**, 1497–99, marble, height 174 cm, St. Peter's Basilica, Rome

■ **David**, 1501–04, marble, height 434 cm, Galleria dell'Accademia, Florence

With his statue of the biblical David, the young Michelangelo created the first monumental male nude since Antiquity (and at the same time one of the most celebrated sculptures in cultural history). Michelangelo freshly interpreted the biblical shepherd boy as a pow-erful hero with controlled energy and personal bravery. The giant statue was intended originally as a support pillar for the choir of the Florentine cathedral; however, after its completion it was placed before the Palazzo Vecchio as a symbol of the city commune. Today, a copy of the statue still stands at this location, while the original is within the Galleria dell'Accademia.

151

High Renaissance in Italy

Other Important Works by Michelangelo	
Battle of the Lapiths and Centaurs, ca. 1490–92, Casa Buonarroti, Florence	Moses, ca. 1513–16, St. Peter in Vincoli, Rome
Bacchus, 1496–97, Museo Nazionale del Bargello, Florence	Victory, ca. 1520–25, Palazzo Vecchio, Florence
Madonna of Bruges, 1498–1500, Our Lady's Church, Bruges	Medici Tombs, 1521–34, Medici Chapel of San Lorenzo, Florence

■ **The Dying Slave**, ca. 1505–16, marble, height 229 cm, Musée du Louvre, Paris

This marble sculpture was originally intended to stand at the monumental tomb of Pope Julius II. Although Michelangelo began the sculpture in 1505, it was not completed until a decade later, and at a reduced size than originally planned. The artist gave away *The Dying Slave* when it had lost its purpose of being used on the tomb. The nude male figure, which appears to be awakening from a deep sleep or fighting against death, symbolizes the soul freeing itself from the bondage of the body.

Michelangelo Buonarroti

His idealization of humankind exceeded all normal boundaries. He made the nude body the main subject of his art, depicting it as ideally beautiful and muscular, while filled with spiritual power and inner resilience. Michelangelo preferred to tackle blocks of marble, but he also created masterworks as a painter.

Many of his works remained incomplete, not only due to the demands of his papal employer, but also because of the high expectations he placed on himself. In his later works, he left aside the ideal harmony and calmness of the High Renaissance and initiated Mannerism. His creations remained popular and in later centuries were inspirations for Rubens (p. 234), Bernini (p. 222), Delacroix (p. 330), and Rodin (p. 364).

■ **The Holy Family (Tondo Doni)**, ca. 1503–04, tempera on wood, diameter 120 cm, Galleria degli Uffizi, Florence

This round composition was Michelangelo's first known painting (and his only certain panel painting). Michelangelo treated this traditional biblical theme in the circular format that was popular in Florence. The nude youths in the background are rather unusual. Michelangelo may have wanted to show a connection between the spiritual world of classical Antiquity and Christianity. The relationship between Christianity and Antiquity was a much discussed topic of the humanist philosophers of the Renaissance.

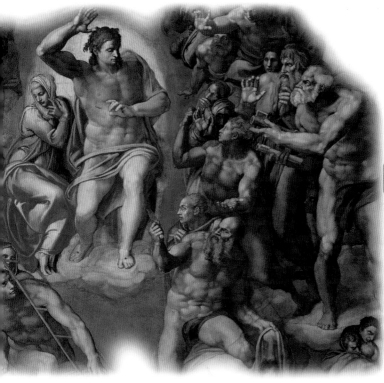

■ **The Last Judgment**, 1534–41, fresco,
17 x 13.3 m, Sistine Chapel, Vatican, Rome

Michelangelo created a gigantic sea of moving
bodies on the façade of the Sistine Chapel in
his fresco *The Last Judgment*. People are
climbing out of their graves to be judged by
Christ. Contrary to Christian tradition, Jesus is
depicted beardless and almost nude. His ath-
letic body is more like that of Apollo or Her-
cules. Michelangelo showed the anguish of the
damned on the right side of the picture with
particular vividness. Most of the characters
were originally depicted nude, but the naked-
ness of many was later painted over.

Michelangelo Buonarroti

The Creation of Adam

This fresco has become something like a symbol of the Renaissance itself. God the Father hovers in the air, carried by heavenly beings. He lets the spark of his divine spirit penetrate man. Man, who has been created in God's image, awakens to life. He is no longer a soulless creature but a creative spirit inspired by the Almighty— a being who strives after divine perfection, as the artists and thinkers of the Renaissance did.

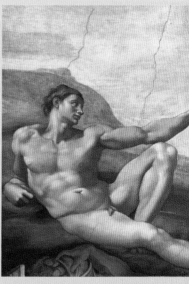

■ Ceiling Frescoes of the Sistine Chapel (complete view), 1508–12, Vatican, Rome

The *Creation of Adam* is a part of the giant ceiling fresco that Michelangelo finished in four years. He depicted Old Testament scenes from the Creation to the story of Noah. These scenes are flanked by large figures of sibyls and prophets.

The Divine Spark
Michelangelo's composition is as simple as it is ingenious: juxtaposing the Earth-bound sphere of Adam with the self-contained divine power of God. The two figures do not touch; however, one can almost feel the divine spark coursing from God's finger to the finger of Adam. This expresses the spiritual connection between God and man.

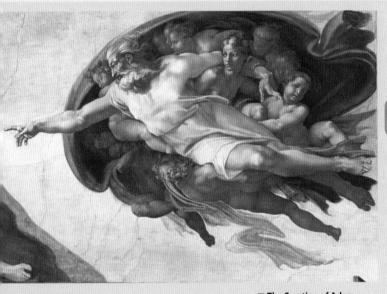

■ **The Creation of Adam**,
1508–12, fresco, 280 x 570 cm,
Vatican, Rome

Michelangelo Buonarroti

Raphael

also Raffael da Urbino, Raffaello Santi, Raffaello Sanzio
ca. 1483, Urbino—1520, Rome

■ Main representative of the High Renaissance in Florence and Rome ■ In the 18th and 19th centuries, his fame surpassed that of Leonardo and Michelangelo ■ Created a series of architectural drafts and significant drawings

ca. 1483 Born to a painter in Urbino in Umbria, where he receives his first training

ca. 1495 Travels to Perugia after the death of his parents and becomes a student of Pietro Perugino

1501 His first documented work, an altarpiece for the church of San Nicola of Tolentino in Città di Castello, is finished

1504 Moves to Florence, where he makes the acquaintance of Leonardo and Michelangelo

1508 Pope Julius II summons him to Rome, where he quickly becomes popular

1509 Works on paintings in the Vatican and operates a large workshop with numerous assistants

1513 Designs the architecture of a sepulcher chapel for the Roman banker Agostino Chigi in Santa Maria del Popolo

1514 Takes over the management of the building of St. Peter's after Bramante's death

1515 Assigned with the supervision and preservation of Rome's antiquities

1520 Dies on his 37th birthday in Rome and is buried in the Pantheon

Neither a brooder like Michelangelo (p. 150), nor a restless researcher like Leonardo (p. 144), Raphael was a handsome man of a pleasant, balanced nature. Intelligent and highly talented artistically, he died at a very young age, at the peak of his career. Born to a painter, Raphael grew up in the lively cultural atmosphere of Urbino and joined the painter Pietro Perugino, whose graceful style he acquired. In search of new inspiration, he traveled to Florence, where both Leonardo and Michelangelo were working. Raphael enthusiastically picked up their new ideas: Leonardo's soft sfumato and Michelangelo's powerful sculptural body language. With his masterfully composed paintings of the Virgin Mary, the young Raphael soon distinguished himself as a leading artist. Pope Julius II

■ **Portrait of Baldassare Castiglione**, ca. 1514–15, oil on canvas, mounted on panel, 82 x 67 cm, Musée du Louvre, Paris

Works by Raphael

The Marriage of the Virgin (Sposalizio), 1504, Pinacoteca di Brera, Milan

Portrait of Agnolo Doni, ca. 1506–07, Palazzo Pitti, Florence

Madonna with the Goldfinch, ca. 1506–07, Uffizi, Florence

The Deposition of Christ (The Entombment), 1507–08, Galleria Borghese, Rome

Alba Madonna, 1508, National Gallery of Art, Washington, DC

The Triumph of Galatea, ca. 1511–14, Villa della Farnesina, Rome

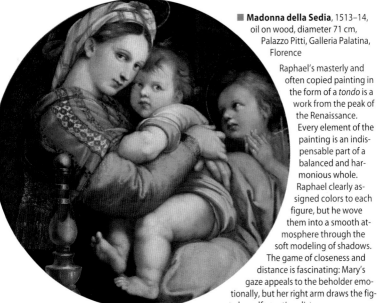

Raphael's masterly and
often copied painting in
the form of a *tondo* is a
work from the peak of
the Renaissance.
Every element of the
painting is an indis-
pensable part of a
balanced and har-
monious whole.
Raphael clearly as-
signed colors to each
figure, but he wove
them into a smooth at-
mosphere through the
soft modeling of shadows.
The game of closeness and
distance is fascinating: Mary's
gaze appeals to the beholder emo-
tionally, but her right arm draws the fig-
ures to herself, creating distance.

157

High Renaissance in Italy

■ **Madonna of the Meadow**, 1505–06, oil on
panel, 113 x 88 cm, Kunsthistorisches Museum,
Vienna

This painting is representative of Raphael's draw-
ings of the Virgin Mary from his Florentine years,
when he first encountered Leonardo. The com-
positional idea of a room-filling triangular group,
inside of which the single figures move freely
and vividly, is in accordance with the ideals he
worked by. Mary looks down in an affectionate
manner at her son, Christ, and John the Baptist.
The pair seem lost in an infantile game, but they
are holding a slender cross, an allusion to Christ's
passion. The smoothly slurred nuances of color
and shade display Leonardo's influence. The
bright landscape and the rotund, idealized faces,
on the other hand, contribute to the tender, af-
fectionate atmosphere of the painting, which
conforms completely with Raphael's own nature.
He varied this type of picture in a whole series of
similar compositions.

Raphael

brought him to Rome to paint large frescoes in the Vatican. Raphael undertook the commission with the help of a large workshop. As an architect, he later took over the construction management of the new St. Peter's Basilica and devoted himself to investigating the city's antiquities. His paintings were always bound to the concepts of balance and harmony. Thus, Raphael solidified his ideal of painting, and it became one that would influence artists for centuries to come.

■ **Philosophy (The School of Athens)**, 1510–11, fresco, width 800 cm, Stanza della Segnatura, Vatican, Rome

Raphael painted a cycle of frescoes for Pope Julius II's library. Originally positioned over the philosophical section of the library, *The School of Athens* is dedicated to philosophy. In the center stand Plato, who is represented with a white beard, and Aristotle. The philosophers are positioned in front of a grandiose architectural framework, which is reminiscent of Bramante's project for the new St. Peter's. Across from this fresco, Raphael painted the *Disputá*, which glorifies Christianity and the place of the Vatican in Christian life. A third fresco, *Poetry*, shows the muses and poetic arts.

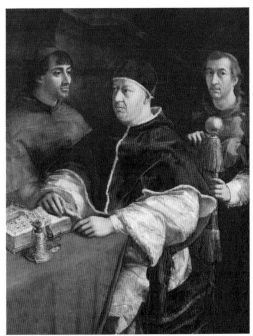

■ **Portrait of Pope Leo X with Cardinals Giulio de' Medici and Luigi de' Rossi**, 1518–19, oil on wood, 154 x 119 cm, Palazzo Pitti, Galleria Palatina, Florence

Pope Leo X, an energetic man, sponsored artists including Michelangelo and Raphael to start new projects. Raphael depicts him in front of an opened codex, holding a magnifying glass. The minor figures of the cardinals increase the significance and dignity of the main figure, and the diagonal placement endows the portrait with room-filling power. Raphael created a new type of representation within portrait painting. He was considered the leading portraitist of his time in Rome.

Raphael

Sistine Madonna

This painting has been counterfeited and duplicated time and time again, making it difficult to recognize its original meaning.

In this work, Raphael proves himself a master painter. As in a stage performance, the green curtains open to reveal the Virgin Mother floating in the clouds. Her robes move as if filled by the wind. Pope Sixtus, for whom the work is named, looks up at Mary, while the holy Barbara closes her eyes devoutly. At the bottom, two infantile angels rest their arms on the image border—an illusionist gimmick that suggests the Baroque and Rococo. Based on a Classical triangular configuration, the composition is unostentatious and dignified. It combines utmost grace with sovereign dignity, deep severity with surprising illusionist effects.

■ **Sistine Madonna**, ca. 1513–14, oil on wood, Alte Meister Gallerie, Dresden

The startled facial expression of the infant Jesus is difficult to interpret. It likely has to do with the painting's original location on the high altar of San Sisto in Piacenza. Directly across from the image of the child was a large crucifix. The Christ child was thus looking at his future—the crucifixion preordained by God.

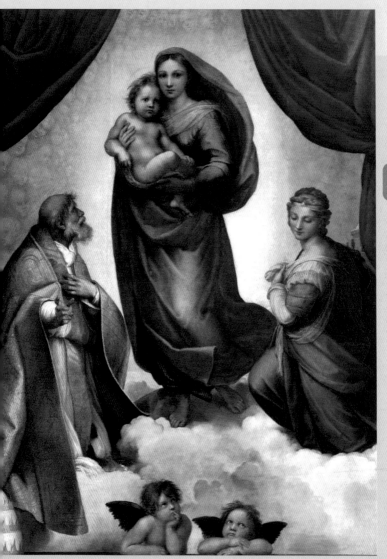

Giorgione

Zorgi da Castelfranco
ca. 1477/78, Castelfranco Veneto–1510, Venice

■ Founder of Venetian High Renaissance painting ■ Developed a unique color usage with soft, nuanced tones and light haziness ■ Often selected poetic, cryptic themes

ca. 1477/78 Born Zorgi da Castelfranco

ca. 1490 Receives his artistic training in Venice, most likely under Giovanni Bellini

ca. 1504 Paints an altarpiece for the cathedral in Castelfranco in Northern Italy

1507 Receives a commission in Venice for the decoration of the Doge's Palace

1508 Paints the façade of the Fondaco dei Tedeschi (House of German Merchants); the young Titian is an assistant

1510 Dies in Venice, apparently of the plague

Giorgione is among the great mysterious figures of art history. Almost nothing is known of his life, and only six or seven paintings can be attributed to him with certainty. Still, he is indisputably considered to be one of the most influential artists of European painting. Giorgione specialized in small, poetic scenes, created for an exclusive circle of refined patrons in Venice. His paintings convey meaning almost entirely through their color. The lines are less important; the drawing recedes behind the interplay of colorful modulations. The landscape plays two roles, serving as the vehicle of meaning and as the atmosphere. The worlds created in Giorgione's works are appealing in a dreamy, tender, and melancholy manner. Giorgione supposedly took inspiration from literary sources and deliberately allowed his works the fascination of multiple interpretations.

Works by Giorgione

Judith, ca. 1504, Hermitage, St. Petersburg

The Sunset (Il Tramonto), ca. 1506–10, National Gallery, London

The Adoration of the Shepherds, ca. 1508, National Gallery of Art, Washington, DC

The Three Philosophers, ca. 1510, Kunsthistorisches Museum, Vienna

■ **Laura**, 1506, oil on canvas on wood, 41 x 34 cm, Kunsthistorisches Museum, Vienna

An inscription on the back states the date of completion and the painter as Zorzo da Castelfranco, Giorgione's name in the Venetian dialect. The laurel branches play on the subject's name, Laura. It is one of the few of Giorgione's remaining portraits, which deeply influenced Venetian portrait painting.

■ **The Tempest**, ca. 1506, oil on canvas, 82 x 73 cm, Gallerie dell'Accademia, Venice

No longer mere background scenery, nature emerges in Giorgione's paintings as the actual subject of the picture. The stormy sky is dramatic and tempestuous. The intended meaning of the figures shown here is still not fully understood.

■ **Sleeping Venus**, ca. 1510, oil on canvas, 108 x 175 cm, Gemäldegalerie Alte Meister, Dresden

This Venus radiates complete peace in her unselfconscious beauty. The unfinished painting was completed after Giorgione's death by his pupil Titian (p. 164), whose early works show his teacher's influence.

Giorgione

Titian

Tiziano Vecellio
ca. 1488–90, Pieve di Cadore–1576, Venice

■ Venetian painter of paramount significance ■ Mastered all genres from portraiture to altarpieces to mythological subjects ■ Underwent a profound style shift over a long creative career ■ Strongly influenced Rubens and Velázquez

ca. 1488–90 Born Tiziano Vecellio in the village of Pieve di Cadore

1508 Frescoes the façade of the Fondaco dei Tedeschi in Venice with Giorgione

1516 Begins *L'Assunta* for the Venetian Franciscan church Santa Maria Gloriosa dei Frari

1545 Goes to Rome

1551 Member of the Scuola Grande di San Rocco

1554 Paints a series of mythological paintings for Phillip II

1566 Vasari visits Titian in his studio

1576 Dies in Venice

Titian is among the greatest masters of the Renaissance. He was one of the most successful artists of his time. Among his patrons were the foremost courts of Italy, the city of Venice, the kings of France and Spain, the Pope, and the Holy Roman Emperor.

He was born in the small Alpine region around Pieve di Cadore. At the age of nine he departed for Venice with his brother. There he learned first the mosaic arts, but he soon switched into the workshop of Giovanni Bellini (p.142). This influence reveals itself in the radiating, localized colors and lucid, harmonious compositions of his early paintings. Equally important for him was Giorgione (p. 162), who took the young painter on as an assistant. Titian's reputation spread rapidly beyond Venice, which he would only rarely leave during the course of his life.

An inventive universalist, Titian never limited himself to one genre of painting. His religious pictures boldly set aside conventional patterns and dared asymmetrical compositions, which continued to be influential into the Baroque period. He established new portrait styles, such as the life-size equestrian portrait of Charles V. In his

■ Assumption of the Virgin (L'Assunta), 1516–18, oil on wood, 690 x 360 cm, Santa Maria Gloriosa dei Frari, Venice

This forceful, animated altarpiece is striking, even at a distance. Titian's powerfully emotional figures became a model for countless painters.

Other Important Works by Titian	
Sacred and Profane Love, 1514, Galleria Borghese, Rome	**Pope Paul III and His Grandsons,** 1545, Galleria Nazionale di Capidimonte, Naples
Madonna of the Pesaro Family, 1519–26, Santa Maria Gloriosa dei Frari, Venice	**Ecce Homo,** ca.1558–60, National Gallery of Ireland, Dublin

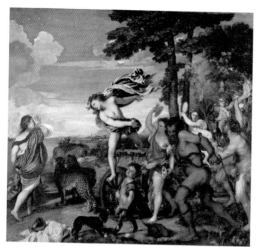

■ **Bacchus and Ariadne**, 1520–23, oil on canvas, 175 x 190 cm, National Gallery, London

The god of wine, Bacchus, is clad only in a piece of cloth. He springs from his chariot toward the alarmed Ariadne, who has just landed on the coast of Naxos. Her form blends in colorful unity with the sky. The right half of the composition brims with a boisterous platoon of music-making maenads and goat-legged satyrs, painted in warm, earthy tones. With its sumptuous use of color and harmonious movement, the painting embodies the Renaissance's ideals of Antiquity.

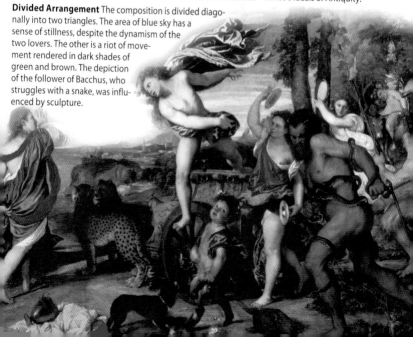

Divided Arrangement The composition is divided diagonally into two triangles. The area of blue sky has a sense of stillness, despite the dynamism of the two lovers. The other is a riot of movement rendered in dark shades of green and brown. The depiction of the follower of Bacchus, who struggles with a snake, was influenced by sculpture.

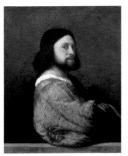

Portrait of a Man, ca. 1512, oil on canvas, 81 x 66 cm, National Gallery, London

It was once thought that this famous painting was a portrait of the contemporary poet Ariosto. In actuality it is most likely a self-portrait of Titian at a younger age.

mythological history paintings, Titian drew upon the entire spectrum of human passion. He named a series of these works *Poesie* and elevated them to the highest level of poetry. His numerous female nudes led the poetic beauty of Giorgione's time into the sensuality and dynamism associated with the Baroque era. In the last phase of his life, Titian underwent a radical shift in style, both in his choice of themes and in his palette, which darkened as he explored different effects of color. He began employing an open, sketchy brushstroke that was highly charged with energy, resulting in an uncoupling of the boundaries between objects and figures.

Titian's work spanned a fundamental shift in epochs from the Venetian High Renaissance through Mannerism to an individual, bolder style, which reached well beyond his time period and can be seen as an influence in the work of Rembrandt (p. 244), Delacroix (p. 330), and even in the Modern period.

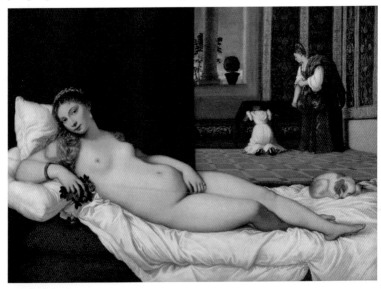

■ **Christ's Crowning with Thorns**, ca. 1570, oil on canvas, 280 x 182 cm, Alte Pinakothek, Munich

In this late work, Titian again takes up a composition which he had painted almost 30 years before. The raw, blunt painting style and the dark, shadowed use of color lend *Christ's Crowning with Thorns* a singular emotional intensity and modernity. Forms and contours give way, as the color alone conveys the scene. Titian's sketchy later style was harshly criticized by the art critic Giorgio Vasari, who knew Titian personally. Until the 19th century, this painting style was disparaged, and criticism was accompanied by accusations of senility and failing eyesight. Only at the beginning of the Modern period were the power and depth of expression recognized. Although apparently unfinished, the painting suggests a radical new conception of art.

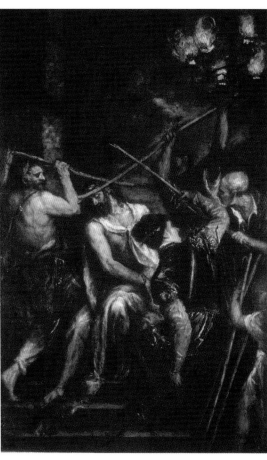

■ **Venus of Urbino**, 1538, oil on canvas, 119 x 165 cm, Galleria degli Uffizi, Florence

Titian's most famous representation of Venus was commissioned by the duke of Urbino, Guidobaldo III della Rovere, and was, with its clearly erotic impli-

cations, assuredly not for the eyes of the general public. Whether the nude beauty represents the Classical goddess Venus is questionable, since she lies in a Renaissance interior, and the two servants in the background are also dressed in

the fashion of the time. While the question of identity may be undecided, the immediate sensuality radiated by the painting is very clear. Unlike Giorgione's *Sleeping Venus* (which Titian completed), *Venus of Urbino* looks directly at the viewer.

Correggio

Antonio Allegri da Correggio
ca. 1489 Correggio—1534 Correggio

■ Important forerunner of Baroque and Rococo ■ Daring motifs of movement and reductions of perspective ■ Created altar and devotional images, large illusionistic dome frescoes, and poetic and sensuous mythological scenes

■ **ca. 1489** Born Antonio Allegri, the son of a merchant, in the small town of Correggio in Emilia

1514 Paints an altarpiece for the San Francesco Church in Correggio

ca. 1518 Presumably travels to Rome, where he studies the work of Raphael and Michelangelo

1519 Undertakes a series of murals for the monastery of San Paolo in Parma

1526 Begins the great cupola fresco in the cathedral of Parma

1534 Dies in Correggio

Correggio worked almost exclusively in the northern Italian province of Parma, but he evidently came into early contact with the work of Leonardo (p. 144) and with the Roman frescoes of Michelangelo (p.150) and Raphael (p.156). Relatively unknown in his lifetime, Correggio later enjoyed enormous appreciation, especially in the 18th century, as he became recognized as a precursor to the Rococo. Correggio developed a soft, nuanced style without severe contours or sharp color contrasts. Nebulous landscape backgrounds and soft light-dark effects gave his paintings a gentle ambience and underscored the mirthfully erotic character of his mythological paintings. His expansive cupola frescoes were enlivened with free-floating figures and were groundbreaking in the art of illusionistic ceiling painting.

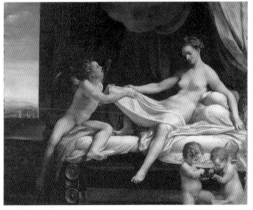

■ **Danäe**, ca. 1531, oil on canvas, 161 x 193 cm, Galleria Borghese, Rome

The painting is one of a series of four depicting Zeus's love affairs as described in Ovid's *Metamorphosis*. The king's beautiful daughter Danäe, who has been locked in a tower by her father, is visited by Zeus in the form of a shower of gold. Cupid helpfully assists Zeus from his position at the foot of the bed. Correggio's sensual and erotic, but never vulgar, painting was a model for the Rococo artists.

■ **The Holy Night (Adoration of the Shepherds)**, 1522–30, oil on canvas, 256.5 x 188 cm, Gemäldegalerie, Dresden

The light in this night scene does not emanate from a natural source, but rather from the newborn Christ child. It symbolizes Christ as the light of the world. Correggio lends the chiaroscuro style of sharp light contrasts an entirely new function, which defines the painting and anticipates the Baroque.

Other Important Works by Correggio

The Mystic Marriage of St. Catherine, ca. 1510, Musée du Louvre, Paris	**Assumption of the Virgin**, 1526–30, dome fresco, Parma Cathedral
Four Saints, 1517, Metropolitan Museum of Art, New York	**Venus and Cupid**, 1524–27, Musée du Louvre, Paris
Ceiling Fresco of Camera di San Paolo, ca. 1518–19, Monastery San Paolo, Parma	**The School of Love**, ca. 1525, National Gallery, London

■ **Jupiter and Ganymede**, ca. 1531, oil on canvas, 163.5 x 70.5 cm, Kunsthistorisches Museum, Vienna

Zeus, in the guise of an eagle, kidnaps the beautiful boy from the earth. Correggio stages the scene in a slender portrait format with dynamic reductions in perspective before an almost watercoloresque, sfumato landscape.

Paolo Veronese

1528, Verona—1588, Venice

■ Executed bright, festive compositions, often on a large scale, with illusionistic spatial effects ■ Supported a large workshop, in which his brother, sons, and nephews also worked ■ Alongside Titian and Tintoretto, dominated the Venetian art scene

1528 Born in Verona to a stonecutter

1541 Learns how to paint in Verona under Antonio Badile, whose daughter he later marries

1551 Paints frescoes in the Villa Soranzo in Castelfranco

1552 Paints the *Temptation of St. Anthony* for the Cathedral of Mantua in his early style, which combines a worm's-eye view with figures inspired by Michelangelo

1553 Settles in Venice

1555 Develops a more mature and personal style

1560 Travels to Rome

1561 Decorates the Villa Maser, which was designed by Andrea Palladio, with illusionistic landscapes and ceiling frescoes that seem to extend the actual architecture of the building

1565–80 Works in a quieter, more Classical style

1577 Undertakes the redecoration of the Grand Council Chamber of the Doge's Palace following its destruction in a fire

1583 Begins lighting his paintings by twilight, creating a more dramatic effect

1588 Dies in Venice

Paolo Veronese was the last great representative of the High Renaissance in Venice. Although he was a contemporary of the Mannerists, he remained virtually unaffected by their turbulent, expressive experiments with style. Under the influence of Titian (p.164) and Michelangelo (p.150), he developed a much more stately, monumental painting style, which anticipated the art of the Baroque era. Veronese executed immense illusionistic ceiling panels in the Doge's Palace, decorated the palaces of rich Venetian nobles with frescoes, and painted altarpieces. He brought the same elegance and magnificence to religious themes as he did to mythological scenes. The visual impact of his paintings was enhanced through a glittering, sumptuous palette of colors. Above all, it was this resplendent coloration that inspired later painters. Giovanni Battista Tiepolo (p. 280), a Rococo painter, and Eugène Delacroix (p. 330) were both greatly influenced by Veronese's work.

Other Important Works by Paolo Veronese	
Ceiling Fresco with the History of Esther, 1555–56, San Sebastiano, Venice	**The Feast in the House of Levi**, 1573, Gallerie dell'Accademia, Venice
Fresco in the Villa Barbaro, ca. 1560–62, Villa Barbaro, Maser	**Mars and Venus**, ca. 1580, Metropolitan Museum of Art, New York
The Family of Darius before Alexander, 1565–70, National Gallery, London	**The Finding of Moses**, ca. 1580, Museo del Prado, Madrid
The Vision of St. Helena, ca. 1570, National Gallery, London	**Allegory of Wisdom and Strength**, ca. 1580, Frick Collection, New York
Dead Christ, 1576–82, Hermitage, St. Petersburg	**Triumph of Venice**, 1580–85, Doge's Palace, Venice

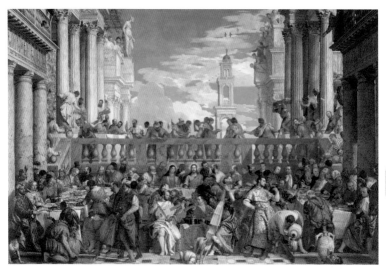

■ **The Wedding at Cana**, 1562–63, oil on canvas, 660 x 990 cm, Musée du Louvre, Paris

The pinnacle of Veronese's art was his large-scale biblical festivity scenes. He stages the animated bustle of the richly dressed figures like a magnificent theater performance. An abundance of naturalistic details, such as the lifelike musicians and dogs, enlivens the crowded scene. The elaborate, illusionistic architecture provides a majestic stage for the action and reveals his familiarity with Venetian Renaissance architects Palladio and Sansovino.

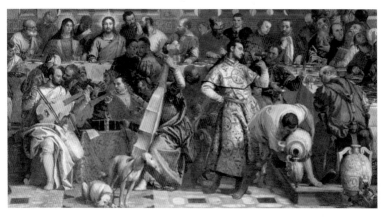

Paolo Veronese

Agnolo Bronzino

Agnolo di Cosimo
1503, Monticelli–1572, Florence

■ Leading exponent of Mannerism in Florence ■ Applied paint in perfect, enamel-like smoothness ■ Developed a new court style of portrait painting
■ Was one of the founding members of the Florentine Academy

1503 Born Agnolo di Cosimo

1523 Works with teacher Pontormo in the Certosa del Galluzzo by Florence

1530 Enters the service of Duke Guidobaldo of Urbino

1533 Paints frescoes in the Medici Villas near Florence

1539 Designs the decorations for the marriage of Cosimo I

1540 Court painter to Cosimo I de' Medici

1572 Dies in Florence

When Bronzino began his artistic career, the High Renaissance had passed its prime. His teacher, Jacopo da Pontormo, belonged to the first generation of Florentine Mannerists, who had abandoned the classic balance and harmony of the Renaissance. From him, Bronzino adapted the colorists' use of brilliant, artificial colors. As court painter to the Medici dukes, he gained a dominant position. He created large numbers of court portraits and designed decorations for celebrations, tapestries, and religious frescoes. His technically perfect, crystal-clear paintings dispel all spontaneity, emotion, and movement. Everything about them is artificial, austere, elegant, and cool—just as court etiquette required.

Other Important Works by Bronzino

Portrait of Ugolino Martelli, ca. 1535, Gemäldegalerie, Berlin	Galleria degli Uffizi, Florence
Portrait of Cosimo I, 1537, Hermitage, St. Petersburg	Crossing the Red Sea, ca. 1540, Palazzo Vecchio, Florence
Portrait of Lucrezia Panciatichi, ca. 1540,	The Deposition of Christ, 1545, Musée des Beaux-Arts, Besançon

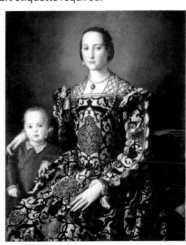

■ **Portrait of Eleonora of Toledo with Her Son Giovanni**, 1544, oil on wood, 115 x 96 cm, Galleria degli Uffizi, Florence

Eleonora was the wife of the first Medici duke, Cosimo I, who appointed Bronzino as court painter. The portrait is impressive because of its brilliant colors and minute detail. It does not portray individual personalities, but rather serves as a formal mask indicating the sitters' social rank.

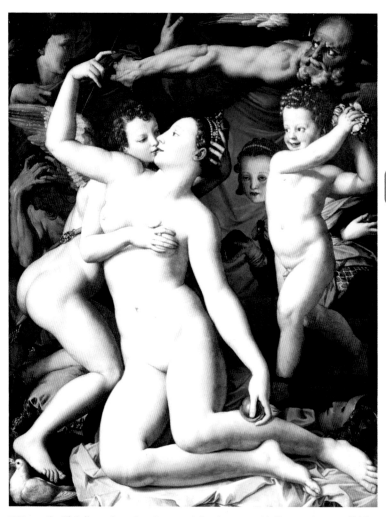

■ **Venus, Cupid, Folly, and Time**, ca. 1540–50, oil on wood, 146.5 x 116.8 cm, National Gallery, London

Bronzino appealed to the taste of his commissioners—the court of the French king, Francis I —with erotic, porcelain like smoothness, artificial composition, and clever symbolism. This is an allegorical picture puzzle about love and lust.

Agnolo Bronzino

Parmigianino

Francesco Mazzola
1503, Parma—1540, Casalmaggiore

■ Made an important contribution to the development of Mannerism ■ Stood at first in Correggio's shadow ■ Created portraits, religious and mythological paintings, and frescoes ■ Influenced the Fontainebleau school in France.

■ **1503** Born Francesco Mazzola in Parma

1521 Sent to Duchy of Viadana, Milan

1522 Decorates two chapels with frescoes in the Parma Cathedral

1523 Works together with Correggio in the Parma Cathedral

1524 Goes to Rome for three years, where he mainly studies Raphael

1527 Flees to Bologna after the sacking of Rome by mercenaries of Charles V

1530 Returns to Parma and paints his most important works, including the partially completed fresco in the church of Madonna della Steccata

1540 Dies in Casalmaggiore near Cremona of a sudden fever

The name Parmigianino refers to the artist's origins in Parma. The son of a painter, he came from an artistic family and must have been a precocious talent. In his early career, he was influenced by the northern Italian painter Correggio (p. 168), who also worked in Parma. Later in Rome, the prematurely deceased Raphael (p. 156) became his great role model, whom, according to his contemporaries, he also physically resembled. Parmigianino was very much a multifaceted painter, a great portraitist, and one of the first artists in Italy to have a command of etching. He is primarily known for his later works, which are considered important testimonials to Mannerism. Their elongated, slim body proportions and unusual perspectives are surprising. It is art of a refined elegance without a lot of dramatics, art which remains distant and deliberated.

■ **Self-portrait in a Convex Mirror**, 1524, oil on half-dome of wood, diameter 24.4 cm, Kunsthistorisches Museum, Vienna

The young Parmigianino put his skill and his fondness for the effects of extreme perspective to the test in this unusual self-portrait. It shows his face and hand, distorted as if viewed in a convex mirror. The effect has even greater impact because the little painting was executed on a flattened dome of wood. Parmigianino took it with him in 1524 to Rome and presented it to Pope Clement VII, who greatly admired it.

■ **Study for the Madonna with the Long Neck**, ca. 1535, red chalk drawing on paper, Galleri dell' Accademia, Venice

■ **Madonna with the Long Neck**, 1534–40, oil on wood panel, 219 x 135 cm, Galleria degli Uffizi, Florence

This painting, arguably the most famous of Mannerism, clearly shows how much the artists in the second third of the 16th century had moved away from the ideals of the Renaissance. Even more strongly than in the preliminary studies, Parmigianino stylized the Madonna and Child's body proportions beyond natural measures. The limbs are extremely long and slim. The noticeably graceful neck of the Madonna perfectly mirrors the column in the background in its alabaster paleness. Parmigianino's elegant composition is full of symbolism. The sleeping Christ child's body forms a cross and recalls death in its limp pose.

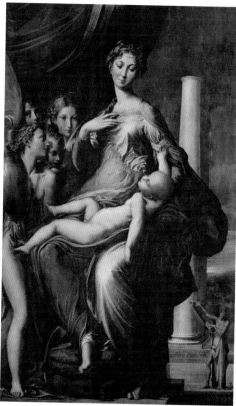

Other Works by Parmigianino

Portrait of Lorenzo Cibo (attributed), 1523, State Museum of Art, Copenhagen

The Myth of Diana and Actaeon, 1524, Rocca, Fontanellato near Parma

Portrait of a Young Woman, 1524–27, (or 1535–37), Gallerie Nazionali di Capodimonte, Naples

The Vision of Saint Jerome, 1527, National Gallery, London

Cupid, ca. 1523–24, Kunsthistorisches Museum, Vienna

Madonna della Rosa, 1528–30, Gemäldegalerie Alte Meister, Dresden

Pallas Athene, ca. 1539, Royal Collection, Windsor

Tintoretto

Jacopo Robusti
1518, Venice–1594, Venice

■ Beside Titian and Veronese, the most important painter of the 16th century in Venice ■ One of the principal agents of Italian Mannerism ■ Painted very quickly ■ Made dramatic art with majestic lighting and perspective

1518 Born Jacopo Robusti in Venice
1539 Works as an independent master
1547–48 Travels to Rome
1565 Becomes a member of the confraternity Scuola di San Rocco and decorates the building
1566 Member of the Florentine Academy
1594 Dies in Venice

Tintoretto worked almost exclusively in Venice. Among the great Venetian painters of the 16th century, he represented the principles of Mannerism most definitively. A tense excitement pulses through his work. Restless, flickering light effects and sharp light-dark contrasts characterize the large compositions he created for Venetian churches, confraternities, and also on commission by the state for the Doge's Palace. He delighted in radically reframing classical religious themes in new ways, using bold space alignments and extreme perspectives.

Works by Tintoretto	
The Adulteress before Christ, ca. 1547, Gemäldegalerie, Dresden	The Origin of the Milky Way, ca. 1575–80, National Gallery, London
Susanna and the Elders, ca. 1560–65, Kunsthistorisches Museum, Vienna	The Last Supper, ca. 1592–94, San Giogio Maggiore, Venice

■ **Nativity**, 1579–81, oil on canvas, 542 x 455 cm, Scuola Grande di San Rocco, Venice

With Tintoretto, the oft-presented subject underwent an audacious restaging: He partitioned the painting into two overlapping levels and placed the newborn Christ child on the false floor of a barn in Bethlehem. His flickering, murky colors and artless, sketchy manner of painting are reminiscent of Titian's later works.

15th–16th century

The Stealing of the Body of St. Mark, 1562, oil on canvas, 398 x 337 cm, Gallerie dell'Accademia, Venice

The recovery of the corpse of St. Mark, who is about to be burned after being martyred, is portrayed by Tintoretto under a heavy, stormy heaven as a dramatic occasion of nothing less than fantastical, visionary force. The left alignment of the buildings in perspective brings a daring weight of depth to the picture. All of the figures are seized in states of intense agitation. His sketchy, tempestuous painting style earned Tintoretto great success during his lifetime, but garnered harsh criticism as well.

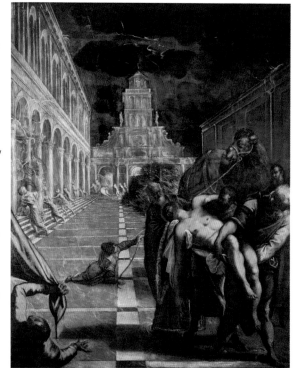

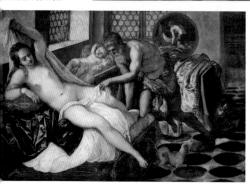

Venus and Mars Suprised by Vulcan, ca. 1555, oil on canvas, 135 x 198 cm, Alte Pinakothek, Munich

The Classical god Vulcan surprises his wife Venus with her lover Mars, who is hiding under a table in the background. This early work by Tintoretto already exhibits his strong interest in perspective, spatial effects, and asymmetrically constructed compositions. Vulcan's form is reflected behind him in the round mirror.

Tintoretto

Giambologna

Jean de Bologne, Giovanni Bologna
1529, Douai–1608, Florence

■ Most significant Italian sculptor between Late Renaissance and Early
Baroque ■ Worked in marble and bronze ■ Created life-size, freestanding
sculptures, monumental garden sculptures, and bronze figurines

1529 Born Jean de Bologne; later receives his first training from the sculptor Jacques Dubroeucq
1554 Goes to Rome
ca. 1556 Settles in Florence
1559 Participates in a contest for sculptors in Florence along with leading sculptors Benvenuto Cellini and Bartolomeo Ammanati
1561 Court sculptor of the Medici
1563 Works in Bologna on the Neptune fountain
1587 Begins the equestrian statue of Cosimo I
1608 Dies in Florence

The Flemish-born Jean de Bologne, who was known in Italy as Giovanni Bologna or Giambologna for short, was the most influential Mannerist sculptor in Italy. Rome exposed him to various influences through the sculpture of Michelangelo (p. 150) and Classical Antiquity. His animated, masterfully composed figures beat an arc between the late work of Michelangelo and the dynamic Baroque style of Bernini (p. 222). Giambologna was esteemed during his lifetime, working predominantly in Florence in the service of the Medici family. With virtuoso technical mastery he probed new possibilities in bronze sculpture, pushing his representations to their limits. His figures appeared to fly, stride, and turn in space. He created sophisticated, sensual scenes and complicated, serpentine groups, whose every aspect was calculated, and which from every viewpoint offer new and surprising stimuli. His bronze figurines were coveted collector's pieces throughout Europe and were greatly influential to both contemporary and later sculptors.

■ **Apennine**, 1580, stone, height over 10 m, Park near Villa Demidoff, Pratolino near Florence

The colossal sculpture, which can be accessed internally, personifies the Italian Apennine mountain range in the form of a bearded man, whose image is reflected in the water of a lake. The borders between nature, sculpture, and architecture blur in this brilliant and astonishing achievement. It evinces the Mannerist inclinations toward crossing boundaries, as well as the popularity of gigantic-scale figures.

■ **Flying Mercury**, 1580, bronze, height 187 cm, Bargello Museum, Florence

Giambologna's most famous figure achieves the impossible—here, in the medium of sculpture, Mercury, the messenger of the gods, appears to conquer the force of gravity and speed away on the breeze with his winged feet. The virtuosic sculptor balances the weight on a single point. Mercury is poised on an air current blown from the mouth of Zephyr, the god of wind. His upward gesture accentuates his weightlessness.

179

Works by Giambologna

Triton, 1560–70, Metropolitan Museum of Art, New York

Samson Slaying a Philistine, ca. 1567, Victoria and Albert Museum, London

Angel, 1596, National Gallery of Australia, Canberra

Hercules and Antaeus, ca. 1600, Rijksmuseum, Amsterdam

Equestrian Statuette of Ferdinando I de' Medici, ca. 1600, Liechtenstein Museum, Vienna

Apollo, ca. 1600, Palazzo Vecchio, Florence

Bull, ca. 1600, Museum of Fine Arts, Boston

■ **Rape of the Sabines**, ca. 1583, marble, height 410 cm, Piazza della Signoria, Florence

Several S-curve-shaped figures loop around each other and spiral upwards into space. It is the perfectly realized compositional conception of a *figura serpentinata*, a twisting figure. The positioning of the figures draws the viewer around the work, revealing new and striking views from each side. Depicted here is the classical legend of the abduction of the Sabine women by the Romans. The force and brutality are expertly conveyed in this dynamic piece. The sculpture constitutes the apex of Giambologna's activity as the official sculptor of the Medici, and attracted wide admiration.

Giambologna

Giuseppe Arcimboldo

1527, Milan—1593, Milan

■ Possibly the most bizarre artist of European Mannerism ■ With his portraits composed of fruits, flowers, or animals, he occupied a unique position in art history ■ Worked mostly in series ■ Enjoyed great fame during his lifetime ■ All but forgotten after his death; today his work is often copied

■ **1527** Born in Milan as the son of a painter

1549 Works together with his father for the Milan Cathedral and designs stain glass windows, among other things

1562 Appointed portrait artist by Ferdinand I at the imperial court in Prague and retains this position under his successors Maximilian II and Rudolf II

1563 Paints his first allegorical portrait—*Summer and Winter*

1580 Raised to the position of gentry by Rudolf II

1587 Returns to Milan

1593 Dies in Milan

Works by Arcimboldo

Winter, 1563, Kunsthistorisches Museum, Vienna

The Water, 1563–64, Kunsthistorisches Museum, Vienna

The Lawyer, 1566, Gripsholm Slott, Sweden

The Cook, ca. 1570, National Museum, Stockholm

The Gardener, or *Vegetables in a Bowl*, ca. 1590, Museo Civico, Cremona

Giuseppe Arcimboldo's career began conventionally as a religious painter in Milan, where he was apprenticed to his father. Arcimboldo's fantastic talent quickly developed after his appointment to the position of court painter for the imperial court in Prague. An active man, he took on many tasks, including serving as costume designer, stage designer, court decorator, and art agent for the emperor, and writing a treatise on painting. Above all, he created a completely new genre of painting in which fruits, flowers, animals, or commonplace articles are arranged to form a recognizable portrait. This style accommodated the era's affinity for the absurd and the unusual. They are to be understood as allegories, as symbolic depictions of the four seasons, the four elements, or individual professions. His paintings were extremely popular during his lifetime and the royal family took pleasure in giving them as gifts to the European courts.

■ **The Librarian**, 1566, oil on canvas, 97 x 71 cm, Skoklosters Slott, Balsta

The curtain is pulled aside and a creature emerges that is nothing but a stack of books. Arcimboldo's imagination created the most abnormal conglomerations and took advantage of the tendency of our perception to search out the familiar forms of faces and human features in most shapes and surfaces. The objects used to create his figures add significance to his portraits.

■ **Emperor Rudolf II as Vertumnus**, 1591, oil on wood, 70.5 x 57.5 cm, Baron R. von Essen Collection, Skoklosters Slott, Balsta

The details are realistic but the whole is totally unreal; nothing but vegetables, fruits, and flowers forming a portrait of the emperor as Vertumnus, the Roman god of vegetation and transformation. It is a play on perception set with visual humor, and illustrates how princes gathered all manner of curiosities from art and nature for their collections.

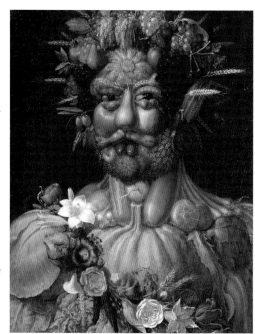

■ **Spring**, 1573, oil on wood, 76 x 63.5 cm, Musée du Louvre, Paris

This profile of a head made of flowers and leaves is an allegory of Spring. It is from the artist's first series of the four seasons, which he painted after his appointment as court painter to Emperor Ferdinand I.

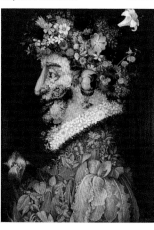

Giuseppe Arcimboldo

El Greco

Domenicos Theotocopoulos
ca. 1541, Candia (Heraklion, Crete)–1614, Toledo

■ Greek, active in Italy, and, for the greater part of his life, Spain ■ Painted mostly religious scenes, but also portraits and a few landscapes ■ With the help of his workshop he made numerous versions of his paintings

1541 Born Domenicos Theotocopoulos on Crete; trains in icon painting

1567 Travels to Venice and trains in Titian's studio

1570 Arrives via Parma in Rome, where he is sponsored by Cardinal Alessandro Farnesse

1577 Establishes himself permanently in Spain and works predominantly for the church

1579 Produces a painting on commission for King Philip II

1614 Dies in Toledo

The name El Greco means "the Greek" in Spanish. Domenicos Theotocopoulos was born in a Cretan mountain village and trained in the Byzantine tradition of icon painting. He was Titian's pupil in Venice and seized upon the influence of Tintoretto. In Spain at the time of the Counter-Reformation, he found a climate of spiritual piety. From these various sources and artistic traditions he created an utterly unmistakable, personal style of great expressiveness. His ecstatic portrayals of saints and images of Christ appealed directly to the religious sentiments of the beholder. Artistically, with their antinaturalistic colors, deliberately distorted figure proportions, and seemingly unreal pictorial space, they point ahead toward a modern form of expressionism.

■ **Laocoön**, ca. 1610–14, oil on canvas, 137.5 x 172.4 cm, National Gallery of Art, Washington, DC

El Greco's only mythological painting deals with the combat of the classical Laocoön and his sons against a great snake. The theme became popular because of a sculpture discovered in Rome in 1506. El Greco deliberately places his figures in opposition to the classical ideal of beauty. Through the lighting, the colors are almost fluorescent.

■ **The Resurrection**, ca. 1600, oil on canvas, 275 x 127 cm, Museo del Prado, Madrid

A lustrously radiant and weightless Christ soars toward heaven. The flickering conduct of light, cool color tones, ecstatic movements, and elongated proportions of the figures are all typical of El Greco. Radical like no other artist of his time, he leaves the realism and beauty ideals of the Renaissance behind in order to attain an increasing intensity of expression.

■ **The Disrobing of Christ at Calvary**, ca. 1580, oil on canvas, 285 x 173 cm, Toledo Cathedral

Draped in a bloodred garment, Christ dominates the composition, closely beset by Roman soldiers, one of whom tears Christ's garment from his body while another sets the timbers of the cross together. El Greco's control of light and color captures the moment before the crucifixion with mounting spiritual intensity.

Other Important Works by El Greco	
Christ Healing the Blind, ca. 1570, Alte Meister Gallerie, Dresden	Christ Driving the Traders from the Temple, ca. 1600, National Gallery, London
The Burial of Count Orgaz, 1586, Santo Tomé, Toledo	View of Toledo, ca. 1610, Metropolitan Museum of Art, New York

El Greco

Rogier van der Weyden

Roger de la Pasture
ca. 1399/1400, Tournai–1464, Brussels

■ Most influential painter of his time in Flanders and Germany ■ Combined the sentimental representation of religious feelings with refined courtly elegance ■ Usually painted on wood ■ Religious images, expert portraits

Works by van der Weyden

St. Luke Drawing the Virgin, ca. 1435, Museum of Fine Arts, Boston

Miraflores Altarpiece, ca. 1435–45, Gemäldegalerie, Berlin

Seven Sacraments Altarpiece, ca. 1451–55, Musées Royaux, Antwerp

Rogier van der Weyden was an internationally renowned artist during his lifetime. He introduced the technique of oil painting, which he had perfected in Flanders, to Italy during a journey to Rome. Many of the methods he developed in his Christian-themed compositions would later be adopted by his successors, particularly those from Germany and the Netherlands.

Van der Weyden combined the slender figure-drawing characteristics of the Gothic period with a sharp, detailed naturalistic style, mixing brilliant colors with an intensive rendition of religious feelings. In spite of his great success during his lifetime, his works fell into oblivion until centuries later when art historians reconstructed his œuvre on the basis of documentary evidence.

■ **Visitation of Mary**, ca. 1435, tempera on wood, 57.5 x 36.2 cm, Museum der Bildenden Künste, Leipzig

Two miraculously pregnant women—Mary and Elizabeth, mother of John the Baptist—meet each other. The tender gestures clearly fuse the theological theme of the painting with a very human dimension. The amazingly precise Flemish landscape replaces the golden background that was commonly found in medieval work. An extensive workshop, and numerous successors, including Hugo van der Goes and Hans Memling, adopted and proliferated van der Weyden's new ideas.

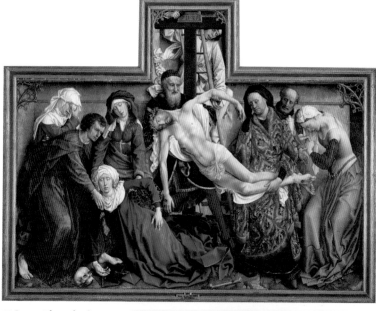

■ **Descent from the Cross**, ca. 1435–40, oil on wood, 220 x 262 cm, Museo del Prado, Madrid

Rogier van der Weyden's most influential painting, with its almost life-size figures, is an exceptionally large format for an early Dutch piece. The painter designed a carved, colored altar without a landscape in the background. He maintained the traditional medieval golden ground without giving up realistic expressions. The figures of Christ and Mary, dressed in blue, dominate the picture. Mary Magdalene, located on the extreme right, combines detailed realism with a subtle depiction of feeling.

Rogier van der Weyden

Jan van Eyck

before 1395, Maaseik—1441 Bruges

■ Founder of Old Dutch painting and its groundbreaking realism ■ Advances in oil painting ■ Mastered central and aerial perspectives ■ Only nine signed works known ■ Held in high esteem in Italy as one of the leading northern European artists of the time

Renaissance in the Netherlands and Belgium

■ **before 1395** Born in Maaseik

1425 Enters the service of Philip the Good, duke of Burgundy, as chamberlain and court painter; undertakes diplomatic assignments to Spain and Portugal on the Duke's behalf

from 1430 Works primarily in Bruges as painter to the court and city

1431 Marries and buys a house in Bruges

1432 Completes the *Ghent Altarpiece,* which was started by his brother Hubert

1441 Dies in Bruges

■ **The Virgin of Chancellor Rolin**, ca. 1434–36, oil and tempera on wood, 66 x 62 cm, Musée du Louvre, Paris

The spiritual and the worldly collide in a single space. The nobleman, dressed in valuable brocade, kneels before Mary, who holds the infant Jesus. In the background, an earthly landscape stretches out in subtle aerial perspective. The room's interior is presented from a central perspective.

Renaissance 1420–1610

Jan van Eyck was long regarded as the inventor of oil painting, but in reality he was the just first person to use this technique definitively in panel painting and to develop its full brilliance and luminance. He applied wafer-thin layers of paint, creating illusionism with the detail of his minute painting technique. His portraits represent the human being in his individual character with sharp realism. His treatment of light and space created the foundation built upon in later Dutch painting.

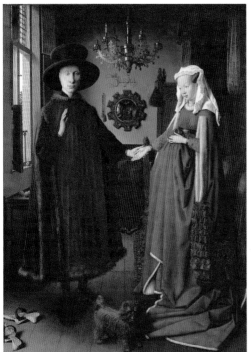

■ **The Arnolfini Wedding**, 1434, oil on wood, 82 x 60 cm, National Gallery, London

The double portrait shows a fashionably dressed couple in their living room. In this picture, van Eyck developed the capabilities of oil painting in the faithful reproduction of light and materials such as fur, cloth, metal, and glass. Many of the minutely observed objects are symbolic. The dog, for example, signifies marital fidelity.

■ **Portrait of a Man in a Red Turban**, 1433, oil on wood, 33 x 26 cm, National Gallery, London

■ **Adam and Eve from the Ghent Altarpiece**, 1432, oil on wood, 350 x 450 cm, St. Bavo, Ghent

These figures, from a polyptych altarpiece, are among the earliest large-scale, naturalistic nude figures of modern times.

Other Important Works by van Eyck	
Madonna in the Church, ca.1418, Gemäldegalerie, Berlin	Portrait of Cardinal Niccolò Albergati, ca.1432, Kunsthistorisches Museum, Vienna
Last Judgment, ca. 1430, Metropolitan Museum of Art, New York	The Lucca Madonna, ca. 1434, Städelsches Kunstintitut, Frankfurt
Portrait of a Man, 1432, National Gallery, London	

Jan van Eyck

Hieronymus Bosch

Jeroen van Aken
ca. 1450, 's-Hertogenbosch–1516, 's-Hertogenbosch

■ Ingenious loner ■ Most original and inscrutable artist of his time
■ Depicted many figures within a bizarre world that was somehow always
linked to Christianity ■ Created luminescent harmony of colors

ca. 1450 Born Jeroen van Aken in a Dutch provincial town to a family of painters who probably originally came from Aachen

1486/87 Joins the Brotherhood of Our Lady, an influential conservative religious group with which he remains connected all his life and for which he carries out many works

1504 Philip the Fair, Duke of Burgundy, commissions a large-scale *Last Judgment* painting

ca. 1510 Changes his style radically; creates compact compositions with large figures that appear to almost leave the painting and stand close to the observer; examples are *Christ Crowned with Thorns* or *Christ Carrying the Cross*

1516 Dies in 's-Hertogenbosch

Hieronymus Bosch most likely spent all of his life in the quiet Dutch town of 's-Hertogenbosch, to which he also owes his name. Little is known about his life, but it has been gathered that he was very much in touch with the spiritual and religious life of his hometown. Bosch was a member of the Brotherhood of Our Lady, a group that worshiped the Virgin. He would remain closely linked to the group throughout his lifetime. Brotherhoods devoted to the worship of the Virgin were popular during the Middle Ages in Europe. Bosch's brotherhood was particularly wealthy, and they were involved with most of the cultural life in 's-Hertogenbosch. His works were held in high esteem during his life. He was especially revered in Spain, where some of his most outstanding and most famous works are located.

Bosch's paintings form a world unto themselves. Their grotesque fantasy scenes are worked out in precise detail and abound with bizarre, insect- and amphibianlike, half-human, and half-animal creatures. The paintings were inspired by the marginal vignettes of medieval book illumination, as well as by Romanesque sculpture. Despite

■ **The Last Judgment**, central panel of a triptych, ca. 1505–10, oil on wood, 164 x 127cm, Akademie der Bildenden Künste, Vienna

Christ sits on his throne, or a rainbow in this case, as the judge of the world. Beneath him, gloominess, violence, and chaos rage over the earth. The apocalyptic turmoil is like a diabolic Gomorrah. The jewel-colored monsters not only arouse dismay, they also hold a strong aesthetic fascination.

Hieronymus Bosch

■ **The Garden of Earthly Delights**, ca. 1505–10, oil on wood, 220 x 389 cm, Museo del Prado, Madrid

This triptych was unparalleled in its time. Although it follows the design of a retractable altar, it was not created for the Church but rather for a private audience. The narration begins on the left wing with the creation of the world. The central panel shows an earthly paradise of sexual excess. Giant fruit, birds, and a crystalline fountain of life allude to Dutch idioms and seem to promise everlasting pleasures. But the idyll is an illusion. This is shown by hell on the right panel, where sinful humanity is punished.

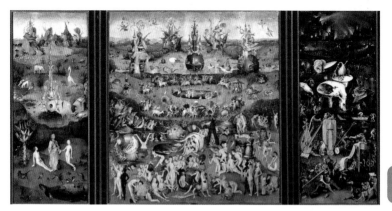

incorporating medieval styles into his work, the artist was revolutionary. No other painter before Bosch had ever dedicated the same amount of space to such creatures and fantasies. The interpretation of his work is more controversial, even today, than that of any other artist preceding the modern era. It has been suggested that much of his inspiration may be traced to proverbs and plays on words. The fears, worries, and tensions of the people in his time articulate themselves in Bosch's work.

In principle, he was a religious moralist with a deeply pessimistic world view who chastised the sinfulness of humanity. His contemporaries drew important moral messages from the threatening worlds he created. Apart from a few imitators, Bosch did not have any immediate successors. However, his fantastic, nightmarish worlds inspired later artists, particularly the Surrealists, such as Salvador Dalí (p. 456) in the 20th century. Although numerous paintings by Hieronymus Bosch can be found throughout the museums of Europe and North America, the artist was widely copied by later artists and only about 30 compositions can be accredited to him with any amount of certainty.

■ **Garden of Earthly Delights**, ca.1510, oil on panel, central panel 220 x 195 cm, wings 220 x 97 cm, Museo del Prado, Madrid

Works by Bosch

The Epiphany (The Adoration of the Magi), ca. 1480–90, Philadelphia Museum of Art

St. Christopher Carrying the Christ Child, ca. 1480–90, Museum Boymans van Beuningen, Rotterdam

Haywain, ca. 1485–90, Museo del Prado, Madrid

Christ Crowned with Thorns, ca. 1500, National Gallery, London

St. Jerome in Prayer, ca. 1500, Musée des Beaux-Arts, Ghent

The Ship of Fools, ca. 1500, Musée du Louvre, Paris

The Temptation of St. Anthony, ca.1505–06, Museo del Prado, Madrid

The Creation of the World, ca. 1504–10, Museo del Prado, Madrid

Hieronymus Bosch

Pieter Bruegel the Elder

ca. 1525–30, Breda–1569, Brussels

■ Created moral and didactic genre paintings of village life and landscapes with religious or mythical figures ■ Acme of 16th-century Flemish painting

ca. 1525–30 Born, probably in Breda

1551 Member of the Antwerp Painters' Guild

1552 Travels to Italy, where he works together with the miniaturist Giulio Clovio

1555 Makes copperplate engraving for the Antwerp publisher Hieronymus Cock

1563 Moves to Brussels

1569 Dies in Brussels

Works by Bruegel

Netherlandish Proverbs, 1559, Staatliche Museen, Berlin

The Harvesters, 1565, Metropolitan Museum of Art, New York

Pieter Bruegel the Elder's beginnings are unknown. His only kindred spirit and predecessor was Hieronymus Bosch (p. 188), whose works he most certainly knew. Though his early works were primarily influenced by the Flemish tradition, Bruegel's later works were more Italianate—probably influenced by his travels to Italy. His paintings and copperplate engravings enjoyed great popularity during his lifetime. As founder and most important member of the Bruegel or Brueghel Dynasty, he was also given the nickname "Peasant Bruegel." The dateable paintings all originated in a time span of only about 10 years. Many of his paintings virtually overflow with figures and are full of allusions to folk sayings and proverbs. The delight taken in the visual narrative often makes them appear humorous, but they are also meant to moralize, and reflect a deeply felt pessimistic view of the world and of humankind. The Dutch genre and landscape painters of the 17th century found inspiration in his work.

■ **The Parable of the Blind Leading the Blind**, 1568, tempera on canvas, 86 x 154 cm, Galleria Nazionale, Naples

Many of Bruegel's paintings make fun of the follies of man. With downright sinister intensity, he pictorially renders the words of Christ from the Gospel of St. Matthew: "But if the blind lead the blind, they shall both fall into the ditch."

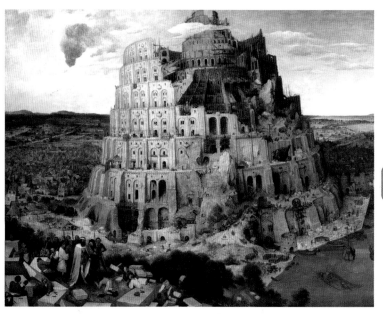

■ **The Tower of Babel**, 1563, oil on wood, 114 x 155 cm, Kunsthistorisches Museum, Vienna

Bruegel describes the biblical story of the building of the Tower of Babel and the subsequent creation of the world's languages with a tremendous amount of detail. The tower was meant to reach heaven, but God prevented this through the confusion of tongues. As with many of Bruegel's paintings, the moral message is evident.

■ **Hunters in the Snow**, 1565, oil on wood, 117 x 162 cm, Kunsthistorisches Museum, Vienna

From a hill, a wide view opens up over a snowy landscape depicted in cold colors. A row of bare trees leads the eye into the distance. The seemingly very natural but carefully calculated picture by Pieter Bruegel was a milestone in the history of landscape painting, particularly because of the convincingly captured mood of the season.

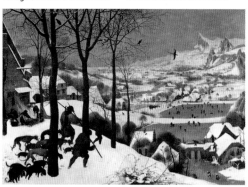

Pieter Bruegel the Elder

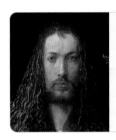

Albrecht Dürer

1471, Nuremberg—1528, Nuremberg

■ Was the dominant figure of the North European Renaissance ■ As an artist, he asserted a universal claim equivalent to that of Leonardo or Michelangelo ■ Conducted systematic studies on proportions and perspective ■ Was also greatly influential as a graphic artist and as a painter

1471 Born in Nuremberg to a goldsmith, with whom he starts an apprenticeship

1486 Enters the workshop of Michael Wolgemut

1490 Travels to Basel, Colmar, and Strasbourg

1494 Returns to Nuremberg, marries Agnes Frey, and travels to Italy

1505 Travels to Italy a second time

1512 Illustrates Emperor Maximilian I's printed prayer book for him

1518 Participates in the Imperial Diet of Augsburg

1520 Travels to the Netherlands

1522 Converts to Luther's teachings

1526 Devotes himself to his theoretical scriptures

1528 Dies in Nuremberg

■ **Feast of the Rose Garlands**, 1506, oil on wood, 162 x 194.5 cm, Národní Gallerie, Prague

This altarpiece depicts the enthroned Madonna giving rosaries to the assembled. The main representatives, Pope Julius II and Emperor Maximilian I, kneel in the front. Dürer has inserted himself in the back right.

Albrecht Dürer's œuvre displays an all-embracing interest in the world around him and in the human form. The artist's style was impacted by a deeply religious influence, as well as his own unconditional will to fathom the laws of art and nature systematically.

Born in the prospering trading town and artistic center of Nuremberg, Dürer was one of the first northern European artists to travel to Italy. He left Germany partly due to an outbreak of the plague, but also because of his desire to broaden his artistic horizon. In Venice, he met Giovanni Bellini, who was by that point quite advanced in years. Dürer made himself familiar with the ideas of Leonardo (p. 144), and studied Mantegna's (p. 140) copperplate

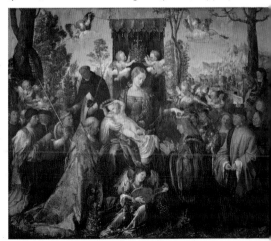

■ **The Four Apostles**, 1526, oil on wood, 215 x 76 cm (each panel), Alte Pinakothek, Munich

Dürer's most famous work was also his last. Two years before his death, the artist donated the two panels with the four apostles John, Peter, Paul, and Mark to his hometown of Nuremberg. The monumental figures reveal the influence of Giovanni Bellini, with whom Dürer had studied while in Venice, through their colored brilliancy and their bulky, statuary appearances. The four men are representative of four different temperaments and ages. In them, the northern Alpine artistic tradition combines with the classical grandeur of Antiquity and the Italian Renaissance. Overall, they reflect Martin Luther's concept of an equitable community of believers in a reformed church.

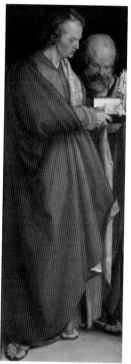
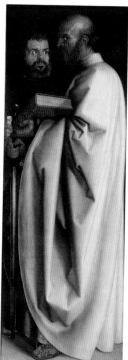

■ **An Artist Using a Perspective Machine**, from *Instructions on Measuring with Compass and Rule*, 1525, woodcut, 13.1 x 18.8 cm, Nuremberg

Dürer's illustration elucidates the use of auxiliary tools for a more exact reproduction of perspective. By means of a tightly clamped thread running through a pulley on the right wall, the two men transfer, point by point, the form of a lute to an image area, which can be folded away to one side.

Albrecht Dürer

engravings. He painted landscapes with watercolors in a surprisingly modern style. Dürer was blessed with excellent skill in both painting and drawing. His portraits, which capture every detail, are among the most striking of his time. His religious paintings are rooted in the art of the North, but they also build a bridge to the Italian Renaissance. He was important in developing the technique of copper engraving and published a graphic series about Christianity, including *The Apocalypse of St. John* and *The Great Passion*. This series brought him sudden fame and exerted great influence on other artists.

Dürer summarized his theoretical findings in written form. He wrote part of an unfinished treatise on painting, including passages on perspective, human proportion, and architectural fortification.

■ **Model of Female Proportions**, 1528, woodcut, from *Four Books on Human Proportions*, Nuremberg

Dürer was convinced that nature followed certain laws. The aim of his studies on proportions was to discover the rules of ideal beauty. He dedicated himself to the intense study of human proportion.

■ **The Great Turf**, 1503, watercolor and gouache on paper, 41 x 31.5 cm, Graphische Sammlung Albertina, Vienna

With great precision, Dürer painted a subtle piece of grassland with dandelions and plants in their actual sizes and in their natural settings. The leaves testify to his endeavor to record every aspect, however fine, in order to finally comprehend their laws. "Because truthfully, art is in nature, and who succeeds in tearing it out, owns it," Dürer once wrote.

■ Melencolia I, ca. 1513–14, copper engraving, 24 x 19 cm

Lost in deep thought, a winged female figure, the embodiment of the melancholic temperament, props her chin up with her hand. She is crowned with a laurel wreath, the symbol of glory and victory, and is surrounded by numerous symbolic objects: an hourglass, which represents the transitory nature of life; a scale, which symbolizes equilibrium and justice; and various geometric figures and tools associated with the liberal and mechanical arts. The richness of motifs found in this copper engraving causes the viewer to reflect, and allows for a multitude of possible interpretations. Since ancient times, melancholy has been considered the gloomiest of the four temperaments, and was also seen simultaneously as the typical frame of mind of artists and learned persons.

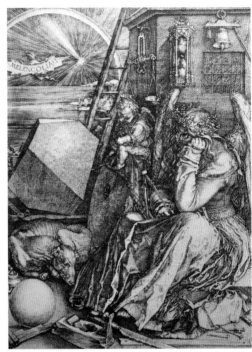

Other Works by Dürer

Self-Portrait at 22, 1493, Musée du Louvre, Paris

Two Musicians, 1503–04, Wallraf-Richartz-Museum, Cologne

The Adoration of the Magi, 1504, Galleria degli Uffizi, Florence

Portrait of a Young Venetian Woman, 1505, Kunsthistorisches Museum, Vienna

St. Anne with the Virgin and Child, 1519, Metropolitan Museum of Art, New York

Portrait of Hieronymus Holzschuher, 1526, Staatliche Museen, Berlin

■ Portrait of Dürer's Mother, 1514, charcoal on paper, 42.3 x 30.5 cm, Staatliche Museen, Berlin

Dürer drew his mother at the age of 63. Without embellishment, he shows his mother as an old woman who has been affected by a hard life. Until then, the representation of the old and the ugly in art had a markedly negative connotation. Dürer's study heralded a reassessment of that ideal.

Albrecht Dürer

Tilman Riemenschneider

ca. 1460, Heiligenstadt or Osterode–1531, Würzburg

■ As a master sculptor, he was among the most significant artists at the begin-
ning of modern times in Germany ■ Riemenschneider combined expressive
religiousness with a realistic depiction of faces ■ He predominantly worked in
unpainted limewood, but also in alabaster, limestone, and marble

ca.1460 Born in Heiligen-
stadt or Osterode in the
Harz mountains

1483 Settles in Würzburg,
where he runs an extremely
successful workshop, joins
the guild of painters, and
lives until his death

1485 Becomes a master
craftsman and obtains citi-
zenship in Würzburg
through marriage

1504 Belongs to the city
council

1520 Becomes Mayor of
Würzburg

1525 During the Peasants'
War, he forms an alliance
with the peasants, for which
he is punished by incarcer-
ation, torture, and the loss
of his fortune after the
victory of the prince's army

1531 Dies in Würzburg

The question of whether Tilman Riemenschneider
should be classified as an artist of the late Gothic or of
the early Renaissance depends purely on one's pers-
pective. The œuvre of this eminent sculptor builds a
bridge between old and new styles. Typi-
cally late-medieval are the rich, intricate
frames of his large altars. However, the
realistic faces of his figures and his care-
fully studied nudes already heralded a
new era, though the artist always re-
mained bound to Christian themes.
He abandoned the popular opu-
lent painting and gilding style of
earlier sculptures and reliefs. His
saints and apostles inspired
viewers to think about the con-
tents of the Bible. This was prob-
ably also his way of responding to
and dealing with the Reformation.

Other Works by Riemenschneider

The Four Evangelists, 1490–92, from the Münnerstadt Altar, Bode Museum, Berlin	Tomb of Bishop Rudolf von Scherenberg, 1495–99, Dom, Würzburg
Saint Jerome and the Lion, 1490–95, Cleveland Museum of Art, Ohio	Tomb of Emperor Henry II and his Wife, 1499–1513, Cathedral of Bamberg
Seated Bishop, ca. 1495, Metropolitan Museum of Art, New York	Holy Blood Altar, 1510–13, Michaels-kapelle, Rothenburg

■ **Adam**, 1510,
pearwood, height 24 cm,
Kunsthistorisches
Museum, Vienna

Although the youthful figure
still corresponds to Gothic
ideals of beauty, the natural-
istic details and the S-shaped
sweep of his slender body dis-
play a newly awoken inter-
est in both the human
body and the artistic rep-
resentation thereof.

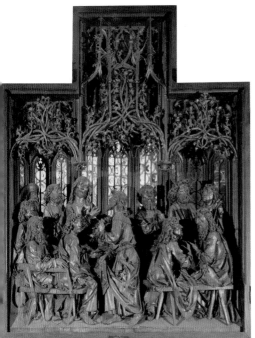

■ **Last Supper**, ca. 1501–05, limewood and pinewood, width 416 cm, Church of St. Jakob, Rothenburg

The apostles are assembled around a table for Christ's Last Supper. The table tilts forward, allowing us a better view of the scene. Christ is depicted on the left a little larger than the rest of the figures, signifying his importance. This exquisitely carved, virtuosic artwork forms the center part of a large, quadripartite altarpiece, *Holy Blood Altar*. The scene unfolds as if on a stage. The figures are worked out of a virtually perfect material. The main emphasis is on the faces, with their individual expressions, full of character and vitality in their animated poses. Through the contemplative faces of the apostles, pictured talking together, believers could relate to the lifelike scene. By breaking through the back plane of the piece, Riemenschneider allowed a particularly vivid display of light. In his compositions, he frequently returned to graphic models by Dürer or Martin Schongauer.

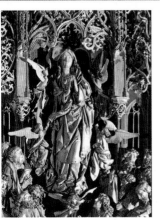

■ **Assumption of the Virgin**, ca. 1505–10, limewood, 7 x 3.5 m, Herrgottskirche, Creglingen-am-Taube

The central shrine of the Altar of Mary, when opened, depicts Mary rising up through the circle of disciples in the sky. The artist created the life-size main figures himself, though he left parts of the giant piece for his workshop to complete.

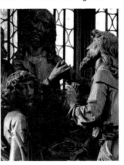

Tilman Riemenschneider

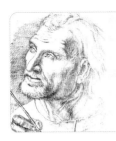

Matthias Grünewald

Mathis Gothardt Neithardt
ca. 1480, Würzburg—1528, Halle

■ One of the greatest German artists of all time ■ Unusually iridescent colors of graded intensity ■ Also worked as an hydraulic engineer, master builder, soap boiler, and colorman

1480 Born Mathis Gothardt Neithardt

1509 Enters the service of the archbishop of Mainz, Ulrich von Gemmingen

1511 Appointed to the post of Chief Master Builder at Aschaffenburg Palace

1516 Appointed court painter to Cardinal Albrecht of Brandenburg, Archbishop of Mainz

1525 Sympathizes with the Reformation and peasant revolts

1528 Dies in Halle

Despite the painter's creative body of work, produced with unusual, idiosyncratic power, hardly anything concrete is known about the artist. Even the name Grünewald is based on a later mistake. In earlier documents he is called Mathis, the Painter. Travels to Italy and France can only be surmised. The total of Grünewald's artistic strength is concentrated in his outstanding major work, the *Isenheim Altarpiece*—a work of shocking emotional force. During his lifetime, the painter was held in esteem as court painter to elector-archbishops, but by the 17th century was nearly forgotten. In the early 20th century he experienced a triumphal rediscovery. Expressionist painters such as Otto Dix drew inspiration from him.

■ **Figure Studies of St. Anthony**, for the *Isenheim Altarpiece* of 1515, charcoal and brush with opaque white on paper, 289 x 203 mm, Kupferstichkabinett, Berlin

This well preserved drawing is a preliminary study of St. Anthony, shown in conversation with St. Paul on the third panel of the *Isenheim Altarpiece*. He has characteristics of Abbott Guido Guersi, commissioner of the painting. Only about 35 drawings have survived.

Other Important Works by Grünewald

Mocking of Christ, ca. 1504, Alte Pinakothek, Munich	Pfarrkirche, Stuppach
	St. Erasmus and St. Maurice, ca. 1520–24, Alte Pinakothek, Munich
Small Crucifixion, ca. 1511–20, National Gallery of Art, Washington, DC	
Stuppach Madonna, ca. 1517–19,	**The Mourning of Christ**, ca. 1523, Stiftskirche, Aschaffenburg

■ **Isenheim Altarpiece**, ca. 1513–15, tempera and oil on wood, 69 x 650 cm, Musée d'Unterlinden, Colmar

The famous *Isenheim Altarpiece* is a monumental polyptych with a total of ten panels, as well as carved figures that are visible when the wings are either opened or closed. The normal view shows on the left and right St. Sebastian and St. Anthony, and below the entombing of Christ. In the center, the crucifixion appears before a dark background; the horribly maltreated body of Christ with limbs writhing in pain, is flanked by the deathly pale Mary dressed in white, frozen in nameless sorrow, and, next to her, John and the despairingly impassioned Mary Magdalene. On the right, John the Baptist points in perfect calm to the dying savior. When the shrine is opened on holy days, there appears the shining vision of redemption. In Grünewald's incredibly expressive representation of the resurrection, the figure of Christ rises up powerfully, in daringly dynamic and celestially luminous colorfulness.

Matthias Grünewald

Albrecht Altdorfer

ca. 1480, presumably Regensburg–1538, Regensburg

■ One of the pioneers of landscape painting in German art ■ Created the first studies of night scenes in Germany and developed a preference for dramatic light phenomena ■ Created autonomous landscape drawings that were not designed as preliminary studies

■ **ca. 1480** Born to a painter
1506 Produces his first signed copper engravings
1511 Travels to St. Florian, near Linz, and makes his first landscape paintings
1515 Works on the margin drawings for Emperor Maximilian I's prayer book
1519 Member of the Regensburg town council
1526 Becomes the city architect of Regensburg
1535 Travels as an ambassador to Vienna
1538 Dies in Regensburg

Around 1500, several German painters, called the Danube School, took an interest in portraying nature and landscapes in a new manner. Albrecht Altdorfer was their most significant representative. Through expressive colors, a fluid, casual way of painting, and with the employment of dramatic mood lighting, Altdorfer revolutionized German art. Next to religious works—which he often brought to life through imaginative architectural backdrops—he dared to draw scenes from ancient mythology, and thereby broke new ground in northern European art. Altdorfer spent most of his life in the trading town of Regensburg. The varying quality of his works is due to the use of a large workshop.

Other Important Works by Altdorfer

St. George, 1510, Alte Pinakothek, Munich

Large Fir, ca. 1512, Kunstsammlungen der Veste Coburg, Coburg

Christ Taking Leave of His Mother, ca. 1520, National Gallery, London

Christ on the Cross, ca. 1520, Museum of Fine

Arts, Budapest

Danubian Landscape, 1520–25, Alte Pinakothek, Munich

The Birth of the Virgin, ca. 1525, Alte Pinakothek, Munich

Lovers, ca. 1530, Museum of Fine Arts, Budapest

■ **The Danube Valley Near Regensburg**,
ca. 1510, pigment on wood, 30.5 x 22.2 cm, private collection

This picture is considered to be one of the first topographically exact landscape paintings in European art. Altdorfer has created a landscape, void of figures, whole in and of itself. This idea was revolutionary for the time. Traditionally, landscapes were backgrounds.

■ **Battle of Issus**, 1529, oil on wood, 158 x 120.3 cm, Alte Pinakothek, Munich

This work is considered one of the most important German paintings. Created for William IV, Duke of Bavaria, it is part of a series of history paintings of Antiquity with Christian themes. Altdorfer's *Battle of Issus* depicts the battle of Issus in 333, in which Alexander the Great defeated the Persian King Darius III. A breathtakingly expansive perspective shows the turmoil of the battle. Despite minute details, the painting achieves an enormous effect. Reflecting events on Earth, the dramatic clouds in the evening sky show the tremendous play of forces within the cosmos and nature. Despite the fairy talelike atmosphere, the setting is identifiable. In the background the Mediterranean Sea, the island of Cyprus, and even the Persian Gulf can be seen.

■ **The Baggage Train**, ca. 1515, woodcut, 39.4 x 38.6 cm, Fine Arts Museum, San Francisco

The panel stems from the series *The Triumph of Maximilian I*, which comprises 136 woodcuts. Altdorfer, Albrecht Dürer, and Hans Burgkmair worked on these carvings. The graphics depict the sergeant and the emperor's magnificent carriages in a lively manner, along with the military baggage. Butlers, transport cars, and tradesmen are all shown in the busy scene. The triumphal procession was a part of the large-scale public enterprises of Emperor Maximilian (1493–1519). Altdorfer was also involved in a commission from Maximilian for a monumental woodcarving work of the sublime gate and several voluminous frame drawings for the emperor's prayer book.

Albrecht Altdorfer

Lucas Cranach the Elder

Lucas Müller
1472, Kronach–1553, Weimar

■ One of the most influential German painter of the Reformation period
■ Friends with Martin Luther, and converted his theological ideas into didactic paintings ■ Also created woodcuts and outstanding portraits

1472 Born Lucas Müller, in upper Franconia, to a painter, from whom he receives his first apprenticeship

1501 Settles in Vienna

1505 Becomes court painter to Frederick the Wise in Wittenberg, and founds a large workshop

1508 Travels to the Netherlands as a diplomat to visit Emperor Maximilian

1525 Is the best man at Martin Luther's wedding

1537 Becomes Mayor of Wittenberg

1550 Paints Emperor Maximilian

1553 Dies in Weimar

Lucas Cranach chose his name according to the town of his birth. Born to a south German painter, he was one of the cofounders of the Danube School in Vienna. As a young artist, he developed a new, lively ideal of landscapes. After his appointment as the court painter in Wittenberg, Cranach's style changed. In altar paintings, portraits, nudes, and hunting scenes, he created a decorative, stylized manner, which enjoyed great popularity. With his nudes, he established a new theme in Northern European painting. Being a business-minded entrepreneur, Cranach founded a prospering workshop that copied his popular picture motifs in innumerable versions. Even today, these paintings can be found in numerous museums all over the world. His son, Lucas Cranach the Younger, continued the workshop, but never achieved the artistic status or success of his father.

Works by Cranach

St. Catherine Altarpiece, 1506, Gemäldegalerie, Dresden

The Holy Family, 1509, Städel Museum, Frankfurt

Portrait of a Prince of Saxony, ca. 1517, National Gallery of Art, Washington, DC

Hercules and Omphale, 1537, Museo Thyssen-Bornemisza, Madrid

Mineral Spring, 1546, Gemäldegalerie, Berlin

■ **The Rest on the Flight into Egypt**, 1504, oil on wood, 69 x 51 cm, Gemäldegalerie, Berlin

At the outskirts of the woods, the Holy Family has settled down to rest together with a host of angles. Cranach created this idyllic early work prior to his assignment as court painter in Wittenberg. The romantic ambience and the lively south German mountainscape show his relation to the Danube School, to which Albrecht Altdorfer also belonged.

■ **Venus,** 1532, oil on wood, 37.7 x 24.5 cm, Städel Museum, Frankfurt

Unlike in Italy, where artists drew on Antiquity, the depiction of the nude was not popular in Northern Europe. However, under the influence of Luther, who had ended his celibacy and married a former nun, marital sexuality began to be regarded as something positive. Almost provokingly, Cranach, in his numerous drawings of Venus, showed off female charms, using ancient mythology as a pretext.

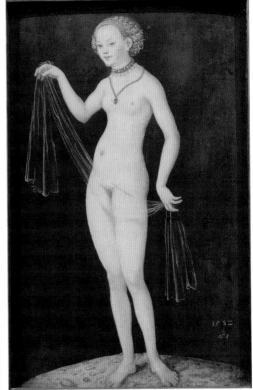

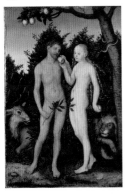

■ **Adam and Eve,** 1533, oil on wood, 50.4 x 35.5 cm, Staatliche Museen, Berlin

In slender, youthful beauty, the first people on earth stand in front of one another. Misled by the serpent, Eve passes her husband the forbidden fruit. He raises it to his mouth, thereby ending the time of innocence and peace.

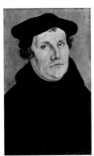

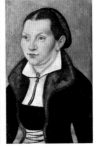

■ **Diptych with the Portraits of Luther and His Wife Katharina von Bora,** 1529, oil on wood, each panel 37 x 23 cm, Galleria degli Uffizi, Florence

The reformer and theologian was close friends with Cranach. The artist produced many portraits of Luther in his workshop.

Lucas Cranach the Elder

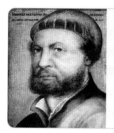

Hans Holbein the Younger

ca. 1497/98 Augsburg–1543, London

■ Was one of the most outstanding and most influential portrait painters of all time ■ As well as portraits, he also created decorative and allegorical mural paintings, paintings for altarpieces, book illustrations, fashion, and jewelry ■ Strongly influenced the style of English portraiture

1497/98 Born in Augsburg to a painter

1515 Enters the workshop of Hans Herbst in Basel

1516 Receives first commissions for portraits

1517 Involved in a stabbing

1519 Marries and becomes a busy member of the painter's guild of Basel

1521 Meets Erasmus von Rotterdam

1526 Moves to London

1536 Is court painter to the English king, Henry VIII

1543 Dies from the plague

Hans Holbein came from a prestigious line of painters and, at a young age, acquired a reputation as a versatile painter and graphic artist in Basel. Like the northern Italian Renaissance artists, especially Leonardo (p. 144), and Jan van Eyck (p. 186), he had an obsession with detail. The iconoclasm of the Reformation prompted him to go abroad. Upon the recommendation of the famous humanist Erasmus von Rotterdam, Holbein went to London, where he established himself as a portrait painter to the English court and the upper classes. His attention to every fold of cloth, each hair, and the reflection of light helped him produce portraits with almost photorealistic perfection. These portraits are characterized by a surprisingly severe, almost geometric composition. His contemporaries believed they were seeing the sitters in real life.

■ **The Body of the Dead Christ in the Tomb**, 1521–22, oil on wood, 30.5 x 200 cm, Kunstmuseum, Basel

This painting depicts, in shockingly minute detail and in an unvarnished manner, the physical reality of death. The image is very unconventional. The dead body of Christ, in its narrow burial tomb, reveals traces of decay.

Other Works by Holbein the Younger

Portrait of Sir Thomas More, 1527, Frick Collection, New York	French Ambassadors, 1533, National Gallery, London
Meyer Madonna, ca. 1528/29, Schlossmuseum, Darmstadt	Portrait of Anne of Cleves, 1539, Musée du Louvre, Paris

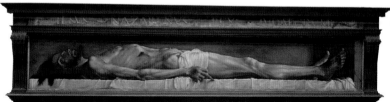

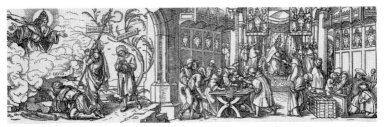

■ The Selling of Indulgences, ca. 1522–23, woodcut, 8 x 27 cm

This woodcut denounces the selling of indulgences in the Roman Church. In contrast to the repentant sinners on the left, Pope Leo X appears on the right being paid for absolution. Presumably Holbein illustrated this small graphic for a Lutheran anti-Catholic pamphlet.

■ Portrait of Henry VIII of England, 1540, oil on wood, 88.5 x 74.5 cm, Galleria Nazionale d'Arte Antica, Rome

As court painter, Holbein was able to tap the full potential of his talent. This portrait of the king, a copy of a lost mural painting in Whitehall Palace, is an icon of power. He also painted the king's wives, Jane Seymour and Anne of Cleve.

■ Portrait of Georg Gisze of Danzig, 1532, oil on wood, 96 x 86 cm, Gemäldegalerie, Berlin

The proud merchant Georg Gisze from Danzig is depicted standing in his workroom, in the corner of a branch office filled with diverse objects. Holbein distorts all things within the picture by altering their perspective. Among the many objects on the table are letters, writing utensils, signet rings, and a pair of scissors, which refer to Georg Gisze's professional rank in society. Many of these items also have a symbolic meaning—the small golden table clock is a reminder of the passage of time and the bouquet of flowers symbolizes faithfulness and modesty.

Hans Holbein the Younger

Baroque

1600–1740

1600–1720
Baroque in Italy

Annibale Carracci
Orazio Gentileschi
Caravaggio p. 218
Guido Reni
Bernardo Strozzi
Artemisia Gentileschi
Pietro da Cortona

p. 220

1620–1700
Baroque in the Netherlands

Frans Hals p. 242
Gerrit van Honthorst
Jan van Goyen
Jan Davidszoon de Heem p. 254

Gianlorenzo Bernini p. 222
Guercino
Luca Giordano
Andrea
Pozzo p. 224

1610–1700
Baroque in Flanders

Peter Paul Rubens p. 234
Frans Snyders
Jacob Jordaens
Anthony van Dyck p. 240
Jan Brueghel
Adriaen Brouwer

p. 222

Rembrandt van Rijn p. 244
Gerrit Dou
Emanuel de Witte
Cornelis de Man
Willem Kalf
Jan Steen p. 250
Jacob van Ruisdael p. 252
Pieter de Hooch
Jan Vermeer p. 256

1620–1730
Baroque in
Germany

Georg Flegel
Johann Liss

1620–1710
Baroque in
France

Nicolas Tournier
Simon Vouet
Georges de la Tour p. 226
Nicolas Poussin p. 228
Claude Lorrain p. 232

| 1680 | 1700 | 1720 | 1740 |

1620–1700
Baroque in
Spain

José de Ribera
Francisco de Zurbarán
p. 266
Diego Velázquez p. 260
Alonso Cano
Bartolomé Esteban Murillo p. 268
Claudio Coello

Johann Heinrich Schönfeld
Joachim von Sandrart
Balthasar Permoser
Andreas Schlüter

Louis Le Nain
Charles Le Brun
Hyacinthe Rigaud

p. 229

Drama, Grandeur, and Pathos

The term *baroque* first described a stylistic period in the 18th century. It is of Portuguese origin and probably derives from the word *barroco*, which is used to describe erratic shape. Initially used in a derogatory way, the term retained a negative connotation for a long time. Thus, in Italy, much of the art of the period is rather spoken of as the art of Seicento (the 1600s). Baroque art developed in Rome and from there it then spread throughout Europe. During the Counter-Reformation, the Catholic Church heavily relied on the influence of art. Rome was baptized as the capital of Christendom, a process led by the preeminent Baroque sculptor and architect Giovanni Lorenzo Bernini. The art-loving climate of the city attracted numerous European artists who, influenced by the art of Raphael and Michelangelo, sought the ideals of the ancient world.

■ **Guido Reni: Aurora**, 1612–14, fresco, 700 x 280 cm, Casino Rospigliosi Pallavicini, Rome

Baroque 1600–1740

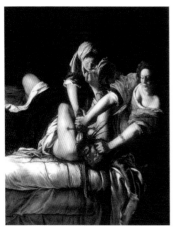

■ **Artemisia Gentileschi: Judith Beheading Holofernes**, ca. 1620, oil on canvas, 199 x 162 cm, Galleria degli Uffizi, Florence

■ **Luca Giordano: The Fall of the Rebel Angels**, ca. 1684, oil on canvas, 198 x 147 cm, Gemäldegalerie, Berlin

1600: A Period of Transition

Stylistically, the 17th century represented a period of transition. After the artificiality of Mannerism, artists looked for new avenues of artistic expression. The brothers Annibale and Agostino Carracci from Bologna aimed to renew painting by returning to Antiquity and the High Renaissance. Caravaggio's painting represented a countermovement to the Carraccis' art. His style of chiaroscuro, rich in contrast and characterized by a surprising naturalism and emotional drama, was adopted by many painters. Utrecht Caravaggists, such as Gerrit Honthorst or Hendrik Terbrugghen, introduced this style to the Netherlands, and Spanish-born José Ribera exported it to Spain. There, painters such as Francisco Zurbarán and Diego Velázquez ushered in the *Siglo d'Oro*, the Golden Century of Spanish painting.

The Height of Flemish Art

Peter Paul Rubens is one of the outstanding figures of his time and embodies the exuberant Baroque style. The well-traveled painter merged Flemish traditions with Italian influences. Rubens emphasized movement, strength, sensuality, and pathos. In his works, large gestures and glowing colors merge, and the formats achieve monumental grandeur. Among his numerous colleagues were the most significant artists of southern Netherlands, such as Jan Brueghel the Elder and Jacob Jordaens. Anthony van Dyck became a brilliant portraitist of the European aristocracy. The portraits of Rubens, van Dyck, and Velázquez reflected the monarchs' claims to power and in turn promoted the artists within their courts. Ceiling and mural paintings created breathtaking spaces within churches and the palaces of the aristocracy, celebrating the triumph of faith and glorifying the monarchs.

Baroque 1600–1740

■ **José Ribera: Boy with a Club Foot**, 1642, oil on canvas, 164 x 95 cm, Musée du Louvre, Paris

■ **Jan Brueghel the Elder: Flowers in a Vase**, ca. 1599–1607, oil on wood, 51 x 40 cm, Kunsthistorisches Museum, Vienna

■ **Jacob Jordaens: The Infancy of Zeus**, ca. 1630, oil on canvas, 147 x 103 cm, Musée du Louvre, Paris

■ **Gerrit van Honthorst: The Concert**, ca. 1620, oil on canvas, 168 x 202 cm, Galleria Borghese, Rome

The Middle Class in Holland

Art in the northern Dutch provinces, which had achieved independence from Spanish rule in the 16th century and were fast becoming world trading powers, developed differently. A flourishing art scene in which countless painters competed with each other for commissions from the patrons developed in the newly wealthy cities of Amsterdam, Delft, and Leiden. Their realistic still lifes, peasant scenes, church interiors, seascapes, and cityscapes provide a reflection of Dutch everyday life. One of the greatest and most im-

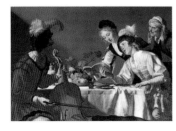

portant painters in Dutch history was Rembrandt van Rijn. With his ingenious use of chiaroscuro and sketchy painting style, he created civic character portraits, self-portraits, biblical scenes, and historic paintings, without ever leaving his Dutch homeland.

Baroque Court Painting in France and Germany

Two of the most important French painters of the French Baroque style—the intellectual classicist Nicolas Poussin and the landscape artist Claude Lorrain, whose mythological, dreamy paintings influenced European landscape painting to a lasting effect—worked in Rome. Simon Vouet introduced Italian Baroque painting to France. There, the art of Baroque painting increasingly submitted to the influence of the all-powerful, peerless master of 17th-century French art, Charles Le Brun. Le Brun was promoted to the position of director of the Academy of Painting and Sculpture, which was founded in 1648, where his influence grew. All commissions in the royal palaces, including Versailles, were directed by Le Brun, who acted as the official painter to the French court. The portrait of Louis XIV, painted by his pupil Hyacinthe Rigaud, is considered the epitome of the High Baroque portrait style.

Baroque 1600–1740

■ **David Teniers the Younger**: **Archduke Leopold Wilhelm in His Picture Gallery**, ca. 1651, oil on canvas, 106 x 129 cm, Museo del Prado, Madrid

■ **Hyacinthe Rigaud: King Louis XIV**, ca. 1694, oil on canvas, 277 x 194 cm, Musée du Louvre, Paris

■ **Simon Vouet: Allegory of Wealth**, ca. 1630/35, oil on canvas, 170 x 124 cm, Musée du Louvre, Paris

The Baroque style served the Counter-Reformation through its lavish glorification of the Church and its themes. In contrast to the rest of Europe, the German courts were weakened extensively for a long period of time due to the religious conflicts of the Thirty Years' War (1618–48) and the upheaval of the Reformation. Some of the most outstanding German painters, such as Adam Elsheimer, who died at a very young age, worked outside of their homeland. At the beginning of the century, Elsheimer created atmospherically illuminated night scenes, and was later accordingly labeled a precursor of Romanticism. Though he generally created small-scale paintings, known as cabinet paintings, his art was influential to Rubens and Rembrandt. The widely traveled Joachim von Sandrart was renowned for his painting as well as his writings chronicling German art, as the Italian-born Giorgio Vasari had similarly done a century before.

Introduction

Caravaggio

Michelangelo Merisi
1571, Caravaggio–1610, Porto Ercole

■ Insisted on the naturalistic representation of the body ■ Positioned his figures to achieve ultimate theatricality ■ Used spotlight lighting for dramatic intensity ■ Preferred violent subjects

■ **1571** Born Michelangelo Merisi on September 28, 1573 in Caravaggio, Italy

1584 Becomes an apprentice to the painter Simone Peterzano of Milan, follower of Titian

1592 Arrives in Rome and works as a painter's assistant

1595 Receives commission to decorate the church of San Luigi dei Francesi

1606 Kills Ranuccio Tomassoni da Terni over a disputed game of court tennis

1607 Flees to Malta, then Naples, to avoid prosecution

1610 Receives a pardon from the pope; misses a boat to Rome that leaves without him

1610 Collapses and dies in Porto Ercole

Caravaggio was one of the most revolutionary artists of the Baroque movement, originating a dramatic style of representing religious subjects that infused spirituality with realism. His naturalistic style was a reaction against the artificiality of Mannerism, and characteristically depicted few carefully detailed figures illuminated by theatrical lighting within a shallow space.

Caravaggio was born near Milan to an architect at the court of Marchese of Caravaggio. He apprenticed to the painter Simone Peterzano before moving to Rome, where he gradually attracted important clients. His early works were small-scale, but meticulously detailed genre paintings called "tableautins." With the help of Cardinal Francesco Del Monte, Caravaggio procured a commission for the Contarelli Chapel of San Luigi dei Francesi which established his artistic reputation.

Caravaggio's style is characterized by heightened chiaroscuro, known as "tenebrism." By dramatically contrasting ⟶

Other Important Works by Caravaggio

Boy with Fruit Basket, 1593, Galleria Borghese, Rome	**Supper at Emmaus**, 1602, National Gallery, London
Young Bacchus, 1593, Galleria degli Uffizi, Florence	**The Incredulity of Saint Thomas**, 1601–02, Neues Palais, Potsdam
The Cardsharps, 1594, Kimbell Art Museum, Fort Worth	**John the Baptist**, 1604, Nelson-Atkins Museum of Art, Kansas City
Amor as Victor, 1598/99, Gemäldegalerie, Berlin	**The Raising of Lazarus**, 1608–09, Museo Nazionale, Messina
Narcissus, 1599, Palazzo Barberini, Rome	

■ **Medusa**, ca.1598, oil on canvas, diameter 55.5 cm, Galleria degli Uffizi, Florence

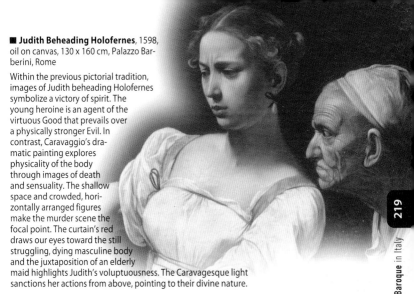

■ Judith Beheading Holofernes, 1598, oil on canvas, 130 x 160 cm, Palazzo Barberini, Rome

Within the previous pictorial tradition, images of Judith beheading Holofernes symbolize a victory of spirit. The young heroine is an agent of the virtuous Good that prevails over a physically stronger Evil. In contrast, Caravaggio's dramatic painting explores physicality of the body through images of death and sensuality. The shallow space and crowded, horizontally arranged figures make the murder scene the focal point. The curtain's red draws our eyes toward the still struggling, dying masculine body and the juxtaposition of an elderly maid highlights Judith's voluptuousness. The Caravagesque light sanctions her actions from above, pointing to their divine nature.

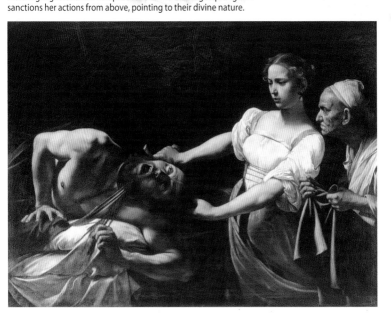

Caravaggio

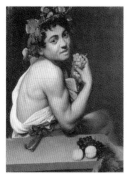

■ **Young, Sick Bacchus (Self-Portrait as Bacchus**), 1593, oil on canvas, 67 x 53 cm, Galleria Borghese, Rome

Scholars consider this melancholy painting to be the artist's self-portrait. It is an advertisement of the artist's versatile skills and it reveals Caravaggio's virtuosity in the depiction of light, representation of textures of various surfaces, and naturalistic display of the nuances of the movements and facial expressions.

light and shade, Caravaggio animated the scene, producing an effect of emotional tension. For the first time, light played a dynamic role that had been, during the Renaissance, reserved for the human body.

Caravaggio's naturalism relied on the careful study of nature. His practice of modeling religious figures on ordinary people and his method of working directly on canvas opposed conventional methods. He was even accused of disregarding beauty altogether.

Caravaggio's original approach allowed him to express introspection and the physical immediacy of religious scenes. While some contemporaries celebrated these innovations, others considered them vulgar. An outspoken critic, painter Nicolas Poussin, proclaimed that Caravaggio "was born to destroy the art of painting."

Caravaggio's style was enormously influential. In Rome, he inspired Giovanni Baglione and Orazio Gentileschi, whose daughter, Artemisia Gentileschi, became one of his most gifted followers. In Naples, Battistello Caracciolo and Carlo Sellitto adapted his techniques and the "Utrecht Caravaggisti" disseminated the style throughout Northern Europe. Rubens (p. 234), Vermeer (p. 256), Rembrandt (p. 244), and Velázquez (p. 260) all reveal Caravaggio's influence.

■ **St. Jerome**, 1606, oil on canvas, 112 x 157 cm, Galleria Borghese, Rome

St. Jerome is represented as an elderly hermit reading at the table in contemplation. His head and beard are innovatively molded and shaped by patches of pigment. The saint's nude, emaciated body, draped in fabric and silhouetted by light, points out the fragility of flesh. His balding head, theatrically spotlighted by Baroque tenebrism, opposes the skull: spirituality juxtaposed to mortality.

■ **The Conversion on the Way to Damascus**, 1601, oil on canvas, 230 x 175 cm, Cerasi Chapel of Santa Maria del Popolo, Rome

Disregarding the tradition of depicting St. Paul's conversion, Caravaggio arranged the composition around the horse, reduced the number of figures, and avoided representing Christ. His dramatically foreshortened, prostrate Paul gestures towards the light streaming onto his body from the upper right. This dynamic perspective directs viewers to follow the diagonal of Paul's body, eschewing the groom, who remains in the dark, blind to the miracle.

Caravaggio

Giovanni Lorenzo Bernini

1598, Naples—1680, Rome

- The most important Baroque sculptor ■ Worked primarily in the service of the popes ■ His dynamic works were groundbreaking for the development of sculpture ■ Created sculpted portraits, mythological and religious groups, monuments, fountains, decorations for celebrations, and architectural design

- **1598** Born to the sculptor Pietro Bernini in Naples; studies under his father

1605 Moves to Rome

1618 Starts building a reputation through a series of life-size marble groups commissioned by Cardinal Scipione Borghese, including *Apollo and Daphne*

1629 Takes charge of all building works on St. Peter's as successor to Carlo Maderna

1656 Commissioned to design the colonnade and forecourt of St. Peter's Basilica

1658 Designs the Church of San Andrea al Quirinale, one of Rome's most important Baroque churches

1665 Travels to Paris and drafts a design for the east front of the Louvre, which is never built

1680 Dies in Rome

Bernini, an accomplished painter, is also famed as the inventor of Baroque sculpture. He understood sculpture as a dramatic narrative and subordinated every detail to the concept of movement. Throughout his career, he increasingly fused sculpture into architecture. Under Pope Urban VIII, he rose to become the definitive designer of Baroque Rome. Supported by a large workshop, he carried out many monumental works of all kinds. He dedicated a major part of his productive capacity to the design of St. Peter's Basilica. Artists from every country spread his influence throughout Europe.

Other Important Works by Bernini

A Faun Teased by Children, 1616–17, Metropolitan Museum of Art, New York	St. Peter's Baldachin, 1624–33, St. Peter's Basilica, Rome
Aeneas, Anchises, and Ascanius, ca. 1618–19, Galleria Borghese, Rome	Busts of Louis XIV, 1665, Musée National de Versailles, Versailles
Truth, 1646–52, Galleria Borghese, Rome	Tomb of Pope Alexander VII, 1672–78, St. Peter's Basilica, Rome

■ **Apollo and Daphne**, 1622–25, marble, height 243 cm, Galleria Borghese, Rome

To escape Apollo, Daphne, a water nymph, changes into a laurel tree.

The young Bernini's mastery is evident in the overall dynamism of the piece as well as in the virtuosic manner of the surfaces. The stone comes to life through the skilled texturing.

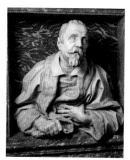

■ **Bust of Gabriele Fonseca**, ca. 1668–75, marble, San Lorenzo in Lucina, Rome

Bernini designed the portraiture of the papal personal physician true to life and illusory. Gestures and facial expressions reflect religious devotion.

■ **Ecstasy of St. Theresa**, ca. 1647, marble, height 3.5 m, Santa Maria della Vittoria, Rome

Bernini illustrates the religious ecstasy of St. Theresa as an overwhelming show of light, movement, eloquent facial expressions, and dramatically rippled surfaces. This sculpture is considered to be one of the masterpieces of High Roman Baroque art. The religious ecstasy appears here as an experience that can be grasped by the senses. While the smiling angel of God is about to bore through the saint with the arrow of divine love, she has already collapsed in a faint. Bernini based his work on the saint's own account.

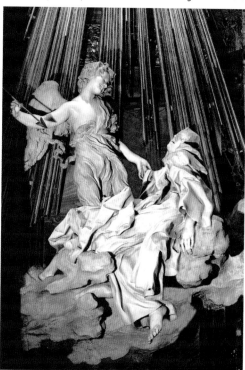

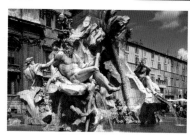

■ **Fountain of the Four Rivers**, 1647–51, travertine and marble, Piazza Navona, Rome

Bernini created a new type of fountain with this spectacular construction. Like a 360-degree piece of stage scenery, the whole dynamic complex of rock, animals, plants, and river gods towers up. The figures embody the four great rivers of the world and concurrently the four continents. The fountain was unveiled in 1651.

Giovanni Lorenzo Bernini

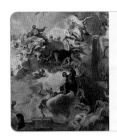

Andrea Pozzo

1642, Trento—1709, Vienna

■ Master of Late Baroque decorative art and illusionistic painting ■ Was a member of the Order of Jesuits, for whom he primarily worked ■ Was a painter, architect, and art theoretician ■ His techniques have made him one of the most remarkable figures of the Baroque period

Other Works by Pozzo

Ceiling Fresco, 1676–78, San Francesco Saverio, Mondovì

Cupola, 1703–07, ceiling, Church of Mary's Ascension, Vienna

Admittance of Hercules to Olympus, 1704–07, ceiling fresco, Liechtenstein Garden Palace, Vienna

Andrea Pozzo, who was born in Trento, joined the Order of Jesuits as a young man and dedicated almost his entire working life to it. His mastery lay in the art of perspective ceiling painting and tromp l'oeil, deceiving the eye into thinking that painting is actual three dimensional architecture or architectural embellishment. Imaginative and daring, he fashioned immense vaulted frescoes into light, unending illusionary spaces. His career high point was the ceiling fresco of San Ignazio in Rome, in which real and painted spaces merge into one. Pozzo continued the tradition of Pietro da Cortona, the founder of Baroque ceiling painting in Rome, increasing the illusion of distance and height with the help of light. Pozzo's writings on perspective were one of the 18th century's most influential works.

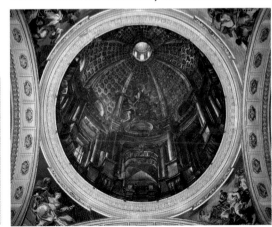

■ **The Apotheosis of St. Ignatius**, 1691–94, fresco, 17 x 36 m, San Ignazio, Rome

The enormous, light ceiling paintings must be viewed from a certain marked spot on the floor, from which vantage point the illusion is perfect. In the center, St. Ignatius, the founder of the Jesuit Order, who was canonized in 1622, appears seated on a cloud. From Christ he receives the ray of celestial light, which then radiates from him to figures on the sides who represent the four corners of the world.

■ **Cupola**, 1685, oil on canvas, diameter ca. 13 m, St. Ignazio, Rome

Extremely convincingly, Pozzo creates the illusion of an actual cupola with the help of an exact perspective construction. This was actually an emergency solution because the real cupola was not built due to a lack of funds and alterations in architectural plans.

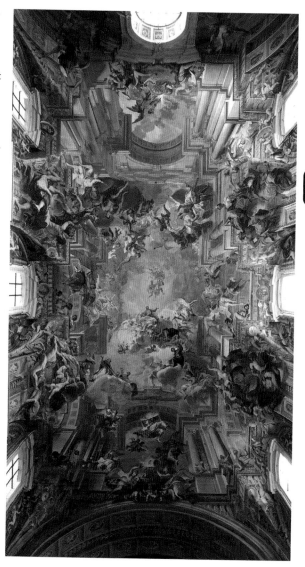

Andrea Pozzo

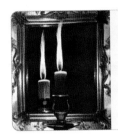

Georges de la Tour

1593, Vic-sur-Seille–1652, Lunéville

■ Master of French painting ■ Lived a secluded life in Lorraine ■ Was influenced by Caravaggio's naturalism and his dramatic light-dark style ■ Created unique nightscapes with candlelight ■ Developed a highly individual, severe and scant style beyond academic conventions of the time

■ **1593** Born in the town of Vic-sur-Seille, close to Nancy

1617 Official documentation of him as a painter

1620 Relocates to Lunéville, where he lives and works until his death

1621–22 Possibly travels to Italy or the Netherlands

1623 Duke Henry purchases a portrait

1639 Carries the title "Peintre Ordinaire du Roi," court painter of the king

1639 King Louis XIII purchases the painting *Holy Sebastian*

1647 Works together with his son Etienne

1652 Dies in Lunéville, likely due to the plague

Works by de la Tour

Hurdy-Gurdy Player, ca. 1620–30, Musée des Beaux-Arts, Nantes

Saint Jerome Reading, 1621–23, Royal Collection, Hampton Court, London

Woman Catching a Flea, ca. 1630–44, Musée Historique, Nancy

The Fortune-Teller, ca. 1632–35, Metropolitan Museum of Art, New York

Georges de la Tour was forgotten for centuries, and it was not until the 20th century that his works, which were at times ascribed to Velázquez (p. 260), Zurbarán (p. 266), or Vermeer (p. 256), were rediscovered and became famous. However, the authenticity of some of his recently discovered works has been questioned.

The beginnings of de la Tour's artistic career remain somewhat unclear. It is possible that he journeyed to Italy or the Netherlands. Obviously, Caravaggio's (p. 218) light-dark painting technique strongly influenced him, and probably reached him through the Dutch Caravaggisti, such as Honthrost or Terbrugghen. De la Tour radically simplifies volumes and light. His cubelike figures emerge like sculptures from dark rooms; illuminated by a torch or a candle, they appear mystical and removed from reality.

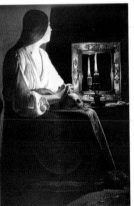

■ **Repentant Magdalene**, ca. 1635–40, oil on canvas, 134 x 92 cm, National Gallery of Art, Washington, DC

Glistening light and deep darkness meet each other in this strongly constructed painting. The contrast does not create dramatic action, however, but rather absolute silence. In the foreground sits the repentant sinner in a monumental and calm manner, meditating on the transitory nature of life, as the symbols of *vanitas*—the skull, the mirror, the candle, and the jewelry—indicate.

■ **St. Sebastian Attended by St. Irene**, ca. 1649, oil on canvas, 167 x 131 cm, Musée du Louvre, Paris

The action of the painting has a meditative rhythm. St. Sebastian, shot with arrows by Roman soldiers, lies in the foreground as if dead, but St. Irene and her pious escorts discover that he is still alive. In a subtle manner, de la Tour directs the viewer's gaze over the diagonally scaled figures through extreme contrast and directed lighting.

■ **Cheater with the Ace of Diamonds**, ca. 1630, oil on canvas, 106 x 146 cm, Musée du Louvre, Paris

In front of a black background, a subtle drama unfolds—three accomplices, to the left, zero in on the money of the inexperienced player. Their glances make the observer a confidant of their foul play.

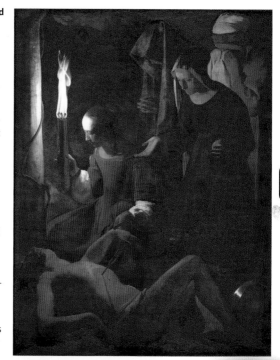

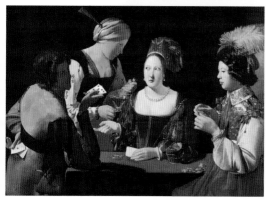

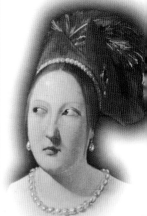

Nicolas Poussin

1594, Les Andelys—1665, Rome

■ One of the most influential and prominent French painters of the 17th century ■ Dealt in detail with mythological art and the art of Classical Antiquity ■ His cool, Classical painting formed a counterbalance to the dramatic art of his contemporary Rubens ■ Poussin spent more than half of his life in Rome

1594 Born in Les Andelys, Normandy, where he receives his first training

1612 Goes to Paris, enthusiastic about the engravings of Raphael

1624 Moves to Rome, where he finally settles and, after a difficult start, finds an exclusive circle of patrons

1640 Reluctantly returns to Paris for two years at the command of Louis XIII

1665 Dies in Rome

Nicolas Poussin first worked for 10 years in various Parisian workshops before he fulfilled his dream of moving to Rome. The eternal city became his adopted home. He studied Raphael and Titian, but foremost the art of Classical Antiquity. He sketched ruins and sarcophagi and, thanks to his fluent command of Latin, read Tacitus and Ovid. Poussin was a very intellectual artist, who never accepted a student or assistant. Claude Lorrain (p. 232) was one of his few friends.

Poussin's compositions are clear and carefully conceived. He would transpose passionate feelings into a cool, rationally subdued language of form based on abstract harmonies. He felt it important to choose the ⌕

■ **The Holy Family on Steps**, ca. 1648, oil on canvas, 68.6 x 97.8 cm, Cleveland Museum, Ohio

From an awe-inspiring low perspective, the Holy Family is shown amid Classical architecture. A youthful John and his mother Elizabeth are pictured with them on the steps. Exactitude and clarity define the composition. Poussin has left no element to chance. The group forms a classic triangle and is harmonized by the use of primary colors.

◀ **Arcadian Landscape with Orpheus and Eurydice**, ca. 1659, oil on canvas, 124 x 200 cm, Musée du Louvre, Paris

This masterfully composed landscape is typical of Poussin's style. This is not a real landscape but rather an idealized, artistically composed one created from set pieces of scenery. The melancholy mood corresponds directly to the tragic story of Orpheus and Eurydice depicted in the foreground.

■ **Et in Arcadia Ego**, ca. 1638–40, oil on canvas, 85 x 121 cm, Musée du Louvre, Paris

In Arcadia, Antiquity's utopian land, shepherds discover a gravestone inscription saying there is death in Arcadia, too.

Nicolas Poussin

appropriate method of execution for each subject: a dynamic or a solemn rhythm of narrative, the appropriate character of the landscape, and the mood of the colors. The sketched layout took precedence over the colors.

Although landscape painting found little appreciation in art theory, Poussin gained respect by treating great literary and philosophical subjects from Classical mythology in his idealized landscapes.

Poussin's influence on the development of academic art into the 19th century can hardly be overestimated; for example, David (p. 300) drew on his style, and even Cézanne (p. 382) and Picasso (p. 428) admired the abstract clarity of his work.

Other Important Works by Poussin	
The Martyrdom of St. Erasmus, 1628, Musei Vaticani, Rome	Triumph of Neptune and Amphitrite, 1634, Museum of Art, Philadelphia
The Inspiration of the Poet, ca. 1630, Musée du Louvre, Paris	Tancred and Erminia, 1634, Hermitage, St. Petersburg
Apollo and Muses (Parnassus), ca. 1630, Museo del Prado, Madrid	Nymph Syrinx Pursued by Pan, 1637, Gemäldegalerie, Dresden
Acis and Galathea, ca. 1630, National Gallery of Ireland, Dublin	Cycle of the Four Seasons, 1660–64, Musée du Louvre, Paris

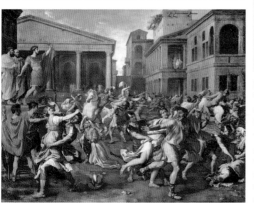

■ **The Rape of the Sabine Women**, before 1655, oil on canvas, 154 x 209 cm, Metropolitan Museum of Art, New York

The many-figured, turbulent composition is arranged similarly to a frieze in the front planes, and shows the strong influence of Classical sarcophagus reliefs and sculptures on Poussin.

■ **The Garden of Flora**,
1630–31, oil on canvas,
131 x 181 cm, Gemäldegalerie
Alte Meister, Dresden

This famous painting shows the
romantic and poetic side of the
classicist Poussin. Despite very
bright and delicate colors, a
melancholy mood radiates from
it. Light of foot, the smiling

goddess of flowers scatters
petals and blooms. Figures of
Antiquity appear in the fore-
ground. They have been trans-
formed into flowers in death.
On the far left there stands a
stone statue of Pan, the god of
nature. In front of the statue,
the hero Ajax falls on his sword,
while, next to him, Narcissus

adoringly studies his reflection.
The pair of lovers, Crocos and
Smilax, are reclining on the
right; behind them stands Hy-
acinthe, the Classical nude and
friend of Apollo. Helios is
driving his sun chariot across
the heavens. The painting's
message could be that life is in
the midst of change.

Nicolas Poussin

Claude Lorrain

also Claude Gellée or Claude Le Lorraine
1604, Chamagne–1682, Rome

■ Most important landscape artist of the 17th century, especially ideal landscapes ■ 250 paintings and 44 graphics have survived ■ Lived predominantly in Rome ■ Influenced landscape painting of the 18th and 19th centuries

■ **1604** Born in Chamagne in Lorraine to poor parents
ca. 1618 Wanders to Rome after the death of his parents, and apprentices under the landscapist Agostino Tassi
ca. 1625 Works for a year in Nancy, capital city of Lorraine
1627 Settles permanently in Rome
1633 Becomes member of the Academy of St. Lukas in Rome
1635 Begins recording his paintings with sketches in his *Liber Veritatis* (*Book of Truth*)
1862 Dies in Rome

Born the child of poor parents, Claude Lorrain, whose name refers to his native Lorraine, had little schooling. Orphaned early in life, he probably made his way to Rome by baking pies. Once there, he began studying painting and eventually rose to become one of Italy's leading landscape artists. Lorrain specialized in the ideal landscape, with origins dating back to Venetian painting ca. 1500. His pictures convey the dreamlike, slightly melancholy feeling of a golden age, far from the reality of daily life. His landscapes were always enlivened by small staffage figures, antique ruins, or harbor facilities. He had an exceptional command of light and color. In his famous backlit views, he was the first artist to attempt to let the sun itself shine in a picture. His influence, especially in England, was immense, and changed both the public perception of nature and the design of parks.

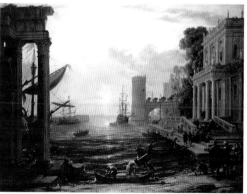

■ **Embarkation of the Queen of Sheba**, 1648, oil on canvas, 149 x 194 cm, National Gallery, London

This magnificent painting shows a habor with fantastic architecture from Classical Antiquity. The rising sun, typical of the painter's harbor scenes, illuminates the view. Among his groundbreaking innovations is the inclusion of the sun itself in the picture as the source of light. Light warms the scene, accentuating the warm colors and harmonizing the whole.

■ **Landscape with the Finding of Moses**, 1639–40, oil on canvas, 209 x 138 cm, Museo del Prado, Madrid

In Claude Lorrain's ideal landscapes there are a lot of biblical or mythological narratives. The slim portrait format of this painting is unusual, but the arrangement of the landscape follows the same Classical laws of harmony as in many of the painter's other works. Dark trees lead into the picture from the left. A second group of trees and the river gently guide the eye off into the distance. The silhouette of mountains disappearing into the misty distance rounds off the composition.

Other Works by Lorrain

Landscape with Cattle and Peasants, 1629, Museum of Art, Philadelphia

Coast View with Apollo and the Cumaean Sibyl, 1646, Hermitage, St. Petersburg

The Crossing, 1648, Musée du Louvre, Paris

The Expulsion of Hagar, 1668, Alte Pinakothek, Munich

■ **Landscape**, 1650, pen-and-ink wash drawing, Museum der Bildenden Künste, Leipzig

Claude Lorrain left behind more than 1000 drawings. This wash drawing with brown ink was executed like an independent picture. However, many such works are just studies of the Roman countryside. Back in his studio, Lorrain would render these landscapes with ruins.

Claude Lorrain

Peter Paul Rubens

Pierre Paul Rubens
1577, Siegen–1640, Antwerp

■ The leading master of the European Baroque ■ Commanded all formats
and genres, created portraits, biblical, and Classical histories, landscapes, animal and hunting scenes, and allegorical paintings ■ Sensual ideal of beauty

1577 Born Pierre Paul Rubens to patricians from Antwerp living in exile

1589 Moves to Antwerp, where he learns painting from Adam van Noort and Otto van Veen

1598 Master of the St. Lukas Guild

1600 Goes to Italy for several years and works in Venice, Mantua, Rome, and Genoa

1628 Travels on a diplomatic mission to Spain

1608 Maintains an extensive workshop in Antwerp

1638 Marries his second wife

1640 Dies in Antwerp

■ **Stormy Landscape**, ca. 1620–35, oil on wood, 147 x 209 cm, Kunsthistorisches Museum, Vienna

As opposed to Poussin or the Dutch, Rubens did not consider nature as something static and stationary but rather as a dynamic continuum in constant change. On the right in the stormy landscape the gods of Antiquity, Jupiter and Mercury, meet the aged Baucis and Philemon.

No painter embodies the style of Baroque better than Peter Paul Rubens, who came from an educated Flemish patrician family. Powerful pathos, emotional drama, sweeping motion, sensuous portrayal of the human body, glowing colors, and a free, fluent brushstroke are characteristic of the painter. He developed this style during his long stay in Italy while studying Raphael, Michelangelo, Titian, Caravaggio, and Veronese. Titian's (p. 164) late works especially influenced Rubens's artistic spontaneity.

Back in his native land, Rubens collaborated with the most important Flemish artists, including the still life painter Jan Bruegel the Elder (p. 192), the animal and still life specialist Frans Snyders, the powerful figure painter Jacob Jordaens, and the young Antony van Dyck (p. 240). He knew how to translate complex, allegorical subjects into sensuous pictures full of life. Because his compo- ⊟

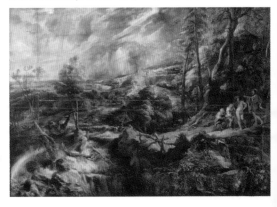

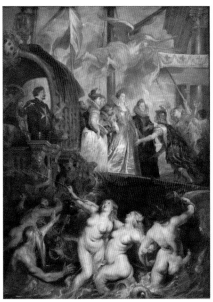

■ **Portrait Study**, 1621, black, red, and white chalk on paper, 25.2 x 20.3 cm, Graphische Sammlung Albertina, Vienna

The study drawing, sketched from life, shows Nicolas, the artist's young son from his first marriage with Isabella Brant in 1609.

■ **The Landing at Marseilles**,
ca. 1623–25, oil on canvas, 394 x 295 cm, Musée du Louvre, Paris

This is part of an extensive series for the French Queen Maria de Medici, and shows her

arrival in Marseilles in the year 1600. Fama, the goddess of fame, is floating over her, while sea deities play about the ship, heralding her arrival. With apparent ease, Rubens embellishes the historic reality.

■ **Rubens and Isabella Brant in the Bower of Honeysuckle**,
1609–10, oil on wood, 178 x 136 cm, Alte Pinakothek, Munich

The double portrait undoubtedly originates from the time of their wedding and shows the life-size pair in the open

air. Both are extravagantly clothed according to the latest fashions, which suit their upper-class standing. The honeysuckle brush is a symbol of wedded love and constancy, echoed in their relaxed gesture and gentle touch.

Peter Paul Rubens

sitions were not based on exact drawings, but rather were alive with a total movement of color, he developed the oil sketch into an important medium in the process of arriving at a finished picture. His immense and extensive body of work would not have been possible without a large, perfectly organized workshop. Alongside painting, he designed festive decorations, tapestries, and book illustrations, as well as the architecture of his own home. Rubens mingled in the leading classes of European society, not only as an artist, but also as a diplomat.

His painting influenced whole generations of painters, up to and including the French Romanticists of the early 19th century like Delacroix (p. 330) and Girodet.

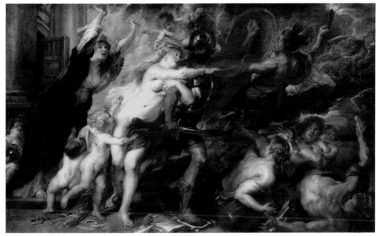

■ **The Consequences of War**, 1638, oil on canvas, 206 x 342 cm, Palazzo Pitti, Florence

Rubens himself explained this allegorical painting in a letter in 1638. Mars, the god of war, storms out of his temple while the nude Venus tries to hold him back. A fury, however, is pulling him into the all-havoc-wreaking war. All of the figures merge into an intertwining torrent of motion from left to right. Even love cannot restrain the brutality of war.

■ Portrait of Susanne Fourment, 1622–25, oil on wood, 79 x 54 cm, National Gallery, London

This famous portrait is of Susanne, the older sister of Rubens's second wife, Helene Fourment. The painter depicts her in daylight under the open sky. The fashionable, wide-rimmed feather hat swathes her face in soft shadows and makes it appear all the more attractive. This artistic trick was admired and often copied by later painters. Like many paintings by Rubens, who preferred to paint on wood, this picture was enlarged by additions on the right and the bottom.

Other Works by Rubens

The Descent from the Cross, ca. 1612, Cathedral of Our Lady, Antwerp

Venus at a Mirror, ca. 1615, Collection Fürst von Lichtenstein, Vaduz

St. Barbara, 1620, Ashmolean Museum, Oxford

War and Peace, 1629–30, National Gallery, London

St. Cecilia, ca. 1632–34, Gemäldegalerie, Berlin

Venus and Adonis, 1635, Metropolitan Museum of Art, New York

Landscape with the Château Steen, ca. 1636, National Gallery, London

The Judgment of Paris, ca. 1636, National Gallery, London

The Three Graces, 1639, Museo del Prado, Madrid

■ Fall of the Rebel Angels, ca. 1619–22, oil on canvas, 433 x 288 cm, Alte Pinakothek, Munich

In 1619, Rubens was commissioned by the duke of Pfalz-Neuburg to paint this altarpiece entirely on his own. This was a special and unusual commission, as a large part of his commissions were usually done by his workshop, while Rubens himself often only laid out the composition and major figures. In this painting, Rubens's composition of figures brings the whole, gigantic picture into swirling motion. The dramatic battle between good and evil is played out while floating free in space. With a billowing red cloak, the archangel Michael defeats the rebellious Lucifer, who appears here as an apocalyptic dragon.

Peter Paul Rubens

The Rape of the Daughters of Leucippus

In a story from ancient mythology, the twin brothers Castor and Pollux abduct the daughters of Leucippus of Argos, despite their being promised to other men. Rubens makes a sensual drama out of it. The women, nearly naked, defend themselves by flailing their arms and imploring the heavens, yet it is ambiguous whether the sensuality of their lovesick abductors is reflected in their own glances. Rubens fully plays out this ambivalence, as well as the charming contrast between the bright, voluptuously round female bodies and the dark men. The background landscape supplies the perfect setting with its cool blue and green tones.

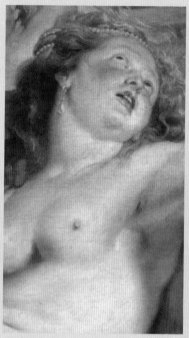

■ **The Rape of the Daughters of Leuccipus,** ca. 1618, oil on canvas, 224 x 210.5 cm, Alte Pinakothek, Munich

Dramatic curves Rubens concentrates the action close up in the foremost picture plane so that the figure group towers up over the low horizon like a sculpture group. He renders the collision of opposed forces as circles and arches.

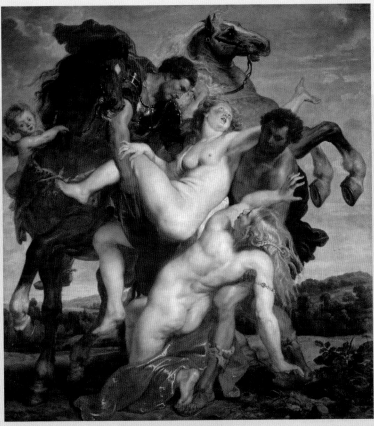

Turbulent brushwork
Rubens's bold brushstrokes
follow the forms of the bodies
and mold them out of color.
Often the individual brush-
strokes remain clearly visible
in the layer of paint. The lively,
sensuous reproduction of skin
tones is based on an interplay
of many shades of color.

Peter Paul Rubens

Anthony van Dyck

1599, Antwerp—1641, London

■ Was the leading Flemish painter next to Rubens ■ The great portraitist of European nobility ■ Developed an elegant, representative style of portraiture that shaped the European art of portrait painting, especially in England, into the 18th century ■ Created religious paintings and some portrait etchings

■ **1599** Born in Antwerp, the 7th child of a wealthy silk trader

1609 At age 10 enters the workshop of Hendrik van Balen; later enters Ruben's workshop

1618 Becomes master in the Antwerp Painters' Guild

1621 Goes to Italy, where he becomes a sought-after portraitist of the aristocracy and studies the works of Titian

1627 Returns after many years to Antwerp

1632 Court painter to the English king

1641 Dies in London

Other Works by van Dyck

The Bearing of the Cross, 1617, St. Paul's Church, Antwerp

Self-Portrait, ca. 1621, Metropolitan Museum of Art, New York

The Mourning of Christ, 1634, Alte Pinakothek, Munich

Equestrian Portrait of Charles I, the King of England, ca. 1637–38, National Gallery, London

When Anthony van Dyck died in London at only 42 years of age, he left behind a shining career that brought him international fame, wealth, and knighthood. Today, aproximately 500 portraits by him are known.

Van Dyck gained attention early in life in his native Antwerp as a precocious painting talent, and Rubens took him into his workshop, promoting his career. Van Dyck also painted religious works, but his great success was primarily due to his unusual portrait painting talent. He was a keen observer and understood how to combine both courtly elegance and dignity with the living immediacy of the image. His brilliant, full-figured portraits never appear stiff or artificial, yet his subjects always maintain a majestic posture that has come to be emblematic of his work.

■ **Cardinal Bentivoglio**, ca. 1623–24, oil on canvas, 195 x 147 cm, Palazzo Pitti, Florence

This life-size portrait is dominated by the vibrant red of the cardinal's robe. Rich velvet draperies and a column in the background create an atmosphere of wealth and masterly dignity. The seated form radiates calm. However, the attentive side-glance reflects the intellectual presence of the sitter, who was a noted humanist and historian.

Baroque in Flanders

■ **Queen Henrietta Maria with Sir Jeffrey Hudson**, 1633, oil on canvas, 219.1 x 134 cm, Samuel H. Kress Collection, National Gallery of Art, Washington, DC

Next to her court dwarf, Jeffrey Hudson, the young English queen appears tall and stately. Van Dyck expertly places cool and warm color tones next to each other in this portrait and plays out the splendor of the velvet and silk materials.

▲ **Portrait of Charles I in Hunting Dress**, ca. 1635–38, oil on canvas, 266 x 207 cm, Musée du Louvre, Paris

The posture of the king conveys superiority and a sense of distance.

■ **Portrait of the Painter Frans Francken II**, 1630, etching

The etching is part of a large-scale series of portraits of 100 important contemporaries that Van Dyck published with the help of other artists. The portrait demonstrates his masterly command of the art of etching. Van Dyck created several portrait series of important contemporaries.

Anthony van Dyck

Frans Hals

ca.1580–1585, Antwerp–1666, Haarlem

■ Painted primarily portraits and a series of scenes from daily life with half-length figures ■ Cultivated a free, loose brushwork ■ Spent most of his life in Haarlem ■ Five of his eight sons also became painters ■ Greatly admired by his contemporaries and later artists, including the Impressionists

ca. 1580–85 Born in Antwerp to a cloth-maker; emigrates with his parents out of the Spanish-occupied southern Netherlands to the North

1591 Lives in Haarlem, where he is possibly the student of the painter and writer Karel van Mander

1610 Accepted into the Haarlem St. Lukas Guild

1649 Paints portrait of philosopher René Descartes

1654 Financial difficulties force him to auction his possessions

1666 Dies in Haarlem

Frans Hals is one of the outstanding portrait painters of the 17th century. He bestowed a completely new type of living presence into those portrayed in his pictures. His genre paintings—humorous scenes from Dutch daily life—concentrated on one or two figures and captured fleeting moments and emotions. It was his spontaneous, decisive manner of painting that was important, and that continued to become more liberal throughout the course of his life. Rapid and full of temperament, he set broad brushstrokes (wet-on-wet) on the canvas. Only when viewed from a distance do the brushstrokes merge into a surprisingly realistic total impression. Not only his clients admired this virtuosity, but also many painters of the 19th century, above all the Impressionists, particularly Vincent van Gogh (p. 386).

■ The Mulatto,

ca. 1628–30, oil on canvas,
75.5 x 64 cm, Museum der
Bildenden Künste, Leipzig

A laughing, colorfully costumed
man turns toward the viewer.
His slightly opened mouth and
shining cheeks give the picture
the feeling of a snapshot. The
rapid, spontaneous brushwork
breathes life into the figure de-
picted, who was most likely
playing the role of a popular
court jester.

◀ Banquet of the Officers
of the St. George Civic Guard,

1616, oil on canvas,
175 x 324 cm, Frans Hals
Museum, Haarlem

Such group portraits were a
Dutch specialty. Frans Hals
gives life to the composition
through his stage direction by
grouping the officers of the
civic guard in a banquet scene
and expanding the picture area
through a view of a landscape.
He arranges the heads in a
rhythmical diagonal that is
emphasized by the slanting
flagstaff jutting upwards.

■ Two Boys
Singing, ca.

1623–25, oil on
canvas, 66 x 52 cm,
Staatliche Kunst-
sammlungen, Kassel

Seeing these boys
singing, one almost
seems to hear them.
The lively, everyday
scene that is cap-
tured here can also
be interpreted in a
more general sense,
namely as a symbol
for music or for a
sense of hearing.

Frans Hals

Rembrandt van Rijn

Rembrandt Harmenszoon van Rijn
1606, Leiden–1669, Amsterdam

■ Outstanding painter of the Dutch Golden Age ■ Even during his lifetime he was highly regarded ■ Had numerous students and imitators

1606 Born Rembrandt Harmenszoon van Rijn to a miller in Leiden

1620 Enrolls at the University of Leiden after studying at the Latin School; his studies are cut short and he begins an apprenticeship as a painter with Jacob van Swanenburgh and later with Pieter Lastman in Amsterdam

1625 Returns to Leiden and opens a studio; becomes established as a self-employed painter in Leiden

1632 Achieves fortune in Amsterdam as a portraitist; begins signing his paintings by his first name only

1632 Begins a large Passion cycle for Netherlands governor Prince Frederick Hendrick of Orange and reaches the height of his fame

1642 Death of his wife Saskia; paints the famous *Night Watch*

1649 His housekeeper Hendrickje Stoffels becomes his life-partner

1656 Encounters financial difficulties despite numerous commissions and must auction off his estate

1669 Dies on October 4 in Amsterdam

Rembrandt Harmenszoon van Rijn was an exceptional visual storyteller and a great interpreter of the human condition. He understood how to convey the nuances of emotion, spiritual feeling, and human character in an extraordinarily lively manner. To this end, he utilized an increasingly unfettered, thickly pigmented style of painting and made light the defining element of his style. Though he never left his Dutch homeland during his lifetime, he was familiar with Italian engravings and prints.

Rembrandt's career as a historical painter began after he left his studies at the University of Leiden. He soon abandoned the brightly colored style of his teacher Pieter Lastman and developed his own style, based primarily on a dramatic staging of light and dark. He achieved fame and fortune in Amsterdam as a portrait painter, but ▭

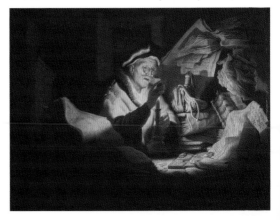

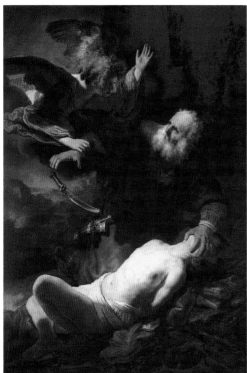

■ **Sacrifice of Isaac**, 1635, oil on canvas, 193 x 133 cm, Hermitage, St. Petersburg

Rembrandt staged this large-scale painting with a high degree of drama. The elderly Abraham has, as God commanded, bound his son Isaac and is on the verge of sacrificing him. He is already bending the head back and raising the knife in order to cut his son's throat. Then, at the last minute, the angel restrains his lethal hand. Rembrandt heightened the tension of this oft-depicted Old Testament scene and seized a dramatic snapshot: The knife still hovers in the air. Two large diagonals connect the figures with one another. Light emphasizes the naked, defenseless body of the victim lying on the ground. Moreover, Rembrandt's use of light directs the gaze to the principal figures' faces and hands: They stand out as light in contrast with their darker surroundings. Next to them, landscape and foreground are engulfed in a half darkness.

■ **The Money Changer**, 1627, oil on wood, 31.7 x 42.5 cm, Gemäldegalerie, Berlin

This early painting shows a man in a dark room surrounded by stacks of books. His wrinkles are echoed in the books' pages. By candlelight, he contemplates a coin. It is possible that this scene, rendered entirely in brown tones, alludes to the biblical parable of the cultivation of grain.

■ **Self-Portrait in a Cap**, 1630, etching, 5.1 x 4.5 cm

This tiny etching is a study of gestures and facial expressions. Rembrandt often used himself as a model and prepared many painted, drawn, and etched studies. The page shows the young artist's loose, comfortable command of the medium and tools of etching as well as his ability to capture realistic facial expressions.

Rembrandt van Rijn

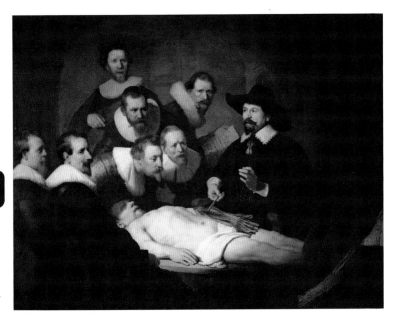

also created notable historical paintings with biblical and mythological subjects. His etchings and drawings have a radical sense of spontaneity.

Rembrandt had numerous students and imitators. They copied his style so perfectly that it is nearly impossible to distinguish between their works and those of his own, a problem that requires careful research even today.

■ Woman Reading,
ca. 1640, pen in brown, 15.6 x 16.6 cm, Kupferstich-kabinett, Berlin

Rembrandt developed a very lively, sketchy drawing technique. He captures this woman with a few energetic strokes. The head of a bearded man with a turban is visible from the reverse side of the page.

■ Anatomy Lesson of Dr. Nicolaes Tulp, 1632, oil on canvas, 169.5 x 216.5 cm, Mauritshuis, The Hague

This typical group painting depicts the Amsterdam-based anatomist Nicolaes Tulp conducting a lesson. Using his scalpel, he reaches into the dissected arm of the corpse lying before him, while he lectures coolly and objectively. In the left half of the painting, a group of students follows the demonstration with rapt attention. As an experienced historical painter, Rembrandt grouped the scene in a lively manner and concentrated on action—a new idea for a Dutch group portrait.

■ **A Woman in Bed**, ca. 1647, oil on canvas, 81.3 x 68 cm, National Gallery of Scotland, Edinburgh

It is possible that this famous painting originally adorned the door to a room or closet. Such illusionistic pictures were not unusual. It has long been assumed that it depicts one of Rembrandt's women. Because the date of this painting is disputed, she could be either the prematurely deceased Saskia von Uylenburgh or one of his later life partners, Geertje Dirckx or Hendrickje Stoffels. It is also possible that a biblical subject was intended: namely, Sara of the Old Testament, who on her wedding night witnessed her husband Tobias conquer a demon. This theme and type of painting is quite typical for Rembrandt.

■ **Self-Portrait**, 1669, oil on canvas, 86 x 70.5 cm, National Gallery, London

Before the modern era, no artist painted himself as frequently as Rembrandt, who depicted himself in all phases of his life. His later self-portraits, which show him as an old man, are especially unusual. This painting was created in the year of his death and was done in the open, rough style characteristic of his later works.

Other Important Works by Rembrandt	
The Artist in His Studio, ca. 1629, Museum of Fine Arts, Boston	His Wife, 1641, Gemäldegalerie, Berlin
Belshazzar's Feast, ca. 1635, National Gallery, London	The Holy Family, 1646, Staatliche Museen, Kassel
The Mennonite Preacher Anslo and	Bathsheba at Her Bath, 1654, Musée du Louvre, Paris

Rembrandt van Rijn

The Night Watch

The name, *The Night Watch*, was first given to this painting long after Rembrandt's death. As a matter of fact, it is a group portrait of the militia company of Captain Frans Banning Cocq and of Lieutenant Willem van Ruytenburgh—Rembrandt's most notable portrait commission. Captain Cocq appears in the center of the painting dressed completely in black, next to his second lieutenant. Yet in no way does this extraordinarily oversize painting work as a portrait. Since Rembrandt successfully transformed the portrait into a scene in motion—similar to a stage entrance and with the same artistic promise—it functions as a great historical painting. One must be aware that the art of painting in the 17th century was divided into various forms, among which historical paintings were the most distinguished, while the art of portraiture was considered much less sophisticated. Rembrandt called into question this hierarchy of forms in a revolutionary manner. His œuvre formed a turning point for painting.

Captain Frans Banning Cocq stands opposite the viewer, his forward-pointing left arm appearing to jut out from the picture. Rembrandt's ingenious use of finely graduated light creates an effect of stark contrast between light and darkness and produces an illusion of depth. The two-part grouping stands out through the sharp contrast between dark and light clothing, which accentuates certain figures. Originally, the composition had an even more dynamic and less symmetrical effect, since the picture was lopped off on the left side.

■ **The Night Watch**, 1642,
oil on canvas, 359 x 438 cm,
Rijksmuseum, Amsterdam

A number of individually char-
acterized figures appear in the
painting, outfitted with various
weapons and uniforms. The
company appears to be situ-
ated at a decampment. The
softly lit figure of a girl in the
background is difficult to inter-
pret: She might be the personi-
fication of glory.

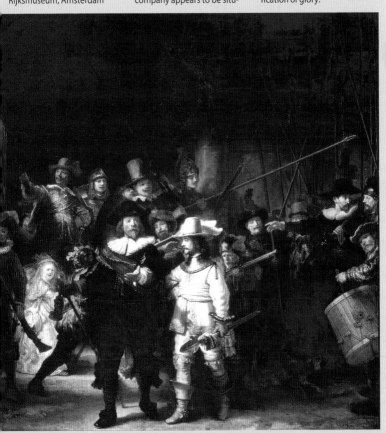

Jan Steen

ca. 1626, Leiden–1679, Leiden

■ An outstanding representative of Dutch genre painting ■ Worked in the artistic centers of Haarlem, The Hague, Delft, and Leiden ■ Painted scenes of daily life with fondness ■ His paintings are rich in figures and often have humorous overtones and moral messages

■ **1626** Born in Leiden to a beer brewer

1646 Studies briefly at the University of Leiden

1648 Member of the Leiden Painters' Guild

1649 Goes to The Hague and marries the daughter of his master Jan van Goyen

1654 Manages a brewery in Delft

1661 Settles in Haarlem

1671 Provost of the painters' guild in Leiden

1679 Dies in Leiden

Other Works by Steen

Easy Come, Easy Go, 1661, Museum Boymans van Beuningen, Rotterdam

Rhetoricians at a Window, ca. 1662–66, Philadelphia Museum of Art, Philadelphia

Feast of St. Nicholas, ca. 1665–68, Rijksmuseum, Amsterdam

Village School, ca. 1670–72, National Gallery of Scotland, Edinburgh

Nocturnal Serenade, ca. 1675, Národní Galerie, Prague

Jan Steen was an inventive and humorous storyteller who understood life as one great comedy of manners. The son of a beer brewer, he learned painting under the genre painter Adriaen van Ostade and the landscape painter Jan van Goyen. In the course of his life Steen created over 700 paintings, including portraits, religious, and mythological subjects. His favorite selections were Dutch scenes of everyday life from the petty bourgeois milieu—tavern scenes and family festivities, village school scenes, or doctors' visits. Such genre pictures enjoyed great popularity in the Netherlands, but did not provide much income. Therefore Steen also earned his livelihood through a brewery and tavern. Since the 18th century, both his works and legacy have steadily become more popular.

■ **The Merry Family**, 1668, oil on canvas, 111 x 141 cm, Rijksmuseum, Amsterdam

This well-known painting by Jan Steen displays a rowdy family celebration. Young and old sing, make music, laugh, and drink wine. The two children at the front right imitate the adults, illustrating a Dutch proverb: "What the folks sing, so whistle the young." Steen apparently composed and staged the chaotic bustle and conceived of the figures as caricatures. Materials and details are masterfully reproduced.

◀ **Skittle Players Outside an Inn**, ca. 1670, oil on wood, 68 x 87 cm, Kunsthistorisches Museum, Vienna

This idyllic painting captures the relaxed atmosphere of a day of rest from work. In the foreground several men play skittles in a smooth sandpit, while others sit in the grass, children play, and a mother shops. The outstanding, and, for Steen, a previously atypical landscape shows his artistic skill.

Jacob van Ruisdael

Jacob Izaaksoon van Ruisdael
ca. 1628/29, Haarlem–1682, Amsterdam

■ Considered the greatest among the countless Dutch landscape painters of the 17th century ■ Developed an unusually wide repertoire of landscape varieties ■ Created about 700 paintings and 100 drawings as well as etchings

1628/29 Born Jacob Izaaksoon van Ruisdael to a frame maker and painter under whom he studies painting

1646 His first dated painting

1648 Accepted as a master into the Haarlem Guild of St. Luke

1650–53 Undertakes several trips to eastern Holland and the Rhine highlands with his friend, painter Nicolaes Berchem

1655 Settles in Amsterdam, where he acquires citizenship in 1659

1682 Dies in Amsterdam

Countless painters in 17th-century Netherlands specialized in landscape painting and set their sights, for the most part, on their own surroundings. Born around 1628–29 to a painter and as the nephew of Salomon van Ruisdael, who was also a landscape painter, Jacob van Ruisdael went beyond the tone-on-tone, flat landscapes that were created by previous generations. He imparted his realistic compositions with a dramatic force and deployed strong light-dark contrasts. His wide repertoire of motifs embraced darker mountain scenes with jagged rocks, wooded landscapes with powerful trees and noisy waterfalls, seascapes, and winter pictures. He often left decorative figures to other painters. His most important pupil was Meindert Hobbema.

■ **The Windmill at Wijk**, ca. 1670, oil on canvas, 83 x 101 cm, Rijksmuseum, Amsterdam

A large sky, rich in clouds, water with ships, flat land, humble houses, and a proud windmill as the focal point—this famous painting by Ruisdael realistically introduced the characteristic Dutch landscape with its typical colors of richly nuanced blue, gray, green, and brown tones. Simultaneously, Ruisdael transforms the actual landscape details into a perfectly balanced composition of great artistic allure.

■ **The Jewish Cemetery**, ca. 1660, oil on canvas, 84 x 95 cm, Gemäldegalerie Alte Meister, Dresden

The Jewish Cemetery numbers among Ruisdael's most significant works. Everything is reminiscent of the transience of all life—the wildly agitated, stormy sky, the half-dead tree, the quick, rushing water, and, of course, the stone sarcophagi. The artist works them toward the foreground as the main motif, gently allowing them to emerge from the darkness. In the early 19th century, the Romantic painter Friedrich (p. 326) saw such dark, symbolically charged landscapes as his inspiration.

Other Important Works by Ruisdael	
Bentheim Castle, 1653, National Gallery, Dublin	The Ray of Sunlight, ca. 1660, Musée du Louvre, Paris
Wooded Landscape with Waterfall, ca. 1665, Wallace Collection, London	Grainfields, ca. 1670–80, Metropolitan Museum of Art, New York

Jan Davidszoon de Heem

1606, Utrecht–1683/84, Antwerp

■ Is among the most outstanding Dutch still life painters ■ Cultivated a brilliant colorfulness and virtuoso manner of detailing in his paintings ■ Combined the precision of the northern Dutch still lifes with the brightness of Flemish painting ■ Many of his still lifes contain a hidden *vanitas* symbolism

1606 Born in Utrecht and is presumably apprenticed to the still life painter Balthasar van der Ast

1626 Works in the university city of Leiden

ca. 1631 His son, painter Cornelis de Heem, is born

1636 Resettles from southern Netherlands to Antwerp, where he joins the painters' guild and becomes acquainted with the Flemish still life paintings of Frans Snyders and Daniel Seghers

1669 Returns to Utrecht for three years

1672 Leaves Utrecht, fleeing from the French invasion

ca. 1683/84 Dies in Antwerp

Works by de Heem

Still Life of Books, 1628, Mauritshuis, The Hague

A Table of Desserts, 1640, Musée du Louvre, Paris

Still Life with a Glass and Oysters, ca. 1640, Metropolitan Museum of Art, New York

Eucharist in Fruit Wreath, 1648, Kunsthistorisches Museum, Vienna

Jan Davidszoon de Heem was the most significant representative of a family of still life painters. This genre developed in the 17th century into a separate branch of painting particularly loved in the Netherlands, and de Heem most likely learned the art through an apprenticeship to the painter Balthasar van der Ast. In the university city of Leiden, he aligned himself with Rembrandt's (p. 244) circle and began painting dark-toned *vanitas*—a type of painting with dark themes of death and the passage of time—and book still lifes. His resettlement in Antwerp ushered in a profound change in the artist's style and subject matter. The sumptuous Flemish still lifes of Daniel Seghers and Frans Snyders inspired him to paint colorful arrangements of fruit, flowers, victuals, and ornate vessels. De Heem kept his characteristically Dutch fine pictorial attention to detail and managed to bridge the traditions.

■ **Still Life with Skull**, undated, oil on canvas, 87.5 x 65 cm, Gemäldegalerie Alte Meister, Dresden

The assortment of flowers is rendered with nothing less than perfect botanical precision. The depicted tulips, carnations, and roses were a costly luxury at the time in the Netherlands. Their fleeting beauty reminded viewers of the transience of all life—which is accentuated by the skull lurking behind the magnificent flowers and the shell.

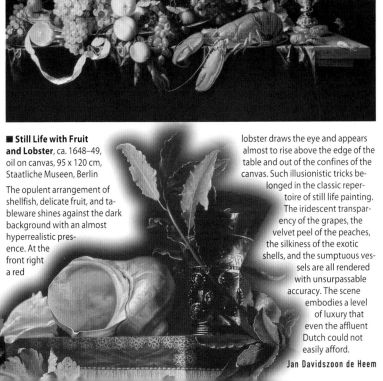

■ **Still Life with Fruit and Lobster**, ca. 1648–49, oil on canvas, 95 x 120 cm, Staatliche Museen, Berlin

The opulent arrangement of shellfish, delicate fruit, and tableware shines against the dark background with an almost hyperrealistic presence. At the front right a red lobster draws the eye and appears almost to rise above the edge of the table and out of the confines of the canvas. Such illusionistic tricks belonged in the classic repertoire of still life painting. The iridescent transparency of the grapes, the velvet peel of the peaches, the silkiness of the exotic shells, and the sumptuous vessels are all rendered with unsurpassable accuracy. The scene embodies a level of luxury that even the affluent Dutch could not easily afford.

Jan Davidszoon de Heem

Jan Vermeer

Johannes Vermeer van Delft
1632, Delft–1675, Delft

■ Considered one of the most significant Dutch painters ■ Started by painting large religious pictures, later also painted city vistas, but preferred calm genre scenes ■ His surviving œuvre comprises only 34 definite paintings

■ **1632** Born Johannes Vermeer van Delft to an innkeeper and art dealer

1653 Marries Catharina Bolnes, who bears him 15 children, and joins the St. Luke's Guild in Delft

1657 Plunges into debt, which haunts him throughout his life

1662 Becomes head of the St. Luke's Guild in Delft

1663 The French diplomat and art enthusiast Balthasar de Moncony visits him in his studio

1672 Evaluates the worth of Italian paintings as an art appraiser

1675 Dies in Delft

■ **The Milkmaid**, ca. 1658–60, oil on canvas, 45.4 x 40.6 cm, Rijksmuseum, Amsterdam

A young maidservant concentrates on cautiously pouring milk into a bowl. The milk flows, time passes, and still this painting emanates calm and timelessness. It is one of Vermeer's best-known masterpieces. The coordinated yellow and blue tones throughout lend the scene a distinguished harmony.

Jan Vermeer painted little, rarely left his hometown of Delft, and died, already deep in debt, at the age of 42. Yet today he is one of the world's most famous painters. Since historical sources provide little information about his life, he is surrounded by legends and speculation.

Born in the Dutch city of Delft, he might have been an apprentice in Amsterdam or Utrecht. His virtuoso treatment of light indicates contact with the Caravaggians

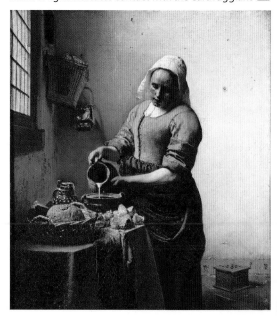

■ **The Art of Painting**,
ca. 1666–67, oil on canvas,
120 x 100 cm, Kunsthistorisches
Museum, Vienna

Comparatively large for Vermeer, this painting depicts a scene in a painter's studio, perhaps Vermeer's own. The pulled-back curtain lends the interior a striking effect of depth and reveals the artist before his canvas and regarding his model, who is posed before a large map of the Netherlands. The book and horn in her hand and the laurel wreath on her head make it clear that she is modeling for a depiction of the Classical muse of History, proclaiming the glory of painting. Thus the everyday studio scene is established as an ambitious allegory of painting and consequently a promotion of Vermeer. The map, book, and the Classical cast beside it signify his intellectual aspirations.

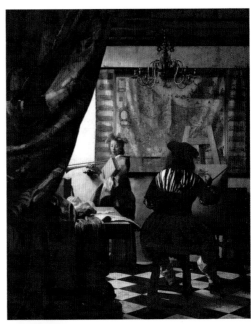

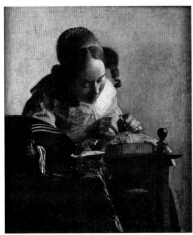

Other Important Works by Vermeer	
The Glass of Wine, ca. 1660, Gemälde-galerie, Berlin	National Gallery of Art, Washington, DC
View of Delft, ca. 1660, Mauritshuis, The Hague	The Geographer, ca. 1668, Städelsches Kunstinstitut, Frankfurt
Woman Holding a Balance, ca. 1663,	Lady Seated at a Virginal, ca. 1673, National Gallery, London

■ **The Lacemaker**, ca. 1669–70, oil on canvas,
24 x 21 cm, Musée du Louvre, Paris

The concentrating girl bends over her work. Vermeer captures the scene with graduated depths of focus—the colorful thread spilling out of the nearby pillow is rendered slightly out of focus, conforming to actual perception when the eye is focused on a distant object.

Jan Vermeer

of Utrecht. Since Vermeer's work was unusually slow, he went into debt and had an art dealership on the side. His works are mostly quiet interior scenes of daily life with one or two figures. His paintings have an extraordinary pictorial allure because of their finely nuanced color harmonies, often concentrated in two tones of blue and yellow, and because of their perfect perspective and exceptional flair for compositional balance. The painter is also thought to have been a pioneer in the use of the camera obscura, an early method of photography that aided exactitude.

Vermeer appears to have been little known in his lifetime. Many of his paintings were, in the 19th century, still attributed to other painters such as Metsu or Pieter de Hooch. Researchers are still working to demarcate his actual œuvre.

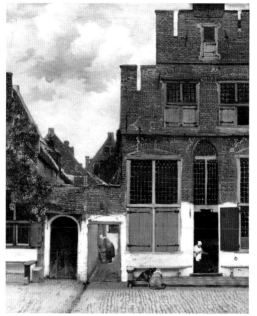

■ **The Letter**, ca. 1668, oil on canvas, 44 x 38 cm, Rijksmuseum, Amsterdam

The elegant female burgher is depicted at an almost voyeuristic distance. From her servant, she receives a love letter. The interior is rendered in perfect perspective. A tiny hole in the paint marks the vanishing point and indicates that Vermeer constructed the perspective with the help of thread held taut from an anchored needle and not by using a camera obscura.

■ **The Little Street**, ca. 1657, oil on canvas, 53.5 x 43.5 cm, Rijksmuseum, Amsterdam

This picture could possibly show the view of the opposite side of the street from Vermeer's own house. The artist probably changed the actual details for compositional reasons. The meticulously observed street scene is extraordinarily naturalistic. It possesses a quiet poetry, with children at play and women absorbed in their workday routines. The painting resembles the street and farm scenes of his Delftian contemporary Pieter de Hooch.

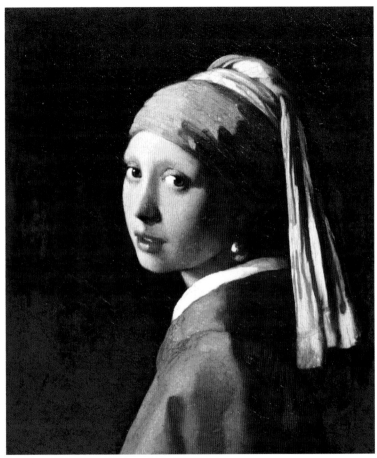

■ The Girl with the Pearl Earring, ca. 1665, oil on canvas, 46.5 x 39 cm, Mauritshuis, The Hague

Although she reveals nothing of her character, the young girl's gaze enthralls viewers. The dewy brilliance of her eyes and the gently opened mouth give her an immediate, animated presence. The spotless skin is rendered in the finest tones. Her iridescent pearl earring and light blue turban lend her an exotic air as she emerges from the inky black background. This painting is one of the most famous pictures in the world, yet much about it remains a mystery. It first emerged at auction in the 19th century and an attempt to identify the subject as Vermeer's eldest daughter, Maria, is still only a hypothesis.

Jan Vermeer

Diego Velázquez

Diego Rodríguez de Silva y Velázquez
1599, Seville–1660, Madrid

■ One of the most important European artists ■ Created magnificent portraits as a court painter ■ Developed an individual painting style with alluring brush-strokes and magnificent colors ■ Was a great influence on later generations

Baroque in Spain

■ **1599** Born Diego Rodrí-guez de Silva y Velázquez
1611 Studies under Fran-cisco Pacheco
1623 Becomes the court painter of Philip IV in Ma-drid
1628 Becomes an asso-ciates of Rubens, who is in Spain as a diplomat
1629 Studies extensively throughout Italy
1649 Travels again in Italy
1650 Member of the Roman Art School
1659 Becomes a knight in the dignified Order of San-tiago
1660 Dies in Madrid

■ **The Feast of Bacchus**, ca. 1628–29, oil on canvas, 165 x 225 cm, Museo del Prado, Madrid

A pale youth with vine leaves in his hair, Bacchus—the Roman god of wine—sits amongst simple farmers having a good time together. *The Feast of Bacchus* is one of Velázquez's earliest paint-ings, and is indicative of his conflict with Cara-vaggio (p. 218), because it is a realistic portrayal of a mythological theme.

Throughout his entire life, Diego Velázquez strove to render reality as faithfully as possible. His paintings ex-hibit this through their lighting, atmosphere, and color, which reveal the individuality of the subjects to the viewer. At the beginning of his career, Velázquez painted realistic genre scenes and drew his influence from the chiaroscuro of Caravaggio's (p. 218) work, which the Span-ish painter José de Ribera brought back with him from Italy to Seville. Velázquez established himself as a portrait artist at the royal court of Madrid, and would later be as-signed to a high office there. Despite this royal appoint-ment, the artist still painted many portraits of average people. His portraits of court dwarfs are touchingly real-istic in their rendering of each sitter's personality. As the portrait artist of the royal family, he linked realism and ⟳

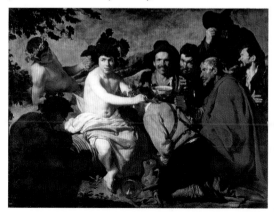

■ **Prince Baltasar Carlos in Hunting Dress**, ca. 1635, oil on canvas, 209.5 x 173 cm, Museo del Prado, Madrid

After his travels in Italy, Veláz-quez tackled a series of large paintings for the new royal pal-ace in Buen Retiro. One of these paintings was this portrait of the six-year-old prince. Veláz-quez resourcefully combined the portrait of the child with the Classical ideal of a rider, silhou-etted against the Spanish Sierra Mountains. The diagonals of the jumping horse and the loosely painted landscape create dynamism.

Diego Velázquez

Works by Velázquez

Christ in the House of Maria and Martha, ca. 1618, National Gallery, London

The Water Carrier of Seville, ca. 1623, Wellington Museum, London

Portrait of Don Luis de Góngora y Argote, ca. 1622–29, Museum of Fine Arts, Boston

The Forge of Vulcan, 1630, Museo del Prado, Madrid

The Surrender of Breda, 1634–45, Museo del Prado, Madrid

The Dwarf Sebastián de Morra, 1643–44, Museo del Prado, Madrid

Portrait of Juan de Pareja, ca. 1649–50, Metropolitan Museum of Art, New York

■ **Portrait of Pope Innocent X**, ca. 1650, oil on canvas, 140 x 120 cm, Galleria Doria Pamphili, Rome

Velázquez painted the pope while on his second trip to Italy, where he adopted the same style of papal portraiture practiced earlier by Raphael and Titian. He captured the Pope's penetrating gaze dryly and vividly, thereby reflecting the personality and determination of the Church's leader. The subtle brushwork plays the deep red tones and white-gray values off one another.

representation together, re-creating famous mythological scenes and history paintings as decoration alongside his subjects, seldom painting religious themes. He acquired his unique *ductus*, or style of brushstroke, after being influenced by Titian's (p. 164) paintings, which he initially encountered among the royal collection, and later studied in Italy. He developed a unique, relaxed painting style with brilliant colors, which would later go on to play an important role, influencing the style of the 19th-century Impressionists. His virtuoso brushwork dissolved definite outlines and materials in an atmospheric continuum of light and color. The themes of his paintings also influenced many 20th-century artists, such as Pablo Picasso (p. 428) and Francis Bacon (p. 494). His most famous works are located almost exclusively in the Museo del Prado.

■ **The Toilet of Venus**,
ca. 1647–51, oil on canvas,
122 x 177 cm, National Gallery,
London

This famous portrait of Venus
belongs to the very few examples of Spanish nudes produced
before the 19th century, and
was probably produced as part
of a private commission. Velázquez demonstrates his reverence for Titian here in the way
the reclined Venus invokes a variety of themes. New to Velázquez is the virtuoso play with
the mirror and the immediacy
of the rendition. This type of
play later becomes more
common. Venus is not shown as
a goddess, but as a nude
woman of flesh and blood.

■ **The Thread Spinners**,
ca. 1644, oil on canvas,
220 x 289 cm, Museo del Prado,
Madrid

This multilayered picture appears, at first, as a simple contemporary work scene of the
manufacturing of royal Spanish
tapestries—in short, a group of
thread spinners. However, in
the background a mythological
scene, the bet between Athena
and Arachne as to whom could
produce the best tapestry, is
shown. Thus, Velázquez plays
with reality.

Diego Velázquez

Las Meninas

Las Meninas means "the maids of honor." This painting portrays the five-year-old child Margarita, the daughter of Phillip IV, surrounded by her ladies-in-waiting as they visit the court painter Velázquez's atelier. This highly complex composition, with nearly life-size figures, creates a striking illusion of reality through the nuanced detail work and the gradually directed lighting. At its heart this painting is a one-of-a-kind reflection of the painting process itself. It is difficult to define the subject matter of the work. The child poses as if for a commissioned portrait. The painter is to the left. Who is he painting, and who are most of the figures in the picture looking at? Velázquez's masterpiece has provoked innumerable questions and theories, and inspired many painters, including Francisco Goya (p. 308) in his *Portrait of Karl IV's Family*.

The Mirror This detail is the key to the painting's structure. The faces of Philip IV and his wife appear in the mirror on the far wall of the room. The royal couple, then, must have also been present when the painting was created, and must then logically be standing somewhere to the left outside the frame of the picture. This means that Velázquez, within the picture, is not looking at the viewer, but at the royal couple. He is painting a life-size portrait of them on another canvas.

The Child Blonde Margarita (1651–73) was the future Austrian queen and bride of Leopold IV. Despite her young age, her face and manner are regal.

The Painter Velázquez painted himself here with brush and palette before an enormous canvas. His chest was later painted over to bear the red cross of the honorable Order of Santiago, into which he was inaugurated in 1659. To obtain this honor, he had to prove that he had never once worked as a manual laborer. *Las Meninas* proves the high skill of his fine craftsmanship.

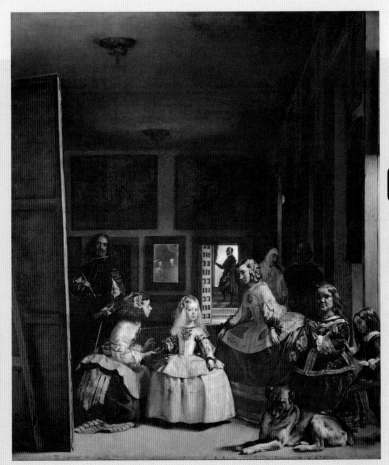

■ **Las Meninas**, ca. 1656, oil on canvas,
320 x 270 cm, Museo del Prado, Madrid

This painting is a compositional masterpiece.
Velázquez painted the group of ladies-in-waiting
with their sweeping gowns around the blonde
child, building, with their round forms, an ani-
mated contrast to the perpendicularly placed
pictures, the door frame, and the mirror in the
background. Light and color direct the viewer's
attention toward the illuminated face of the deli-
cate child. Vélazquez, the painter to the left, con-
trasts her strongly. He regresses halfway into the
dark room, yet somehow appears bigger than all
the other figures. The tiny male person within the
door frame is emphasized through contrasts as
he observes the entire scene.

Diego Velázquez

Francisco de Zurbarán

1598, Fuente de Cantos–1664, Madrid

■ The most famous painter of Caravaggism in Spain ■ Never traveled outside of Spain ■ Used his art to serve the Counter-Reformation ■ Created entirely new themes in painting within his large monastery paintings, and is numbered among the greatest artistic inventors of Spanish painting

■ **1598** Born in Fuente de Cantos in the Estremadura as a merchant's son

1614 Travels to Seville to study under Pedro Diaz de Villanueva and thereby comes into contact with the young Velázquez

1617 Manages a workshop in Lierena, which works for the Sevillian monasteries

1629 Establishes himself in Seville following an official invitation

1633 Receives the title "Pintor del Rey" from King Philip IV

1634 Paints his mythological sequence for the royal palace Buen Retiro

1647 Paints numerous paintings to be exported to America

1664 Dies in Madrid

■ **Still Life**, ca. 1633, oil on canvas, 46 x 84 cm, Museo del Prado, Madrid

Zurbarán's small number of still lifes do not deviate from the Spanish still life tradition, which typically involves having a few objects stand out strongly before a darkened background. This still life is practically modern in its radical simplicity.

Francisco de Zubarán personified Catholic Spain of the 17th century through his religiously infused work. He eliminated unnecessary details from his images. Figures stand in front of dark backgrounds as if carved out by sharp light. Violent light and shadow effects direct the viewer's attention to the essential—the religious meaning. Simultaneously, his pictures are characteristic of a dry realism that has its roots within the Spanish artistic tradition.

Zubarán's chiaroscuro developed as a result of Caravaggio's (p. 218) influence, similar to his contemporary Velázquez (p. 260), Honthorst in the Netherlands, or La Tour (p. 226) in France. Yet no one cultivated the aesthetics of religion the way Zubarán did. He created large painting sequences for the monasteries in Seville and neighboring provinces. His style only became calmer and more sensitive under the influence of Murillo (p. 268), whose style prevailed at the time.

■ **St. Bonaventura at Prayer**,
1629, oil on canvas, 239 x 222
cm, Gemäldegalerie, Dresden

This painting is part of a series
about St. Bonaventura that Zur-
barán created for the Fran-
ciscan school in Seville. The
saint kneels in prayer before
the papal tiara, in order to find
out the name of the chosen
priest from the angels as the
gathering of eligible cardinals
waits to the right. This picture
was created at the height of
Zubarán's career and demon-
strates his very fine brushwork.
He places strongly lit surfaces
against a profound darkness.
The wondrous representation
achieves convincing dimen-
sions through the precisely
rendered subject.

Francisco de Zurbarán

Bartolomé Esteban Murillo

1617, Seville–1682, Seville

■ Famous for his soft, idealized Madonnas ■ Made childhood scenes a popular new theme of genre painting ■ Developed a supple, gossamer brushwork without sharp light or color contrasts ■ Was the first Spanish painter to win international fame ■ Paved the way for Rococo

■ **1617** Born to a doctor in Seville, where he also later studies painting with Juan del Castillo

1645 Becomes the indisputable master of Sevillian painting; marries Beatrice Sotomajor y Cabrera

1648 Travels to Madrid to study the works of Rubens, Van Dyck and Velázquez

1658 Cofounds the Academy of Art in Seville

1660 The leading master of painting founds the Academy of Art in Seville and is the first president

1682 Dies in Seville after a fall from the scaffolding in the Capuzine Cathedral in Cadiz

Other Works by Murillo

The Return of the Prodigal Son, ca. 1667–70, National Gallery of Art, Washington, DC

Girl and Her Duenna, ca. 1670, National Gallery of Art, Washington, DC

The Vision of St. Antony of Padua, ca. 1660–80, Hermitage, St. Petersburg

The Two Trinities, 1681, National Gallery, London

Like Velázquez, Murillo was born in Seville, but his career, work and artistic temperament separated him from his older contemporary. In his early career, Murillo adopted the contrasted, realistic chiaroscuro style of Zubarán (p. 266). However, by 1650 he had developed a completely new artistic style which created a delicate harmony totally opposite to realism. He softened sharp contrast through supple shaping and diffuse warm light. Contours are blurred, and anything overtly dramatic has been obliterated. Murillo thus binds his ideal in terms of beauty and form with the Renaissance figures Raphael (p. 156) and Fra Angelico (p. 132). His sheer, unconstrained style, called *estilo vaporoso*, paved the way for the Rococo style of art. Murillo had many imitators and was extremely popular in the 18th and 19th centuries.

■ **The Immaculate Conception**, ca. 1670, oil on canvas, 206 x 144 cm, Museo del Prado, Madrid

Mary floats atop the moon's crescent toward heaven. Humble and meek in prayer, she looks toward God. Cherubs hold a mirror, a symbol of purity, and a palm leaf, which represents martyrdom. This type of image glorifies Mary as the immaculate mother of God, free of original sin. Murillo varied this image on many occasions throughout the Counter-Reformation, during which such images were common.

■ **Young Boys Playing Dice**, ca. 1670–75, oil on canvas, 146 x 108.5 cm, Alte Pinakothek, Munich

Murillo was much admired as a religious painter in Spain, but the collectors of Europe favored his genre pictures, especially his scenes of children. These pictures always demonstrate poor, tattered street urchins within a vaguely defined environment. In this picture, two of the youths are totally absorbed in their game of dice, as the third standing child bites into his bread. They invoke the pity of the viewer through their poverty; they are shown as the children of God through their angelic faces. They emanate an absent-minded happiness and vitality and seem to be completely content with their small

joys. The charm of their childish innocence comes forth out of the squalid background. Murillo's naturalistic manner keeps his works from drifting into trite sentimentality.

18th
Century

Jean-Honoré Fragonard: The Swing, 1767, oil on
canvas, 81 x 65 cm, Wallace Collection, London

18th Century

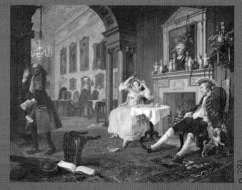

p. 293

272

1700	1710	1720	1730	1740

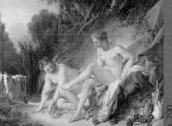

p. 290

1600s–1867
Printmaking in Asia

Honami Koetsu
Nishikawa Sukenobu
Kitagawa Utamaro
Hokusai Katsushika

p. 300

1750–1800
Neoclassicism

1750 1760 1770 1780 1790

Anton Raphael Mengs
Jean-Antoine Houdon
Francisco de Goya y Lu-
cientes p. 308
Jacques-Louis David
p. 300
Antonio Canova
Bertel Thorvaldsen
Jean-Auguste-Domini-
que Ingres p. 304

Isoda Koryusai
Toshusai Sharaku
Ando Hiroshige

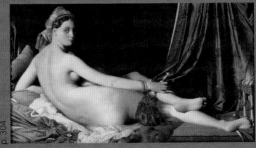

p. 304

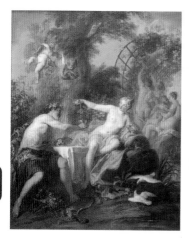

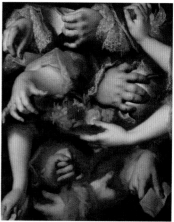

18th Century

Rococo and Neoclassicism defined the 18th century, the stylistic shift reflecting the period's socio political changes in aesthetic terms. Rococo evolved out of a reaction against the grandiose nature of Baroque. Principally, Rococo was born out of the desire of the aristocratic courtiers for a more playful, lighter art. Originally, the style was limited to interior design. Rococo derives from the French word *rocaille*, meaning stone, which refers to the organic imagery that adorned walls and ceilings. The same exuberant aesthetic was gradually adapted by the fine arts. The new approach to painting is revealed in the works of the leading Rococo painters: Giovanni Battista Tiepolo, Jean-Honoré Fragonard, François Boucher, and Jean-Antoine Watteau. The mood of their bright, frolicsome paintings contrasted sharply with the grave importance and somber drama that was characteris-

■ **Noël-Nicolas Coypel: Venus, Bacchus, and the Three Graces**, undated, oil on canvas, 101 x 82 cm, Musée d'Art et d'Histoire, Geneva

■ **Nicolas de Largillière: Study of Different Types of Hands**, ca. 1715, oil on canvas, 65 x 53 cm, Musée du Louvre, Paris

■ **Angelika Kauff-mann: Self-Portrait**, 1787, oil on canvas, 65 x 51 cm, Neue Pinakothek, Munich

■ **Jean-Marc Nattier: Portrait of Tsar Peter the Great**, undated, oil on canvas, 142.5 x 110 cm, Hermitage, St. Petersburg

tic of the preceding Baroque creations. The works' subject matter further revealed the drastic change from the previous style. The hallmark of Rococo, the *fête galante*, was a genre that focused on scenes of leisure in outdoor settings. Other subjects included mythological narratives, such as François Le Moyne's *Hercules and Omphale* and Noël-Nicolas Coypel's *Venus, Bacchus, and the Three Graces*. Again, in contrast to the earlier styles of Baroque, the pictorial treatment of the subject is lighter and more vivacious.

The genre of portraiture became more important and underwent a similar evolution. Now, the painter concentrated more on achieving an effect of graceful elegance, rather than creating a feeling of imposing dominance in the aristocratic sitter. The new focus is visible in the *Portrait of Tsar Peter the Great* by Jean-Marc Nattier or in the *Self-Portrait* by Nicolas de Largillière.

Perhaps because of its origin as an interior decorative style, Rococo paid particular attention to surfaces. The skillful differentiation between skin and fabric in Largillière's *Study of Different Types of Hands* illustrates this focus on textures.

The shift to Neoclassicism in art is closely allied with the change in political circumstances in France. The Revolution engendered a demand for a new type of artistic expression that differed radically from the light-hearted Rococo. However, the beginnings of the stylistic change were already visible in the more reserved works by Chardin. The mature Neoclassical style drew on the Classical art and literature of ancient Greece and Rome. The painters Jacques-Louis David and Jean-Auguste-Dominique Ingres were the movement's most influential figures. David's works frequently relied on color and grand drama in multi-figural narratives, while Ingres's more severe compositions depended on the strength of contour lines to

■ **Anton Raphael Mengs: The Penitent Mary Magdalene**, 1752, oil on canvas, 47.5 x 63.5 cm, Gemäldegalerie, Dresden

■ **Antonio Canova: Cupid and Psyche**, 1787–93, marble, height 155 cm, Musée du Louvre, Paris

■ **François Le Moyne: Hercules and Omphale**, 1724, oil on canvas, 184 x 149 cm, Musée du Louvre, Paris

pull them together. Although the signature Neoclassical works represented Classical or contemporary historical events, the movement also explored religious (Anton Raphael Mengs's *Penitent Mary Magdalene*) and mythological subjects (Antonio Canova's *Cupid and Psyche*). The ennobling and inspiring themes of sacrifice, heroism, and morality were a uniting factor. The rule of proportion and order in Neoclassical art had a profound effect on portraiture, which simultaneously became more idealized and realistic, as in the paintings of Joshua Reynolds and in the sculptures of Jean-Antoine Houdon (*Voltaire*).

The 18th century was also the golden age of the Japanese Ukiyo-e school of wood-block printmaking. The Ukiyo-e aesthetic would later significantly impact the development of Western art in the 19th century.

Jean Siméon Chardin

1699, Paris–1779, Paris

■ Presented the imagery of the commonplace as quietly noble ■ Infused the simplest of gestures with a sense of importance ■ Avoided obvious moralizing ■ The famous writer and philosopher Dennis Diderot was among his most ardent supporters

● **1699** Born in Paris
1728 Studies at the Académie Royale de Peinture et de Sculpture
1740 Gains an audience with King Louis XV
1743 Advises at the Académie Royale
1755 Treasurer at the Académie Royale
1757 Has a studio and an apartment at the Louvre
1761 Works hanging paintings in the Salon
1774 Resigns from the Académie Royale
1779 Dies on December 6 in Paris

Jean Siméon Chardin elevated the status of the still life genre within the hierarchy of French art. In contrast to a conventional preference for history paintings, Chardin drew on the Dutch tradition. He painted ordinary subjects on a small scale. Although attaining fame, he never gained the official acceptance of the Academy. Chardin often depicted women, servants, and children, always treating his bourgeois subjects respectfully. Technically, Chardin meticulously conveys the realism of each texture. His palette is intentionally subtle, so as not to interfere with the centrality of the narrative. He fell out of favor for a short period before being revived by the Goncourt brothers, Gide, and Proust. His innovative subject choices and preference for realism had a profound impact on Cézanne (p. 382), Matisse (p. 408), and Van Gogh (p. 386).

■ **Rabbit, Thrush, Straw**, 1755, oil on canvas, 38.5 x 45 cm, Musée de la Chasse et de la Nature, Paris

Chardin presents a collection of objects, including the dead rabbit, in a precise but simple manner. The work is dry in terms of visual interest. The gradations of colors and tactile differences are subtle to such a degree that they are indiscernible. The still life tells no story and presents no obvious moral lessons, instead relaying a feeling of quite reflection to the viewers.

■ **The Governess**, 1739, oil on canvas, 46.7 x 37.5 cm, National Gallery of Canada, Ontario

The portrayal of a governess with a child reveals emotion ordinarily reserved for more glamorous characters. Chardin relays the intimate interaction through his sympathetic observation. The viewer is allowed a glimpse of their daily relationship.

Other Works by Chardin

House of Card, 1737, Galleria degli Uffizi, Florence

The Draftsman, 1737, Musée du Louvre, Paris

Boy with Peg Top, ca. 1737, Musée du Louvre, Paris

The Messenger, 1739, Musée du Louvre, Paris

The Pleasures of Private Life, 1746, National Museum, Stockholm

■ **Soap Bubbles**, 1734, oil on canvas, 60 x 73 cm, County Museum of Art, Los Angeles

An adolescent boy occupies his time by blowing soap bubbles. The composition centers around the image of this fragile sphere. However, the whole work concentrates on the boy's absorption in the process of blowing. The meditative tone is characteristic of Chardin's paintings. This feeling imbues the scene and establishes an atmosphere of quiet patience and introspective concentration.

Jean Siméon Chardin

Giovanni Battista Tiepolo

also known as Gianbattista or Giambattista Tiepolo
1696, Venice—1770, Madrid

■ Used bright colors ■ Viewed painting as an art that should be pleasing to the eye ■ His subjects belong to the realm of playful fantasy ■ Tiepolo was celebrated for his ceiling paintings ■ His style was ornamental and theatrical

■ **1696** Born in Venice

1710 Becomes a student of Gregorio Lazzarini

1717 Gains acceptance into the Fraglia guild of painters

1725 Receives a commission from the Archbishop of Udine

1730's Begins working steadily throughout Italy

1740's Receives commissions from foreign patrons throughout Europe

1755 Becomes the first president of the Venetian Academy

1762 Receives a commission from the king of Spain to decorate the throne room in the royal palace

1770 Dies in Madrid on March 27

Other Works by Tiepolo

The Three Angels Appearing to Abraham, 1726–29, fresco, Palazzo Patriarcale, Udine

Apollo and the Continents, 1752–53, fresco, Residenz, Würzburg

Woman with a Mandolin, 1755–60, Detroit Institute of Arts

Giovanni Battista Tiepolo achieved fame as a painter of church frescoes. His diverse subjects ranged from biblical stories to ancient history and mythology. Popularized by prints, his lasting influence survived as late as Goya's time. He developed the style of Baroque by emphasizing its theatricality, but avoiding its chiaroscuro. Simultaneously, his works reveal a love of Rococo ornamentation. He viewed painting as an expression of joyful fantasy and potrayed his aristocratic patrons as divinities. His art was about pleasure and play. It characteristically included various viewpoints within the same composition, crowded spaces, an illusion of painting being sculpture, a smoothness of brushstrokes and palette, and intense lightning.

■ **Martyrdom of St. Agatha**, ca. 1755, oil on canvas, 184 x 131 cm, Staatliche Museen, Berlin

The subject of this composition is the martyrdom of St. Agatha. The color scheme of the painting consists of vibrant blues, whites, yellows, and oranges. Agatha is at the edge of the space, supported by a servant, who crushes a dress against the saint's bleeding wounds. The indifferent page showcases severed breasts on a silver platter.

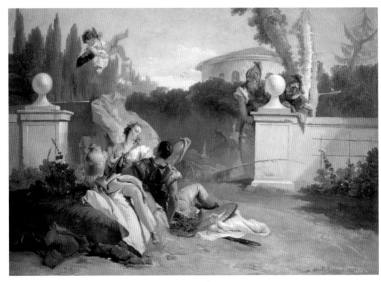

■ Rinaldo and Armida in the Garden,
ca. 1742, 186.8 x 259 cm, Art Institute of Chicago

This painting illustrates a story about a crusading knight. The painting is a visualization of a dream. The subtle pastel colors, airy brushwork, and the beautiful setting of a glorious landscape convey a feeling of fantasy. A multitude of figures and trees crowds the space, creating a sense of tense movement. The fabric of Armida's dress swirls elegantly around her body.

■ The Banquet of Anthony and Cleopatra,
ca. 1747, (detail), 650 x 300 cm, Palazzo Labia, Venice

Cleopatra presiding over a sumptuous feast was created for the king of Poland. The elaborate architectural details and crowded composition convey a message of opulence, abundance, and decadence. The scene focuses on the queen of Egypt, who takes a pearl from her earring and dips it in a glass of vinegar. This central gesture adds to a mood of extravagant carelessness.

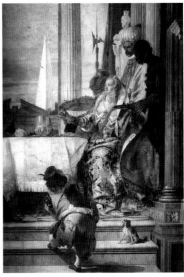

Giovanni Battista Tiepolo

Jean-Honoré Fragonard

1732, Grasse—1806, Paris

■ Exemplified Rococo style ■ His brushwork was characteristically rapid and fluid ■ Used a palette with warm, pastel colors ■ The paintings' atmospheres are playful and full of joy ■ Influenced by Dutch and Flemish depictions of love for landscapes ■ His primary subjects were passionate lovers

1732 Born on April 5

1748 Studies with Boucher for two years

1748 Studies with Chardin

1753 Begins studying at the École Royale des Élèves Protégés

1756 Travels to Rome and enrolls at the French Academy there

1763 Travels to the Netherlands

1767 Stops exhibiting at the Salon

1772–73 Revisits the Netherlands and Italy

1793 Receives an appointment to the post of Conservateur at the Louvre from Jacques-Louis David

1806 Dies on August 22 from a heart attack

■ **Le Feu aux Poudres**, before 1778, oil on canvas, 37 x 47.5 cm, Musée du Louvre, Paris

This painting is one of a pair, titled *La Chemise Enlevée*. Its subject is a scene of a seemingly amorous interaction between a young girl and Cupid. The palette and brushwork lend to the romantic, dreamlike feel.

As one of the most eminent Rococo artists, Jean-Honoré Fragonard enjoyed enormous popularity among his private upper-class patrons. Besides being a renowned painter, Fragonard earned a reputation as an adept draftsman and a skillful printmaker. His stylistic development as an artist benefited from the influences of the French Baroque and the Dutch and Flemish schools of art.

Despite receiving a classical training as a history painter Fragonard favored genre scenes. The artist's lighthearted works manifested the joyful spirit of Rococo. His main subjects were noblemen and noblewomen, and aristocratic lovers dressed in elegant costumes. The care-

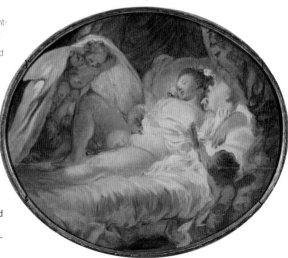

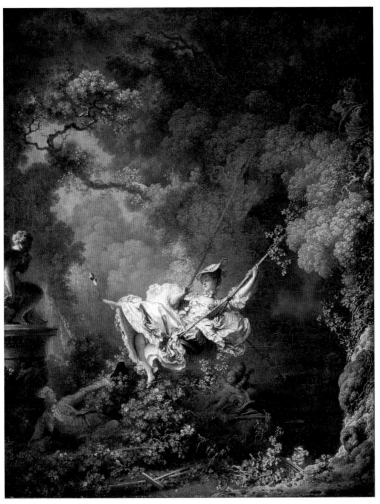

■ **The Swing**, 1767, oil on canvas, 81 x 65 cm, Wallace Collection, London

The painting, full of symbolism, shows a flirtatious interaction between a girl on a swing and her admirer. The shoe, dropped by the girl in her excitement, is a symbol of lost virginity. The Venus , dolphins, and garden allude to the same message of amorous love and illicit passion.

Jean-Honoré Fragonard

Other Works by Fragonard

Young Woman Playing with a Dog, 1765–72, Fondation Cailleux, Paris

Man Playing an Instrument, 1769, Musée du Louvre, Paris

Music Lesson, 1769, Musée du Louvre, Paris

Portrait of Denis, 1770, Musée du Louvre, Paris

Blind Man's Bluff, ca. 1773, National Gallery of Art, Washington, DC

Adoration of the Shepherds, ca. 1775, Musée du Louvre, Paris

Murder of Feraud, 1795, Musée du Louvre, Paris

free and sometimes mischievous scenes often take place in tranquil, idyllic landscapes full of foliage and blooms. Fragonard's preference for these natural surroundings stemmed from the influence of Dutch artists.

His pictorial style is characterized by a free, vigorous, and flowing brushwork, a pastel palette of pinks, blues, and greens, sophistication, and grace. Fragonard's fondness for the subtle palette can be traced to his love of Tiepolo (p. 280).

In his later works, Fragonard was forced to contend with the popularity of Neoclassicism and, unable to follow the new trend, he lost popularity and became almost forgotten until the Impressionists revived his fame and reputation.

■ **Pygmalion**, 1770, oil on canvas, 55 x 45 cm, Musée du Berry, Bourges

A statue of a beautiful woman brought to life by its creator was a popular subject adapted by contemporary French artists from mythology. Enlivened by Pygmalion's desire, a marble beauty moves in this painting, slightly bending toward the bearded sculptor. The whole composition revolves around their silent interaction. The images of fluffy clouds and pink-bodied muses swirl around the central axis of the two lovers, animating the scene by the dynamism of circular upward movement. The soft colors and gentle brushwork create an atmosphere of reverie.

■ **A Young Girl Reading**, 1776, oil on canvas, 82 x 65 cm, National Gallery of Art, Washington, DC

This work explores a theme of domesticity. The painting shows a young, elegantly dressed woman absorbed in the process of reading. The gentle lighting softly illuminates her profile. The subtle palette of pinks in the pillow behind her back and yellows of the wall create a quiet harmony.

■ **The Bolt**, ca. 1777, oil on canvas, 73 x 93 cm, Musée du Louvre, Paris

Conveying a sense of violence, *The Bolt* presents another side of an amorous encounter. The setting implies a romantic tryst, but the characters' actions and the overturned furniture suggest something else. The man's reach for the bolt translates as hostile. The theatrical figures are arranged and spotlighted within the pictorial space for maximum melodramatic impact.

Rococo in France

Jean-Honoré Fragonard

Antoine Watteau

1684, Valenciennes–1721, Nogent-sur-Marne

■ Most famous as a painter of fêtes galantes ■ Elevated the status of genre painting ■ Drew on Italian theater and ballet for his characters and composition ■ Painted romantic and idealized images of French aristocracy ■ Influenced by Rubens and Titian ■ Created a sense of elegiac nostalgia in his works

● **1684** Born on October 10 in Valenciennes
1702 Leaves for Paris
1703 Studies with painter Claude Gillot
1708 Works with Claude Audran, a curator of the Luxembourg Palace
1709 Attempts to win Prix de Rome but fails
1712 Accepted as a full member of the Academy
1717 Received by the Academy under the title "Le Peintre des Fêtes Galantes"
1719 Visits England to seek treatment for tuberculosis
1720 Returns to Paris
1721 Dies on July 18 at Nogent-sur-Marne

■ **The Embarkation for Cythera**, 1717, oil on canvas, 129 x 194 cm, Musée du Louvre, Paris

This painting displays a colorful and elegant group of beautifully dressed lovers visiting the birthplace of Venus: Cythera, the island of love. This piece is exemplary in illustrating Watteau's portrayal of *fête galante*. Signs of departure create a sense of melancholy in the piece.

Jean-Antoine Watteau infused Baroque with light and color and paved the way for Rococo. He devised a new genre of *fête galante* and was also among the inventors of the chinoiseries and singeries ornamental motifs.

Arriving in Paris at the age of 18, he worked as a copyist of Flemish genre paintings, apprenticed with Claude Gillot, who introduced him to the Commedia dell'Arte, and studied with Claude Audran, the interior decorator and the curator of the Luxembourg Palace. Having been accepted as a member of the Academy, Watteau began to enjoy popularity among the wealthy bourgeoisie. Watteau established genre painting as a category of elegance and grace. His subtly expressive, charming paintings produce a sense of nostalgia and melancholy. His style, influenced by Rubens (p. 234) and Titian (p. 164), impressed European landscape and genre painters, decorative artists, and writers.

■ **Pierrot**, ca. 1718–19, oil on canvas, 184 x 149 cm, Musée du Louvre, Paris

The character from the Commedia dell'Arte of the rejected lover, Pierrot appears here as a melancholy clown. Watteau sympathetically relays his sense of alienation. Dressed in a customary white costume, Pierrot stands in the foreground of a landscape. Other characters—the doctor, Léandre, Isabelle, the Capitaine—hide in the background.

Other Works by Watteau	
Jupiter and Antiope, 1712, Musée du Louvre, Paris	Fêtes Vénitiennes, ca. 1719, National Gallery of Scotland, Edinburgh
Venus disarms Amor, 1710, Musée Condé, Chantilly	L'Enseigne de Gersaint, 1720, Charlottenburg Palace, Berlin
The Festival of Love, ca. 1717, Gemäldegalerie, Dresden	
Mezzetin, 1718–19, Metropolitan Museum of Art, New York	

Watteau's technique drew on Italian comedies and ballets for inspiration. The composition here appears choreographed as a graceful ballet scene.

François Boucher

1703, Paris—1770, Paris

- His art continued the Rococo tradition ■ His paintings were explicitly erotic and sensual ■ The purpose of his works was to be pleasing and decorative ■ His output was extremely versatile ■ His figures were characterized by soft and flowing curves ■ He used a palette of pale pinks, greens, and blues

1703 Born September 29 in Paris
1723 Becomes the winner of the Prix de Rome
1727 Travels to Italy to study art
1731 Returns to France
1734 Appointed faculty member at the Royal Academy
1755 Receives a position as a director of the Gobelins factory
1765 Earns a post as a painter to the king, a post as a director of the Royal Academy, and becomes the chief designer of the Royal Porcelain Works
1770 Dies on May 30 in Paris

■ **Vulcan Presenting Venus with Arms for Aeneas**, 1751, oil on canvas, 320 x 330 cm, Musée de Louvre, Paris

The subject of this work is the story of Venus receiving armor from her husband for her demigod son. Venus is alluringly playful, pointing at the grim Vulcan. The light pinks and corals that depict Venus and the cherubs are Boucher's signature colors.

François Boucher became one of the most popular French painters of his time. His celebrity was fueled by the patronage of the Marquise de Pompadour. Boucher's works are distinctively Rococo and much more sensual than the art of his predecessors. He was a diverse artist, succeeding in both small- and large-scale projects. He was also prolific in both the fine and the decorative arts—interior ornaments, tapestries, porcelains, and prints.

Antoine Watteau (p. 286), who first introduced the genre of fête galante into the art world, influenced ⊐

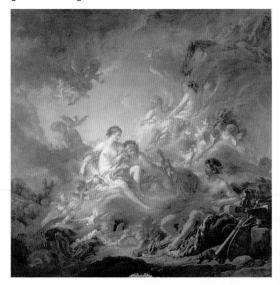

■ **Portrait of the Marquise de Pompadour**, 1756, oil on canvas, 201 x 157 cm, Alte Pinakothek, Munich

One of the most frequent subjects of Boucher's portraits was Madame de Pompadour. This painting presents the glamorous courtesan, depicted with an open book near a writing desk, as an aspiring *literati* and a follower of the Enlightenment. Each surface—from the rich fabrics to the opulent dress—is attentively observed.

Other Important Works by Boucher	
The Cherub Harvesters, ca. 1733, Museum of Fine Arts, Houston	The Toilet of Venus, 1751, Metropolitan Museum of Art, New York
The Triumph of Venus, 1740, Stockholm Nationalmuseum, Stockholm	The Rising of the Sun, 1753, Wallace Collection, London
A Lady Fastening Her Garter (La Toilette), 1742, Museo Thyssen-Bornemisza, Madri	The Odalisk, 1753, Musée du Louvre, Paris
	The Chinese Market, ca. 1768, Rijksmuseum, Amsterdam

François Boucher

Boucher's style. Boucher's art exhibits the same preferences for natural settings. His paintings feature modern revelers and mythological characters. His subjects are often flirtatious aristocratic couples, play-acting at being shepherds in tranquil landscapes.

His art does not aspire to philosophical depths or lessons of moral enlightenment. Rather, his pastorals are openly superficial and amusing as illustrations of the unrestrained French courtiers. His gentle color palette and soft finish were inspired by Rubens (p. 234). Among Boucher's numerous followers, few succeeded in imitating his light touch. His most successful disciple was Fragonard (p. 282).

Boucher lost his popularity with the development of the new style of Neoclassicism, which promoted the values that critics felt Boucher's mischievous works lacked.

■ **Diana Leaving Her Bath**, 1742, oil on canvas, 56 x 73 cm, Musée du Louvre, Paris

The canvas shows the mythological goddess of the hunt dressing after a bath. Contrary to traditional depictions of Diana as an unapproachable and aloof virginal deity, Boucher presents her as a reserved but enticing young woman. Her languorous, voluptuous body is earthly, not divine, and mythological subject matter takes a subordinate role to the erotic undertones of the scene. Boucher casts his viewer in the role of a voyeur who catches a glimpse of the delicately colored naked flesh.

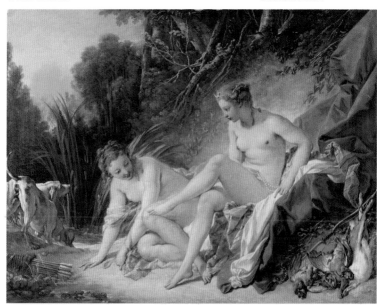

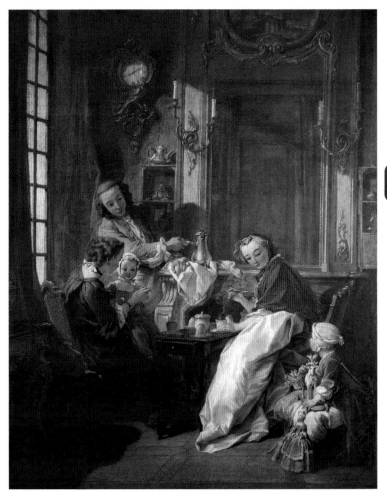

■ **Le Petit Déjeuner**, 1739, oil on canvas, 81.5 x 65.5 cm, Musée du Louvre, Paris

After getting married, Boucher began depicting domestic genre scenes. In contrast to his typically sensual paintings, this composition centers around an intimate interaction between members of the artist's family at their morning meal. A strong light from the window to the left spotlights the scene and illuminates the details of the elaborately ornamented room.

François Boucher

William Hogarth

1697, London–1764, London

■ His palette was limited but his colors were balanced and rich ■ He filled paintings with numerous details, each adding significance to the whole ■ In his oil paintings, the pigment was built up to create a weighty texture ■ His brushstrokes were free and loose, but expressive

1697 Born on November 10

1712 Becomes apprenticed to an engraver

1720 Establishes himself in the engraving business

1726 Receives a commission to illustrate a book by Samuel Butler

1732 Finishes his series *A Harlot's Progress*

1735 Finishes his series *A Rake's Progress*

1743 Finishes his series *Marriage à la Mode*

1753 Begins work on his treatise, *The Analysis of Beauty*

1757 Receives a position as sergeant painter to King George II

1764 Dies on October 26

Works by Hogarth

Don Quixote, 1738, engraving for book illustration

The Shrimp Girl, ca. 1740, National Gallery, London

Self-Portrait with Pug-Dog, 1745, Tate Britain, London

Hogarth's Servants, 1758/59, Tate Britain, London

William Hogarth was very important in establishing British art as an independent stylistic school. He began as an engraver, illustrating books. Although he endeavored to become a painter of monumental history canvases, he instead achieved fame as an illustrative painter. Hogarth earned his reputation as an author of pictorial series, which portrayed various social vices and suggested a definitive moral lesson to be learned from the narrative. Drawing on his earlier training, Hogarth used engravings to disseminate his series to both the aristocratic and common audiences.

He primarily focused on contemporary subjects, introducing contemporary themes and modernizing British art. Hogarth was also a famous portraitist, establishing the individuality of his sitters. His style is characterized by acute observations and aggressive, sketchy brushwork.

■ **Simon, Lord Lovat**, August 1746, etching, 33.4 x 22.4 cm, Tate Britain, London

Hogarth created this etching of the infamous criminal while Lord Lovat was on his way to being tried and eventually executed for treason. The artist's talent as a portraitist is evident in his masterful observations, which convey the physiognomic characteristics of the subject. He concentrates on the facial expression, capturing the guile and the absence of remorse with a few skillful lines. Lovat's facial expression and body language imply evil.

■ **The Tête à Tête**, ca. 1744, picture II in the series *Marriage à la Mode*, oil on canvas, 68.6 x 88.8 cm, National Gallery, London

The characters are newlyweds: the son of an impoverished nobleman and the daughter of a rich merchant. Both exemplify contemporary vices. The husband, returning home to his new bride, hides a lady's hat in his pocket. The wife is exhausted from playing cards all night. The butler holds unpaid bills in his hand. The painting of Cupid encircled by ruins echoes the moral of the story.

■ **A Rake's Progress 3: The Orgy**, ca. 1734, oil on canvas, 6.25 x 7.52 cm, Sir John Soane's Museum, London

This painting is one of a series of eight that Hogarth engraved and disseminated as prints. The subject of the cycle is the disintegration of the life of the young Tom Rakewell. This scene takes place in a brothel: Tom lolls drunkenly, near the door a street singer performs, and a prostitute is removing her stockings in the foreground. *A Rake's Progress,* like many of Hogarth's works, has a clear moral message. Rakewell's fall, the result of debauchery and decadence, is a strong warning.

William Hogarth

Thomas Gainsborough

1727, Sudbury—1788, London

■ Concentrated on contemporary subjects ■ Was famous for achieving good likenesses of his sitters ■ Influenced by Dutch artists such as Rubens and William Hogarth ■ Used diffused light and fluid brushwork ■ Drew on observations of nature and was able to express the individuality of his subject

■ **1727** Born May 14

1740 Goes to London to train as an artist

1748–49 Returns to Sudbury, focuses on portraiture

1761 Sends work to the Society of Arts exhibition in London

1769 Sends works to the Royal Academy's exhibitions

1780 Commissioned to paint the portraits of the royal family; becomes their favorite painter

1788 Dies on August 2

Thomas Gainsborough was the leading landscape painter and one of the most important portraitists of 18th-century Britain. At the age of 14 he began training with the London engraver, Hubert Gravelot, and later joined William Hogarth's (p. 292) studio. Because he was not very successful during this time, he returned home and began painting portraits. After participating in royal exhibitions, he attracted aristocratic patrons, becoming one of the founding members of the Royal Academy and a favorite portraitist of the the royal family. Gainsborough's style is characterized by a sense of immediacy, resulting from light brushwork, and an impression of innocence and grace. His talent transformed common subjects into elegant and poignant images.

■ **Portrait of Queen Charlotte**, 1781, oil on canvas, Royal Collection, London

This portrait is a depiction of Queen Charlotte, the German-born wife of George III. The queen is clothed in all the period's elegant and glamourous style. Her restraint and stature proclaim her royal status. The artist meticulously worked out the drapery of the elaborate white dress, richly adorned with lace and ribbons, with his trademark light and airy brushwork, paying close attention to detail.

Works by Gainsborough

Portrait of Peter Darnal Muilman, Charles Crockatt, and William Keeble, 1753, private collection

The Blue Boy, 1770, The Huntington, San Marino, California

Portrait of a Lady in Blue, 1777–79, Hermitage, St. Petersburg

Marie Jean Augustin Vestris, ca. 1781–82, Tate Britain, London

Mrs. Thomas Hibbert, 1786, Neue Pinakothek, Munich

The Market Cart, 1786, National Gallery, London

■ Morning Walk, 1760, oil on canvas, 236 cm x 179 cm, National Gallery, London

The double portrait was commissioned to commemorate the marriage of William and Elizabeth Hallet. The painting is an example of the artist's mature style. Contrary to the established tradition, Gainsborough innovatively placed the elegant couple within the natural setting of a park with a dog, a symbol of fidelity, at their side. The couple's romantic stroll through the beautiful landscape symbolizes their joined path in marriage.

■ Robert Andrews and His Wife, ca. 1750, oil on canvas, 70 x 119 cm, National Gallery, London

This unconventional double portrait displays the artist's mastery of skill within the outdoor setting. Painted on his return home to Sudbury, the artist shows the newly married Robert Andrews and Francis Carter. The landcape, the gun and the wooden bench display Andrews's estate and wealth.

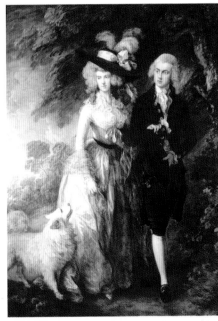

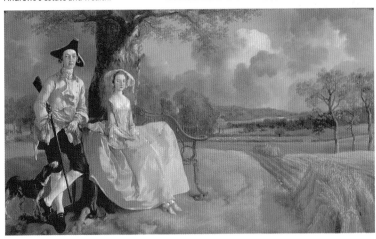

Thomas Gainsborough

Joshua Reynolds

Sir Joshua Reynolds
1723, Plympton by Plymouth–1792, London

■ Dedicated his life to elevating British portraiture to the status of the "Grand Style" ■ Competed with Thomas Gainsborough as the leading portraitist of the time ■ Favored women and children in natural settings as models for his works

■ **1723** Born July 16

1740 Apprenticed to portraitist Thomas Hudson

1749 Travels to the Mediterranean Sea

1752 Returns to London

1764 Establishes the Literary Club

1768 Becomes the first president of the Royal Academy

1769 Writes and presents the first of his *Discourses*

1769 Knighted by King George III

1784 Becomes the royal painter to the king

1792 Dies on February 23

Works by Reynolds

The Marlborough Family, 1777–78, Blenheim Palace, Oxfordshire

Alexander, 10th Duke of Hamilton, 1782, National Gallery of Scotland, Edinburgh

Mrs. Mary Robinson, ca. 1783, Wallace Collection, London

Mrs. Siddons as the Tragic Muse, ca. 1783, The Huntington, San Marino, California

Joshua Reynolds created his first portrait at the age of 12. He was trained as a portrait painter in London and then traveled to Italy, where he became determined to incorporate aspects of Italian history painting into English portraiture. In his portraits he quoted elements from past masterpieces, using classical poses and settings for the contemporary sitters. Ultimately, Reynolds established himself as one of the greatest portraitists of his time, creating an amazing number of portraits during his life.

Reynolds was also a respected writer on the subjects of art and aesthetics. He wrote his famous *Discourses,* which discussed the objectives of art and elevated the status of the artist in British society. Because of his artistic reputation and his impressive connections, he received a post as the first president of the new Royal Academy of Art.

■ **The Young Prophet Samuel at Prayer**, ca. 1780, oil on canvas, 89 x 70 cm, Musée Fabre, Montpellier

The young prophet kneeling in the center of the composition raises his face to the opening in the dark sky. Reynolds draws on the heritage of Rembrandt, exploring the interaction of dark and light. Using a soft, warm palette of browns and beiges, he creates the golden light of God that illuminates the boy.

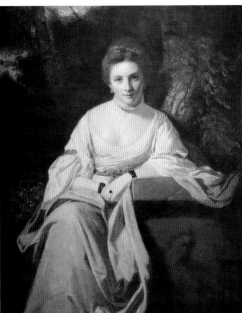

■ **Portrait of Nelly O'Brien**, 1763, oil on canvas, 125.1 x 100.1 cm, Hunterian Museum and Art Gallery, Glasgow

The sitter for this portrait was a famous courtesan. Reynolds reveals her social status by posing her with another famous mistress, Danäe. The young woman appears elegant, poised, and completely at ease. Reynolds is fascinated with the play of light and shadows, exploring their effect on different surfaces: her body, the dress, and the lush greenery. Through this dynamic, the artist teases out the shapes and forms of his subject. There is a sense of a mutual attraction between the artist and his model. She gazes out in an intimate and expressive way, engaging the viewer in a private conversation. The subdued palette and soft treatment of her alluring features combine to create an ennobling image of the model.

■ **Cupid Unfastens the Belt of Venus**, 1788, oil on canvas, 127.5 x 101 cm, Hermitage, St. Petersburg

A playful Cupid unties the blue ribbon holding together Venus's garments. The lively palette reveals a Venetian influence, while the sensuality of the scene's varied textures draws on the French tradition.

Joshua Reynolds

Joseph Wright of Derby

1734, Derby–1797, Derby

■ Contrasted light and dark in a manner similar to Caravaggio's use of chiaroscuro ■ His signature artificial lighting earned the artist his celebrity ■ Derby's most famous paintings present industrial themes in a romantic light ■ His color palette consists of muted browns, greens, and yellows

■ **1734** Born September 3
1751 Becomes a student of a popular portraitist, Thomas Hudson
1765 First exhibition at the Incorporated Society of Artists
1773 Travels to Italy
1776 Enrolls at the Royal Academy
1777 Returns to Derby
1781 Becomes an Associate of the Royal Academy
1784 Leaves his position as an Associate
1785 Organizes his own exhibition of paintings in London
1797 Dies on August 29

Born in Derby, one of the centers of the Industrial Revolution, Joseph Wright introduced the subject of science into British art. Contrary to conventional practice, he avoided London and still managed to succeed in becoming a renowned artist of his time. Wright trained as a portrait painter, but became famous as a master of dramatically lit genre scenes. Wright was also celebrated as a creator of moody landscapes. It was after visiting Italy that the artist developed his signature style of combining rustic landscapes and night lighting. His characteristic use of chiaroscuro reveals the influence of Caravaggio (p. 218), and his preference for dark interiors draws on Rembrandt (p. 244), while his predilection for realism and genre subjects harks back to the Dutch artistic tradition. Wright's subjects range from the local gentry to laborers, from scientists to Italianate characters.

■ **A Grotto in the Kingdom of Naples, with Banditti, at Sunset**, ca. 1777, oil on canvas, 122 x 174 cm, private collection

This Italianate landscape depicts a picturesque cavern and bandits while studying the contrast between the darkness of the cave interior and the brightness of the sunset. The saturated colors used to render the bandits struggling with their victim enliven the composition and reflect the warm glow of the sun behind them.

■ **The Blacksmith's Shop**, 1771, oil on canvas, 125.7 x 99 cm, Derby Museum and Art Gallery, Derby

The industrial scene is illuminated by an artificial source. The image celebrates the power of human achievements. The color scheme consists mostly of shades of brown, highlighted by bright touches of whites and yellows.

Other Works by Wright

The Orrery, 1766, Derby Museum and Art Gallery

The Experiment on a Bird in the Air Pump, 1768, National Gallery, London

The Alchemist, in Search of the Philosopher's Stone, Discovers Phosphorus, 1771, Derby Museum and Art Gallery, Derby

Sir Brooke Boothby, 1781, Tate Britain, London

■ **The Old Man and Death**, ca. 1780, oil on canvas, 63.5 x 76.2 cm, Walker Art Gallery, Liverpool

Created during the later phase of Wright's artistic career, this allegorical work incorporates elements of Classical literature and mythology. The moralizing narrative draws on a story by Aesop. The protagonists, an old man and Death, are shown in a natural setting of a meticulously observed landscape. The man, recoiling in fear, and the skeleton are highlighted by the setting sun.

Joseph Wright of Derby

Jacques-Louis David

1748, Paris—1825, Brussels

■ David was fascinated by subjects from Classical history and biblical narratives ■ His works are full of accurate archaeological details ■ The artist's history paintings are full of theatrical drama and are intended to be ennobling and moralizing ■ His portraits customarily idealize their subjects

1748 Born on August 30
1764 Enrolls at the Académie Royale
1774 Wins the Prix de Rome
1792 Participates in the National Convention
1794 Arrested, incarcerated, and then freed
1799 Becomes an official painter for Napoleon
1815 Exiled after the fall of Napoleon
1825 Dies on December 29 in Brussels

Jacques-Louis David played an important role in establishing the popularity of Neoclassicism. The new movement exhibited a preference for grand history paintings. Consequently, David's choice of subjects in his large-scale canvases tends toward Classical history. Alternatively, he casts contemporary political figures in the heroic roles of the past. The latter approach enabled David to present the existing leaders of the country as legitimate, by equating them with Classical rulers. As a result, David's paintings became appropriated by the official regime as vehicles of propaganda. David was an active participant in contemporary political life. He helped organize state-sponsored fairs, and designed costumes, uniforms, ⌐⊃

■ **The Death of Marat**, 1793, oil on canvas, 162 x 128 cm, Musées Royaux des Beaux-Arts, Brussels

The idealized, softly lit portrait depicts Marat as a martyr. David draws on the iconography of Michelangelo's *Pieta* (p. 150). Marat appears moments after his death, retaining the warm color and flexibility of life, still holding onto the letter he was writing. The pose, the closed eyes, and the sliding arm convey the finality of death.

Other Important Works by David	
Christ on the Cross, 1782, oil on canvas, Church of St. Vincent, Mâcon	The Oath of the Horatii, 1784, oil on canvas, Musée du Louvre, Paris
Andromache Mourning Hector, 1783, oil on canvas, Musée du Louvre, Paris	Madame Récamier, 1800, oil on canvas, Musée du Louvre, Paris

■ **The Intervention of the Sabine Women**, 1799, oil on canvas, 385 x 522 cm, Musée du Louvre, Paris

The subject is based on the ancient Roman myth of the Sabine women appeasing the warring groups of their fathers and husbands. The figures are arranged as actors in a theatrical play; the composition is symmetrically centered around a figure of a woman with outstretched arms.

■ **The First Consul Crossing the Alps at the Grand-Saint-Bernard Pass**, 1799, oil on canvas, 259 x 221 cm, Musée National du Château de Malmaison

David presents Napoleon as a romantic hero. The composition is inspired by an equestrian sculpture of Peter I by Falconet. Napoleon controls his steed, raising his arm in a commanding gesture. His bright cloak swirls in the wind, echoing the windswept mane and tail of the horse.

Jacques-Louis David

posters, and other decorations for the state. Most of all, his Neoclassical paintings successfully express the aesthetics and cultural principals of his time. David garnered celebrity by successfully and clearly relating the moral message of his paintings to the viewers. Stylistically, he relied on the uncluttered simplicity of his compositions and employed a primacy of line to color. His self-imposed stylistic limitations paralleled the popular new fashion for austerity and stoicism, which contrasted with the decadent frivolity of the earlier Rococo style. Precise outlines, chiseled forms, a virtuoso skill of conveying the diversity of textures, and highly finished surfaces characterized his style. Among David's most famous students were such artists as Girodet, Gros, and Ingres (p. 304).

■ **Coronation of the Emperor Napoleon I and Coronation of the Empress Josephine**, 1805–07, oil on canvas, 629 x 979 cm, Musée du Louvre, Paris

This large-scale work is over 500 square feet and contains 150 figures. David derived his composition from Rubens' *Coronation of Queen Marie de Medici*. The painting presents the newly appointed emperor of France, whose face is illuminated by a subtle light, crowning his wife. The pope blesses the empress as members of Napoleon's and Josephine's families and various political figures look on. Despite the impressive number of figues, attention is drawn to the protagonists in the center of the scene through the use of bright colors.

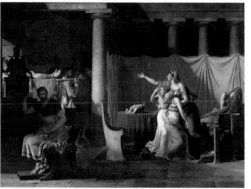

■ **The Lictors Returning to Brutus the Bodies of His Sons**, 1789, oil on canvas, 323 x 422 cm, Musée du Louvre, Paris

David presented the story of Brutus, who sentenced his sons to death for treason, in terms of a patriotic self-sacrifice. The stoic, suffering Brutus, inspired by Michelangelo's *Isaiah*, is removed from the spotlight and set apart from the hysterical women. Confined to a dark corner of the composition, Brutus is alone in his despair.

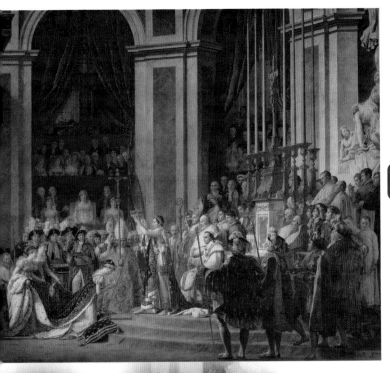

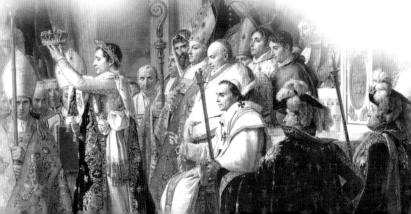

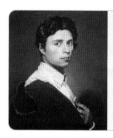

Jean-Auguste-Dominique Ingres

1780, Montauban–1867, Paris

■ Often described as linear and smooth ■ His treatment of subjects usually conveyed a feeling of cold detachment ■ Meticulous attention to detail ■ The artist's images of feminine sensuality created an effect of austere sensuality

1780 Born on August 29

1791 Enrolls at the Royal Academy of Arts in Toulouse

1797 Trains under David

1801 Wins the Prix de Rome

1824 Returns to Paris

1834 Director of the French Academy of Rome

1841 Returns to Paris

1845 Honorary rank in the Legion of Honor

1855 Receives a gold medal at the Universal Exhibition

1867 Dies on January 14

Jean-Auguste-Dominique Ingres was a student and a great competitor of his teacher, Jacques-Louis David (p. 300). Ingres is considered to have been the last representative of the grand tradition of Classical history painting. His influences drew on diverse sources—from the Italian Renaissance to the Dutch School. However, the artist's style always tended toward a highly detailed finish.

Ingres is most famous for his portrait paintings. The artist considered drawing a skill that was primary in creating a work of art. Accordingly, the portrait genre allowed the painter to demonstrate his unequalled skill of controlled and precise contouring, his love for representing textures and surfaces, and a talent for capturing likenesses in ▭

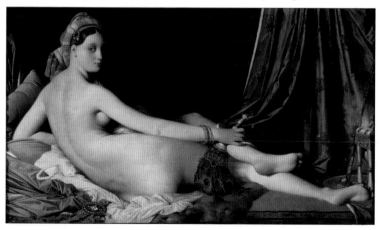

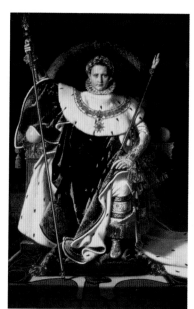

Neoclassicism in France

■ **Portrait of Napoleon on the Imperial Throne**, 1806, oil on canvas, 259 x 162 cm, Musée de l'Armée, Paris

This exceptionally panned portrait of Napoleon confronted contemporary viewers with a sense of strong, stark immobility mixed with a lack of emotion. Ingres's image of imperial power presents a stiff Napoleon on an elaborately decorated throne. The presence of the medieval symbols of royal legitimacy such as a scepter, a hand of justice, and a sword is intentional: By including the regalia, the work reveals Napoleon as the rightful heir to previous rulers. The treatment of light and color makes this work particularly rich.

■ **Oedipus Explaining the Enigma of the Sphinx**, 1808–27, oil on canvas, 189 cm x 144 cm, Musée du Louvre, Paris

A naked youth confronts a half-woman, half-animal Sphinx in front of a cave. The scene is an allegory of the victory of intellectual reason, personified by Oedipus, over irrationality, represented by the winged monster. The physical beauty of the male body, accentuated in the sunlight, opposes the bestial disunity of the part-lion, part-bird, part-human Sphinx.

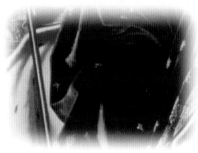

◄ **The Grand Odalisque**, 1814, oil on canvas, 91 x 162 cm, Musée du Louvre, Paris

The style of this painting draws on the Italian Mannerists. The model twists her impossibly long back toward the viewer with an aloof glance. The saturated turquoise and red colors contrast with the cold flesh tones. The rich textures and objects shown accentuate the exotic eroticism.

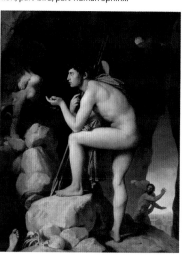

Jean-Auguste-Dominique Ingres

a manner of heightened detailing. The painter's signature stylistic austerity enabled him to ascribe a feeling of importance to his single figures. However, the same style detracted from his dramatic multiple-figure compositions, which were criticized for their lack of unity and sense of constricted dynamic.

Ingres' other subjects drew on mythology, ancient history, and imagery of the Orient. In the latter genre, Ingres acquired a reputation as a great painter of feminine sensuality and exotic eroticism. The linear perfection of his feminine subjects conveyed a cold allure, rather than the intimacy of living flesh.

Ingres was highly influential, both in his time and for later artists. Among his students were Théodore Chassériau, Hyppolyte Flandrin, Henri Lehmann, and Eugene-Emmanuel Amaury-Duval. He was also highly regarded and admired by later artists such as Edgar Degas (p. 360), Henri Matisse (p.408), and Pablo Picasso (p. 428).

■ **Apotheosis of Homer**,
1827, oil on canvas,
386 x 515 cm, Musée du Louvre,
Paris

The composition of this painting centers around the figure of Homer, who faces the viewers head on. He appears to completely disregard the characters at his feet. The angel crowns Homer; the two women who are seated at the edge of Homer's throne represent the poet's greatest poems: the *Iliad* and the *Odyssey*. Other characters represent Dante, Molière, and Poussin. The palette is pastel and the arrangement of pictorial elements is highly formal. The scene is set against the background of a Roman temple.

■ **Joan of Arc at the Coronation of Charles VII in the Cathedral of Reims**, 1854, oil on canvas, 240 x 178 cm, Musée du Louvre, Paris

The figure of Joan of Arc became very important to the cultural image of France. This painting was commissioned for a memorial in her honor. The work presents her religious devoutness in support of the French royal lineage. The haloed patron saint of France is depicted standing next to the high altar, which is decorated with other religious figures in low relief on its gold façade and encrusted with colorful jewels. Joan of Arc wears highly polished armor. To her right, a helmet and gloves gleam on a dark step. In her right hand she holds up a banner; the red of the wooden pole emphasizes the diagonal axis of the composition. Her military attributes are neutralized by feminine elements such as her skirt and long hair. Her connection to the French government is reiterated in the fleur de lis background.

■ **Portrait of Baroness Betty de Rothschild**, 1848, oil on canvas on wood, 142 x 102 cm, private collection, Paris

Revealing his skills as a portraitist, Ingres captures his sitter's likeness and the nuances of her facial expression in an idealized manner. She looks out at the viewers, creating a sense of intimate connection. At the same time, the artist pays as much attention to the fashionable dress as he does to his sitter's face. The gleaming surface of the silk appears physically tactile and accentuates the richness of the portrait. The Baroness is spotlighted, emerging from the dark background.

Other Important Works by Ingres	
Mademoiselle Riviere, 1806, Musée du Louvre, Paris	Princess de Broglie, 1851–53, Metropolitan Museum of Art, New York
Jupiter and Thetis, 1811, Musée Granet, Palais de Malte, Aix-en-Provence, France	The Turkish Bath, 1862, Musée du Louvre, Paris

Jean-Auguste-Dominique Ingres

Francisco de Goya

Francisco José de Goya y Lucientes
1746, Fuendetodos—1828, Bordeaux

■ Goya's style is difficult to evaluate because it evolved over the years ■ Made sympathetic images of ordinary people ■ Portraits of nobility and the royal family were satiric ■ His art conveyed raw emotion and humanism

■ **1746** Born on March 30
1760 Begins training with a local painter
1775 Begins working for the Royal tapestry factory
1780 Elected a member of the Royal Academy of San Fernando
1789 Becomes a court painter
1795 Becomes Academy's director of painting
1808 Retains his status during Napoleon's reign
1814 Is pardoned by the King for collaboration with Napoleon's government
1824 Moves to France
1828 Dies on April 16

Francisco de Goya's artistic career spans more than 60 years and several sociopolitical changes in Spain. He was very versatile, producing numerous paintings, engravings, and drawings and working as a designer of tapestries. The artist's pictorial innovations established him as one of the first modern painters and impacted future generations of artists in the nineteenth century. Among his influences were such diverse masters as Rubens (p. 234), Velázquez (p. 260), Tiepolo (p. 280), and Antonio Raphael Mengs.

His style was a drastic departure from the imposing paintings of David (p. 300) and Ingres (p. 304), characterized by the theatricality of expression and the grandeur of their compositions. Goya was noted for the emotional satiric, realism of his works. Rather than presenting reality combined with an elevating and ennobling morality,

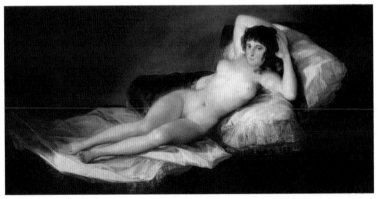

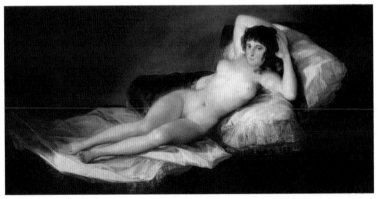

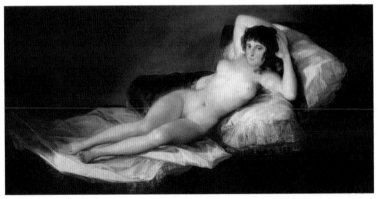

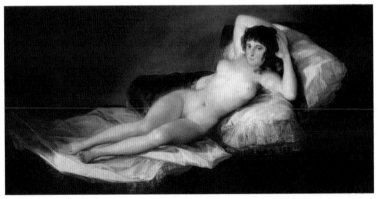

■ **Christ on the Cross**, 1780, oil on canvas, 255 x 153 cm, Museo del Prado, Madrid

Goya submitted *Christ on the Cross* as his presentational and admittance work to the Royal Academy in Madrid. He drew his stylistic inspiration from paintings on the same subject by Diego Velázquez and Antonio Mengs. The upturned face of Christ looks to the heavens, with a Classical expression of suffering. The artist follows traditional canons and uses a black background to accentuate the soft, yellowish tones of Christ's body. Gentle lighting adds a dreamlike quality to the dramatic scene of the crucifixion, and Christ takes precedence over all other things—the cross, background, and setting. The painter subtly models his shapes, and his brushstrokes are so light that they almost disappear.

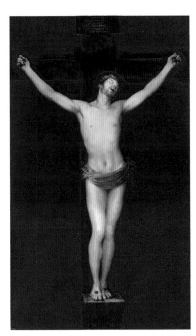

■ **Saturn Devouring His Son**, ca. 1821, oil on plaster backed canvas, 146 x 83 cm, Museo del Prado, Madrid

This mythological work, one of Goya's *Black Paintings*, represents the cannibalistic god of time consuming his child. The figure of Saturn dominates the scene, his grip overpowering the victim's body. The brightness of the red blood is striking against the dark palette.

◀ **Nude Maja (Maja Desnuda)**, ca. 1800, oil on canvas, 97 x 190 cm, Museo del Prado, Madrid

One of the most famous paintings by the artist, this work is considered to be the first nude with no literary allusions. Because of this lack of literary reference, the piece was quite controversial. It is one half of a pair, serving as the counterpart to the other painting, *The Clothed Maja (La Maja Vestida)*. Both display the alluring subject in the same reclining position.

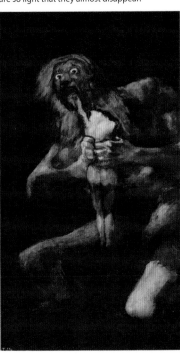

Francisco de Goya

the artist explored the dreariness and plainness of life. Within his insightful approach to the human condition, he did not differentiate between nobility and common classes.

In contrast to his predecessors, who drew on narrative, Goya's works introduced drama through drastically modern representational innovations. His paintings are characterized by a bold palette, a lack of modeling, and flattened visual distortions.

During his own time, Goya was famous as a portraitist. Today he is noted for his explorations of the depths of the human psyche and his antimilitarism.

Other Works by Goya

Blind Man's Buff, 1788–89, Museo del Prado, Madrid

Duchess of Alba, 1797, Hispanic Society of America, New York

Charles IV and his Family, 1800, Museo del Prado, Madrid

The Clothed Maja, ca. 1801, Museo del Prado, Madrid

Time and the Old Women, ca. 1810, Musée des Beaux-Arts, Lille

Christ on the Mount of Olives, 1819, Escuelas Pías de San Antón, Madrid

Self-Portrait with Doctor Arrieta, 1820, Institute of Arts, Minneapolis

Don Manuel Osorio Manrique de Zuñiga, 1788, Metropolitan Museum of Art, New York

Majas on Balcony, 1800–14, Metropolitan Museum of Art, New York

■ **The Sleep of Reason Produces Monsters**, 1799, 215 x 150 cm, Plate 43, Caprichos first edition, etching with aquatint, Metropolitan Museum of Art, New York

The subject of this etching, which was part of the series entitled *Caprichos*, is the visualization of a nightmare. Goya was influenced by Albrecht Dürer's depiction of an artist tormented by melancholia. In this autobiographical work, Goya shows himself surrounded by grotesque creatures produced by the irrational side of his creativity. The creatures of the night hover about, lurking in the shadows and haunting his dreams.

■ **The Third of May, 1808: The Execution of the Defenders of Madrid**, 1814, oil on canvas, 266 x 345 cm, Museo del Prado, Madrid

The painting was commissioned by the king as a political statement against the Napoleonic regime. The depiction of the massacre of rebels takes on a symbolic significance through the contrast between the regulated violence and the chaotic submission. The opposition between light and dark parallels the gap between the repetitiveness of identical figures of soldiers and the individuality of their victims.

■ **The Straw Mannikin**, 1791–92, oil on canvas, 267 x 160 cm, Museo del Prado, Madrid

This painting is one of a series of cartoons that were intended as templates for wall tapestries. The rustic, decorative characters were chosen by the king to propagate a carefree, jovial feeling. The composition centers on the tossing of the straw puppet on a blanket. Although the ritual is a playful activity, the stiffness of the women and the unnatural shape and movement of the puppet created an atmosphere of awkward uneasiness.

Francisco de Goya

Japanese Prints

1600–1890s

■ The Ukiyo-e influenced the development of modern art, impacting the styles of Toulouse-Lautrec, Monet, van Gogh, and Gauguin ■ The woodblocks depicted travel scenes, episodes from contemporary life, and Kabuki performances ■ The lengthy process involved artists, publishers, and engravers

■ **1600–1860** Ukiyo-e woodblock prints in Japan flourish as popular art for the masses

1760–1849 Hokusai Katsushika

1797–1858 Ando Hiroshige

1867 Parisians see the first formal exhibition of Japanese arts and crafts at the World's Fair

1890s The prints grow in popularity in Europe

The art of Ukiyo-e prints developed in Japan as a result of the development of a middle-class consumer demand for contemporary genre scenes. The word *ukiyo* translates as "a picture of the floating world," which means an image of Earth-bound life. During the Edo period in Japan, the lifestyle in urban centers was referred to as *ukiyo*. The term described the fashions, entertainment, and decadence of the cities.

Ukiyo-e prints represent ordinary life, retaining a traditional interest in landscape painting. They are characterized by an absence of depth, clear and opaque colors, ⟳

18th Century

■ **Ando Hiroshige: Sudden Shower at Shono Station**, ca. 1833, from *Fifty-Three Stations of the Tokaido Road*, 22 x 34.5 cm

This somewhat whimsical scene of the cloudy, dusky sky and the wind-bent trees shows the effects of rain on peasant travelers. The diagonal lines of the pouring rain and running people in traditional dress add to the dynamism of the image.

▶ **Ando Hiroshige: Plum Estate, Kameido**, 1857, from *One Hundred Famous Views of Edo* woodblock print, 34 x 23 cm, Brooklyn Museum, New York

The focus of the composition is the plum tree with its spreading branches and white flowering blossoms. The close up view positions the viewer inside the scene.

◀ **Hokusai Katsushika: The Great Wave**, ca. 1830, from *Thirty-Six Views of Mount Fuji*, woodcut, 24.6 x 36.2 cm

Today, this is one of the most popularly reproduced woodblock prints. The power of the sea and its untamable force is an important aspect of Japanese life.

■ **The Bridge in Fukagawa**, by Hokusai Katsushika, ca. 1820, woodblock print, 28 x 40 cm, Staatliche Kupferstichkabinett, Dresden

This detailed representation of a bridge reveals outside influences in its shading, coloring, and perspective. Although the Ukiyo-e woodblocks usually focused on genre scenes, the prints also continued with more traditional representations of natural settings. Hokusai, who was a well-regarded landscape printmaker, was also one of the first artists to allow a European artistic style to impact woodblocks. Because European goods were prohibited in Japan, Hokusai had to study smuggled engravings of western art.

spatial flatness, narrativity, the intent of close inspection by the viewer, and a focus on line in drawing. The perspective is suggested by the positioning of objects—the items represented at the bottom are considered to be in the foreground and the ones in a higher position are considered to be in the background. Ukiyo-e's style had a significant effect on the French Impressionists in its choice of everyday contemporary subject matter and in the distinctive palette and composition.

Hokusai Katsushika and Ando Hiroshige became particularly well-known in the West. Hokusai left nearly 30,000 prints, paintings, and drawings. His most influential work was the 15-volume Manga series that focused on views of the Fuji Mountain. Hokusai responded to Western influences, introducing new elements into his works. Hiroshige, who became known in the West after his death, was one of the most important Ukiyo-e artists. His most famous work is *Fifty-Three Stations on the Tokaido Road*, a series of scenes from the famous route through Japan.

18th Century

Other Japanese Works

Hokusai Katsushika: Mount Fuji in Clear Weather with a Southerly Breeze, ca. 1831, ink on paper/woodcut, Rijksmuseum, Amsterdam

Hokusai Katsushika: The Waterfall Where Yoshitsune Washed his Horse, ca. 1832, woodcut, 38.2 x 26.4 cm

Ando Hiroshige: Dyers' Quarter, Kanda, 1857, from One Hundred Famous Views of Edo; woodblock print, Brooklyn Museum, New York

Ando Hiroshige: Sanno Festival Procession at Kojimachi I-chome, 1857, from One Hundred Famous Views of Edo, woodblock print, Brooklyn Museum, New York

■ **Hokusai Katsushika: The Actor Sakata Hangoro III in the Role of Chinzei Hachirono Tametomo**, 1791, woodblock, 31.4 x 13.5 cm, Boston Museum of Fine Arts

This portrait of an actor in his costume is an example of a common type of print that depicted performers from the Kabuki theater, reflecting its prominence as a form of entertainment that the middle-classes were able to enjoy during the Edo period. The subjects of the plays were geared toward the unsophisticated tastes of the audience and focused on episodes from legends and contemporary life. In Kabuki theater all characters were played by male actors. Images of the actors, such as this work, became very popular.

Japanese Prints

19th Century

19th Century

1780–1850
Romanticism

William Blake
Caspar David Friedrich
p. 326
Joseph Mallord William
Turner p. 336

1848–1900
Pre-Raph-aelites, Arts and Crafts, Victorian Classicists

Thomas Woolner
James Collinson
Arnold Böcklin p. 338

p. 347

1850–1900
Realism and Naturalism

| 1800 | 1810 | 1820 | 1830 | 1840 |

John Constable p. 334
Théodore Géricault
p. 328
Eugène Delacroix p. 330
Thomas Cole
Emanuel Gottlieb Leutze
Frederic Edwin Church

William Holman Hunt
Dante Gabriel Rossetti
p. 340
Frederic Stephens
John Everett Millais
Edward Burne-Jones
James McNeill Whistler
p. 342
William Morris
Edward Robert Hughes

Jean-Baptiste-Camille
Corot p. 344
Jean-François Millet
p.346
Adolf von Menzel p. 352
Gustave Courbet p. 348
Edouard Manet p. 354
Ilya Repin p. 350
Thomas Eakins
Henry Ossawa Tanner

p. 337

1860–1900
Impressionists

Camille Pissarro p. 358
Edgar Degas p. 360
Auguste Rodin p. 364
Pierre-Auguste Renoir
p. 366
Claude Monet p. 370
Georges Seurat p. 376
Mary Cassatt p. 378

1860–1900
Post-Impressionists

Paul Cézanne p. 382
Paul Gauguin p. 390
Vincent van Gogh p. 386

p. 391

1880–1920
Art Nouveau, Jugendstil

1860	1870	1880	1890	1900

Henri de Toulouse-Lautrec p. 380
Henri Rousseau
Frédéric Bazille
Alfred Sisley
Gustave Caillebotte
Childe
Hassam

1850s–1900
Symbolism, New Romanticism

Pierre Puvis de
Chavannes p. 396
Gustave Moreau
Odilon Redon
Ferdinand Hodler p. 398
Mikhail Vrubel
James Ensor p. 394
Edvard Munch p. 392
Leon Spilliaert

Louis Comfort Tiffany
Antoni Gaudí
Alphonse Mucha
Charles Robert Ashbee
Gustav Klimt p. 400
Aubrey Beardsley
Egon Schiele p. 402

1898–1908
Primitivism, Fauvism

Henri Matisse p. 408
Georges Rouault
Raoul Dufy
Charles Camoin
André Derain p. 406
Amedeo Modigliani p. 404

19th Century

The 19th century saw the origin and development of a wealth of stylistic movements. Romanticism developed during the latter half of the 18th century as a reaction against Neoclassical idealized rationality and objectivity. The principal characteristic of Romanticism was the importance of emotion over the rule of reason. The color palette became more saturated and subjects acquired a more dramatic feeling. The French painters Théodore Géricault and Eugène Delacroix became the leading artists of the movement. Both produced works that focused on scenes of heightened emotional content. Both artists explored the pictorial possibilities of the melancholic, the discontented, and the exaggerated.

A Spanish painter, Francisco Goya, and an English artist, William Blake (*Satan Rousing the Rebellious Angels*), were other important figures of the Romantic

■ **Gustave Caillebotte: The Floor-Scrapers**, 1875, oil on canvas, 102 x 146.5 cm, Musée d'Orsay, Paris

■ **Henri Rousseau**: **The Dream**, 1910, oil on canvas, 204 x 298.5 cm, Museum of Modern Art, New York

■ **Gustave Moreau: Orpheus**, 1865, oil on canvas, 154 x 99.5 cm, Musée d'Orsay, Paris

movement. Although these painters principally created narrative works, a number of Romantics were landscape artists, such as Thomas Cole (*Expulsion Moon and Firelight*), J. M. W. Turner, John Constable, and Caspar David Friedrich.

The premise of Romanticism established imagination as a legitimate criterion when creating art, and led to the development of the theory of art for art's sake. This approach held that art should not concern itself with other subjects, such as literature, history, or religion, but instead exist as an independent branch of learning. James

McNeill Whistler's purely subjective *Nocturne* embodied the new independence of art and anticipated the later developments of the Impressionists. The movements of Pre-Raphaelitism and Arts and Crafts pursued a different objective that combined subjectivity with a desire to connect art to other disciplines. The Pre-Raphaelites were a group of seven English painters who looked to pre-Renaissance art as a source of authentic expression. They drew on literature for their symbolic content. Among the leading representatives of the movement were Dante Gabriel Rossetti, William Holman Hunt (*The Hireling Shepherd*), John Everett Millais (*Ophelia*), and Edward Burne-Jones.

Naturalism was developed by a group of artists known as the Barbizon School, who combined a Romantic atmosphere with realistic observations of nature. Artists such as Théodore Rousseau, Jean-Baptiste Corot, and Jean-François Millet comprised the

■ **Mikhail Vrubel**: **Seated Demon**, 1890, oil on canvas, 114 x 211 cm, Tretyakov Gallery, Moscow

■ Alphonse Mucha: Dance, 1898, lithograph, 38 x 60 cm

■ William Blake: Satan Rousing the Rebellious Angels, ca. 1800, watercolor on paper, 34.3 x 42 cm, Victoria and Albert Museum, London

group that worked on landscapes in the forest of Fontainebleu.

The Realist movement entirely rejected the idealization and emotionality of Neoclassicism and Romanticism. Paintings by Gustave Courbet, Gustave Caillebotte (*The Floor-Scrapers*), Honoré Daumier, and Thomas Eakins (*The Agnew Clinic*) embody the style. Drawing on the northern European genre tradition, the Realists stayed away from mythological and historical subjects and represented ordinary subjects from contemporary life

Impressionism relied on Realism for its choice of ordinary subject matter. The movement was driven by scientific realism. It was influenced by the advances in the understanding of human vision and drew on the novel aesthetics of Japanese woodcuts and modern photography. Rejected by the Academy, the Impressionists, such as Camille Pissarro, Edgar Degas, Claude Monet, Alfred Sisley (*Le Brouillard*), and Rosa

Introduction

Bonheur (*Labourage Nivernais: Le Sombrage*) created snapshots of modern life and recorded the effects of light on their subjects with weighty, rough brushstrokes. The Neo-Impressionism of Pointillist Georges-Pierre Seurat and of Primitivist Henri Rousseau (*The Dream*) were offshoots of Impressionism.

Post-Impressionism developed directly out of Impressionism. The later movement continued with an Impressionist approach toward shaping forms with color, but rejected its premise of scientific objectivity. The group included Paul Cézanne, Vincent van Gogh, and Paul Gauguin. They held that individual and subjective expression took precedence over accurate re-

■ **William Holman Hunt: The Hireling Shepherd**, 1851, oil on canvas, Manchester City Galleries, Manchester

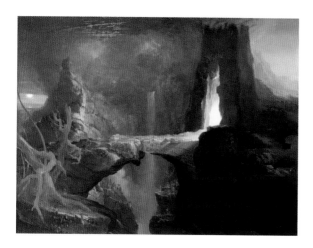

creation of reality. The Post-Impressionists worked in a variety of styles and most artists spanned several other stylistic movements.

Paul Gauguin and van Gogh can also be identified with the Symbolist movement. They believed that certain colors, reductive shapes, and spiritual subjects would draw an emotional response from the viewers. Other Symbolists, such as Piérre Puvis de Chavannes, Gustave Moreau (*Orpheus*), Edvard Munch (who also belonged to the Berlin Secession), and Mikhail Vrubel (*Seated Demon*) drew on literary and mythological sources for their decadent Symbolism.

Art Nouveau was closely related to Symbolism. Its ideas were adapted by Gustave Klimt and Alphonse Mucha (*Dance*) who incorporated decorative design elements into their figural images.

Fauvism, lead by Henri Matisse, drew on Post-Impressionism and used vivid colors in a highly subjective, aggressive way.

Caspar David Friedrich

1774, Greifswald–1840, Dresden

■ Most famous German landscape painter of his time ■ His symbolic works drew on Christian mysticism and realistic observation of nature ■ Believed contemplating the spiritual power of nature led to a deeper understanding of life ■ Reinterpreted the genre of landscape in terms of Romanticism

■ **1774** Born September 5 in Greifswald, Germany

1781 His mother dies

1787 His brother dies trying to save Friedrich from drowning

1794 Enrolls at the Academy of Art in Copenhagen

1798 Goes to Dresden

1810 Member of the Royal Prussian Academy of Art in Berlin

1816 Member of the Dresden Academy of Art

1840 Dies on May 7 in Dresden

Caspar David Friedrich was one of the most important German Romantic landscape painters. In contrast to the traditional approach to landscapes, Friedrich imbued his natural scenes with a deep sense of religious symbolism. His northern views were not overtly emblematic, but rather implied a sacred mysticism. Friedrich's favorite subjects included mysterious church ruins, foggy cemeteries, and moonlit forest landscapes. He utilized a cool palette and severe lighting to create feelings of melancholy and tragic loneliness. He rejected purely figural presentations in favor of an unorthodox blend of religious spirituality and contemporary landscapes. Friedrich believed that nature's spiritual power could help man to better understand life. Although his fame faded after his death, his art was rediscovered and influenced later Romantic artists.

■ **Man and Woman Contemplating the Moon**, ca. 1824, oil on canvas, 34 x 44.1 cm, Alte Nationalgalerie, Berlin

Two silent figures emerge in a moonlit landscape. Their dark silhouettes appear against a hazy foreground in contrast with the incandescent stretch of night sky. The image of a lifeless tree with bristly twigs adds to the foreboding tone of the work. He painted other variants of this subject, including *Two Men Contemplating the Moon*, ca. 1820.

■ **Wanderer Above the Sea of Fog**, ca. 1818, oil on canvas, 94.8 x 74.8 cm, Kunsthalle, Hamburg

The lonesome figure on a mountain is most likely a self-portrait by the artist. He is dressed in a black coat and holds a walking cane. He has turned his back to the viewers and appears absorbed in the process of observing the thick, drifting tufts of fog. The perspective of the composition and the positioning of the only human figure force the viewer's gaze to follow the perspectival diagonal toward the fog. On the horizon, a mountain range magnifies the feeling of space.

■ **The Abbey in the Oakwood**, 1809–10, oil on canvas, 110 x 171 cm, Schloss Charlottenburg, Berlin

Friedrich depicts leafless trees in the winter landscape surrounding the abandoned architectural wreck of the abbey's ruins. The grave markers appear in the bleak foreground. The work conveys a feeling of gloom and loss,

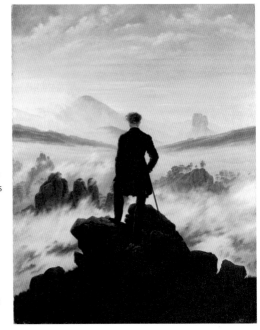

referencing not only the passage of earthly life, but the decline of Germany in the wake of the Napoleonic Wars as well.

Other Works by Friedrich

Tetschen Altar (Cross in the Mountains), 1807–08, Gemäldegalerie, Dresden

Chalk Cliffs of Rugen, 1818–19, Museum Oskar Reinhart, Winterthur

The Sea of Ice, ca. 1823–25, Kunsthalle, Hamburg

Riesengebirge, 1835, Hermitage, St. Petersburg

The Solitary Tree, 1821, Alte Nationalgalerie, Berlin

Monk by the Sea, 1809–10, Alte Nationalgalerie, Berlin

Cloister Cemetery in the Snow, 1817–19, destroyed in 1945

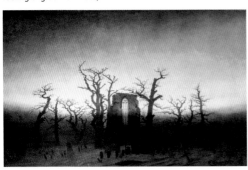

Caspar David Friedrich

Théodore Géricault

1791, Rouen—1824, Paris

■ His works epitomize Romanticism ■ Michelangelo, Rubens, and Caravaggio influenced his style ■ He translated certain Neoclassical elements into the more theatrical and emotionally heightened world of Romanticism ■ He preferred to depict dramatic and shocking subjects

■ **1791** Born September 26 in Rouen, France

1812 Submits his first painting to the Salon

1816 Meets Ingres while in Italy

1818 Becomes a cavalry officer to French royalists

1819 *The Raft of the Medusa* wins a medal at the Salon

1820–22 Travels to England to paint horse races and jockeys and make prints of London's poor

1824 Dies January 26 from a horseback-riding injury

Théodore Géricault exemplifies the Romantic movement. This is particularly evident in his preference for dramatic narratives. Géricault explored emotionally heightened scenes, depicting images of suffering, death, and triumph. He made numerous studies of the human body, both living and dead, and observed patients at a psychiatric hospital. These portraits of the insane and images of the dying became compelling visual spectacles because of their expressive pathos.

From his early attraction to the naturalism of Michelangelo (p. 150), Géricault retained an interest in realism, indicated by his careful attention to details, textures, and tones. Stylistically, he achieved dramatic effects by using bold, saturated colors, bright light, and explicit modeling. He brushed light into his dark compositions with amazing naturalness. His style was very influential, especially on Delacroix and the Realist movement.

■ **Heads Severed**, 1818, oil on canvas, 50 x 61 cm, Nationalmuseum, Stockholm

The graphic imagery of severed human heads is presented from the impartial stance of a still life painter. Géricault meticulously observed the gradual decay of human tissue and portrayed it with shocking detail. The gruesome depiction of the severed heads of a man and woman is shockingly realistic.

■ The Raft of the Medusa,
1819, oil on canvas, 491 x 716
cm, Musée du Louvre, Paris

This monumental work was in-
spired by a contemporary
shipwreck, mishandled by the
crew and covered up by the
government.
Because of

the subject matter, this paint-
ing was highly controversial. It
combined Neoclassical idealiza-
tion with Romantic heightening
of emotions. The glorified treat-
ment of the bodies contrasts
with the realistic representation
of suffering in
the aftermath
of tragedy.

Works by Géricault

An Officer of the Imperial
Horse Guards Charging, 1814,
oil on canvas, 349 x 266 cm
Musée du Louvre, Paris

Portrait of a Woman Suffering
from Obsessive Envy, ca. 1822,
oil on canvas, 71 x 58 cm, Musée
des Beaux-Arts, Lyons

**■ Woman with
a Gambling
Mania,** 1822, oil on
canvas, 77 x 65 cm
Musée du Louvre, Paris

The subject satisfies the Ro-
mantic interest in the idiosyn-
cratic and extreme. Géricault
undertook painting portraits
of the insane at the behest of
Dr. E. J. George. He desired to
capture the physiognomies of
the mad.

Théodore Géricault

Eugène Delacroix

Ferdinand-Victor-Eugène Delacroix
1798, Charenton-Saint-Maurice–1863, Paris

■ His pictorial style manifested characteristics of French Romanticism ■ Characterized by the vivid colors and bravura brushwork ■ His choice of subjects showed a fascination with dramatics and Oriental exoticism

■ **1798** Born April 26 in Charenton-Saint-Maurice

1816 Enrolls at l'Ecole des Beaux-Art in Paris

1822 First exhibition at the Salon

1825 Goes to England

1828 Receives a commission to create illustrations for Goethe's *Faust*

1832 Travels to North Africa for six months

1855 Exhibits at the Universal Exposition in Paris

1863 Dies on August 13 in Paris

Eugène Delacroix was one the most famous and influential painters of the French Romantic movement. Delacroix's style seemed to be a result of his opposition to the Neoclassical movement, revealing this earlier style as a cold and distanced representation of the emotional reality of human existence. He did, however, employ a Neoclassical focus on the human figure and its elegant classicism, in combination with the heightened drama and emotional turbulence of Romanticism. In accordance with Delacroix's style of Romanticism, works were to convey the truth of inner feelings. Though theatrically exaggerated, Delacroix's intense images of tragic humanity avoid a sense of melodrama and retain their integrity.

Among his influences were the Old Masters, such as Rembrandt (p. 244) and Michelangelo (p. 150), as well as several of his contemporaries, like Géricault (p. 328) ⊂⊃

■ **Algerian Women in Their Apartments**, 1834, oil on canvas, 180 x 229 cm, Musée du Louvre, Paris

This rendering of a darkly intimate harem scene features dark-haired women in traditional costumes amidst carefully observed architectural and decorative elements. Delacroix's works depicting exotic subjects became very popular. Such depictions catered to the fascination of the French public with the representations of mysterious foreign places and the Orient.

■ **The Death of Sardanapalus**, 1827, oil on canvas,
392 x 496 cm, Musée du Louvre, Paris

Byron's play describing the suicide of a defeated Assyrian
king was the inspiration for this work. The painting focuses
on the massacre, carried out on the king's orders. The image
of destruction and murder contrasts with the visual sumptu-
ousness of the setting. The wealth of opulent colors and
the writhing fig-
ures of dying
concubines
create a feel-
ing of both
horror
and sen-
suality.
Amid the
energy of
the scene, the king
looks on with a look
of detachment.

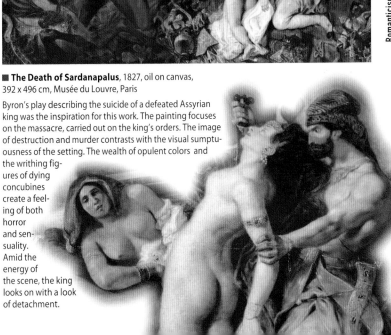

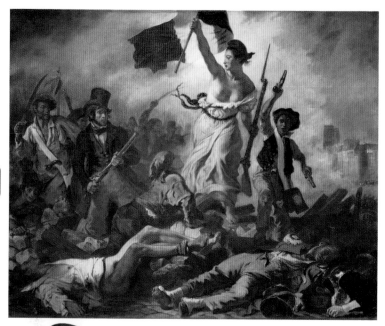

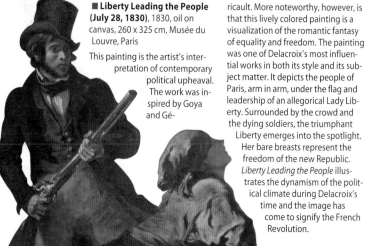

■ **Liberty Leading the People (July 28, 1830)**, 1830, oil on canvas, 260 x 325 cm, Musée du Louvre, Paris

This painting is the artist's interpretation of contemporary political upheaval. The work was inspired by Goya and Géricault. More noteworthy, however, is that this lively colored painting is a visualization of the romantic fantasy of equality and freedom. The painting was one of Delacroix's most influential works in both its style and its subject matter. It depicts the people of Paris, arm in arm, under the flag and leadership of an allegorical Lady Liberty. Surrounded by the crowd and the dying soldiers, the triumphant Liberty emerges into the spotlight. Her bare breasts represent the freedom of the new Republic. *Liberty Leading the People* illustrates the dynamism of the political climate during Delacroix's time and the image has come to signify the French Revolution.

and Constable (p. 334). Delacroix was a very versatile artist who painted portraits; grand religious, literary, historical, and mythological works; and occasionally even still lifes and landscapes. His bright and saturated palette drew on the Venetian Baroque, and his brushwork was energetic, intense, and aggressive.

Delacroix was an important influence on later generations of artists, such as Matisse (p. 408), Cézanne (p. 382), and Picasso (p. 428). He had a stylistic impact on the development of Impressionism and his interest in Orientalism would later affect the Symbolists.

Other Works by Delacroix

Orphan Girl at the Cemetery, 1823, Musée du Louvre, Paris

The Massacre at Chios, 1824, Musée du Louvre, Paris

Apollo Vanquishing the Python, 1850–51, Musée du Louvre, Paris

Lion Hunt, 1860–61, Art Institute of Chicago, Chicago

333

Romanticism in France

■ **The Boat of Dante**, 1822, oil on canvas, 189 x 246 cm, Musée du Louvre, Paris

The Barque of Dante, illustrating a scene from *The Divine Comedy* by Dante, established Delacroix's artistic reputation. The theatrically structured composition drew on Géricault's *Raft of the Medusa* in both tone and composition. He depicts Dante and Virgil on their way across the tumultuous waters of hell. The two figures stand in the barque against the ominous red of the background. Surrounded by the bodies of the damned attempting to board their boat, Dante leans towards Virgil, seeking support and protection.

Eugène Delacroix

John Constable

1776, East Bergholt–1837, Hampstead

■ Constable's landscapes were distinguished by their naturalism and direct rendering of the scenes ■ His style was characterized by use of broad, spontaneous brushstrokes, thick application of pigment, and a fresh color palette ■ Constable slowly garnered recognition at the age of 53

■ **1776** Born on June 11 in East Bergolt, England

1796–98 Studies with John Thomas Smith and George Frost

1799 Enrolls at the the Royal Academy

1801–06 Tours Derbyshire, Kent, and the Lake District

1821 Moves to Hampstead because of his wife's health

1824 Awarded a gold medal at the Paris Salon

1829 Receives full membership of the Royal Academy

1837 Dies on March 31 in Hampstead

■ **River Landscape**, 1820, oil on canvas, Museo Lazaro Galdiano, Madrid

This restless landscape appears to go beyond the joyful characteristics and messages of tranquility and contentment with simple pleasures that are normally found in Constable's work. The darker colors in this scene present a more moody and intense view of nature. The dusky image of the skies creates an atmosphere of an uneasy waiting.

19th Century

A famous landscape painter, John Constable presented his audience with charming views of the English countryside. His works were impacted by Ruisdael (p. 252), Lorrain (p. 232), and Gainsborough (p. 294), and in turn influenced Delacroix (p. 330) and the Barbizon School.

Constable worked either on small, meticulously detailed paintings, usually done from direct observation, or grand-scale natural scenes, painted in his studio. His intimate scenes reveal a poetic relationship to and sincere fondness for natural surroundings. The artist's personal approach infuses his works with deep emotional sentiment. Constable became increasingly fascinated with observing weather phenomena, such as clouds, and made multiple studies of the same subjects under different weather conditions.

■ **Cloud Study**, 1822, oil on paper, 24 x 30 cm, private collection, Sotheby's, London

Between the years 1821 and 1822, Constable produced multiple studies of cloud formations in various weather conditions and in different media. The artist's goal was to observe and capture the fleeting effect of light and the way it changes the appearance of the sky in order to later utilize these studies in his landscapes. This work was painted quickly, using abrupt brushwork and a limited palette of blues, whites, and yellows.

■ **The Hay Wain**, 1821, oil on canvas, 130.2 x 185.4 cm, National Gallery, London

Featuring a Suffolk site near the river Stour, this grand-scale, studio-created landscape was based on drawings from previously completed open-air studies. Here, Constable depicts a lush green meadow, a rustic cottage, and a small group of peasants gathering hay in the distance. The title takes its name from a type of horse-drawn cart, which is featured in the water in the foreground of the composition.

Other Important Works by Constable

Wivenhoe Park, Essex, 1816, oil on canvas, National Gallery of Art, Washington, DC	Fitzwilliam Museum, Cambridge
The White Horse, 1819, oil on canvas Frick Collection, New York	**The Opening of Waterloo Bridge**, 1829, oil on canvas, Yale Center for British Art, New Haven
Gillingham Mill, 1824, oil on canvas,	**The Glebe Farm**, 1830, oil on canvas, Tate Britain, London

John Constable

J. M. W. Turner

Joseph Mallord William Turner
1775, London–1851, Chelsea

■ Explored the chiaroscuro effect in color ■ Was fascinated by images of weather phenomena ■ His seascapes remain idyllic and Romantic in their destructiveness

● 1775 Born Joseph Mallord William Turner on April 23 in London
1779 Enrolls at the Royal Academy
1802 Becomes full member at the Royal Academy
1807 Becomes professor of perspective at the Royal Academy
1814 Is one of the founders of the Artists' General Benevolent Institution
1837 Gives up his post as a professor of perspective
1845 Becomes acting president of the Royal Academy
1846 Moves to Chelsea
1851 Dies on December 19

■ Ulysses Deriding Polyphemus—Homer's Odyssey, 1829, oil on canvas, 132.5 x 203 cm, National Gallery, London

This depiction originated from the Classical myth of Ulysses. After avenging Neptune with his defeat over the Cyclops, Ulysses, marked by red, waves a flag atop his ship. The giant Polyphemus appears above the ship as a cloud-formed figure.

19th Century

J. M. W. Turner belongs to the school of Romanticism. His art shows influences by Joseph Wright of Derby (p. 298), Wilson de Loutherbourg, and Nicolas Poussin (p. 228). He worked in diverse media, producing watercolors, oil paintings, and engravings. The artist's mature style retained the effect of the freshness and fluidity of his earliest works in watercolor. He favored seascapes, exploring the drama of storms and thunder.

His style is characterized by clarity and brightness. In Turner's landscapes, the color and light are the subjects, as well as the building blocks of his compositions. Usually, Turner's color palette consists of pure, brilliant hues of reds and yellows. He avoids shadowing and vacillates between using thin and thick layers of pigment. His signature flooding light dissolves forms almost to an abstraction.

■ **The Fighting "Temeraire" Tugged to Her Last Berth to Be Broken Up**, 1838, oil on canvas, 91 x 122 cm, National Gallery, London

The inanimate subjects of the sun-setting seascape are accorded personalities via a play of colors and vigorous brushwork. An old ship being dragged by a steamer is the focus of this grand composition. The noble and stately *Temeraire* follows an aggressively energetic steamer in a cloud of red to its death, while other ships fade away into the horizon.

Other Works by Turner

The Burning of the Houses of Lords and Commons, 1835, oil on canvas, 92 x 123 cm, Philadelphia Museum of Art, Philadelphia

Slavers Throwing Overboard the Dead and Dying—Typhoon Coming On (The Slave Ship), 1840, oil on canvas, 90.8 x 122.6 cm, Museum of Fine Arts, Boston

Sunrise with Sea Monsters, ca. 1845, oil on canvas, 91.5 x 122 cm, Tate Gallery, London

J. W. M. Turner

Arnold Böcklin

1827, Basel—1901, San Domenico, near Fiesole

■ Began as a landscape painter ■ Böcklin's art drew on the notion of pictorial symbolism ■ A majority of his subjects were inspired by Classical Greek and Roman mythology ■ Big parts of his œuvre show a fascination with death ■ His paintings served as a basis for a musical composition by Rachmaninov

■ **1827** Born in Basel on October 16
1846 Enrolls at the Dusseldorf Academy of Art and studies under Schirmer
1850 Travels to Rome in March
1856 Returns to Munich and remains for four years
1860 Accepts a position of a professorship at the Weimar Academy of Art
1862–66 Stays in Rome
1886–92 Settles in Zurich
1892 Moves to San Domenico
1901 Dies on January 16

Arnold Böcklin's works are difficult to categorize and are usually considered to belong to the Symbolist school of art within the movement of Art Nouveau. His style was greatly influenced by Romanticism and his paintings reveal a nostalgia for the mythical world of Antiquity. His fascinating art conveys feelings of melancholia for the fantasy of the Classical imagination. Fabled characters, such as centaurs and naiads, frequently set within Classical architectural elements, populate most of his scenes. His choice of subjects reveals a fascination with death and sexuality, and his paintings are often dark in nature. Böcklin's approach to painting significantly influenced the Surrealist movement, impacting Max Ernst (p. 454), Salvador Dalí (p. 456), and Giorgio de Chirico.

■ **The Isle of the Dead**, 1886, oil on canvas, 80.7 x 150 cm, Museum der Bildenden Künste, Leipzig

One of the five versions done between 1880 and 1886, this melancholy work is an expression of grief. Traveling across a dark expanse of water, led by a white-clad figure carrying a coffin, the boat heads to the silent, cypress-covered island.

◀ **Mary Magdalene Grieving over the Body of Christ**, 1867 oil on canvas, 84 x 149 cm, Kunstmuseum, Basel

An oft-recurring theme throughout art history, this biblical narrative served here as inspiration. The dark colors and dramatic expression make this a° highly affecting and symbolic work. There is a discomforting feeling of the unwelcome intrusion into the subjects' lives, leading us into the artist's deeply personal vision of death and grieving.

Other Works by Böcklin

Nymph and Satyr, 1871, oil on canvas, 107.9 x 154.9 cm, Philadelphia Museum of Art

Venus Rising from the Waters, 1872, tempera on wood, 59 x 46 cm, Stiftung Kunsthaus Heylshof

The Plague, 1898, tempera on wood, 149 x 105 cm, Kunstmuseum, Basel

■ **Playing in the Waves**, 1883, oil on canvas, Neue Pinakothek, Munich

Expressed in a dramatic fashion, this work depicts splashing mermaids and lascivious tritons. Contrary to a joyful interpretation of the title, the figures here are not idealized. Their bodies are awkwardly positioned to create an overall feeling of grotesqueness.

Arnold Böcklin

Dante Gabriel Rossetti

1828, London–1882, Birchington-on-Sea

■ The artist aspired to become both a poet and a painter ■ Most works were literary-based ■ His art found an ardent supporter in renowned art critic John Ruskin ■ His work played a vital role in evolution of the Symbolist movement ■ Subjects were women, depicted either as seductresses or pure virgins

Dante Gabriel Rossetti, a founding force behind the Pre-Raphaelite Brotherhood, had a distinctive nostalgic style that drew on the art of the Middle Ages. The movement was linked to the literary world of such authors as Dante, Shakespeare, Goethe, Coleridge, and Poe. Rossetti himself was a talented writer, whose poetry was populated by the same characters as his paintings. He could not choose between poetry and art and attempted to combine both media through complicated symbolism. Rossetti never achieved full critical recognition and instead increasingly relied on a small group of private patrons who collected his watercolors. The theme of romantic love, as expressed through the images of mysterious and beautiful women, became his only subject. Rossetti's heroines came from his readings and appeared in his paintings as long-haired, vivid beauties full of a calm yet heavenly grace.

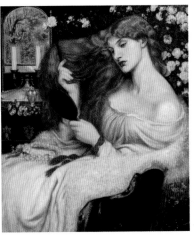

■ **Lady Lilith**, ca. 1868, oil on canvas, 95.3 x 81.3 cm, Delaware Art Museum, Wilmington, Delaware

Behind Lilith, within the window-shaped mirror flanked by candles, an image of the garden of Eden, from which she was expelled, is revealed. Her face is half-turned as she gazes into a handheld mirror. Her body, covered by a white dress, seemingly melts into the white covering of the chair. Atop this myriad of details, Lilith's long, red hair is the most noticeable element of this work, and it stands out dramatically against her pale skin.

Other Works by Rossetti

St. George and the Princess Sabra, 1862, watercolor on paper, 52.4 x 30.8 cm, Tate Britain, London

Beloved, 1865-66, oil on canvas, 82.6 x 76.2 cm, Tate Britain, London

Monna Vanna, 1866, oil on canvas, 88.9 x 86.4 cm, Tate Britain, London

Veronica Veronese, 1872, oil on canvas, 105.4 x 86.4 cm, Delaware Art Museum, Wilmington

Proserpine, 1877, oil on canvas, 116.8 x 55.9 cm, private collection, London

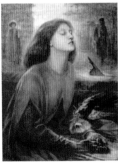

■ **Beata Beatrix**, 1863, 86.4 x 66 cm, Tate Britain, London

Rossetti used Dante's character to symbolically express the grief he experienced as a result of his wife's death. With eyes closed to this world, Beatrice receives a white poppy, symbolic of death, from a haloed red bird, while a divine light of spiritual rebirth illuminates the scene. In the background the image of love is depicted in a red dress, which hints at the path to immortality.

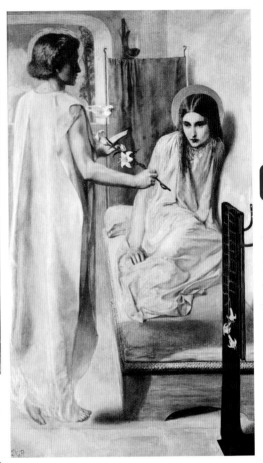

■ **Ecce Ancilla Domini! (The Annunciation)**, 1849–50, oil on canvas, 72.4 x 41.9 cm, Tate Britain, London

Among the possible inspirations for this work are Simone Martini, Sandro Botticelli, and Roger van der Weyden. Contrary to tradition, Rossetti shows Mary rising from her bed, interrupted from her sleep. The focal point is the white lily, which is being carried by Gabriel. The whiteness of the lily is the unifying element of the composition.

Dante Gabriel Rossetti

James McNeill Whistler

James Abbott McNeill Whistler
1834, Lowell–1903, Chelsea, London

■ His paintings drew from Japanese and Chinese art, which can be seen in his composition and the minimalism of his palette ■ Believed art should focus on arrangement of colors ■ His titles focused on formal elements in paintings

■ **1834** Born on July 11
1856 Studies under Gleyre in Paris
1859 Settles in London
1884 Becomes a member of the Society of British Artists
1886 Receives the post of president of the Society of British Artists
1892 Awarded Légion d'Honneur
1898 Becomes president of the International Society of Sculptors, Painters, and Gravers
1903 Dies on July 17

■ **Arrangement in Grey and Black: Portrait of the Painter's Mother**, 1871, oil on canvas, 144.3 x 162.5 cm, Musée d'Orsay, Paris

The title of the painting points to the artist's desire to focus on the formal aspects of the subject matter and tonal qualities of the work, rather than on any hidden symbolic significance. At the same time, Whistler sensitively conveys the strength of her character through her dignified pose and the haunting profile.

The American-born James McNeill Whistler spent the majority of his life in Europe. Whistler's public persona of a dandy was partly responsible for his unprecedented recognition by the Parisian modern masters Édouard Manet (p. 354) and Edgar Degas (p. 360). His works exemplified the nondidactic aesthetic of the art for art's sake movement. His palette is restricted and subtle.

Whistler collected Japanese prints and Chinese blue-and-white pottery. His art drew on the culture of the Orient, which was becoming a popular inspiration for the French Modernists at the time. His paintings and his interest in design and architecture reveal an incorporation of the non-Western aesthetic of the decorative and non-monumental.

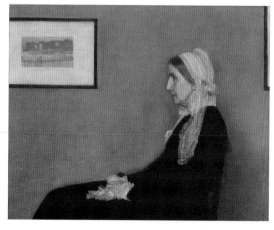

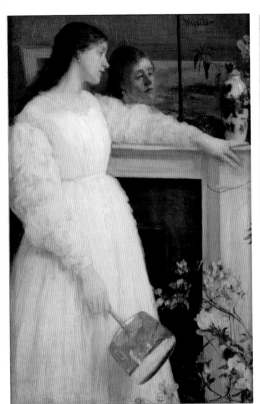

Other Works by Whistler

Nocturne in Black and Gold: The Falling Rocket, 1875, oil on wood, 60.3 x 46.6 cm, Detroit Institute of Arts

Symphony in White, No. 1: The White Girl, 1862, oil on canvas, 214.6 x 108 cm, National Gallery of Art, Washington, DC

Fighting Peacocks, 180.3 x 472.5 cm, Freer Gallery, Washington, DC

At the Piano, 1858–59, oil on canvas, 67 x 91.6 cm, Taft Museum, Cincinnati

Arrangement in Grey and Black, No. 2: Portrait of Thomas Carlyle, 1872–73, oil on canvas, 171.1 x 143.5 cm, Glasgow Museum and Art Gallery

■ **Symphony in White, No. 2: The Little White Girl**, 1864, oil on canvas, 76.5 x 51.1 cm, Tate Britain, London

The work's style draws on Velásquez's *Toilet of Venus* for its composition and on the Pre-Raphaelites for its stylistic characteristics. A young woman in a floating, light white gown, holding a Japanese fan, is captured in the moment of looking at her reflection in the mirror over the fireplace. Her face, framed by red hair, appears in reflection as pensive and melancholy. The work, which is highlighted by several smudges of bright red, pink, and blue, otherwise retains a narrow palette of neutrals, characteristic of Whistler. A poem by Swinburne dedicated to the painting is glued to its frame.

Jean-Baptiste-Camille Corot

1796, Paris–1875, Paris

■ Became one of the most influential members of the Barbizon School ■ As a landscape painter, he affected the development of Impressionism, anticipating its plein-air technique ■ As a figure painter, he influenced later artists including Degas and Picasso, who explicitly refer to Corot's innovations

Naturalism in France

● **1796** Born July 16 in Paris
1822 Begins working as a painter in the studio of Michallon
1822 Moves to the studio of Jean-Victor Bertin
1825 Spends three years in Italy
1845 Commissioned by the city of Paris to paint an altarpiece for a Parisian church
1848 Elected to the Salon Jury and again in 1849
1854 Visits Auvers, travels in Holland and Belgium
1855 Wins a first-class medal at the World Exhibition
1875 Dies on February 22 in Paris

Jean-Baptiste-Camille Corot is a representative of the Barbizon School of art, which drew on the Neoclassical tradition of landscape painting, introducing more contemplative, poetically romantic, and idyllic scenes of nature. Although he began as a history painter, Corot is most famous as a landscape artist who inspired later generations of painters through his directness in naturalistic images. Stylistically, his brushstrokes are soft and his lighting is luminous. Contrary to his personal dislike of modernity and urbanity, Corot is considered to be one of the important sources for the Impressionists. Primarily, it was the nonnarrative, nonidealized, and nonaffected quality of his paintings that made him an unlikely model for the 19th-century avant-garde. In the later years of his artistic career, Corot began producing images of female nudes that would influence van Gogh (p. 386) and Gauguin (p. 390).

■ **Bridge at Narni**, 1826, oil on paper, 34 x 48 cm, Musée du Louvre, Paris

The small, brightly colored landscape is free of human figures. The painting retains the artist's characteristic softness of focus and fluidity of composition. The planes between foreground and background are not clearly differentiated, producing an impression of a large distance between the viewers and the scene. Yet the delicate greens and browns remain clear and vivid.

19th Century

■ **The Bath of Diana**, 1855, oil on canvas, 168 x 257 cm, private collection

The Bath of Diana illustrates the artist's interest in classicizing genre paintings that combined images of serene landscapes with human figures. Corot, who never fully embraced the inno-

vations of the Barbizon School, did not focus here on nature as the exclusive subject of the painting. Rather, he delegated the landscape to the more traditional role of setting for the narrative. Although the narrative is traditional, Corot's painting lacks mythical symbolism.

■ **Woman with a Pearl**, ca. 1869, oil on canvas, 70 x 55 cm, Musée du Louvre, Paris

This portrait of a young girl in Italianate dress is one of the best figure studies by the painter. The palette is almost monochromatic, focusing the attention on the model. Among the possible influences is Leonardo's *La Belle Ferronnière*, which could have provided the inspiration for both the pose and the costume.

The composition is constructed along the lines of a theater set, where the actors perform among the feathery trees on a dimly lit set. The soft yet formal style of the *Bath of Diana* probably served as inspiration for Paul Cézanne's images of nude bathers (p. 384).

Other Works by Corot

Repose, 1860, oil on canvas, Corcoran Gallery, Washington, DC

Orpheus Leading Eurydice from the Underworld, 1861, oil on canvas, Museum of Fine Arts, Houston

Souvenir of Mortefontaine, 1864, oil on canvas, Musée du Louvre, Paris

Agostina, ca. 1866, oil on canvas, National Gallery of Art, Washington, DC

Jean-Baptiste-Camille Corot

Jean-François Millet

1814, Gruchy—1875, Barbizon

■ His genre works are unusually monumental ■ Achieved fame mainly after his death, living the majority of his life in poverty, supporting himself by portrait painting ■ Among his influences were Paul Delaroche, Nicolas Poussin, and Eustache Le Sueur ■ Instrumental in the creation of the Barbizon School

1814 Born on October 4 to a peasant family

1833 Becomes an apprentice to a local portraitist

1835 Starts working in the studio of Lucien-Theophile Langlois

1837 Becomes a student at l'École des Beaux-Arts

1840 Has his first Salon exhibition

1849 Moves to Barbizon

1864 Receives a medal for his *Shepherdess Guarding Her Flock*

1868 Receives a Cross of the Légion d' Honneur

1875 Dies on January 20

Jean-François Millet belonged to the school of Realism. His drawings and his paintings of everyday life concentrated on rural scenes of northern Europe. Millet was born to a peasant family in Normandy, which influenced his preference for presenting rural life as a universal and idealized vision of humanity. He rendered French peasants as figures with a transcendant inner nobility and included their back-breaking work in his compositions. However, Millet's portrayal of the common people was defined more by a personal connection to their way of life than by his politics. His focus on ordinary people attracted artists such as Monet (p. 370), Pissarro (p. 358), and van Gogh (p. 386). Millet's stylistic characteristics, such as his light palette, vigorous brushwork, and fondness for pastels, also impacted the development of Impressionism.

■ **Death and the Wood-cutter**, 1858–59, oil on canvas, 77.5 x 98.5 cm, New Carlsberg Glyptotek, Copenhagen

The painting represents an imagined scene of the sudden arrival of a white-hooded Death before a woodcutter. The surprised woodcutter drops his work, recoiling from Death's hand, slumping down into eternal sleep. Death carries its traditional attributes—a scythe and an hourglass.

19th Century

■ **The Gleaners**, 1857, oil on canvas, 33 x 44 cm, Musée du Louvre, Paris

One of the most famous of Millet's works, *The Gleaners* portrays the collecting of the harvest leftovers, which is one of the least respected agricultural activities. The sympathetic portrayal of the three peasant women contrasts with their implied social status. Their bodies are illuminated by an almost divine sunlight, presenting them with a religious sacredness. The women take on a monumental significance. Their slow movements are as enduring and timeless as the expansive field and sky that stretch beyond the line of the horizon, and the tediousness of the work can be sensed.

■ **The Sower**, 1850, oil on canvas, 101.6 x 82.6 cm, Museum of Fine Arts, Boston

This large-scale painting presents a towering, muscular figure, depicted in a momentous style. Reminiscent of Michelangelo (p. 150), the peasant is glorified. The whole composition centers on the gesture of sowing, caught in midair, creating the effect of a suspended motion.

Other Works by Millet

The Walk to Work, 1851, oil on canvas, private collection

The Angelus, 1857–59, oil on canvas, Musée d'Orsay, Paris

Man with a Hoe, 1860, oil on canvas, Getty Center, Los Angeles

Potato Planters, ca. 1861, oil on canvas, Museum of Fine Arts, Boston

Jean-François Millet

Gustave Courbet

1819, Ornans–1877, La Tour du Peilz

■ Conceived of his works as vehicles for establishing social justice by transcending class differences ■ Originated and led the French Realist movement, which he defined as a pictorial technique, as well as an outlook on life in general ■ Works featured ordinary subjects, given a dramatic flair

■ **1819** Born on June 10 in Ornans

1839 Travels to Paris, where he studies with Charles Steuben

1855 Turned down by the World Exhibition, he organizes his own exhibition, "Le Réalisme"

1870 Placed, by the Commune, in charge of the Parisian art museums

1870 Is awarded but refuses to accept the Légion d'Honneur from Napoleon

1871 Arrested and imprisoned

1872 Settles in Switzerland

1877 Dies in Tour du Peilz, Switzerland, on December 31

Other Works by Courbet

The Meeting, 1854, oil on canvas, Musée Fabre, Montpellier

The Painter's Studio: A Real Allegory, 1855, oil on canvas, Musée d'Orsay, Paris

L'Origine du Monde, 1866, oil on canvas, Musée d'Orsay, Paris

Active during the 19th century, Gustave Courbet established the movement of Realism in French art by rejecting most of the earlier traditions in favor of candid representations of reality. He created figure compositions, nudes, still lifes, landscapes, and portraits. Courbet's provocative style focused on ordinary subjects and was based on direct observation of these subjects, avoiding any idealization of their shapes or proportions. The artist also introduced an unusual method—using a palette knife to build up a surface of pigment on his canvases to create a tactile, realistic brushwork. Courbet's method of representation was inspired by such naturalistic artists as the Le Nain brothers, Géricault (p. 328), and Millet (p. 346).

■ **The Stone Breakers,** ca. 1849, oil on canvas, 170 x 300 cm, destroyed during World War II

The large-scale painting captures a scene from the lives of ordinary workers. The figures of two men, old and young, represent the hardships that transcend generations. Stone breaking is particularly strenuous work.

■ **Young Ladies on the Banks of the Seine**, 1856–57, oil on canvas, 174 x 200 cm, Musée du Petit Palais, Paris

This piece is an example of how Courbet deals with the bourgeoisie. Unlike his other works, which primarily deal with average folk and workers, in *Young Ladies on the Banks of the Seine*, Courbet depicts the two women in a drowsy summer atmosphere with a vibrant palette. The setting and positioning of the figures are very naturalistic, giving the viewer the impression of being a voyeur who has happened upon the lounging women.

■ **A Burial at Ornans**, 1849–50, oil on canvas, 314 x 663 cm, Musée d'Orsay, Paris

One of Courbet's most famous works, *A Burial at Ornans* was presented at the Salon by the artist when he was still relatively unknown in the Parisian art world. Here he treats a new subject on a grand scale. Earlier depictions of burials were often religious depictions of Christ or saints, or deal with the death of someone from nobility. Here, however, average, middle-class people are arranged in a Classical, friezelike manner, attending the funeral of one of their own. Because of the grand scale and Classical treatment of such a mundane subject as country people, this painting was quite controversial.

Gustave Courbet

Ilya Repin

1844, Chuguev–1930, Kuokkala

■ The Russian painter's work contained all the components of 19th-century Realism ■ Famous as a sensitive portraitist who revealed individual personalities ■ Represented social subject matter and produced moody landscapes ■ Characterized by a saturated palette and attention to detail

1844 Born in the Ukraine

1858 Apprentices to an icon painter

1864–71 Enrolls at the St. Petersburg Academy of Arts

1873–76 Lives in Paris

1876 Becomes a member of the Academy

1878 Joins the Abramtsevo Circle

1894 Becomes a professor at the Academy

1898 Becomes director of the Academy

1900 Moves to Finland

1930 Dies in Kuokkala

■ **Ivan the Terrible and His Son, Ivan, November 16, 1581**, 1885, 199.5 x 254 cm, oil on canvas, Tretyakov Gallery, Moscow

One of Repin's few historical works, this bloody scene of familial murder presents an event from the past in a universally readable narrative. It depicts the aftermath of the crime, focusing on the dynamic between the horrified father, despairing at his actions, and the helpless, dying son.

Ilya Repin is the most famous 19th-century Russian Realist painter. His works range from depicting contemporary Russian life to landscapes to portraits to historical scenes. The human figure remained his focus, and even his landscapes are often populated by people. His intense but reserved style held a momentous sway over the development of Russian art during his time and beyond. Stylistically, his palette was bright and lively, contrasting with the often gloomy narratives in his works. Repin's scenes are frequently socially critical, representing the hardships of the lower classes in the Russian Empire with remarkable sympathy. His historic scenes are highly dramatic, and his portraits are extraordinary psychological observations.

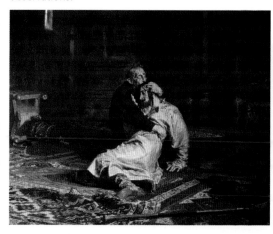

■ **Autumn Bouquet: Portrait of Vera Il'yinichna Repina, Daughter of the Artist**, 1892, 111 x 65 cm, oil on canvas, Tretyakov Gallery, Moscow

Repin was renowned as a skilled portraitist. *Autumn Bouquet* is a bright and lively portrait of the artist's daughter in the natural setting of an orchard in the fall. The vitality of the colors of her bouquet matches the warmth of the girl's face, offsetting the coolness of the landscape and gray sky.

Other Works by Repin

Reply of the Zaporozhian Cossacks to Sultan Mahmoud IV of Turkey, 1880–91, Russian Museum, St. Petersburg

Religious Procession in Kursk Province, 1880–83, Tretyakov Gallery, Moscow

Realism in Russia

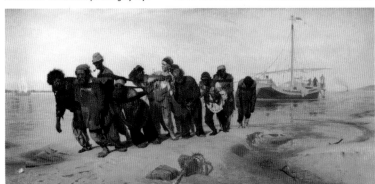

■ **Bargemen on the Volga**, 1870–73, oil on canvas, 131.5 x 281 cm, Russian Museum, St. Petersburg

The painting introduces the subject of the hardship of physical labor on a monumental scale. Repin drew his images of haulers from direct observation during his trip along the Volga River. The haulers are portrayed individually, with distinct characteristics of age, features, and body types, as though in a group portrait.

Ilya Repin

Adolph von Menzel

Adolph Friedrich Erdmann Menzel
1815, Wroclaw—1905, Berlin

■ Depicted historic genre scenes from the life of Frederick the Great and keenly observed scenes from everyday life ■ Became a celebrity in Prussian society and was honored many times, receiving the Order of the Black Eagle

- **1815** Born in Wroclaw
1833–34 Attends the Royal Academy of Art, leaves after six months
1839 Commissioned to illustrate Franz Kugler's History of Frederick the Great
1853 Joins the Royal Academy of Art
1875 Appointed a professor and to the Senate
1855 Travels to Paris
1867 Receives the Cross of the Légion d'Honneur
1884 Has his first solo show
1885 Receives a doctorate from Berlin University
1905 Dies in Berlin

Adolph von Menzel belonged to the school of German Realism. Although he did not receive any official artistic training and was ultimately self-taught, he achieved international celebrity and was awarded numerous national honors. During his prolific artistic career he produced more than 10,000 works. As a Realist, he strove for an objective, true-to-life representation of the world. Menzel's fame grew after he created 400 engravings to illustrate a book about the life of German Emperor Frederick the Great and subsequent other books on the emperor and the Prussian Army. His works—from historical paintings to genre scenes—are typically well-researched, extremely observant, and full of exact details. His choice of color, lighting, and his overall modern style of painting preempted the Impressionist movement.

Works by von Menzel

Presentation of Rewards to the Participants of the Festival, 1829, 1854, Hermitage, St. Petersburg

The Departure After the Party, 1860, Carnegie Museum of Art, Pittsburgh

Afternoon in the Tuileries Gardens, 1867, National Gallery, London

Interior of St. Peter's Church in Vienna, 1873, Regional Art Gallery, Liberec, Czech Republic

■ **Room with Balcony**, 1845, oil on cardboard, 58 x 47 cm, Alte Nationalgalerie, Berlin

The painting shows Menzel's room in Berlin. The composition is very original; with its empty center and absence of human figures anywhere in the scene, the subject matter is new—an interior. The artist's modern, vigorous brushwork and saturated palette curiously predate the Impressionist works of Degas (p. 360).

■ **A Flute Concert of Frederick the Great at Sanssouci**, 1850–52, oil on canvas, 142 x 205 cm, Nationalgalerie, Berlin

This is an example of a historical genre. Traditionally, historical paintings focus on the highest dramatic moment, but Menzel's scene opposes this conventional manner and instead depicts a pleasant, soothing scene. The lighting is warm; candles accentuate the vibrant pinks and blues.

■ **Portrait of General Hans Karl von Winterfeldt**, 1860, charcoal and pencil on paper

One of numerous portraits of dignitaries produced by the artist, this image avoids any idealization. The work exemplifies the expert skill of Menzel as a Realist draftsman. He has captured an exact likeness of the sitter.

Adolph von Menzel

Édouard Manet

1832, Paris–1883, Paris

■ His controversial works set in motion an avant-garde group of artists who would comprise Impressionism ■ His works focused on the passing moments of modern life ■ His style was characterized by an unforgiving and candidly observed realism ■ His brushwork was intentionally visible and unpolished

● **1832** Born on January 23 in Paris

1850 Begins artistic training with Thomas Couture

1853 Travels to Italy

1856 Establishes his own artistic studio

1856–57 Travels to northern Europe and Italy

1863 Exhibits at the Salon des Refusés

1867 Organizes a major exhibition paralleling the Exposition Universelle

1881 Receives a second-class Légion d'Honneur Award

1883 Dies on April 30

The name Édouard Manet is usually placed at the origin of the history of modern art. This French painter, who focused on scenes of contemporary life, was the first to concentrate primarily on the material visibility of paint. In order to challenge the traditional approach to painting, he provocatively revealed the mechanics of painting itself, rather than solely exploring the subject matter represented by an artwork. He was a revolutionary figure who bridged two movements—Realism and Impressionism. Inspired by Velázquez (p. 260) and Goya (p. 308), he would later influence Degas (p. 360) and Monet (p. 370).

Although he was admired by the Impressionists and was a supporter of the style, he never counted himself among them. Manet differed from the Impressionists in that he never adapted the plein-air practice of paint- ⟶

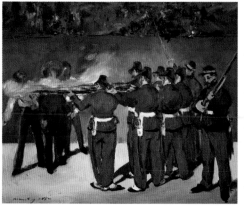

■ **Execution of the Emperor Maximilian of Mexico**, 1867, oil on canvas, 252 x 305 cm, Staatliche Kunsthalle, Mannheim

The subject of this painting, which was directly inspired by a similar work by Goya, depicts an incident from contemporary history. Just as Goya did, Manet reinterpreted the genre of history painting in terms of modernity. The artist's detached representation is conveyed by the cool atmosphere of the work, achieved by the icy palette of grays, greens, and blues, the severe lighting, and the strong geometric shapes.

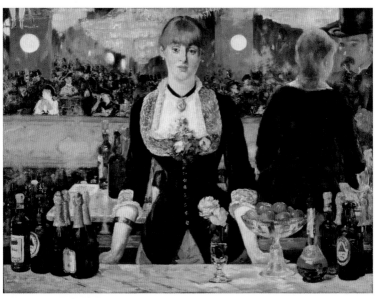

■ **A Bar at the Folies-Bergère**, 1882, oil on canvas, 96 x 130 cm, Courtauld Institute of Art, London

This painting was the last important work by the artist before his death. It depicts a scene at the Parisian nightclub Folies-Bergère. A modern reinterpretation of Diego Velázquez's *Las Meninas* (p. 265), it explores the rendering of mirror reflection and doubling. The image is primarily a portrait of a barmaid, facing the viewers from behind a bar. The mirror reflects the crowd in attendance.

■ **Berthe Morisot**, 1872, oil on canvas, 55 x 40 cm, Musée d'Orsay, Paris

A starkly lit portrait depicts French painter Berthe Morisot, who was married to Manet's brother. Manet did several portraits of the sitter. This work explores the possibilities of a limited palette with a predominance of black, linking the painting to the visual language of photography. Berthe Morisot appears exotic and broodingly beautiful.

Édouard Manet

ing in the outdoors, never surrendered his preference for pairing black with white, and never lost the strong outline of forms and figures in his paintings. Furthermore, the artist never completely relinquished his focus on the subject matter. As a controversial presence on the modern art scene, Manet anticipated Impressionism in his use of visible, free brushstrokes, saturated colors, the flattening of perspective, the absence of what was considered a significant narrative, and a focus on momentary scenes from modern life. His subjects included modern historic scenes, snapshots of Parisian night life, images of urban dwellers in outdoor settings, portraits, and still lifes. His art was often considered scandalous for its suggestive subject matter.

Other Works by Manet
The Dead Toreador, 1864, oil on canvas, National Gallery of Art, Washington, DC
The Fifer, 1866, oil on canvas, Musée d'Orsay, Paris
Portrait of Émile Zola, 1868, oil on canvas, Musée d'Orsay, Paris
The Balcony, 1868, oil on canvas, Musée d'Orsay, Paris
Breakfast in the Studio, 1868, oil on canvas, Neue Pinakothek, Munich
Nana, 1877, oil on canvas, Hamburger Kunsthalle, Hamburg

■ **Olympia**, 1863, oil on canvas 130.5 x 190 cm, Musée d'Orsay, Paris

One of the most influential paintings in the history of modern art, this painting draws on the traditional Renaissance representations of Venus for influence. Titian's *Venus of Urbino* (p. 166) was *Olympia's* direct pictorial source. Instead of a goddess, Manet depicts a courtesan, serene and alluring, with a flower in her hair, a black neck ribbon, and an ornamental shawl beneath her. The black kitten at her feet fuels the sense of feminine prowess.

■ **Luncheon on the Grass**, 1862–63, oil on canvas, 208 x 265.5 cm, Musée d'Orsay, Paris

The work was originally titled *The Bath (Le Bain)* and when it was first exhibited it caused a public scandal. In this grand painting, the artist re-invented the traditional genre of a French mythological pastoral, which would have ordinarily figured nymphs in natural surroundings. A combination of realistically depicted nude women and stylishly dressed men was perceived as outrageous by its 19th-century audience. The woman in the foreground is presented without pretense of idealization or literary reference. She meets the viewers' gaze calmly and directly, unconcerned with her nudity. This scene is particularly provocative because the men, lost in an exchange with each other, are equally casual about the women's appearance.

Camille Pissarro

Jacob Camille Pissarro
1830, Charlotte Amalie–1903, Paris

■ Used diverse techniques, often within the same painting ■ Had no clear followers, except his son ■ Lived in poverty throughout most of his life ■ Famous for his art and for his radical political views

Camille Pissarro was an important French Impressionist painter, who greatly contributed to the development of both Impressionism and Post-Impressionism. He participated in all of the Impressionist exhibitions, which he was highly instrumental in establishing. A person of great integrity, the artist was well respected within his artistic circle. He collaborated with Monet (p. 370), Gauguin (p. 390), and Cézanne (p. 382), forging an especially close bond with the latter. His subjects were primarily rural and urban French landscapes, which were sometimes populated by figures of peasants or even city dwellers. His style was less constant than his contemporaries', which made him an unlikely model to follow. Throughout his career, Pissarro continuously experimented with various techniques. In his works, he adapted Impressionism, Neo-Impressionism, and Pointillism as a model for his brushwork and composition, and even sometimes combined a range of styles within the same painting.

■ **Foxhill, Upper Norwood**, 1870, oil on canvas, 34.9 x 45.7 cm, National Gallery, London

While staying in England during the Franco-Prussian War, Pissarro produced several landscapes of the English countryside. The road curves into the composition, creating a diagonal entry into the scene.

■ **Peasants Resting**, 1881, oil on canvas, 82 x 66 cm, Toledo Museum of Art

This Impressionist work shows two women relaxing in the forest. The women have intentionally awkward poses and there is a lack of differentiation between the planes of their bodies. This results in their pictorial absorption into the landscape, signifying their oneness.

Other Works by Pissarro

The Red Roofs, 1877, oil on canvas, Musée d'Orsay, Paris

Peasant Girl Drinking Her Coffee, 1881, oil on canvas, Art Institute of Chicago

Young Girl With a Stick, 1881, oil on canvas, Musée d'Orsay, Paris

Boulevard Montmartre: Rainy Weather, Afternoon, 1897, oil on canvas, private collection

■ **L'Avenue de l'Opera, Snow, Morning**, 1898, oil on canvas, 65 x 82 cm, Museum of Fine Arts, Houston

A diverse crowd of Parisians, rendered in black, floods the crowded avenue, traveling in different directions. Pissarro creates a characteristically urban image of the ceaseless activity and movement of Paris. The dull, muted colors of his palette accentuate the weather that he is portraying—a snowy day.

Camille Pissarro

Edgar Degas

Hilaire Germain Edgar Degas
1834, Paris–1917, Paris

■ Degas began his career as a Classical painter of historic subjects ■ He was interested in representations of the human figure ■ Among his influences were Botticelli, Holbein the Younger, Poussin, and Japanese prints

Edgar Degas was one of the leading figures of French Impressionism. He produced numerous paintings, sculptures, prints, and sketches. Although he began his artistic career with the study of Classical art and was a follower of Ingres (p. 304) and Delacroix (p. 330), Degas soon began exploring his interest in scenes of modern 19th-century life. His main focus was the human figure in the contemporary setting. Degas's images of the body eventually became less and less idealized. His repertoire included scenes of the races, cityscapes, ballet dancers, and bathers. In presenting his compositions, Degas used his signature technique of structuring the scenes like accidental snapshots captured by an urban passerby.

The main difference between Degas and the Impressionists was his refusal to adapt the plein-air technique.

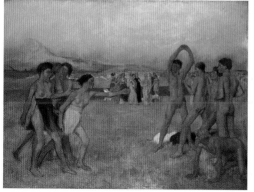

■ **Young Spartans Exercising**, ca. 1860, oil on canvas, 109.2 x 154.3 cm, National Gallery, London

Degas presented this painting at his debut showing in the official Salon. The work retains some traditional elements found in Neoclassical historical works, such as its literary source. However, at the same time, this canvas is characterized by a purely modern lack of idealization of the human body, and the figures tend to look slightly archaic.

■ **At the Races, Amateur Jockeys**, ca. 1876–80, oil on canvas, Musée d'Orsay, Paris

One of his favorite subjects, the horse races allowed Degas to explore the dynamics of the movement of horses and their riders. The painter, who was a frequent observer at the races, created sketches from life. Though he did not actually paint at the races, once back in his studio, he combined sketches to develop bright and seemingly spontaneous paintings.

■ **Portraits in a New Orleans Cotton Office**, 1873, oil on canvas, 74 x 92 cm, Musée des Beaux-Arts, Pau

As a part of Degas's paintings presenting snapshots of modern life, this image captures a moment in a busy day at the New Orleans Cotton Exchange. With his typically detailed insight, the artist observes the formally clad businessmen at work. The contrasting colors of their black-suited silhouettes on the soft green and sandy brown background infuse each gesture with a sense of significance and portray the men in a stark fashion.

Edgar Degas

■ Dancers, Coming up the Stairs, ca. 1886, oil on canvas, 39 x 86.9 cm, Musée d'Orsay, Paris

A snapshotlike capture of a random moment in the dance studio.

Despite this difference, Degas, in his choice of ordinary subjects from everyday life in 19th-century Paris, his exploration of the medium of pastels, his creation of recurring images of the same subject in various settings, and his use of asymmetrical compositions, which drew on contemporary developments in photography and Japanese prints, was an Impressionist artist. His palette is characterized by saturated and bold colors and visible impasto brushwork—a technique that involves a thick layering of paint on the canvas. Degas's painting technique later influenced Mary Cassatt (p. 378), Walter Sickert, and Henri de Toulouse-Lautrec (p. 380).

Other Works by Degas

The Dancing Class, ca. 1873–75, Musée d'Orsay, Paris

Henri Rouart in Front of His Factory, ca. 1875, Carnegie Institute Museum of Art, New York

Place de la Concorde, 1876, Hermitage, St. Petersburg

The Absinthe Drinker, 1876, Musée d'Orsay, Paris

Woman Ironing, 1882, National Gallery of Art, Washington, DC

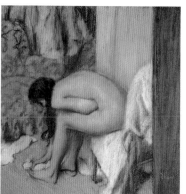

■ Nude Wiping Her Left Foot, ca. 1885–86, oil on canvas, 54 x 52 cm, Musée d'Orsay, Paris

In Degas's images of bathers, he avoided any idealization of the bodies, representing their shapes and dynamics with detached realism.

■ Little Dancer, Aged Fourteen, ca. 1881, bronze, polychrome paint, tulle skirt, satin bow, wood stand, height 98 cm, Tate Modern, London

Going blind in his last years, Degas turned to creating sculptures of dancers.

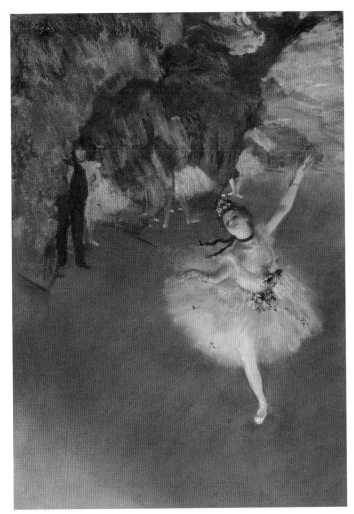

■ **Prima Ballerina**, 1876–77, pastel on paper, 58 x 42 cm, Musée d'Orsay, Paris

Degas's images of ballet dancers explore the movement and physicality of the female body. The use of pastels allows the painter to focus on the labored pose and tense expression of the star on stage while maintaining the dreamlike atmosphere of the stage lights.

Edgar Degas

Auguste Rodin

François-Auguste-René Rodin
1840, Paris–1917, Meudon

■ Received traditional training in the Academy ■ His monumental sculptures were intensely realistic ■ As a sculptor, Rodin was responsible for modernizing art ■ His fame subsided after his death but was revived shortly thereafter

1840 Born December 12
1864 Rejected by the Salon
1877 Shows *The Age of Bronze* at the Salon
1889 Helps establish the Société Nationale des Beaux-Arts
1893 Chosen as President of Sculpture of the Société Nationale des Beaux-Arts
1900 Knighted by the Order of Leopold of Belgium
1903 Becomes the Commander of the Légion d'Honneur
1917 Dies on November 17

Auguste Rodin was a central figure in the development of French sculpture, and his influence drastically redefined the genre. His exploration of tension and dynamism was combined with nudes that drew on the tradition of Michelangelo (p. 150). In his works, he did not attempt to fool the viewer into believing the illusion of sculpted reality. On the contrary, his sculptures freely reveal their man-made nature through their rough finishes and in the way that they seem to still be in the process of emerging from the medium. Rodin's radical new vision was bolstered by his skilled formal representation of the human intellect. His revolutionary approach to the depiction of the human form, which was his fundamental subject, escaped any overt literary, historical, or mythological allusions and avoided narratives.

■ **The Thinker**,
1881, bronze,
71.5 x 40 x 58 cm
Musée Rodin, Paris

The Thinker started as an element of *The Gates of Hell*, and was intended to represent Dante, author of *The Divine Comedy*. It was designed to function as a door for the Parisian Musée des Arts Décoratifs. Today the sculpture appears as the embodiment of heroic strength and intelligence and the work is widely copied.

Other Works by Rodin

The Age of Bronze, ca. 1877, plaster, Musée d'Orsay, Paris

The Gates of Hell, 1880–1917, bronze, Rodin Museum, Philadelphia

The Burghers of Calais, 1884–86, bronze, Rodin Museum, Philadelphia

Iris, Messenger of the Gods, 1890, bronze, Los Angeles County Museum of Art

Amor and Psyche, ca. 1890, marble, Musée du Petit Palais, Paris

Eve, ca. 1902, bronze, Walker Art Gallery, Liverpool

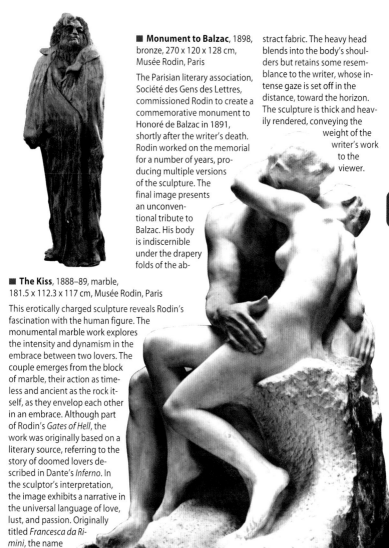

■ **Monument to Balzac**, 1898, bronze, 270 x 120 x 128 cm, Musée Rodin, Paris

The Parisian literary association, Société des Gens des Lettres, commissioned Rodin to create a commemorative monument to Honoré de Balzac in 1891, shortly after the writer's death. Rodin worked on the memorial for a number of years, producing multiple versions of the sculpture. The final image presents an unconventional tribute to Balzac. His body is indiscernible under the drapery folds of the abstract fabric. The heavy head blends into the body's shoulders but retains some resemblance to the writer, whose intense gaze is set off in the distance, toward the horizon. The sculpture is thick and heavily rendered, conveying the weight of the writer's work to the viewer.

■ **The Kiss**, 1888–89, marble, 181.5 x 112.3 x 117 cm, Musée Rodin, Paris

This erotically charged sculpture reveals Rodin's fascination with the human figure. The monumental marble work explores the intensity and dynamism in the embrace between two lovers. The couple emerges from the block of marble, their action as timeless and ancient as the rock itself, as they envelop each other in an embrace. Although part of Rodin's *Gates of Hell*, the work was originally based on a literary source, referring to the story of doomed lovers described in Dante's *Inferno*. In the sculptor's interpretation, the image exhibits a narrative in the universal language of love, lust, and passion. Originally titled *Francesca da Rimini*, the name was changed to the broader *The Kiss*.

Auguste Rodin

Pierre-Auguste Renoir

1841, Limoges–1919, Cagnes

■ His works frequently portrayed bathers and women in domestic scenes and were characterized by an ennobling quality ■ He was the most popular and the most reproduced among all the Impressionist painters ■ The artist's paintings celebrated the joy and beauty of the everyday

■ **1841** Born on February 25
1854 Works as a porcelain painter
1860 Admitted to l'École des Beaux-Arts
1874–77, 1882 Exhibits with Impressionists
1877 Founds art magazine *L'Impressionniste*
1883 Solo exhibition
1891 Receives a commission from the Musée du Luxembourg
1919 Dies on December 3 in Cagnes

Auguste Renoir is one of the most renowned artists of the French Impressionist movement. His pictorial method of painting, revealed in his stylistic preferences, expresses a typically Impressionist manner of handling pigment and the construction of composition. Also, Renoir often painted outdoors. His style was influenced by his colleagues and friends, Manet (p. 354), Bazille, and Sisley, and his choice of subjects drew on the Rococo pastoral masters Boucher (p. 288), Watteau (p. 286), and Fragonard (p. 282).

During his artistic career, the painter evolved a great deal. He went through a range of subjects and styles. While his earlier works focused on scenes from 🔁

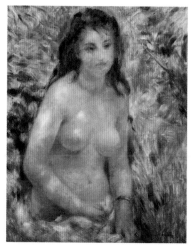

Other Important Works by Renoir	
Portrait de Romaine Lacaux, 1864, Cleveland Museum of Art	Phillips Memorial Gallery, Washington, DC
The Swing, 1876, Musée d'Orsay, Paris	Two Sisters, 1881, Art Institute of Chicago
The Luncheon of the Boating Party, 1881,	Bathers, ca. 1918, Barnes Foundation, Merion, Pennsylvania

■ **Nude in the Sunlight**, ca. 1876, oil on canvas, 81 x 64.8 cm, Musée d'Orsay, Paris

The image of a young woman is one of the signature subjects of the artist. Renoir focuses on the soft beauty of the nude, contrasting the silky texture of her skin, rendered in a luminous gold, with the rougher surfaces of the foliage that surrounds her. The painting comes alive as the specks of light play on her sensual body.

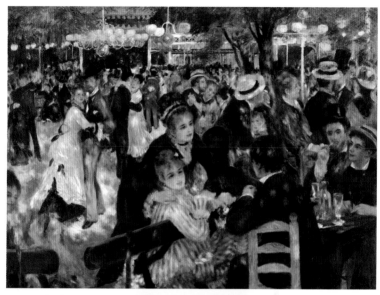

■ **Le Moulin de la Galette**,
1876, oil on canvas,
131 x 175 cm, Musée d'Orsay,
Paris

The setting for the multi-figured composition of this large-scale painting is an area near the Bohemian section of Paris, Montmartre, which was a popular place of entertainment for middle-class Parisians. The main characters are based on real Parisians—the women are Renoir's models and the men are his painter-colleagues. The painting is characteristically illuminated by a bright light, creating a play of sun specks and shadows on the dancing and sitting figures that populate the bustling scene.

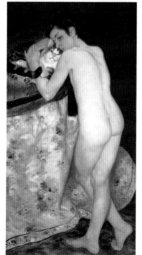

■ **Young Boy with a Cat**,
1868–69, oil on canvas,
124 x 67 cm, Musée d'Orsay,
Paris

There is no clearly recognizable narrative or any explicit significance to this chilly and distant image, which centers on the interaction between a boy and his pet. The youth is positioned with his back to the viewers, and while stroking the cat, he somewhat awkwardly looks over his shoulder. One of the earliest works by the artist, this portrait of a strikingly pale adolescent male nude is unusual both for Renoir, whose œuvre traditionally focuses on women or nature, and for the art world.

Pierre-Auguste Renoir

contemporary life, in his later creations he began to explore more traditional subjects—such as portraits and figural compositions. Despite these changes, throughout his career, Renoir remained continuously loyal to the theme of the nude. His approach to the representation of femininity drew on the well-established tradition of Rubens's (p. 234) sensual depictions of women. The latest phase in the painter's creative progression was particularly defined by a prolific production of female nudes. This change in subject matter was concurrent with a change in style. His style evolved from a more restrained decorative aesthetic—characterized by linearity and a cool palette, which was most likely inspired by Manet (p. 354)—into a more vigorous and seemingly spontaneous use of brushwork that employed brighter colors.

■ **The Bridge of the Railway at Chatou,** 1881, oil on fabric, 66 x 54 cm, Musée d'Orsay, Paris

One of the few nature scenes by the painter, the depiction of a foliage-covered landscape shows a location that seems to be outside of any modern urban metropolis. The work conveys a feeling of contentment. Despite this removed feeling, the painting also includes elements of technological progress, such as the railroad. These modern elements destabilize the seemingly pastoral joy of the scene.

■ **The Reader,** ca. 1874,
oil on canvas, 46.5 x 38.5 cm,
Musée d'Orsay, Paris

Both the composition and the
subject of this painting were in-
spired by a work by Fragonard
(p. 282). Unlike the earlier artist,
Renoir positioned the reader di-
rectly in the foreground, con-
fronting the viewer with her
gentle, freshly colored face,
which engages us despite the
fact that her eyes are half-
closed, concentrating on the
book. She is shown in a state of
absorption, half-smiling in re-
sponse to an inner thought set
off by her book.

Pierre-Auguste Renoir

Claude Monet

Oscar-Claude Monet or Claude Oscar Monet
1840, Paris–1926, Giverny

■ Monet's innovations had an impact on many artists ■ His style was characterized by rapid, visible brushwork and a bright palette ■ His works were usually finished in his studio ■ Monet's paintings created a material surface with paint

- ■ **1840** Born November 14
- **1845** Moves to Le Havre
- **1859** Starts studying at the Académie Suisse
- **1860** Serves in the military in Algeria
- **1862** Works in the studio of painter Gleyre
- **1865** Admitted to the official Salon in Paris
- **1870** Moves to London because of the war
- **1871** Moves to Argenteuil
- **1874, 1876–79** Participates in the Impressionist exhibitions
- **1883** Settles in Giverny
- **1926** Dies on December 5 in Giverny

Claude Monet was a founding member of French Impressionism, and remained a representative of the style throughout his artistic career. In fact, it was a painting by Monet, titled *Impression: Sunrise*, that gave the Impressionist movement its name after it was exhibited in the Salon. Monet was committed to the plein-air method of painting, the focus on landscape as his principal subject, and the exploration of the pictorial representation of the properties of light. His works also intentionally eschew any narrative. Instead, they focus on representing effects of sunshine and shadows in color.

His late works, which avoided featuring human figures and man-made objects completely, are especially representative of the theory of Impressionism. The subjects of his early works included street scenes of the city, images of industry, and snapshots of Parisians at the beaches ⬤

■ **Gare Saint-Lazare**, 1877, oil on canvas, 75.5 x 104 cm Musée d'Orsay, Paris

This interior image inside a famous train station in Paris, which Monet recreated seven times, explores the appearance of light through the clouds of steam. It represents one of the rare instances when the artist turned to the subject of modern industry and depicted a scene common to the urban life of Paris. Usually Monet's paintings depicted rural scenes from the countryside.

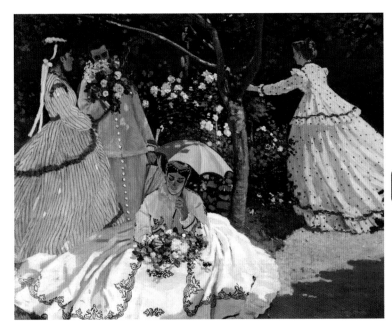

■ **The Magpie**, 1868–69, oil on canvas, 89 x 130 cm, Musée d'Orsay, Paris

This landscape's focus is on the interaction between light and snow. The artist's palette is severely reduced so that the luminous winter white of the snow works with the blue-gray and purple-gray of the shadows and the pale gold of the specks of sunlight.

■ **Women in the Garden**, 1866–67, oil on canvas, 256 x 208 cm, Musée d'Orsay, Paris

This grand early work includes human figures in the landscape, yet Monet treats them in the same manner as other natural elements. The artist principally focuses on the play of light and shadow on their bodies and the fabric of their clothes, rather than on their facial features.

Other Important Works by Monet	
Impression: Sunrise (Impression, soleil levant), 1872, Musée Marmottan, Paris	Madame Monet and Her Son Jean, 1875, National Gallery of Art, Washington, DC
The Boulevard des Capucines, 1873, Nelson-Atkins Museum of Art, Kansas City	Grainstack (Snow Effect), 1890, Museum of Fine Arts, Boston

Claude Monet

and in the gardens. He adapted a genre of painted series, which allowed the artist to explore the same subjects, such as haystacks, façades of buildings, and water lilies, with varied lighting or in different seasons and times of day. Monet's brushwork is characteristically Impressionistic, consisting of impasto strokes of color that build up the tactile surface of his paintings and lend to their dreamlike quality. His innovations had a significant effect on other Impressionists, who considered him to be a source of stylistic inspiration.

■ **The Cathedral of Rouen: The Portal and the Tour Saint-Romain, Bright Sun**, 1894, oil on canvas, 107 x 73 cm, Musée d'Orsay, Paris

An example of Monet's series depicting the Rouen Cathedral, this image of the church's west façade was based on several studies of the building. The actual painting was completed in the artist's studio from memory. Altogether, he created 20 paintings of the same subject. This image shows the building at sunrise and captures the glow of the morning on the façade, focusing on the play of colors in shadow and light. The thick impasto paint builds up and shapes the stone exterior. Shadowed recesses and illuminated planes effectively mold the surface.

■ **Water Lily Pond, Pink Harmony**, 1899, oil on canvas, 89 x 93 cm, Musée d'Orsay, Paris

After his move to Giverny, Monet began to paint images of the lily pond in the water garden he created on the estate (see photo). The flowers, pond vegetation, water, and reflections in the water are the only subjects of this painting. The pictorial treatment of the scene illustrates a characteristically Impressionistic focus on the painterly surface. The spatial flatness, the angle, and the arching bridge reveal the influence of Japanese prints on the Impressionist's style. The subject suited the artist's interest in the effects of light perfectly.

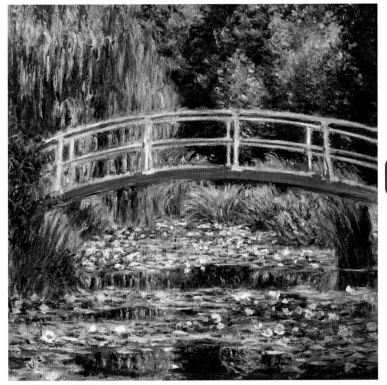

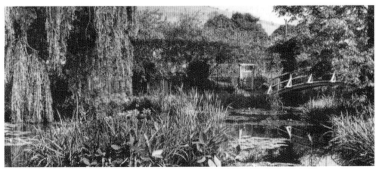

Claude Monet

Water Lilies

Having achieved public success, Claude Monet bought a house in Giverny and grew a beautiful water lily garden around the house, with a Japanese bridge leading across the pond. Having shaped an aesthetically

stunning setting, Monet began producing a series of images that featured his surroundings. From 1890 until his death, the artist retained a fascination with the subject of water lilies. As in his other thematic cycles, here Monet also explored

the varying effects of light throughout different times of day and in changing seasons on the same scene. By observing the same subject in different natural conditions, he was able to fully capture the essence of his subject.

Monet's water lilies record the minute changes in tone and light with scientific objectivity. In this way, these works reveal his remaining adherence to the more technical objectives of the Impressionist approach to representation. Yet the viewer cannot help but be struck by a sense of the personal significance of these works to the artist. The inanimate objects, such as water, sky, and flowers, come alive in these inspired works, where lively, vigorous brushwork creates an effect of vibrancy. Rather than a still surface, the water seems to quiver, and the peaks and valleys of faint ripples make the picture appear to be in constant motion. The water curves around the textured blooms, their stems, and the luxurious water foliage shifting in their reflections. The physical materiality of the built-up pigment conveys a sense of a palpable realistic presence and accurately conveys the serenity of the pond.

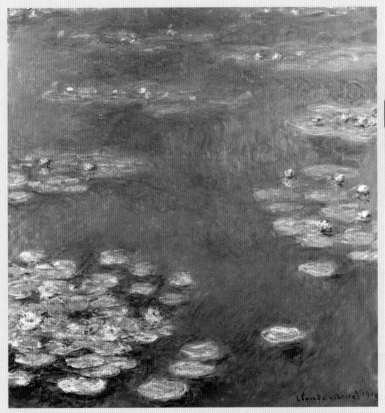

■ **Water Lilies**, 1908, oil on canvas, 92 x 89 cm, private collection

Monet's image of water lilies captures a transitory occurrence and infuses it with a sense of an overwhelming importance. Together with the impression of continuous, organic transformation, he conveys a feeling of the powerful vastness of the wild landscape, where water is the focus of the composition. The monumental panorama of the painting has no conventional narrative and instead presents the fleeting harmony of the moment.

Claude Monet

Georges Seurat

1859, Paris–1891, Paris

■ Pointillism was also known as Divisionism, since it broke down color into dots of pigment ■ Wanted to define the creative process in objective, technical terms ■ His theory was based on the contemporary understanding of optical color perception ■ The style anticipated Cubism and Constructivism

■ **1859** Born December 2 in Paris

1870s Enrolls at the drawing school in Paris, studies with the sculptor Justin Lequien

1878 Admitted at l'École des Beaux-Arts, studies with the artist Henri Lehmann

1879 Joins the military

1884 Becomes one of the founders of the Société des Artistes Indépendants

1886 Joins with the Impressionists for their last exhibition

1891 Dies on March 29

Other Works by Seurat

Seated Woman, 1883, Solomon R. Guggenheim Museum, New York

Bathers at Asnières,1884, National Gallery, London

Evening, Honfleur, 1886, Museum of Modern Art, New York

The Circus Sideshow, 1888, Metropolitan Museum of Art, New York

Le Chahut, 1889–90, Kröller-Müller Museum, Otterlo

Horses in the Water, ca. 1890, Courtauld Institute of Art, London

Georges Seurat was a leading representative of the Neo-Impressionist movement in 19th-century French art. He pioneered the style of Pointillism, a philosophy of color that relied on contemporary scientific understanding and theories of vision. By adopting such a philosophy as his approach to painting, Seurat attempted to create a system that would predetermine his palette by the way each color conveys a specific emotion. The artist believed that each variation in color corresponded to a viewer's emotional reaction, producing an effect of calmness, joy, or sadness. These reactions created a language, known as chromoluminarism. His monumental images consisted of variously colored points that, when viewed from afar, blended colors into subtle shading, formed shapes, and generated a modeling effect. His paintings focused on contemporary subjects and need to be viewed at a distance in order for the dots to coalesce into a coherent image.

■ **Model, Front View (Study for Les Poseuses)**, 1886–87, oil on wood, 25 x 16 cm, Musée d'Orsay, Paris

A nude figure, constructed of dots of predominantly blue and orange, appears to be frozen in a statuesque pose. The varying amounts of each color in different areas create shading and light.

Impressionism in France

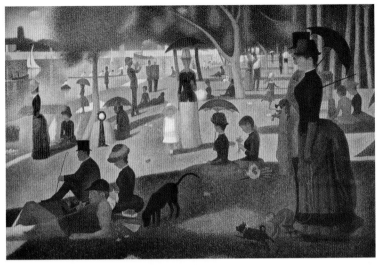

■ **Sunday Afternoon on the Island of La Grande Jatte**, 1884–86, oil on canvas, 207.6 x 308 cm, Art Institute of Chicago

The grand landscape, which was based on sketches from life, depicts an island retreat. A colorful urban crowd is enjoying a summer day. The figures convey an impression of immobility, because they are rendered geometrically. Even the shadows seem to be unable to move.

■ **The Circus**, 1891, oil on canvas, 186 x 150 cm, Musée d'Orsay, Paris

This painting was not finished at the time of its exhibition, but even as an incomplete work it reflects the mathematical harmony that is characteristic of Pointillism. The image of the circus performance is a collection of different types of figures rendered geometrically using circles, rectangles, and lines as the base for the composition. Diagonals and arcs give the image dynamism.

Georges Seurat

Mary Cassatt

1844, Pittsburgh–1926, Château de Beaufresne, near Paris

■ The American-born Mary Cassatt fully immersed herself in the culture of French Impressionism ■ She was greatly influenced by Japanese woodblock prints ■ Her feminine subjects were sensitive and strong at the same time

■ **1844** Born May 25 in Pittsburgh, Pennsylvania
1861 Starts the Pennsylvania Academy of the Fine Arts
1865 Travels to Europe
1868 Admitted to the Paris Salon
1877 Meets Degas
1879–86 Exhibits with the Impressionists
1893 Commissioned to create a mural for the Chicago Worlds Exposition
1904 Joins the Légion d'Honneur
1914 Awarded a gold medal by the Pennsylvania Academy
1926 Dies on June 14 near Paris

As a successful female painter, Mary Cassatt is unique in the history of 19th-century art. Although she was born in America, she spent most of her life in France, where she became one of the most successful artists among the Parisian Impressionists. Cassatt was principally influenced by Edgar Degas (p. 360), as well as by Renoir (p. 366) and Caillebotte, yet her style was deeply personal and individual. She limited her subjects to domestic representations of women with children performing household tasks or more glamorous images of women taking part in upper-class, urban leisure activities. Cassatt produced oil paintings, pastels, and, after becoming interested in Japanese art, started creating prints. Her paintings are characterized by an emotional realism of observation, unconventional compositional arrangements with seemingly spontaneous angles, reductive forms and shapes, and flattened spatial perspective.

Other Works by Cassat

Miss Mary Ellison, 1877, National Gallery of Art, Washington, DC

Little Girl in a Blue Armchair, 1878, National Gallery of Art, Washington, DC

Mrs. Robert S. Cassatt, The Artist's Mother, ca. 1889, Fine Arts Museums of San Francisco

The Bath, ca. 1891, Art Institute of Chicago

■ **Girl Arranging Her Hair**, 1886, oil on canvas, 75.1 x 62.5 cm, National Gallery of Art, Washington, DC

Here, the artist sympathetically interprets the frequently depicted subject of a woman at her toilet as an intimate moment. She constructed the composition to achieve the greatest possible harmonious effect, even intentionally arranging the furniture to echo the motion of the girl's arms.

■ **The Loge**, 1882, oil on canvas, 79.8 x 63.8 cm, National Gallery of Art, Washington, DC

Another popular theme, women at the theater, allowed the artist to reflect on the projected social image of women in public settings. Cassatt depicts two young women in expensive box seats. One of the women hides shyly behind her fan, while the other sits confidently forward. The lavish dresses, fan, and background reflect the opulence of the theater experience.

■ **The Boating Party**, 1893–94, oil on canvas, 90.2 x 117.5 cm, National Gallery of Art, Washington, DC

The Boating Party reveals the influence of Japanese prints on Cassatt's style. It is most explicitly visible in the asymmetrical positioning of the human figures, the sparsity of the composition, the opaque colors, and the spatial shallowness. The artist's main subjects are the woman and child.

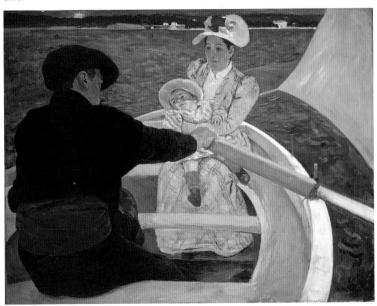

Mary Cassatt

Henri de Toulouse-Lautrec

Henri Marie Raymond de Toulouse-Lautrec-Monfa
1864, Albi–1901, Malromé

■ Was a frequent visitor of the places he depicted, including cabarets, theaters, and the brothels of Montmartre ■ Collected Japanese art, which influenced his diagonal compositions, opaque colors, and flat perspective

■ **1864** Born Henri Marie Raymond de Toulouse-Lautrec-Monfa

1881 Moves to Paris

1882 Studies with Léon Bonnat and Fernand Cormon

1888 Joins Les XX, a group of Modernists in Brussels

1889 Exhibits at the Salon des Indépendants

1897 Committed to a mental hospital

1901 Dies in September

Henri de Toulouse-Lautrec was a French artist who is most famous for his lithographs, illustrations, and posters which featured the decadent nightlife of 19th-century Paris. Born to an aristocratic family, Toulouse-Lautrec's choice of artistic profession was in part due to a debilitating illness (his legs ceased to grow at the age of 14) that precluded him from living a physically normal life. However, as an avant-garde artist and a representative of the contemporary bohemian lifestyle, Toulouse-Lautrec enjoyed a vital, unconventional life. His provocative works represent the theaters, cabarets, brothels, and cafés of the bohemian area of Paris, Montmartre.

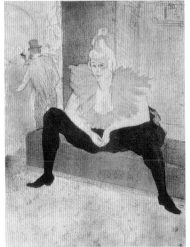

Other Important Works by Toulouse-Lautrec	
Ambassadeurs: Aristide, 1892, Bruant, private collection	Yvette Guilbert Greeting the Audience, 1894, Musée Toulouse-Lautrec, Albi
Rue des Moulins, 1894, National Gallery of Art, Washington, DC	The Passenger of 54–Yacht Cruise, 1896, Städel Museum, Frankfurt

■ **Seated Female Clown, Mlle. Cha-U-Kao**, 1896, 52.7 x 40.5 cm, publisher Gustave Pellet, Paris

Toulouse-Lautrec's posters are iconic of shows. This Japanese-inspired work portrays a famous entertainer who was popular in fin de siècle Paris, named Cha-U-Kao, who performed at the Moulin Rouge cabaret. The bright palette of the poster consists of black, red, and yellow. The work displays the model in an indecorous pose, with her legs spread wide apart and clasped hands, sitting near the entrance.

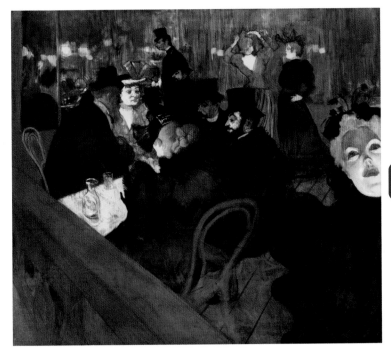

■ **At the Moulin Rouge**, 1892, oil on canvas, 133.5 x 141 cm, Art Institute of Chicago

The setting of this work is a snapshot of a crowd of visitors at the Moulin Rouge. The scene is harshly lit and conveys a somewhat ominous atmosphere at the bohemian haunt. The painting focuses on several idiosyncratic figures of real-life personalities. The spectral green face of May Milton is in the foreground, the red-haired Jane Avril is in the center, a group of Lautrec's friends sit at the table, while he can be seen in the background. The green tinted atmosphere is reminiscent of the color of absinthe, a popular drink at the time.

Paul Cézanne

1839, Aix-en-Provence–1906, Aix-en-Provence

■ He intended to reveal the internal structure of objects ■ Produced still lifes, nudes, series of Mont Sainte-Victoire, and portraits ■ These inconsequential subjects allowed him to examine the surface texture, mass, color, and form of the objects ■ His paintings negated the traditional approach to perspective

■ **A Modern Olympia**, ca. 1873–74, oil on canvas, 46 x 55.5 cm, Musée d'Orsay, Paris

Inspired by Manet (p. 354), Cézanne created a version of the other painter's *Olympia*. By using a palette knife, he gave the painting a free, tactile, and unfinished look and included more of the setting than Manet did.

Born in the provincial French town of Aix, Paul Cézanne became one of the world's greatest modern artists. His art created a bridge between the more traditional styles of the 19th century and the radical changes that took place in 20th-century avant-garde. He developed a strong individual style within the Post-Impressionist movement and impacted contemporary artists, as well as exerted a powerful influence on later stylistic movements. His approach to pictorial representation was based on a constructive method of adding figures' planes together to create a complete whole. This idea would be revisited by Picasso (p. 428) and Braque. Cézanne himself drew on the art of the Impressionists and concentrated on explor- ➣

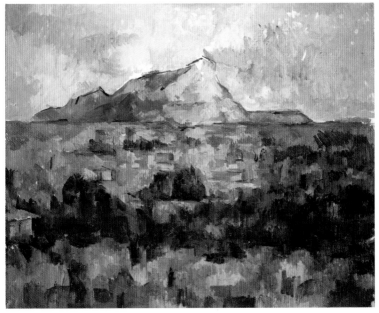

■ **La Montagne Sainte-Victoire**, ca. 1904–06, oil on canvas, 65 x 81 cm, private collection, Switzerland

This dramatic canvas is characteristically constructive, anticipating Cubism. The color palette is constrained, using pastel browns, greens, and yellows. Cézanne produced around sixty paintings that depicted Mount Sainte-Victoire, located near his home in Aix-en-Provence. The painting of series allowed the artist to explore the same subject from different viewpoints and in different lighting.

■ **Still Life with Plaster Cupid**, 1895, 70 x 57 cm, Courtauld Institute of Art, London

This unusual still life incorporates a plaster cast of Cupid by Puget in the foreground and a drawing after another sculpture, *The Flayed Man*, in the background. The dynamism of the figural images contrasts with the total immobility of the fruit, yet echoes the curves.

Other Works by Cézanne

Bathers at Rest, 1875–76, The Barnes Foundation, Merion

Madame Cézanne in a Red Armchair, 1877–78, Museum of Fine Arts, Boston

Self-Portrait with Palette, 1885–87, collection of the artist's family, Paris

Woman in a Green Hat (Madame Cézanne), 1894–95, The Barnes Foundation, Merion

Paul Cézanne

ing objects as a collection of forms. The artist was also more concerned with the visuality of paint than the subject matter. By painting the same subject matter, such as apples, oranges, or mountains, Cézanne was able to develop his technique fully. He methodically studied the different effects of light and perspective and how these brought out different facets of the subject. These facets were captured using different planes of color and showed the different geometric components of objects. By fracturing form through abstraction, the artist attempted to capture the change of objects in relation to their state in space. Because of these revolutionary ideas in the treatment of both subject and medium, his influence can be seen in the art of the Expressionists, Cubists, Fauves, and even Futurists.

■ **Large Bathers**, 1899–1906, oil on canvas, 208 x 249 cm, Philadelphia Museum of Art

One of Cézanne's favorite subjects, the theme of bathers, is explored here in a way that combines traditional and modern approaches to the image of nudes in a natural setting. Drawing on the genre of pastorals, Cézanne positions his bathers in a symmetrical arrangement within the landscape. His treatment of the bodies is characteristically avant-garde, relying on block shapes of subtly changing colors.

■ **Portrait of Gustave Geffroy**, 1895, oil on canvas, 116 x 89 cm, Collection of Mr. and Mrs. Rene Lecomte, Paris

This portrait of the art critic, who supported Cézanne, was developed in the same vein as his still lifes. The focus is on the collection of books, which are treated with more attention and sophistication than the face of the sitter.

Paul Cézanne

Vincent van Gogh

Vincent Willem van Gogh
1853, Groot-Zundert–1890, Auvers-sur-Oise

■ The Post-Impressionist painter and draftsman created numerous drawings, watercolors, prints and oil paintings ■ Became an iconic artist after his death ■ He is known as much for his madness and tragic death as for his paintings

● **1853** Born on March 30
1869 Apprenticed to a Parisian art dealer
1877 Returns to the Netherlands
1879 Works as a preacher
1880 Begins painting in Brussels
1881 Studies with Anton Mauve in The Hague
1885 Studies at the Academy of Fine Art in Antwerp for 3 months
1888 Moves to Arles
1889 Committed to St. Rémy mental asylum
1890 Commits suicide

Almost completely unknown during his lifetime, Vincent van Gogh is today one of the most famous painters in the world. He started as an artist at the rather mature age of 27 and lived a short life, yet he was extremely prolific and produced more than 2000 works. During his brief artistic career, he occasionally collaborated with other contemporary artists, namely Paul Gauguin (p. 390), on establishing a new stylistic movement, and he is regarded as one of the leading artists of Post-Impressionism in France. After he moved from the Netherlands to the south of France, his palette changed from the darker range of his early years to more saturated and vivid colors. Van Gogh limited his subjects to numerous self-portraits, depictions of ordinary people observed in their natural environment, interior scenes, still lifes, and landscapes. His mature style is characterized by bold colors and impasto, tactile brushstrokes. His stylistic innovations and approach to art as a means of ⬭

■ **Self-Portrait with Bandaged Ear and Pipe**, 1889, oil on canvas, 51 x 45 cm, private collection, Chicago

This image was created after van Gogh's mental breakdown, which resulted in him cutting off his ear. The self-portrait depicts the artist in bandages. Wearing a hat and smoking a pipe, he looks out at the viewer. The color palette is particularly intense because of the greens and reds, which are opposite colors and make each other stand out. The space is shallow and the lines are handled firmly through the thick paint.

Potato Eaters, 1885, oil on canvas, 81.5 x 114.5 cm, Vincent van Gogh Museum, Amsterdam

This genre scene, which was based on several studies, was intended to relay to the viewers a feeling of the coarseness of rural life. The dim lighting from an oil lamp, the grim faces of the peasants around the rustic table, and their stocky figures create the realistic effect of earthiness and the setting's relationship to the countryside. The stylistic exaggerations, the harsh contouring, and the distortions of the lines, characteristic of van Gogh's more mature style, are already visible in the painting. Unlike his other famous works, here one sees a quieter use of color.

Night Café in Arles, 1888, oil on canvas, 70 x 89 cm, Yale University Art Gallery, New Haven

The painting explores color in its symbolic and expressive role. Here, the artist used colors more arbitrarily than before in order to express himself, rather than to reproduce visual appearances, atmosphere, and light. The brushstrokes characteristically build up, creating an effect of tactility.

Vincent van Gogh

Post-Impressionism in France

387

personal expression, rather than a reproduction of reality, would later go on to influence Fauvism and Expressionism. The fascination often felt for van Gogh stems not only from his considerable artistic achievements but also from the famously dramatic events of his turbulent life. His biography is in many ways defined by his ongoing mental illness, which caused the famous episode of the artist's self-mutilation—cutting his ear off—and which tragically ended in his suicide. Van Gogh's works only received public recognition after his death, and today he is widely celebrated.

Other Works by van Gogh

Shoes, 1888, Metropolitan Museum of Art, New York

Irises, 1889, Getty Museum, Los Angeles

La Berceuse, 1889, Metropolitan Museum of Art, New York

Van Gogh's Room at Arles, 1889, Musée d'Orsay, Paris

Tree Roots, 1890, Van Gogh Museum, Amsterdam

Cottages, 1890, Hermitage, St. Petersburg

■ **Starry Night**, 1889, oil on canvas, 73.7 x 92.1 cm, Museum of Modern Art, New York

One of the most recognizable of van Gogh's paintings, this image was based on the artist's observation of the landscape in Saint-Rémy. The swirling lines and the distorted shapes create an intense emotional atmosphere.

19th Century

■ **Vase with Fourteen Sunflowers**, 1889, oil on canvas, 100 x 76 cm, Seiji Togo Memorial Yasuda Kasai Museum of Art, Tokyo

This painting is one of van Gogh's famous series depicting flowers in full bloom. The bright palette is playfully intense and the impasto technique creates a sculpted effect showing the artist's hand.

Vincent van Gogh

Paul Gauguin

1848, Paris–1903, Hira Oa in the Marquesas

■ Spatial shallowness, exaggerated shapes and colors, and a vivid palette are typical of his style ■ The meaning of his images can only be found by understanding his personal iconography of symbols ■ Produced numerous self-portraits that explored different sides of his complicated personality

■ **1848** Born on June 7
1855 Moves back to France from Peru
1872 Works as a stockbroker
1874 Meets the Impressionists
1876 Exhibits at the Salon
1880–82 Exhibits with the Impressionists
1883 Quits working at the stock market
1886 Travels to Pont Aven, Brittany
1888 Meets van Gogh
1891 Travels to Tahiti
1901 Moves to Hira Oa in the Marquesas
1903 Dies on May 8

Paul Gauguin is an important representative of the French Post-Impressionist movement. Extremely prolific, he produced many paintings, woodcuts, decorative objects, and sculptures. His style evolved throughout his career: It went through a stage of Cloisonnism, characterized by flat, brightly colored, strongly contoured shapes, and later a stage of Synthetism, characterized by a fusion of form and color. The artist relied on Impressionism, to which he was introduced by Pissarro (p. 358), before moving to a more stylized technique that drew on Cézanne (p. 382), French folk art, and Japanese prints. He also became fascinated with the "primitive" art of ancient Egypt, India, and Polynesia. His earlier subjects focused on religious themes, but after moving to Tahiti his subject matter primarily included scenes of island life and images of the native inhabitants.

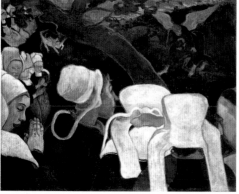

■ **Vision After the Sermon (Jacob Wrestling with the Angel)**, 1888, oil on canvas, 73 x 92 cm, National Gallery of Scotland, Edinburgh

The colorful painting centers on a biblical struggle between a mortal and an angel. This symbolizes an internal struggle between one's human and divine natures. The artist described the scene as a manifestation of the female audience's daydream, inspired by the sermon. Gauguin included himself in the crowd, portraying the role of a priest.

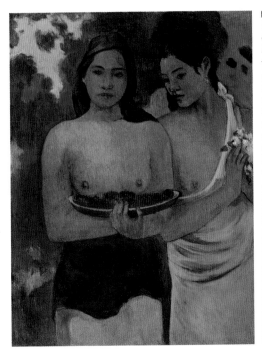

■ **Two Tahitian Women**, 1899, oil on canvas, 94 x 72.4 cm, Metropolitan Museum of Art, New York

These exotic nudes are frequently considered to be a manifestation of Gauguin's inherent misogyny. Often depicted, the images of women are exotic and enticing. The blooms they offer to the viewers suggest a symbolical parallel between the free gifts of nature and their own sexual availability.

Other Works by Gauguin

The Yellow Christ, 1889, oil on canvas, Albright-Knox Art Gallery, Buffalo

Caricature Self-Portrait, 1889, oil on wood, National Gallery of Art, Washington, DC

The Spirit of the Dead Keep Watch, 1892, oil on burlap mounted on canvas, Albright-Knox Art Gallery, Buffalo

Post-Impressionism in France

■ **Where Do We Come From? What Are We? Where Are We Going?**, 1897, oil on canvas, 139 x 375 cm, Museum of Fine Arts, Boston

Completed after an attempted suicide, this work expressed Gauguin's view of life. Unfolding from right to left, the image is most likely an allegory for differ-ent stages of existence throughout a lifetime, but the complicated personal symbolism employed by Gauguin limits our understanding of the narrative.

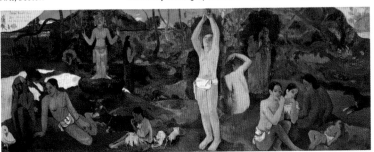

Paul Gauguin

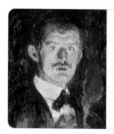

Edvard Munch

1863, Løten—1944, Ekly estate near Oslo

■ His works were disseminated throughout Europe via prints ■ Munch's figures were characterized by void faces and flaccid bodies ■ His paintings conveyed a sense of anxiety, tension, and depression, drawing on his emotional and mental state ■ His color palette was infused with symbolic significance

- **1863** Born December 12
- **1880** Studies at the Royal School of Design in Kristiania
- **1881** Enrolls at the Royal School of Drawing
- **1885** Travels to Paris
- **1889** First solo show in Kristiania
- **1892** Exhibits in Berlin
- **1909** Receives the Royal Order of St. Olav
- **1933** Receives the Grand Cross of the Order of St. Olav
- **1944** Dies on January 23

A Norwegian painter working in the style of Symbolism, Edvard Munch was active during the latter half of the 19th century. His intense, tortured, and highly psychological images embodied the depressive and anxiety-ridden mentality of fin de siècle northern European culture. The artist's color palette was heavily influenced by the French Post-Impressionists. Munch principally explored images of victimized or menacing feminine sexuality. The artist filled his works with a subjective symbolism that revealed his inner struggles with relationships and sexuality. Both his style and his subject matter became important catalysts for the establishment of the German Expressionist movement.

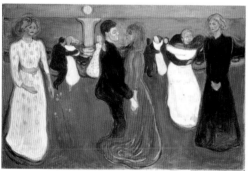

Other Works by Munch

Evening on Karl Johan, 1892, Rasmus Meyer Collection, Bergen

The Storm, 1893, Museum of Modern Art, New York

Madonna, 1893–94, Munch Museet, Oslo

Self-Portrait, 1895, Museum of Fine Arts, Houston

Two Beings (The Lonely Ones), 1895, Art Gallery of New South Wales, Sydney

■ **The Dance of Life**, ca. 1899, oil on canvas, 124.5 x 190.5 cm, National Gallery, Oslo

The Symbolist work is an allegory of the life of a woman. She moves from a virginal state, symbolized by white, to a stage of sexual maturity, indicated by the close dance, to an asexual phase in old age. As a young girl, she is further associated with youthfulness by a blooming flower, as a woman by a passionate red, and as an old woman by a mourning black.

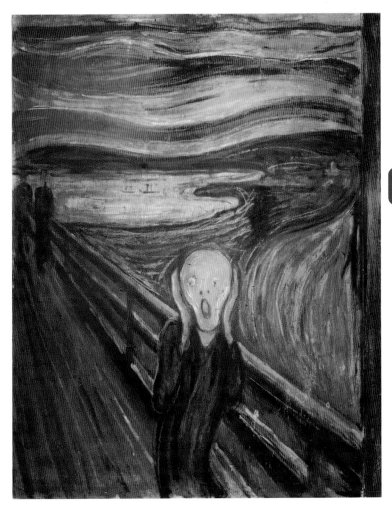

■ **The Scream**, 1893, waxed crayon and tempera on paper, 91 x 73.5 cm, National Gallery, Oslo

The Scream is Munch's most recognizable work. The painting reveals his personal inner turmoil. Munch was haunted by loneliness, fear, and anxiety in the face of the turn of the century's modernity. A symbolic representation of human despair, the morbid image was inspired by a Peruvian mummy that had just been found.

Edvard Munch

James Ensor

James Sidney Ensor
1860, Ostend–1949, Ostend

- In his early years, he was considered controversial ■ His argumentative relationship with Les XX led to the group's split ■ His most famous works contain explicit criticism of the government, the Church, and the military

- **1860** Born on April 13 in Ostend, Belgium
- **1877–80** Studies at the Académie de Bruxelles
- **1883** Joins a group known as Les XX ("The Twenty"), which would later include Pissarro, Monet, Seurat, Gauguin, Cézanne, and van Gogh, among others
- **1883–88** Exhibits with Les XX
- **1887–1900** His most productive and original period
- **1929** Knighted and made a baron by King Albert
- **1949** Dies on November 19 in Ostend, Belgium

James Ensor was a Belgian Symbolist who had a long and prolific artistic career. Although he remained in his native city of Ostend for the majority of his life, Ensor established himself as an internationally acclaimed innovative painter. Besides paintings, he also produced theater and ballet sets and numerous prints and etchings. In his earlier works, Ensor principally concentrated on portraiture, drawing on such diverse sources as the Old Masters and the Impressionists. Later, he became fascinated with more mystical subjects.

His style influenced his contemporaries, including those who formed the group Les XX, and he became one of its leading representatives, producing works that impacted the future Expressionists and anticipated Surrealism.

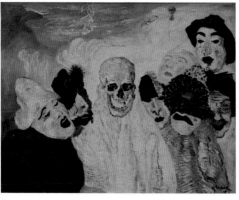

■ **La Mort et les Masques**, 1897, oil on canvas, 78.5 x 100 cm, Musée d'Art Moderne et d'Art Contemporain, Liège

The painting draws on one of Ensor's favorite themes—exploring the symbolic implications of the images of carnival. The work centers around the figure of death surrounded by a masquerading crowd. The masked faces appear just as hideous and threatening as the skull of death. Rather than hiding the crowd's inner truth, the masks reveal their character, emphasizing the grotesqueness of their inner demons.

Other Important Works by Ensor

Tribulations of St. Anthony, 1887, Museum of Modern Art, New York	Skeletons Warming Themselves, 1889, Kimbell Art Museum, Fort Worth
Masks Confronting Death, 1888, Museum of Modern Art, New York	Skeletons Fighting for a Smoked Herring, 1891, Royal Museums of Fine Arts, Brussels

■ **Entry of Christ into Brussels**, 1898, etching and watercolor, 23.8 cm x 30.5 cm, Tehran Museum of Contemporary Art

The painting is a reinterpretation of a dogmatic subject in terms critical of a contemporary political situation. Ensor provocatively gave the figure of Christ the artist's own facial features, making thus a personal connection to the scene, and he located the narrative in contemporary Brussels instead of biblical Jerusalem. This further modernized the traditional story. This painting was quite scandalous at the time.

James Ensor

Pierre Puvis de Chavannes

1824, Lyon–1898, Paris

■ Considered a Symbolist, his art was quite slow in achieving recognition
■ Combined Italian "primitives" and Delacroix with an interest in Corot's landscapes ■ Anti-Classicism, expressed in simplified forms and a limited palette, was combined with idealized subjects and a preference for pictorial symmetry

■ **1824** Born December 14

1844 Studies with Eugène Delacroix in Paris

1874 Commissioned to decorate the Panthéon

1889 Commissioned to decorate the Sorbonne

1880 Commissioned to decorate a museum in Amiens

1891 Commissioned to decorate the Hôtel de Ville

1895 Commissioned to decorate the staircase of the Boston Public Library

1898 Dies on October 24 in Paris

■ **Hope**, 1872, oil on canvas, 70.5 x 82 cm, Walters Art Museum, Baltimore

This work depicts a fragile girl sitting on a hill. She is the personification of Hope. The painting symbolizes the sadness of war through the choice of cemetery setting, the crosses, and the ruins in the background. Hope's inclusion in the destroyed landscape symbolizes a yearning for peace via the olive branch, the pure white dress, and the growing flowers.

Pierre Puvis de Chavannes was an important French painter during the latter half of the 19th century. He produced monumental murals that decorate a number of Parisian public buildings such as the Panthéon, the Sorbonne, and the Hôtel de Ville. The artist strove to produce works that imitated the effect of fresco; however, in reality, his murals were painted on canvas and then attached to the walls. His subjects were allegorical figures arranged in wide symbolic narratives. Puvis's color palette tended towards the use of pastels. The simplified forms in his images, the spatial flatness, restrained compositions, and antidramatic approach to organizing panoramas with statuesque figures endeared him to such Modernists as Toulouse-Lautrec (p. 380), van Gogh (p. 386), Gauguin (p. 390), and Matisse (p. 408).

■ **The Poor Fisherman**, 1881, oil on canvas, 155 x 192.5 cm, Musée d'Orsay, Paris

Puvis treats the biblical subject in modern terms. Through a simplified composition and a calm palette, he conveys the significance of the figures through their austerity, rather than through the use of a dramatic narrative.

Other Works by Puvis

Rest, ca. 1863, National Gallery of Art, Washington, DC

Allegory of Life, ca. 1873, Hermitage, St. Petersburg

Young Girls at the Seaside, 1879, Musée d'Orsay, Paris

Inter Artes et Naturam, ca. 1890, Metropolitan Museum of Art, New York

The Benefits of Peace, 1890, National Gallery of Canada, Ottawa

■ **Pleasant Land**, 1882, oil on canvas, 24.6 x 47cm, Musée Bonnat, Bayonne

This panel was intended for the living room in a private residence of a Parisian collector, Leon Bonnat. Its composition, with the curving shore near the expanse of the sea, the spatial flatness of the arrangement, and the classically inspired figures of women and children, would later inspire one of the paintings by Seurat. Other than the bright blue of the sea, the palette is quite subdued.

Symbolism in France

Pierre Puvis de Chavannes

Ferdinand Hodler

1853, Berne–1918, Geneva

■ Hodler's earlier works were decorative and principally influenced by the style of Art Nouveau ■ The artist's later paintings showed a predilection for personal mysticism ■ His style revealed a tendency toward monumentality, spatial flatness, a bright palette, strong lines, and a repetition of simplified forms

● **1853** Born in Berne on March 14

1867 Begins his studies with a local painter of landscapes

1871 Travels to Geneva, where he studies with Barthélémy Menn

1878 Travels to Madrid, where he studies the art of Rubens and Velázquez

1900 Receives a Gold Medal for his art at the Paris World's Fair

1912 Receives the post of an officer in the French Foreign Legion

1914 Condemns German military and is excluded from German museums

1918 Dies on May 19

Other Works by Hodler

Tired of Life, 1892, Neue Pinakothek, Munich

The Disillusioned One, 1892, Los Angeles County Museum of Art

The Day, ca. 1904, Kunsthaus, Zurich

The Sacred Hour, ca. 1907, Cincinnati Art Museum, Ohio

Woman in Ecstasy, 1911, Musée d'Art et d'Histoire, Geneva

A painter and printmaker, Ferdinand Hodler is among the most recognizable names of the 19th-century Swiss art scene. Hodler admired the Old Masters, such as Hans Holbein (p. 206), Dürer (p. 194), Rubens (p. 234), and Velázquez (p. 260). He started his career drawing on works by Corot (p. 344), Delacroix (p. 330), and Ingres (p. 304), and produced works in the style of Impressionism. Hodler began, however, to take an interest in the contemporary movements of Symbolism and Art Nouveau. His color palette became simpler and bolder, and his style grew more stylized and expressionistic, relying on distortions and exaggerations to convey an intellectual message to the viewer.

His subjects included landscapes, portraits, and group compositions. Under the influence of Gauguin (p. 390), the artist developed a unique style, called Parallelism, which was characterized by a rhythmic arrangement of strongly outlined figures.

■ **Wilhelm Tell**, 1897, oil and tempera on canvas, 255.5 x 195.5 cm, Solothurn Art Museum

The image of a Swiss national hero, this painting is also a self-portrait of Hodler. The artist thereby relates himself to the hero. The painting was inspired by a sculpture of Tell in Altdorf and depicts the hero as a larger-than-life protector of his people, coming through the clouds with welcoming arms. His towering presence is accentuated by the perspective.

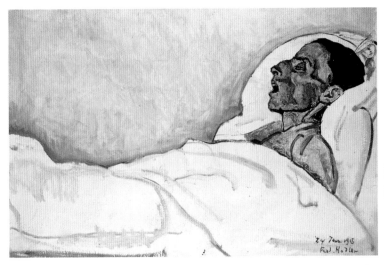

■ The Dying Valentine Godé-Darel, 1915, oil on canvas, 60.5 x 90.5 cm, Kunstmuseum, Basel

Painted from real-life observations of his companion, who was dying of cancer, this intimately tragic image was the last in the series of works documenting her illness. Completed a day after her death, it is infused with painful sincerity and reflects the emotional toll her death took on the artist. Hodler expertly captured her pain.

■ Study of a Head of an Italian Woman, 1910, 34.5 x 40 cm, Wallraf-Richartz Museum, Cologne

The painting is a romantic, passionate depiction of a raven-haired woman. Her facial features are carefully observed in a realistic, somewhat stylized manner, yet rendered in bright colors. The work is characterized by strong, angular energy conveyed via powerful and sensitive contours and saturated, vivid colors. The painter captured the exotic nature of the model by establishing a vigorous dynamism in the composition and brushwork.

Ferdinand Hodler

Gustav Klimt

1862, Baumgarten near Vienna–1918, Vienna

■ Klimt's style was symbolic and ornamental ■ His works were characterized by bold colors and jeweled and gold repetitive elements ■ Decorative stylization, sumptuous elegance, and an interweaving of human figures and inanimate objects ■ His usual subjects were erotically charged and highly dramatic

● **1862** Born on July 14
1878 Enrolls at the Kunstgewerbeschule
1891 Joins the Cooperative Society of Austrian Artists
1897 The first president of the Vienna Secession
1900 Wins the Grand Prix at the Paris World's Fair
1905 Quits the Vienna Secession, creates Kunstschau
1918 Dies on February 6

Gustav Klimt was one of the founding members of Austrian Symbolism and a leader of the Viennese Art Nouveau movement. He produced a large number of oils, drawings, and murals. His subjects included images of femmes fatales, portraits, and nudes. He also created stylized allegories and landscapes. His works reflect the fin de siècle Viennese culture with its implications of psychological tension, eroticism, and decadence. Among Klimt's influences were the arts of Egypt, Byzantium, medieval Europe, Albrecht Dürer (p. 194), and the modern Symbolists, such as Max Klinger, Franz von Stuck, and Fernand Khnopff. His style is characterized by a decorative elegance, a preference for gold, flatness, and patterning. His work is romantically erotic and often deals with themes of love and life.

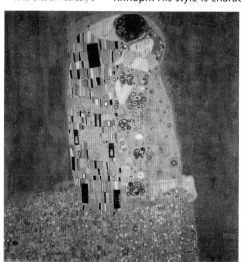

Other Works by Klimt

Judith and Holopherne, 1901, oil on canvas, Österreichische Galerie Belvedere, Vienna

The Beethoven Frieze, 1902, Secession, Österreichische Galerie Belvedere, Vienna

Beech Grove I, 1902, oil on canvas, Gemäldegalerie Neue Meister, Dresden

Poppy Field, 1907, oil on canvas, Österreichische Galerie Belvedere, Vienna

Danae, 1907–08, oil on canvas, Galerie Würthle, Vienna

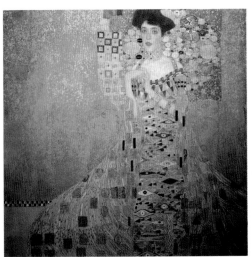

■ **Portrait of Adele Bloch-Bauer I**, 1907, oil, silver, gold on canvas, 138 x 138 cm, Neue Galerie, New York

One of Klimt's numerous portraits of Viennese upper-class beauties, this image presents a wealthy socialite as an icon of intellectual and cultured femininity. The painting's style draws on the tradition of Byzantine Imperial mosaic portraiture with its gold and bejeweled aesthetic. The elegant figure is enclosed in the background and in her sumptuous dress. Her face stands out in its decorative environment, as the model intensely looks out of the frame and confronts the viewers.

■ **Death and Life**, ca. 1916, oil on canvas, 178 x 198 cm, Dr. Rudolf Leopold Collection, Vienna

The subject matter is reflected in both the imagery and in its pictorial treatment. The opulence of the decoratively constructed surface opposes the seriousness of the subject. The artist depicts the contrast between life and death. To the right we see Life—birth, motherhood, intimacy, and love shown through a knotted mass of women throughout all stages of life. To the left, Death awaits, gawking greedily and covered in religious symbols that echo tombstones.

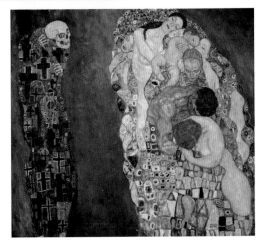

◀ **The Kiss**, 1907–08, 180 x 180 cm, Österreichische Galerie Belvedere, Vienna

The only features shown in the foreground of this highly luxurious depiction of an amorous interaction are the faces and hands of the two lovers, who are embracing on a bed of flowers. Despite the beauty of the scene, the couple are at the edge of a cliff. The background is hidden by the gold that symbolically unifies the entire composition.

Gustav Klimt

Egon Schiele

1890, Tulln—1918, Vienna

■ Translated his traumatic life experiences into psychologically intense paintings ■ Was particularly infamous for highly sexual depictions of young girls ■ His self-portraits reveal him as an unhappy, discordant person, and ambiguously feminize his body

1890 Born on 12 June in Austria

1906 Enrolls in the Akademie der Bildenden Künste in Vienna

1907 Studies with Gustav Klimt

1909 Leaves the Akademy; helps to found the Neukunstgruppe

1909 Exhibits at the Vienna Kunstschau

1910, 1912 Exhibits with Neukunstgruppe

1911 Exhibits with the Secessionists in Munich

1912 Arrested and imprisoned for immorality

1913 Has his first solo show

1918 Dies from Spanish influenza on October 31

Egon Schiele was an Austrian Expressionist painter and draftsman. His major stylistic influence was drawn from Gustav Klimt (p. 400), as well from the Arts and Crafts movement. He focused on the human body as his principal subject, producing highly erotic images of male and female nudes. During his very short artistic life, Schiele established a controversial reputation. He was even briefly imprisoned for creating works that portrayed sexual images of very young female models, considered obscene. The artist was also an accomplished portrait painter, especially successful in the production of numerous self-portraits. His works were deeply personal revelations of internal psychological turmoil and provided a glimpse into the artist's inner world, which was fraught with tragic loneliness and unfulfilled desire. The inspired rawness and tormented honesty of his paintings shocked contemporary audiences. Schiele's short, tumultuous life has come to epitomize him as a tortured artist.

Other Works by Schiele

Self-Portrait with Black Vase, 1911, Historisches Museum der Stadt, Vienna

Pregnant Woman and Death, 1911, National Gallery, Prague

Agony, 1912, Neue Pinakothek, Munich

Sitting Woman with Legs Drawn Up, 1917, Narodni Galerie, Prague

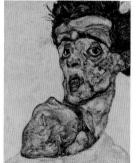

■ **Self-Portrait with Naked Shoulder Pulled Up**, 1912, oil on paper, 42.2 x 33.9 cm, Leopold Museum, Vienna

This dramatically distorted self-image personifies masculinity in crisis, characteristic of the European culture at the beginning of the 20th century. In this portrait, Schiele expresses himself in terms of submission and defeat, and exposes himself as a persecuted and isolated figure. The image is highly distorted.

■ **Death and the Maiden**, 1915–16, oil on canvas, 150 x 180 cm, Österreichische Galerie, Vienna

The symbolism of this melancholic painting is revealed only through its title. The subtly allegorical image represents a young woman and a man embracing on a white sheet in the foreground of a rocky landscape. She clings desperately to the male figure of Death, who nestles the woman's head with one of his hands, pulling it toward his chest. The vibrant colors used in depicting the woman contrast starkly with the gray-green tones of Death.

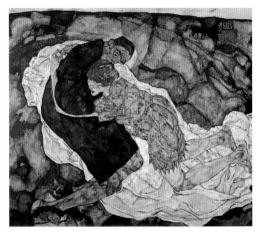

■ **Reclining Woman with Green Stockings**, 1917, gouache and black crayon on paper, 29.4 x 46 cm, private collection

Schiele's representations of women traditionally draw on his understanding of femininity and female sexuality as something that is both appealing and morbid. The model contorts her body into a somewhat tortured position that maintains its appearance of erotic attractiveness. Her face is devoid of any strong expression as she stares frankly at the viewers. Her body is roundly abstracted.

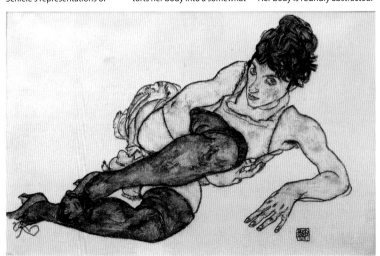

Egon Schiele

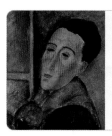

Amedeo Modigliani

1884, Livorno—1920, Paris

■ Modigliani's unique and elegant style drew on primitive non-Western aesthetics ■ His portraits mainly featured his lovers, friends, and patrons ■ He was virtually unknown during his life, which was filled with poverty and addiction ■ A Romanian sculptor, Constantin Brancusi, introduced him to sculpture

1884 Born on July 12 in Italy
1898 Enrolls at the Livorno Art Academy
1901 Travels around Italy
1902 Enrolls at Scuola Libera di Nudo in Florence
1903 Enrolls at Reale Istituto di Belle Arti in Venice
1906 Settles in Paris
1907 Joins the Société des Artistes Indépendants
1908–11 Exhibits at the Salon des Indépendants
1914 Participates in the Twentieth-Century Art exhibition in London
1920 Dies on January 24

Amedeo Modigliani was born in Livorno, Italy, but established himself as an artist in Paris. He was a painter, a draftsman, and a sculptor. His body of works principally consists of portraits, female nudes, and some sculptures. He is known to have produced only three landscapes and very few still lifes. Modigliani worked in his studio, posing and studying his models indoors. Among his most pronounced influences were the primitive arts of archaic Greece, Egypt, Africa, and medieval Europe. Except for the archaic Greek art, which he observed during his studies in Italy, the foreign stylistic sources were available to him in Parisian museums, which he visited frequently. His works also reflect such disparate influences as the art of the Italian Renaissance and the Impressionist works by Toulouse-Lautrec (p. 380).

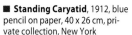

■ **Standing Caryatid**, 1912, blue pencil on paper, 40 x 26 cm, private collection, New York

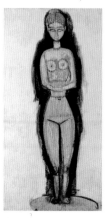

Modigliani produced around 70 drawings of caryatids, in various media on both paper and canvas, as preparatory studies for sculptures. As with his other works, the sketches are highly stylized, sensual, linear, and draw on primitive images of the female body. This elegant image appears to reflect the architectural function of caryatids as sustaining columns in Greek temples. Her massive lower body can provide the support, while the upper part is more decorative as a capital.

Other Works by Modigliani

Madame Pompadour (Portrait of Beatrice Hastings), 1915, Art Institute of Chicago, Chicago

Lolotte, 1916, Musée National d'Art Moderne Centre Georges Pompidou, Paris

Portrait of the Art Dealer Paul Guillaume, 1916, Civico Museo d'Arte Contemporanea, Milan

Elena Pavlowski, 1917, Phillips Collection, Washington, DC

Seated Nude, 1917, Koninklijk Museum voor Schone Kunsten, Antwerp

The Servant Girl, ca. 1918, Albright-Knox Art Gallery, Buffalo

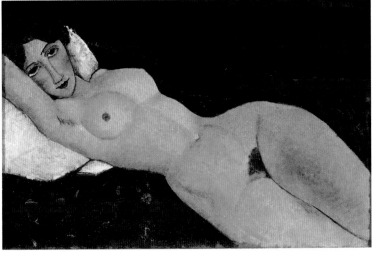

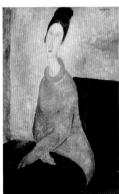

■ **Jeanne Hébuterne in a Yellow Sweater**, 1918–19, oil on canvas, 100 x 64.7 cm, Solomon R. Guggenheim Museum, New York

Modigliani depicts his companion using the stylized terms of African art.

■ **Reclining Nude**, 1917, oil on canvas, 60 x 92 cm Staatsgalerie, Stuttgart

Modigliani's main subject was the reclining female nude. The image draws on the traditional representation, established by Titian (p. 166) and Giorgione (p. 162), of an erotic nude. This painting's modernity is revealed in the overt sexuality of the displayed body that has no allusions to mythology. The thick-lined outline seen here is also typical of Modigliani's work.

■ **Head**, ca. 1911, limestone, Perls Galleries, New York

Modigliani's meeting with the artist Constantin Brancusi resulted in his interest in sculpting. This female head is typical of his sculpted work. The piece reveals the same linear elegance and primitive elements that are characteristic of his paintings. Her long neck, slender facial oval, small mouth, narrow almond-shaped eyes, weighty lids, and thin nose simultaneously refer to African masks, Egyptian sculptures, and medieval carvings. Reference to ancient works is further secured in the use of limestone.

Amadeo Modigliani

André Derain

1880, Chatou, near Paris—1954, Garches, near Paris

■ Was one of the first connoisseurs of African art ■ Became more traditional and produced more conventional works later in his career ■ Besides painting and prints, he produced sculptures and designed theater sets ■ His mature style was characterized by a boldness of line, saturated palette, and structure

Fauvism in France

■ **1880** Born in Chatou, near Paris
1898 Studies at the Académie Carrière in Paris
1900 Sets up a studio
1900 Serves in the military
1905 Takes part in the Salon d'Automne
1907 Moves to Montmartre in Paris
1916 Has his first solo exhibition in Paris
1954 Dies as a result of a truck accident

André Derain's vivid works, with their unconstrained use of color, epitomized the tenets of Fauvism. In the earlier phase of his artistic development, Derain was greatly influenced by early Italian paintings and Gothic art. Later in his career, the artist turned to Seurat (p. 376), Cézanne (p. 382), and Gauguin (p. 390) for his stylistic inspiration. He was one of the first artists to become fascinated with the arts of Africa, especially masks. Throughout his artistic career as a painter, a creator of illustrations, and a printmaker, he frequenty changed his style, trying his hand at Impressionism, an early Cubism, which drew on Picasso (p. 428) and Braque's work, and finally, Realism.

■ **Harlequin and Pierrot**, 1924, oil on canvas, 175 x 175 cm, National Gallery of Victoria, Melbourne

The sparse image is a stylistic reinterpretation of traditional representations of theatrical characters as a symbolist statement. Harlequins and clowns appear frequently in early 20th century art.

Other Works by Derain

L'Age d'Or, ca.1905, Tehran Museum of Contemporary Art

Henri Matisse, 1905, Tate Modern, London

London Bridge, 1906, Brooklyn Museum of Art, New York

La Chasse, 1943, MacKenzie Art Gallery, Saskatchewan

■ **Charing Cross Bridge**, 1901, oil on canvas,
81 x 100 cm, Musée d'Orsay, Paris

These images, which combine nature and in-
dustry, were a popular subject matter amongst
the Impressionists. In this work, Derain explicitly
refers to earlier styles as his source of inspiration.
At the same time, he reinterprets the outside
scene in the provocative terms of Fauvism, rend-
ering the image with a subjective and bold color
palette.

■ **The Harbor of Collioure**, 1905, oil on canvas,
46 x 38 cm, private collection

The Harbor of Collioure is one of the many images
of the small Mediterranean town that were pro-
duced by the painter. The Catalan town was a
popular subject for Fauves. Matisse also painted
several pictures of the town and the harbor. An
excellent example of Fauvism, the colors seem to
jump out of the canvas at the viewer, clearly
exhibiting the freshness of the environment.

André Derain

Henri Matisse

Henri Émile Benoît Matisse
1869, Le Cateau-Cambrésis–1954, Nice

■ Began as an artist under Symbolist painter Gustave Moreau ■ His choice of subjects was influenced by Renoir, with whom he shared a fondness for depictions of voluptuous nudes ■ Balanced color palette

■ **1869** Born Henri Émile Benoît Matisse December 31
1889 Confined to a hospital, starts painting
1892 Attends École Nationale des Arts Décoratifs
1895 Enters the studio of Gustave Moreau
1905 Participates in a Fauvist show
1908 Opens art school
1925 Joins the Légion d'Honneur
1954 Dies on November 3

Henri Matisse is one of the pivotal figures of French Modernism. He garnered celebrity as a leading representative of Fauvism. The movement received its name from a derisive description of Fauvists as "wild beasts," and included the painters André Derain, Georges Braque, Raoul Dufy, and Maurice de Vlaminck. Throughout his artistic development, Matisse was influenced by Impressionists such as Manet (p. 354) and Renoir (p. 366), by Pointillist Seurat (p. 376), and Post-Impressionists Cézanne (p. 382) and Gauguin (p. 390). He was also a lifelong friend of Picasso (p. 428). Matisse's more conservative style is characterized by realism and a focused treatment of the composi-

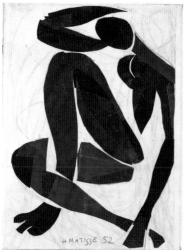

H MATISSE 52

■ **Blue Nude IV**, 1952, 102.9 x 76.8 cm, cutout and gouache, Musée Matisse, Nice-Cimiez

During a health crisis, Matisse began to occupy himself with the physically easier art of paper cutouts and collages from colored paper. A dynamic nude female figure bends her arms and turns three-quarters toward the viewers. The geometric monochromatic shape, cut out from the paper and painted blue, is almost abstract. The vibrant blue accentuates the line of the figure.

■ **Portrait of the Artist's Wife**, 1912–13, 145 x 97 cm, oil on canvas, Hermitage, St. Petersburg

This image of Mme. Matisse is strikingly stylized, the effect reinforced by the use of the strong contour line of her face. The color palette is limited to a cool range of blues and navy. This work was created near the end of their relationship, and their marital troubles can be seen in Matisse's palette. Her eyes are a dead black.

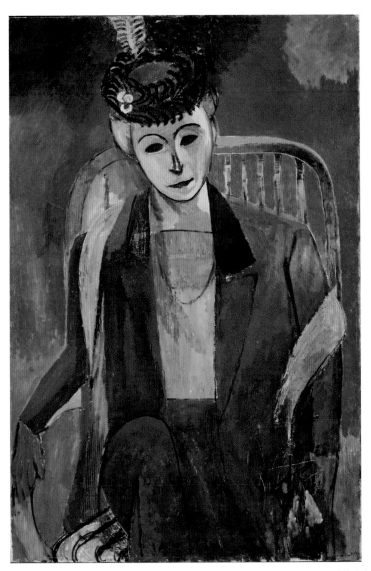

Henri Matisse

tional settings. Rather than confronting the influence of the earlier stylistic movements, Matisse attempted to show the continuity of artistic tradition in his works. His subjects ranged from portraits to nudes to still lifes. His preference for a saturated color palette, dynamic line, and unmodeled shapes anticipated the development of the Abstract Expressionists. Matisse principally depended on the wealthy Russian art collector Sergei Shchukin, who commissioned many of his works for a private residence. Later, when he experienced trouble with his motor skills, he continued making art through cutout collages.

Other Works by Matisse

Luxe, Calme et Volupté, 1904, Musée d'Orsay, Paris

Green Line, 1905, Royal Museum of Fine Arts, Copenhagen

La Danse I, 1909, Museum of Modern Art, New York

Odalisque with Red Culottes, 1921, Centre Georges Pompidou, Paris

The Pink Nude, 1935, Baltimore Museum of Art

■ **The Joy of Life**, 1905–06, oil on canvas, 175 x 241 cm, Barnes Foundation, Merion

The fantastical landscape, populated with voluptuous nudes, represents a mythological Arcadian idyll. The subject was probably drawn from Cézanne's *Three Bathers*. The women lounging and frolicking around the field and the forest are probably nymphs. The figures are divided into groups. Several women dance in the background, while two nymphs lounge in the fore-ground. A couple is holding each other, two women gather flowers near the forest, and a shepherd is playing a flute. The colors are bright and lively, the flooding light is golden, and the whole effect is one of calmness, sensuality, and contentment.

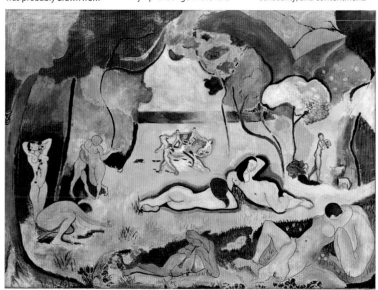

■ **Harmony in Red**, 1908, oil on canvas, 180 x 220 cm, Hermitage, St. Petersburg

The bright interior scene depicts a woman setting a table with fruit, wine, and flowers. The predominant color is red, which covers the walls and the tablecloth. The artist plays with the perspective of the land-scape in the background, creating an ambiguity as to whether the landscape is a framed painting or a window onto the outside world.

■ **The Music**, 1910, oil on canvas, 260 x 389 cm, Hermitage, St. Petersburg

This painting was commissioned for the decoration of a grand private residence. Matisse has rendered the image in a characteristically simplified manner, avoiding any unnecessary details. Each of the red, primitive-inspired nudes is equally as loud in their coloration as they are in their music-making.

Henri Matisse

20th Century

before 1945

Pablo Picasso: **Guernica**, 1937, oil on canvas,
349.3 x 776.6 cm, Museo Nacional Reina Sofia, Madrid

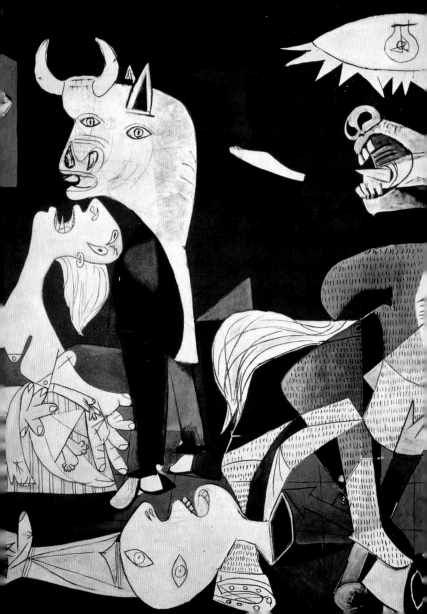

20th Century

p. 423

1905–1940s
Expressionism

1909–1914
Futurism

Giacomo Balla
Carlo Carrà
Umberto Boccioni p. 436
Gino Severini
Luigi Russolo

p. 447

1916–1924
Dada

| 1900 | 1905 | 1910 | 1915 | 1920 |

Wassily Kandinsky
p. 424
Emil Nolde
Georges Rouault
Gabrielle Münter
Ernst Ludwig Kirchner
p. 422
Franz Marc
Richard Gerstl
Max Beckmann p. 426
Amedeo Modigliani
Oskar Kokoschka
August Macke
Otto Dix

1908–1920
Cubism

Kasimir Malevich
Natalia Goncharova
Fernand Léger
Pablo Picasso p. 428.
Georges Braque
Robert Delaunay
Sonia De-
launay
Marc Chagall
p. 434

Jean Arp
Raoul Hausmann
Marcel Duchamp p. 446
Kurt Schwitters p. 444
Hannah Höch

p. 429

Art before 1945

1919–1933
**Bauhaus,
De Stijl,
Constructivism**

Lyonel Feininger
Piet Mondrian p. 440
Paul Klee p. 438

p. 452

1924–1950s
Surrealism

Jean Arp
Giorgio de Chirico
Man Ray p. 460
Max Ernst p. 454
Joan Miró p. 458
René Magritte
Salvador Dalí p. 456

1925	1930	1935	1940	1945

p. 441

Walter Gropius
Josef Albers
Liubov Popova p. 442
László Moholy-Nagy

1930s–1940s
New Realism

Edward Hopper p. 450
George Grosz p. 448
Frida Kahlo p. 452

p. 459

Figurative and Abstract

Early Modern Art in the 20th Century

Modern art denotes neither a specific period in art history nor an international style, but rather an artistic attitude. Like this period's history, the development of modern art in the first half of 20th century in Europe is characterized, on the one hand, by deep fissures, and on the other, by huge innovations and fundamental changes to an entire generation of young artists. Moreover, two world wars, the Russian Revolution, fascism, and the prohibition and destruction of modern art in Nazi Germany created significant obstacles. The title of a 1925 book, *Die Kunstismen* ("The Isms of Art"), illustrated the central challenge to characterizing modern art. There was no longer a uniform style for the period; rather, art was fragmented into numerous "isms": Expressionism, Cubism, Futurism, Simultanism, Con-

■ **Fernand Léger: The Smoking Soldier**, 1916, oil on canvas, 130 x 97 cm, Kunstsammlung Nordrhein-Westfalen Düsseldorf

■ **Kasimir Malevich: Black Square**, ca.1923, oil on canvas, 106 x 106 cm, Hermitage, St. Petersburg

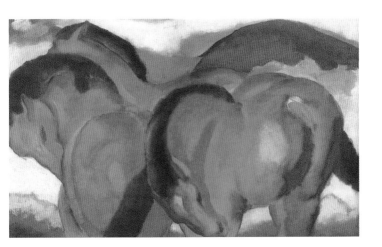

■ **Franz Marc: The Little Blue Horses**, 1911, oil on canvas, 61.5 x 101 cm, Staatsgalerie, Stuttgart

structivism, Dadaism, Verism, Surrealism, and New Realism. The notion of the avant-garde is part of the history of modern art. It is no accident that the concept was adapted for the art world from a term used in warfare. The term avant-garde designated bold reconnaissance troops; hence, avant-garde artists were supposed to march at the forefront and foster growth. The avant-garde is always in forward motion. In a fast-paced dynamic such as this, the avant-garde skirmishes and clashes with others and itself, pursuing one style after another, and creating -ism after -ism. This unprecedented outpouring of creative powers put an end to the practice of copying the natural world. The first half of the 20th century is generally seen as shaped by the two great themes of the "abstract" and the "figurative," as well as a constant redefinition and expansion of artistic concepts.

Introduction

Expressionism, Cubism, Futurism

The decisive shift toward modern art came in 1914 with the beginning of World War I. The early avant-garde formed almost simultaneously in Dresden, Munich, Paris, and Rome. In 1905, Ernst Ludwig Kirchner, Fritz Bleyl, Erich Heckel, and Karl Schmidt-Rottluff cofounded Die Brücke, marking the beginning of German Expressionism. Rooted in Gothic and Romantic art and influenced by van Gogh and Matisse, this antibourgeois movement was shaped by a dramatic simplification and the desire to liberate color from the constraints of the natural world. In 1911, focus shifted to metropolitan life in Berlin, where most Expressionists were living. In Munich, Kandinsky, Münter, Alexei Jawlensky, and Marianne von Werefkin, as well as Marc, Macke, and Klee, pursued similar goals of liberating color and simplifying form. At the end of 1911, the group Der Blaue Reiter ("The Blue Rider") was formed. Its influences derived from folk art, Pa-

■ **Hannah Höch: Cut With the Kitchen Knife ...**, 1919–20, photomontage, 114 x 90 cm, Staatliche Museen, Berlin

■ **Otto Dix: Card Playing War Cripples**, 1920, oil and collage on canvas, 110 x 87 cm, Nationalgalerie, Berlin

▶ **Constantin Brancusi: Sleeping Muse**, ca. 1910, bronze, 27 cm, Metropolitan Museum of Art, New York

■ **Robert Delaunay: Hommage à Blériot**, 1914, tempera on canvas, 250.5 x 251.5 cm, Kunstmuseum Basel

■ **Georgia O'Keeffe: Two Jimson Weeds**, 1938, oil on canvas, 121.9 x 101.6 cm, private collection

risian Cubism, and the Naïve painter Henri Rousseau. In 1910, Kandinsky began to paint his first abstracts, venturing into a spiritual, mystical world of pure expression.

Meanwhile, the Cubist experiments with form fragmentation, begun by Picasso and Braque in 1907, were advancing in Paris. Léger developed a style using simple geometric forms, while Delaunay explored Cubism with the bright, urban color palette of Orphism.

The catalyst for the independent variations of abstraction can be traced to Italian Futurism. Artists such as Boccioni and Balla wished to depict the simultaneity of sensations and the mutual pervasiveness of space and time. In 1915 the Russian artist, Malevich, succeeded in raising a variation of Cubo-Futurism to abstract Suprematism, while other Russian post-October Revolution artists developed a left-wing revolutionary Constructivism, and the Dutch De Stijl movement developed a markedly geometric abstraction.

Dada, Surrealism, New Realism

Initially it appeared as though the advance of abstraction was unstoppable. Yet, in response to the apolitical nature of abstract and Expressionist art, emphasis shifted during the war. Disillusioned and traumatized by grueling battles, artists rallied against war. Emanating from the Zurich-based Dada movement of 1916, Dada centers formed in Berlin, Cologne, Paris, Geneva, and New York. Artists united in the struggle against the middle class, the military, and capitalism. Influenced by the Socialist utopias of the October Revolution as manifested in the Constructivism of El Lissitzky, Vladimir Tatlin, and Popova, and inspired by the ghost towns, mechanical puppets, and automation of the paintings by de Chirico, Carrá, and Giorgio Morandi, the Dadaists developed a versatile style emphasizing these themes. Using the new media of photomontage and collage, Höch, Hausmann, and

■ **Giorgio de Chirico: Joys and Enigmas of a Strange Hour**, 1913, oil on canvas, 83.7 x 129.5 cm, private collection

■ **Alexander Calder: Crinkly with Red Disk**, 1973, mobile, Kunstmuseum Stuttgart

René Magritte: The Menaced Assassin, oil on canvas, 152 x 195 cm, Museum of Modern Art, New York

John Heartfield condemned contemporary life, while Grosz and Dix shocked the public with their veristic, satirical works. The short-lived Dada revolt led to a flat, object-oriented style of painting called New Objectivity. This caustic form of Realism spread from Europe to America, where it influenced Dennis Hopper and Georgia O'Keeffe.

Dadaist montages and Verism came to Paris in 1924, where Surrealism was forming. The Surrealists juxtaposed bourgeois capitalist culture with dreams and automatism. With its polymorphic, graphic, and abstract impressions and its magical-poetic reality, the movement grew. Until the beginning of World War II, Surrealism, the Bauhaus, and De Stijl were the dominant artistic movements. By 1939, the Nazis had denounced modern art as "degenerate," defamed its exhibitions, removed it from museums, and the great exodus of artists to America had begun.

Introduction

Ernst Ludwig Kirchner

1880, Aschaffenburg–1938, Frauenkirch near Davos

■ Was counted among the leading painters and graphic artists of the Dresden-based artists group known as Die Brücke ■ Leading representative of German Expressionism ■ Famous for his large-scale Berlin street scenes ■ His works were deemed "degenerative art" by the Nazis

■ **1880** Born in Aschaffenburg

1901–05 Studies architecture in Dresden

1905 Founds Die Brücke in Dresden with Erich Heckel, Karl Schmidt-Rottluff, and Fritz Bleyl; beginning of German Expressionism

1911 Moves to Berlin

1915 Sanatorium stay in Switzerland

1917 Relocates to Frauenkirch near Davos

1937 More than 600 works are confiscated by the Nazis for being "degenerate"

1938 Commits suicide in Frauenkirch

■ **Four Bathers**, 1910, oil on canvas, 75 x 100 cm, Von der Heydt Museum, Wuppertal

During the Dresden years, Kirchner portrayed mankind and nature as equal partners in harmony. The powerful, simplified nudes are both overcome by and fully integrated with the landscape. Both landscape and figures are rendered in bright, unrealistic colors.

In 1905, Kirchner was actively involved in the founding of the artistic group Die Brücke ("The Bridge") in Dresden and was the greatest talent among this coalition of artists. The art of Die Brücke is characterized by intense and often emotionally violent imagery. After Neo-Impressionistic beginnings, Kirchner fell under the influence of Munch (p. 392), van Gogh (p. 386), Gauguin (p. 390), and Fauvism, which led to a formal and colorful simplification of style as well as the separation of color from object. In 1911, inspired by Cubism, he developed an expressive, fragmented language of form while in Berlin. During his war experience, Kirchner suffered a nervous breakdown. He settled in Switzerland in 1917. Here, during the mid-1920s, he created simplified, dynamic, mountainous landscapes with luminous colors and ornamental abstractions.

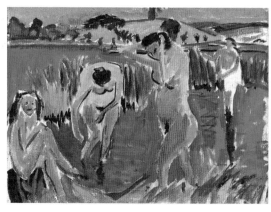

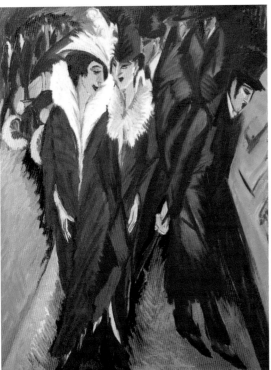

■ **Street, Berlin**, 1913, oil on canvas, 120.6 x 91.1 cm, Museum of Modern Art, New York

In Berlin, Kirchner changed his style. The primary theme became life in the metropolis, focusing on city squares, streets, and the mundane big city dweller. Inspired by Cubism, his new style of painting follows the drama and hectic pace of modern life. Angular and severely fragmented, larger-than-life groups of figures are connected directly with the observer through the use of nervously agitated brush lines and stark color contrasts.

Expressionism in Germany

Works by Kirchner

Seated Girl, Fränzi Fehrmann, 1910/1920, Institute of the Arts, Minneapolis

House under the Trees, 1913, Nationalgalerie, Berlin

Potsdam Square, 1914, private collection

Soldier's Bath, 1915, Museum of Modern Art, New York

Mountains, 1921, private collection

■ **Standing Female Nude**, 1917, polychromatic wood sculpture, height 63 cm, Stein Collection, Cologne

Expressionists such as the early avant-garde painters were generally fascinated with "archaic" cultures. They found a direct expression of emotion embodied in early "primitive" African and South Sea sculptures and wanted to incorporate this into their own work. Kirchner created several sculptures inspired by this ideal. This art would later be deemed "degenerative" by the Nazis.

Ernst Ludwig Kirchner

Wassily Kandinsky

1866, Moscow–1944, Neuilly-sur-Seine

■ Pioneer of modern art and "pure painting" ■ Created the first largely abstract paintings ■ Kandinsky was a leading art theorist ■ Cofounder of the artist group The Blue Rider ■ Instructor at the Bauhaus ■ Developed a universal language of abstraction

Works by Kandinsky

Kandinsky, as an art theorist, is one of the pioneering forerunners of 20th-century modern art. By liberating color from the object, he created the breakthrough that led to abstract art. In 1896, Kandinsky went to Munich to become a painter. His early work is influenced by Russian folk art, Art Nouveau, and late Impressionism. Because of the influence of Fauvism, the liberation of color from its subject became increasingly important after 1900. In early 1912, he cofounded the group known as The Blue Rider with Franz Marc, August Macke, Paul Klee (p. 438), and Gabriele Münter. He was forced to leave Germany in 1914 and went to Moscow, but returned in 1921 and worked as an instructor of form theory at the Bauhaus in Weimar and Dessau. He emigrated to France in 1933 and died near Paris in 1944.

■ **Gedämpfte Glut**, 1928, watercolor and gouache, 36.5 x 25.1 cm, Ulm Museum, Ulm

Kandinsky's expressive paintings attained an increasingly fixed geometric form and a constructive freshness, first in 1917 through the influence of Russian Constructivism and then later in the Bauhaus years. This stylistic change was part of his aspiration to a formal universal language of art. His penetrating and overlapping forms, surfaces, and lines enter into an exciting interplay.

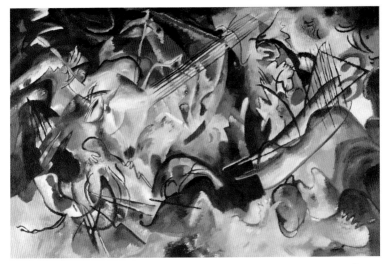

■ **Composition VI**, 1913, oil on canvas, 195 x 130 cm, Hermitage, St. Petersburg

For Kandinsky, the revolutionary move toward abstract art meant a new form of observation, stemming from a return to the spiritual, which Kandinsky felt was removed from reality. Although he had already done a purely abstract watercolor in 1910—the first one in the mainstream art world—Kandinsky initially remained associated with objective art, as a comparison between the two paintings shows. Although colors are the focus in *Composition VI*, individual objects and figures are still recognizable. Color is divorced not only from the object, but also from the lines. Hazy and blurred lines are increasingly common and became a deliberate stylistic device until 1913, when the last remotely recognizable relics of the physical world in Kandinsky's *Compositions* and *Improvisations* dissolve into completely rhythmic forms of color.

■ **Landscape with Church,** 1913, oil on canvas, 78 x 100 cm, Folkwang Museum, Essen

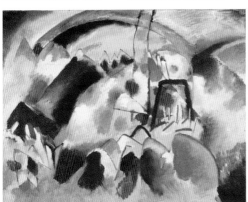

Wassily Kandinsky

Max Beckmann

1884, Leipzig–1950, New York

■ One of the most important German painters and graphic artists of the modern period ■ Created haunting allegories of lonely individuals uprooted by war ■ Portrayer of Neue Sachlichkeit, or New Objectivity ■ His later works were primarily monumental symbolic triptychs

■ **1884** Born in Leipzig

1899 Studies at Weimar's Kunstakademie

1907 Member of the Secession in Berlin

1914 Serves in the war

1915 Moves to Frankfurt am Main

1925 Teaches at the Städel School of Art

1937 His work labeled "degenerative art" by the Nazis, he flees to Amsterdam

1948 Moves to the USA; professor at the Brooklyn Museum Art School in New York

1950 Dies in New York

The German painter and draftsman is considered to be one of the leading chroniclers of the human condition in the modern era. In 1907, after completing his studies, he created an early body of work in Berlin that was dramatic and Impressionistic. During the war, where he served as a medic, his style evolved into a more expressive realism, focusing on isolated, endangered individuals. In the 1920s, Beckmann taught at the Städel School of Art in Frankfurt am Main. In 1933 he fled to Holland from the Nazis, then went to America in 1948. His New Objectivity style from the Weimar Republic period evolved after 1933 into more monumental and artistically relaxed compositions, including nine triptychs which are characterized by their use of a highly symbolic mythology.

Other Important Works by Beckmann

Sinking of the Titanic, 1912, St. Louis Art Museum, St. Louis	Birds' Hell, 1938, St. Louis Art Museum, St. Louis
Self-Portrait in Tuxedo, 1927, Busch-Reisinger Museum, Cambridge, MA	Argonauts Triptych, 1949–50, National Gallery of Art, Washington, DC

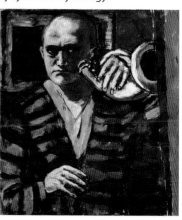

■ **Self-Portrait with Horn**, 1938, oil on canvas, 110 x 101 cm, Neue Galerie, New York

Almost no other artist of the modern era has made as many self-portraits as Max Beckmann. He gave us a complex psychological insight into his personality, portraying himself as one marked by war, self-assured, and powerful in *Smoking*, or as a despairing reminder and a prophetic voice.

■ **The Night**, 1918, oil on canvas, 133 x 154 cm, Kunstsammlung Nordrhein-Westfalen, Düsseldorf

As a result of his experiences during the war, Beckmann's style underwent radical changes. His art became characterized by graphic, realistic harshness. The main work from this period, *The Night* depicts flayed people alongside their torturers. Its sharp-edged, expressive composition, with sharp angles and distorted perspectives, creates a feeling of claustro-phobia within the tight space of the canvas. The characters, torturers and tortured alike, are bound within the canvas. As in war, no one benefits from this situation. The nightmarish torture scene symbolizes mankind's position in an apocalyptic world. In depicting the apex of the dramatic scene, Beckmann has locked his characters in an eternal hell. His later works, employing New Objectivity, were much calmer. They primarily focused on city life, still lifes, and portraiture.

Max Beckmann

Pablo Picasso

Pablo Ruiz Picasso
1881, Málaga–1973, Mougins

■ The most significant and versatile modern artist of the 20th century ■ One of the most productive artists ever, with 15,000 paintings, 660 sculptures, and countless drawings and prints ■ Pioneered the Cubist style

1881 Born in Málaga, considered a prodigy, father arranges first exhibition

1897 Studies in Madrid; begins the first of many stays in Paris

1900 Develops his "Blue Period"

1904 Relocates to Paris; develops his "Rose Period"

1906/07 Influenced by Cézanne and African sculpture, paints *Demoiselles d'Avignon*

1907–14 Collaborates with Braque on Analytical and Synthetic Cubism

1914 Begins to develop a Neoclassical metaphorical style

1925 Begins a convergence with Surrealism

1929–31 Constructive anthropomorphic iron sculptures

1935 Begins to combine expressive deformation and individual symbolism

1937 Paints the antiwar piece *Guernica*

1944 Member of the Communist Party

1968 Frenetic period

1973 Dies in Mougins

This Spanish artist is one of the great figures of 20th-century modern art. Picasso formed his figures out of inert matter and breathed life into them through the fire of his creativity. Striving for absolute beauty and engaged in a lifelong search for authentic painting, he created works of great forcefulness and honesty. These were rooted in tradition and yet free of all orthodox restrictions. Picasso's central theme, which he pursued relentlessly throughout his career, was the human condition. He participated in and fathered many diverse forms of modern art with his inexhaustible creativity and stylistic diversity, yet he never ventured into one genre: abstraction. Humankind, and living creatures in general, remained his lifelong obsession. His complete attention was directed at this. He shattered the human form and deformed its body, captured it in flat surfaces or rounded it out, flooded it with color or withdrew the color entirely. He illustrated man as a suffering individual, as a beast, visualized man as a potent lover, and woman as a strange magical being—he drove ⟳

■ **The Dove**, 1949, lithograph, 54.5 x 70 cm, created for the World Peace Conference

As well as being a renowned painter and sculptor, Picasso was also a graphic artist who mastered the techniques of etching and lithography. As a result, *The Dove* is one of his best-known motifs. After World War II, he designed a poster for the World Peace Congress, which took place in Paris in April 1949; the white bird became a powerful symbol of the worldwide longing for peace.

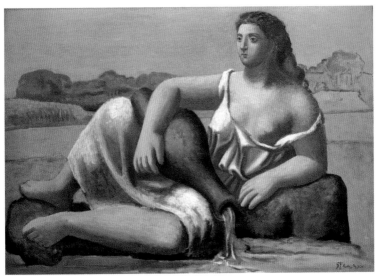

■ **The Source**, 1921, oil on canvas, 64 x 90 cm, Moderna Museet, Stockholm

Picasso was frequently preoccupied with the subject of bathers. For example, this allegory was incorporated in numerous 1920 paintings with Classical female forms in water. Powerful, sensual female bodies sit, stand, or move along barren shores. Nothing detracts from the completely self-referential, melancholy figures, which seem disproportionately oversized, even monumental, for the space.

■ **Violin, Glass, Pipe, and Anchor**, 1912, oil on canvas, 81 x 54 cm, Národní Galerie, Prague

The development of Cubism is one of the greatest ventures of modern art. This pioneering achievement is the result of an artistic dialogue between Braque and Picasso circa 1909. This painting is a good example of the first phase of Analytical Cubism. It attempts to represent each three-dimensional image on a flat surface. The painting's subject is divided into numerous facets and surfaces, which are repeated in parallel layers.

Pablo Picasso

the human form to the brink of non-representation, but never beyond it.

Picasso's paintings and sculptures revolutionized the treatment of space in art. His versatility and innovation evolved throughout his career into many different styles and would later influence the formation of new artistic movements.

Other Important Works by Picasso

Acrobat and Young Harlequin, 1905, Barnes Foundation, Merion

Portrait of Ambroise Vollard, 1910, Pushkin Museum of Fine Art, Moscow

La Suppliante, 1937, Tate Modern, London

Massacre in Korea, 1951, Musée Picasso, Paris

Bathers, 1956, sculpture group of 6 figures, Staatsgalerie, Stuttgart

Reclining Female Nude with Cat, 1964, Steegmann Collection, Stuttgart

Matador and Nude, 1970, Berggruen Collection, Berlin

■ **Guernica**, 1937 oil on canvas, 349.3 x 776.6 cm, Museo Nacional Reina Sofia, Madrid

This monumental painting, with its passionate accusation, is considered to be the ultimate antiwar painting. This is evident in the directness of agony, mourning, and horror illustrated by the destruction of form that spans the picture's entire surface. On April 26, 1937, Franco's allies bombed Basque Guernica and destroyed it. Picasso began his preliminary studies on May 1 and displayed the mural at the Paris International Exhibition in June.

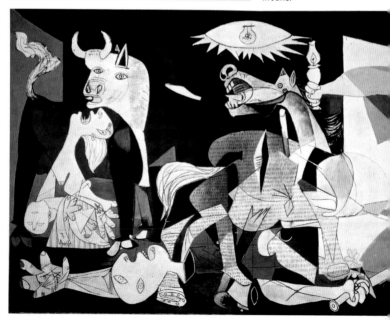

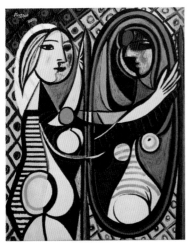

■ **Girl Before a Mirror**, 1932, oil on canvas, 162.3 x 130.2 cm, Museum of Modern Art, New York

The unusually colorful, multisurfaced, and ornamentally effective painting shows Picasso's new young beloved, Marie-Thérèse Walter, in a dual portrait. The motif of mirror-image doubling is an allusion to the myth of Narcissus, with which the artist was intensely preoccupied at the time. Thus, reflection is always a symbol for reflective self-discovery.

■ **Man with a Lamb**, 1944, bronze, 222.5 x 78 x 72 cm, Philadelphia Museum of Art

Picasso spent the war years in Paris and declined all offers of emigration. Created in Paris, this monumental "Good Shepherd" is, in the clear and realistic language of form, an appeal to humanity in dark times.

Cubism in France

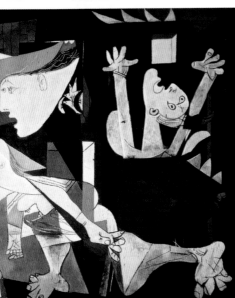

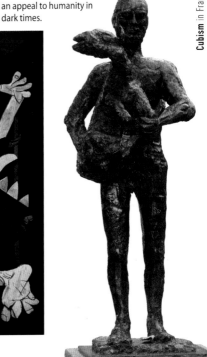

Demoiselles d'Avignon

This epochal work, which marks the beginning of modern art, was not created in a single act of ingenious creativity, but was prepared over the course of months through numerous composition sketches and studies, in which the artist contrasted statuary and plasticity in the human figure. Picasso, influenced by Cézanne's (p. 382) *Bathers*, concerns himself with the schematization of the body and its reduction to shapes and volumes. In the course of the work, the bodies, the field of vision, and color all melt into a single faceted unit. A narrative can be found only in the small still life at the bottom of the picture.

In the spring of 1907, Picasso began his preliminary studies and in June commenced work on the painting. The first "Iberian version" was developed. Soon thereafter, the artist was so moved during a visit to an ethnographic museum of ancient sculptures from French colonial Africa that he completely reworked three figures. In July 1907, the picture was complete. In the end, he decided in favor of a stagelike production of the five women aligned with the viewer.

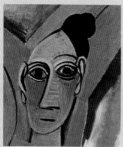

His contemporaries found the painting alien and terrifying. They failed to recognize it as new or revolutionary. In the heavily typecast faces, anything portraitlike was completely removed. The body sizes are correspondingly reduced. Both "African" women in the right half of the painting, with their totem-style masklike faces, call to mind the carved female figures that had so strongly impressed Picasso in the ethnographic museum. In a 1937 discussion he acknowledged the shocking effect of tribal art and the magical allure it exerted upon him. The magic was created by diverting power from the archaic figures. "If we bestow a form upon these spirits, then we become free," he said. Because of the later radical and spectral deformation of their faces, which simultaneously express both anarchical life-energy and fear of death, the women had an almost fetishistic effect. Thus, Picasso depicted danger through the feminine figure.

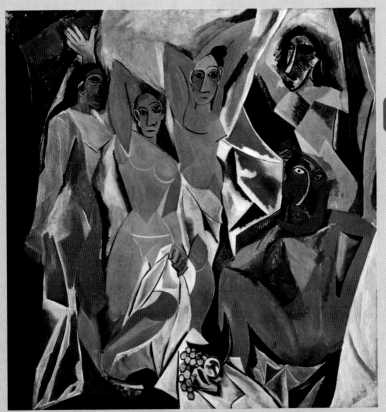

■ **Demoiselles d'Avignon**, 1907, oil on canvas, Museum of Modern Art, New York

Pablo Picasso

Marc Chagall

1887, Vitebsk—1985, Saint-Paul-de-Vence

■ Is among the most influential of Russian-Jewish artists ■ Crossed borders between Eastern and Western European cultures ■ He combined Cubism with folk art motifs ■ Leading graphic artist ■ Chagall's art was also inspired by Fauvism and he often used a bright palette

● **1887** Born in Vitebsk, Belarus

1910–14 Lives in Paris

1914 First exhibition in Berlin; returns to Russia

1922 Lives in Berlin; learns techniques of etching

1923 Moves back to Paris

1937 Becomes French citizen; criticized for "degenerate art" in Germany

1941 Emigrates to America; first color lithographs

1948 Returns to France for good

1985 Dies in Saint-Paul-de-Vence

■ **Over Vitebsk**, 1915–20, oil on canvas, Museum of Modern Art, New York

Around 1914, he created several portraits of elderly Jews—men moving about as "air men"—as symbols for the tragic greatness of rabbis and beggars. This is illustrated here in this Cubist-inspired painting. Soaring above the houses is a metaphor for the bitterly poor existence of these people.

Chagall crossed borders between Eastern and Western European cultures. He saw himself as a member of the international avant garde as well as a Russian Jewish artist. He did his early work in Paris in 1910. He combined the faceted form of Cubism with themes and motifs from Russian and Jewish folk art, as well as intense colors liberated from their subjects, an approach inspired by French Fauvism and Orphism. This style had a lifelong influence upon his unique, gravity-defying artistic vision. His paintings focused on the simple life of the Jewish ghetto, as well as the hectic hustle and bustle of the French metropolis. His main focus included images of theaters and circuses. Decorative etchings and lithograph cycles from world literature and the Bible played important roles during the later period of his work.

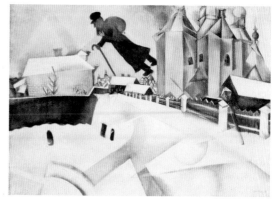

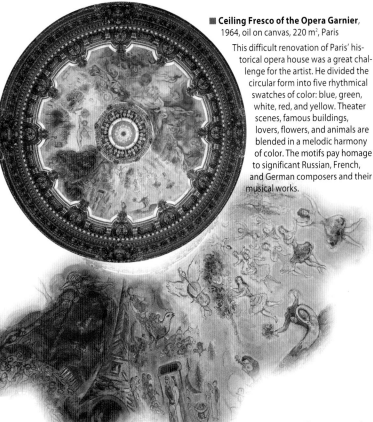

■ **Ceiling Fresco of the Opera Garnier**, 1964, oil on canvas, 220 m², Paris

This difficult renovation of Paris' historical opera house was a great challenge for the artist. He divided the circular form into five rhythmical swatches of color: blue, green, white, red, and yellow. Theater scenes, famous buildings, lovers, flowers, and animals are blended in a melodic harmony of color. The motifs pay homage to significant Russian, French, and German composers and their musical works.

Other Important Works by Chagall	
I and the Village, 1911, oil on canvas, Museum of Modern Art, New York	Russian Museum, St. Petersburg
Paris Through My Window, 1913, Solomon R. Guggenheim Museum, New York	The White Crucifixion, 1938, oil on canvas, Art Institute of Chicago
The Promenade, 1917, oil on canvas, State	Elijah's Chariot, 1971, mosaic, Musée National Message Biblique Marc Chagall, Nice

Chagall, in his work, expressed happiness and optimism through bright and vivid colors. These colors, separated from their figures, convey a sense of childish fun. He was fascinated with the magical worlds of the circus, theater, and music—he often depicted jugglers, artists, clowns, dancers, stage actors, and animals. The first monumental mural with these themes was created in 1920 for Moscow's Jewish Chamber Theater. Throughout his life, Chagall would continue to create large-scale works, including designing the set for Stravinsky's *Firebird*.

Marc Chagall

Umberto Boccioni

1882, Reggio—1916, Verona

■ The Italian painter and sculptor was one of the founders and main representatives of Futurism ■ His work was associated with the broken, multiperspective forms of Cubism during the height of the movement ■ Much of his work deals with capturing change and movement in space

■ **1882** Born in Reggio di Calabria

1898 Travels to Rome, studies with Giacomo Balla

1906 Travels to Paris, Russia, and Padua

1907 Moves to Milan; works as an advertising artist

1910 Meets Marinetti; first solo exhibition in Venice

1911 Learns of the Cubists via Guillaume Apollinaire

1912 Participates in the first Futurist exhibition in Paris, with exhibitions in London, Berlin, and Brussels following

1913 Participates in the "Erster deutsche Herbstsalon" in Berlin

1915 Joins the military

1916 Dies following a riding accident

Other Works by Boccioni

The Street Enters the House, 1911, Sprengel Museum, Hannover

Elasticità (Elasticity), 1912, Civicio Museo d'Arte Contemporanea, Milan

Dynamism of a Speeding Horse + Houses, 1914–15, Solomon R. Guggenheim Museum, New York

The Italian painter, sculptor, and writer is one of the leading artists of the Futurism movement. Boccioni studied with the painter Giacomo Balla in Rome, who acquainted him with the art of the Impressionists. In 1910, both painters signed Marinetti's *Futurist Manifesto*, which had been written the year before. Later, Boccioni himself wrote two manifestos about Futurism. In 1912, he participated in the first Futurist exhibition in Paris. Also inspired by Cubist experimentation, he sought to create a synthesis between time, place, form, color, and tone within both painting and sculpture. From 1912 onward, he changed the traditional understanding of sculpture.

■ **Unique Form of Continuity in Space**, 1913, bronze, 114 x 84 x 37 cm, Museum of Modern Art, New York

Everything is in motion in this monumental striding sculpture. The surface is tumultuously divided and the anatomy distorted as it appears to stride through space.

■ **The Laugh**, 1911, oil on canvas, 110.2 x 145.4 cm, Museum of Modern Art, New York

Boccioni and the other Futurists had great faith in the future. He glorified technology and the noisy, fast-paced lifestyle of the modern world. He sought to portray the saturation, transparency, and simultaneity of fervent impressions in dynamic actions, indivisible from one another and characterized by the union of the subject with its surroundings. Time and movement, the two primary concerns of the Futurist movement, and the depiction of sound, tone, noise, and laughter play important roles in the painting.

■ **Charge of the Lancers**, 1915, tempera and collage on pasteboard, 32 x 50 cm, Museo d'Arte Contemporanea, Milan

The Futurists were excited by war, which they saw as an effective provocation against everything outdated. They often combined a Cubist multi-layered perspective, division of form, and movement in aggressive, striking interpretations.

Umberto Boccioni

Paul Klee

1879, Münchenbuchsee, near Berne–1940, Muralto

■ Klee was a significant German painter and an art theorist ■ He was also considered a poet among modern artists ■ Combined an abstract-constructivist style with luminous colors and fantastical configurations ■ Influenced further generations with his teachings and theories on art

■ **1879** Born in München-buchsee near Berne

1900 Studies at the Munich Academy of Fine Art

1911 Is involved with Der Blaue Reiter, participates in their second exhibition

1914 Visits Tunisia with August Macke and Louis Moilliet

1920 Begins teaching at the Bauhaus in Weimar and, after 1924, in Dessau

1924 Lectures and exhibits with Die Blaue Vier in the USA

1930 Begins teaching at the Düsseldorf Academy

1933 Is suspended from teaching and ostracized for producing "degenerate art," emigrates to Switzerland

1940 Dies after an extended illness in Muralto

■ **Evening Separation**, 1922, water color on paper, 33.5 x 23.2 cm, Klee family collection, Berne

During his tenure as a Bauhaus instructor, Klee was intensely preoccupied with color. He translated his theories into abstract works, as with this composition of delicate horizontal shades of color.

Paul Klee, a painter, draftsman, and graphic artist, is one of the most significant representatives of modern art. Just as important as his art is his influence on the art world as an art teacher and art theorist. As a professor, he was able to influence many artists. Klee thought of art as a creative act equivalent to that found in nature. "Art does not reproduce the visible, rather it makes visible," he wrote. His early work, inspired by Symbolism, was comprised of both drawings and etchings. He achieved a liberating breakthrough in the way he used color, largely because of a 1914 trip to Tunisia, as well as because of his acquaintance with Kandinsky (p. 424) and Delaunay. Klee's artistic vision was shaped by the unknown, free association, and memory, which he translated into a final burst of creativity with poetically titled works.

Other Works by Klee

On a Motif from Hamamet, 1914, Kunstmuseum Basel

Cosmic Composition, 1919, Kunstsammlung Nordrhein-West-falen, Düsseldorf

Attrappen (Omega 5), 1927, Thyssen-Bornemisza Collection, Madrid

Ad Parnassum, 1932, Kunstmuseum, Berne

The Future Man,1933, Kunstmuseum, Berne

Red Waistcoat, 1938, Kunstsamm-lung Nordrhein-Westfalen, Düsseldorf

■ **The Golden Fish**, 1925, oil and watercolor on paper on cardboard, 49 x 69 cm, Kunsthalle, Hamburg

With respect to its contents and composition, Klee's famous goldfish is somewhere between poetic inspiration and austere construction. The luminous fish floats motionless in deep blue water and is surrounded by symmetrically arranged small red fish, blue water plants, and waves.

■ **In the Desert**, 1914, watercolor on rice paper, 27.6 x 23.7 cm, Franz Mayer Collection, Zurich

Klee went to Tunisia in 1914 with two other painters. Inspired by his experience with the colorful and light-intensive landscape, he rediscovered painting. The watercolors, overlaid with a network of geometric forms, are clear compositions of luminous, translucent swathes of color with softly tinted transitions, in which fragments of architecture and landscape shine.

Paul Klee

Piet Mondrian

Pieter Cornelis Mondriaan
1872, Amersfoort–1944, New York

■ Founder of austere, geometrically abstract Neoplasticism ■ Cofounder of the Dutch De Stijl movement ■ Was an important art theorist ■ Produced theories about architecture and city planning with his works

1872 Born Pieter Cornelis Mondriaan
1892–94 Studies at the Amsterdam Academy
1911–14 Relocates to Paris
1917 Founds De Stijl in the Netherlands with artist and architect Theo van Doesburg, and develops Neoplasticism
1919–38 Settles in Paris
1931 Joins the Abstraction-Creation group
1940 Emigrates to New York
1944 Dies in New York

Piet Mondrian is the founder of Neoplasticism—a severely abstract art that uses only primary colors, black, white, and gray in the shapes of squares or rectangles arranged vertically and horizontally. In the search for a "universal" reality, he succeeded in developing a complete abstraction largely through the influence of Parisian Cubists. In 1916, he became acquainted with Theo van Doesburg, founded the De Stijl art movement with him, and, in a journal of the same name, published his own art theories. Mondrian considered his paintings , which were continuously growing in abstraction, to be an allegory for a harmony that ought to encompass all aspects of life. His ideas impacted architecture and city planning.

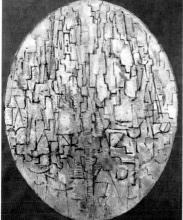

■ **Tableau No. 3: Oval Composition**, 1913, oil on canvas, 94 x 78 cm, Stedelijk Museum, Amsterdam

Through the influence of Cubism, Mondrian's work from 1910 to 1914 developed an abstraction in which concrete objects remain somewhat recognizable. Here we see his use of the geometric planes found in Cubist paintings.

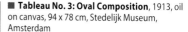

Other Important Works by Mondrian	
Composition in Color B, 1917, Kröller-Müller Museum, Otterlo	Composition with Double Line and Yellow, 1932, National Gallery of Scotland, Edinburgh
Tableau No. IV: Lozenge Composition with Red, Gray, Blue, Yellow, and Black, ca. 1924, National Gallery of Art, Washington, DC	Victory Boogie Woogie, 1942–44, Gemeentemuseum, The Hague

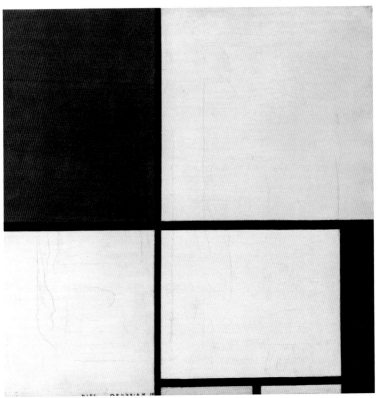

■ **Composition with Red, Yellow, and Blue**, 1929, oil on canvas, 45.2 x 45 cm, Wilhelm-Hack Museum, Ludwigshafen

Mondrian's main works are limited to a rigid abstraction within a geometric framework, in which horizontal and vertical lines form a single rectangle using the primary colors red, yellow, and blue.

■ **Broadway Boogie Woogie**, 1942–43, oil on canvas, 127 x 127 cm, Museum of Modern Art, New York

In his later work, Mondrian created ascetic paintings of surprising dynamism. In the *Boogie Woogie* series, a rhythmic and colorful work, a lattice "dances" in formal rectangles across the surfaces of the paintings.

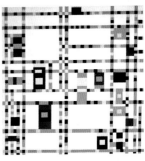

Piet Mondrian

Liubov Popova

Ljubov Sergejevna Popova
1889, Iwanowskoje, near Moscow—1924, Moscow

■ Was one of the leading female artists of the Russian avant-garde ■ Her early work was in the style of Cubo-Futurism ■ Helped develop an authoritative Russian Constructivism ■ Created abstract geometric works of many shapes

■ **1889** Born in Ivanovskoe near Moscow

1907–09 Studies art in Moscow

1912–14 Studies in Paris with Jean Metzinger; travels in Italy

1916 Member of the Supremus group, founded by Malevich

1918 Official commissions for shows and decorations

1920 Member of the Institute of Artistic Culture; docent at the Artistic-Technical Workshop

1922 Sketches for patterns and clothing

1924 Dies in Moscow

Popova is one of the most significant female artists of the 20th century. She catalyzed and, after the October Revolution, decisively shaped the Russian avant-garde art scene. She is considered one of the cofounders of Constructivism in the Soviet Union. In the early years of the revolution she helped the government by creating propaganda posters and designs for books and theater sets. Her early Cubist work was created after a prewar period of study in Paris. Around 1916, she joined the Russian art movement Supremus, and later developed her style into more abstract compositions, in which she translated Constuctivist principles of line, surface, space, and color ratio into her works. Around 1921, after one last exhibition, she completely gave up painting in favor of pragmatic art. Popova died at 35 of scarlet fever.

Other Works by Popova

Composition with Figures, 1913, Tretyakov Gallery, Moscow

Painterly Architectonics: Black, Red, Gray, 1916, Tretyakov Gallery, Moscow

Birsk, 1916, Solomon R. Guggenheim Museum, New York

Painterly Architectonics, ca. 1916/17, Weinberg Bequest and Collection, Switzerland

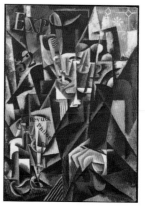

■ **The Philosopher**, 1915, oil on canvas, 89 x 63 cm, The State Russian Museum, St. Petersburg

Popova developed the style of Russian Cubo-Futurism from a synthesis of the refractions found in French Cubism and the "power lines," sequential repetition, and an intense use of color found in Italian Futurism. The style is characterized by an intense spatial presence and large-scale analysis of form. Although Popova strove to create a Russian art form, this painting is clearly a product of her studies in Paris.

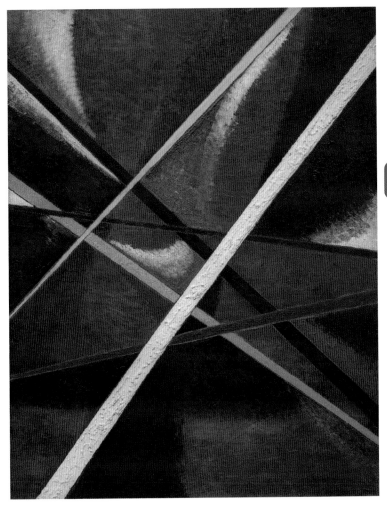

■ **Spatial Force Construction**, 1921, oil on plywood, 83.5 x 64.5 cm, Tretyakov Gallery, Moscow

The 1916 abstract painting *Painterly Architectonics* displays an unprecedented wealth of form and color. In the later *Spatial Force Constructions*, Popova developed the style of the autonomous line, liberated from its form, and given special significance as an elementary means of expression. The lines create a dynamism throughout.

Liubov Popova

Kurt Schwitters

1887, Hannover—1948, Kendal

■ One of the most versatile German Dadaists ■ Influenced by the social utopia of Russian Constructivism ■ Painter, graphic artist, and poet ■ In Hannover, founded unique form of Dada, which he termed Merz ■ Created countless collages from the byproducts of civilization

■ **1887** Born in Hannover

1909–14 Studies at the Dresden Akademie

1918 Contact with the Zurich and Berlin Dadaists; begins his friendship with Hans Arp and Hannah Höch

1922 Becomes familiar with De Stijl through van Doesburg

1923 Founds the magazine *Merz*; earns a living as a commercial artist and typographer

1923–36 Works on his first *Merzbau*

1937 Flees to Norway after his art is labeled "degenerate" by the Nazis

1940 Flees to England

1948 Dies in Kendal in the Lake District

The German painter, poet, and sculptor was one of the leading representatives of the Dada movement, which formed in reaction to the catastrophe of World War I and was critical of middle-class art and culture. He founded a unique form of Dada, which he called Merz, in Hannover in 1919. Schwitters's Merz œuvre was not politically oriented like Berlin's Club Dada, but rather more playfully poetic, self-parodying, and ironic, an attitude that is illustrated in his nonsense poems *An Anna Blume* and *Ursonate*. In 1923, he began his most significant work, the *Merzbau*. The *Merzbau* was a sort of nested, cavelike Constructivist architecture that created a new type of environment inside his house by incorporating a vast array of materials and objects into the rooms. *Merzbau* was destroyed in an air raid during the war. He began a second building in Norway during his exile, and then a third one in England, where he fled in 1940.

■ **Untitled (Merzbild Pink Yellow)**, 1943, assemblage, 34.1 x 26.5 cm, Kurt and Ernst Schwitters Foundation, Hannover

Schwitters was a passionate collector of objects, which included not just the relics of civilization but also those formed by nature, such as rocks, leaves, and especially driftwood, which he gathered on the beach during his exile in

Norway and employed in his numerous relief collages. This 1943 work consists of these kinds of natural found objects. But it also shows how completely Schwitters separates the found material from its original nature and incorporates the distribution of forces into the sculptural process. The raw wood recedes into its material state and subordinates itself to the overall aesthetic concept, which is artistically pronounced in this later work.

■ **Zuban Merz 366**, 1922, collage of partially colored printed pieces of paper and transparent silk paper mounted on board, 14.8 x 11.2 cm, private collection, Berlin

In 1919, Schwitters developed his own form of Dada in Hannover, where he lived until his emigration. It was created from a love of nonsense, as he himself said. He called it Merz, a word fragment from *Kommerz* (German for "commerce"). He selected this term not by chance, since his collages were equally critical of both middle-class culture and the pursuit of profit. He pasted together, in a very real sense, the wreckage, fragments, and relics of his time. They appear chaotic and arbitrary, but are very consciously composed, tightened into a constructive framework, and often, as with *Zuban*, named after word fragments.

■ **This Is Spring for Hans Arp**, 1930, relief, wood, painted, 61.5 x 51 cm, Pinacoteca Casa Rusca, Locarno

Dedicated to Hans Arp, this piece is characteristic of Schwitters's Constructivist work. In 1929, he co-founded the Cercle et Carré with Arp and others in Paris to counter Surrealism with constructive art.

Other Important Works by Schwitters	
Construction for Noble Ladies, 1919, Los Angeles County Museum of Art	sammlung Nordrhein-Westfalen, Düsseldorf
Cherry Picture, 1921, Museum of Modern Art, New York	Kleine DADA Soirée, 1923, Art Gallery of New South Wales, Sydney
Merz Picture 25A: The Star Picture, 1920, Kunst-	Merzbarn, 1947–48, Hatton Gallery, Newcastle

Kurt Schwitters

Marcel Duchamp

Henri-Robert-Marcel Duchamp
1887, Blainville–1968, Neuilly-sur-Seine

■ One of the most important representatives of the avant-garde ■ Influential catalyst of modern art ■ Invented the readymade ■ Founded the Dada movement in New York ■ Composed numerous theoretical writings on art

1887 Born Henri-Robert-Marcel Duchamp

1904 Moves to Paris and studies at the Académie Julian

1913 Withdraws from traditional painting

1915 Moves to New York

1920 Cofounds Société Anonyme, the first American forum for modern art exhibitions

1923 Returns to Paris

1941 Moves to America

1942 Exhibits his portable museum, *Box in a Valise*, in which his work, writings in miniature, and facsimiles are assembled

1968 Dies in Neuilly

Works by Duchamp

Bottle Rack, 1914, readymade, Staatsgalerie, Stuttgart

Chocolate Grinder No. 2, 1914, Philadelphia Museum of Art, Philadelphia

Fountain, 1917, authorised replica 1964, readymade, private collection

Box in a Valise, 1963, Loïc Malle Collection, Paris

This French artist is considered to be one of the most important avant-garde artists and one of the most influential trailblazers of 20th-century modern art. After Impressionistic beginnings, Duchamp discovered Cubism, which he associated with the Futurist Moment movement around 1910. In 1913 he created his first readymade, or everyday manufactured object that is selected by an artist as a work of art. These works became a starting point for the development of found art. Thereafter, he occupied himself primarily with conceptual inquiries into art and the search for an "antiart." In 1915, Duchamp went to New York, where he participated in many pre-Dadaist activities. Inspired by contacts with Parisian Dadaists, he cofounded the journal *New York Dada* in 1920 and planned an American branch of the movement.

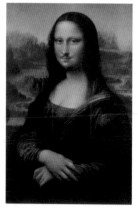

■ **L.H.O.O.Q.**, 1930, color reproduction of Leonardo da Vinci's *Mona Lisa*, readymade, painted over, private collection

None of Duchamp's other readymades was so closely associated with Dada as the bearded and mustached *Mona Lisa*. In 1919, he worked on a piece for the first time in a similar manner. The bearded *Mona Lisa* is seen today as an icon of Dadaism, as the final assault upon middle-class culture. The piece was featured on the title page of a newspaper and inspired the Berlin Dadaists to "improve paintings of Antiquity."

■ Nude Descending a Staircase No. 2, 1912, oil on canvas, 147 x 89 cm, Museum of Art, Philadelphia

Around 1910, Duchamp moved away from Cubism and at the same time began to experiment with Futuristic splinter movements. His most famous painting from this phase, in which he combined the faceted Cubist form with the dynamics of a downward movement, was deemed a betrayal by the Cubists. Capturing the movement of modernity was a Futurist ideal. In this painting, Duchamp has captured and fragmented the movement of a nude descending stairs.

■ Bicycle Wheel, original 1913, third version 1951, readymade, reconstruction of the original, height 126 cm, Hessisches Landesmuseum, Darmstadt

In 1913, Duchamp first put forward a banal object—a bicycle wheel—as a work of art. He reversed it by mounting it on top of a stool. Thus, he created the concept of the readymade. Duchamp altered the industrially mass-produced items so that they were not, or not only, trivial. He furnished them with a signature and an inscription. With these works he changed the understanding of art, first in Paris, and then in New York in 1915.

Marcel Duchamp

George Grosz

Georg Ehrenfried Gross
1893, Berlin—1959, Berlin

■ A left-oriented cofounder of the Dada movement in Berlin ■ Developed an individualistic, realistic-satiric style of drawing ■ Turned to the New Objectivity in 1925

1893 Born as Georg Ehrenfried Gross in Berlin

1909–13 Studies painting in Dresden, Berlin, and Paris

1914 Volunteers for military service

1917 Opposes the war and anglicizes his name in protest; the *Little Grosz Portfolio* appears

1918 Founds the Berlin Dada Club

1920 Co-organizes the International Dada Exhibition

1933 Moves to America

1959 Dies shortly after returning to Berlin

This German painter, brilliant drawer, graphic artist, and caricaturist was one of the founders of the Berlin Dada movement in 1918. Grosz had a decisive influence on the group's political orientation, which had Communist sympathies. His experience as a soldier on the front lines had made him a staunch opponent of war. By 1917, he had developed a unique, realistic-satiric, and deliberately naïve style of drawing that was heavily influenced by the Futurist movement. His political and critical drawings, paintings, and Dadaistic photomontages are filled with biting scorn aimed at bourgeois culture, capitalism, and the ruling class. In the middle of the Weimar Republic period, Grosz's style became more realistic and approached New Objectivity—an artistic style that was characterized by a brutally distorted interpretation of subjects in order to depict an ugly and critical reality. In his later works, created after his flight from Nazi Germany to the United States, he presented somber visions of war and dictatorship.

■ **Portrait of the Author Max Herrmann-Neisse**, 1925, oil on canvas, 100 x 101 cm, Staatliche Kunsthalle, Mannheim, Germany

In this portrait, Grosz emphasizes what is most typical about his subject. With cool practicality, he shows every vein and wrinkle on the impressive head and the gaunt hands of the little, badly formed man. The painter created not only a passing portrait of the poet, but also a typical depiction of a critical intellectual of the Weimar Republic.

■ **Pillars of Society**, 1926, oil on canvas, 200 x 108 cm, Nationalgalerie, Berlin

In this allegory of the Weimar Republic, Grosz introduces, with biting mockery, typical characters of the ruling class—the former aristocratic student wearing a swastika, the reactionary "journalist," the Social Democratic "politician" waving a small, nationalistic German flag, as well as the besotted "military chaplain" and bloody soldiers. Behind them, houses are already burning. *Pillars of Society* is eerily prophetic.

Other Works by Grosz

Metropolis, 1916/17, collection of Thyssen-Bornemisza, Madrid

To Oskar Panizza (The Burial of the Poet Oskar Panizza), 1917/18, Staatsgalerie, Stuttgart

Self-Portrait and Model, 1928, Museum of Modern Art, New York

I Am Glad I Came Back, 1943, Arizona State University, Tempe, Arizona

■ **Daum Marries Her Pedantic Automaton "George" in May 1920, John Heartfield is Very Glad of It**, 1920, watercolor and collage, 42 x 30.2 cm, Berlinische Galerie, Berlin

Grosz shows the influence of the Italian *Pittura Metafisica*'s mechanical marionettes. It is a self-ironic piece made on the occasion of his marriage to Eva Peter (Daum).

George Grosz

Edward Hopper

1882, Nyack–1967, New York

■ Painter, graphic artist, and illustrator ■ One of the most important American Realists of the modern era ■ Developed an expressive style that revealed the loneliness and isolation of modern man ■ Concentrated on American themes ■ Depicted architecture and landscapes

1882 Born in Nyack, New York

1900 Studies graphics, illustrations and painting in New York City

1906 First journey to Paris; studies the Old Masters; later travels to London, Amsterdam, Brussels, and Berlin

1913 Takes part in the Armory Show; works as an illustrator and advertising artist

1923 Turns to watercolors and works as a freelance artist

1933 In New York's Museum of Modern Art

1967 Dies in New York

■ **The House by the Railroad**, 1925, oil on canvas, 60.7 x 72.7 cm, Museum of Modern Art, New York

Besides pictures of empty cities, Hopper depicts forlorn landscapes time and time again. Vast, empty skies rise as the backdrop for lonely and monumental buildings. The use of sharp lighting creates hard, deep shadows and reinforces the impression that the subject is unreal and dreamlike.

This painter, illustrator, and graphic artist is considered the most important American Realist of the 20th century. Hopper followed both the American Realistic tradition as well as the international Realism style that arose in the 1920s. Hopper studied painting in New York and traveled several times to Paris, where he greatly admired French artists, particularly Manet (p. 354). After 1920, he developed a characteristic method of composition. Through his treatment of light and its effect on mood, he expressed the typical American outlook on life and the lonely alienation of the individual in modern society. Hopper is also famed for his depictions of architecture and landscapes.

■ **Nighthawks**, 1942, oil on canvas, 84.1 x 152.4 cm, Art Institute, Chicago

Like no other image, this painting illustrates the feeling of abandonment experienced by the individual. Hopper achieves this impression through a seemingly simple but well thought-out composition. He emphasized the coldness of

the picture by employing flat, smooth, straight-edged layers. Diagonals direct the eye toward the scene's center. It is viewed as though through a window, and light plays an important role in setting the mood. Twilight's heavy shadows, silence, and stillness evoke a strong sense of loneliness that has made Hopper famous.

Other Works by Hopper

Gas, 1940, Museum of Modern Art, New York

August in the City, 1945, Norton Museum of Art, West Palm Beach, Florida

Woman in the Sun, 1961, Whitney Museum of American Art, New York

■ **The Automat**, 1927, oil on canvas, 71.4 x 91.4 cm, Des Moines Art Center, Des Moines

Hopper concentrated entirely on American themes, which he depicted in a realistic style fully developed in the 1920s. Hopper's realism had little to do with modern Realism and New Objectivity, nor did he have much of a relationship with his European contemporaries. His style was rather more closely related to French Impressionism and to artists like Manet and Degas, whom he admired, yet his themes are very American.

Edward Hopper

Frida Kahlo

Magdalena Carmen Frieda Kahlo y Calderón
1907, Coyoacán—1954, Mexico City

■ Counted among the most important female artists of the modern age
■ Close to the Surrealists ■ Created self-portraits of great intensity, which
poetically expressed her pain and passion ■ Existential female iconography

1907 Born Magdalena Carmen Frieda Kahlo y Calderón

1925 Suffers severe accident, begins to paint

1926 Meets fresco painter Diego Rivera

1927 Marries Rivera

1932 Lives in the USA

1938 Exhibitions in New York and Paris

1939 Divorce from Rivera and remarriage to him in 1940

1942 Cofounder of the Seminario de Cultura Mexicano, joins "Los Fridos"

1946 National prize for painting

1954 Dies in Mexico City

This Mexican painter was among the most important artists of the 20th century. Frida Kahlo began to paint after suffering a severe car accident at the age of 18. This accident confined her to bed and later led to further complications in her life, which was marked by physical and emotional suffering. Clearly influenced by Mexican folk art and by the Realism of her husband, Diego Rivera, her seemingly naïve pictures center on her personal suffering. The intensity of these candid self-portraits reflects the passion of her inner dialogue and the directness with which she tells her story. Besides these works, she also painted many still lifes and genre scenes depicting the everyday life of average Mexicans. Some of her most puzzling pictures are close to Surrealism. The artist herself commented, "I have never painted dreams. I painted my reality." She died an early death at the age of 47, after a long illness.

Other Works by Kahlo

The Bus, 1929, collection of Dolores Olmedo Foundation, Mexico City

My Birth, 1932, private collection

A Few Small Snips, 1935, collection of Dolores Olmedo Foundation, Mexico City

The Chick, 1945, collection of Dolores Olmedo Foundation, Mexico City

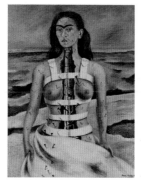

■ **The Broken Column**, 1944, oil on canvas on hard fiber, 40 x 30.7 cm, collection of Dolores Olmedo Foundation, Mexico City

This iconlike self-portrait portrays her as a beautiful young woman and shows her closeness to Surrealism, especially Max Ernst. She looks the viewer in the eye; her body, enveloped by a steel corset, is open so that her broken (spinal) column shows through. This painting conveys both her strength and her vulnerability.

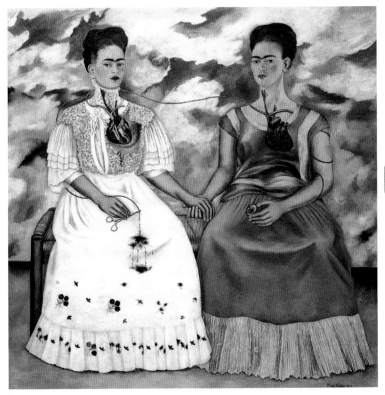

■ **The Two Fridas**, 1939, oil on canvas, 173.5 x 173 cm, Museo de Arte Moderno, Mexico City

There was a gap between reality and the mythical beings Kahlo invented to make her life bearable. By transferring her pain to a representative, to a second Frida, she was able not only to face her pain but also to drive it away. In this controlled distance from herself lies the artistic power of this picture. The double portraits with their open hearts also reveal the pain caused by her separation from Diego Rivera. One Frida holds a small portrait of Rivera, while the other pinches shut her bleeding vein. Her double selves are portrayed in a dreamlike setting.

Frida Kahlo

Max Ernst

1891, Brühl–1976, Paris

■ As painter, graphic artist, and sculptor, Ernst was among the leading and most multifaceted artists of the modern age ■ Member of Dadaists of Cologne and Paris ■ Developed Surrealist painting imbued with the interpretation of dreams and the unconscious ■ Discovered many innovative techniques

■ **1891** Born in Brühl, Germany

1910–14 Studies art history, archaeology and other fields at the University of Bonn

1914 War service; meets George Grosz and the Herz-felde brothers

1918 Marries the art histo-rian Luise Straus

1919 Helps found the Dadaist group in Co-logne

1920 Meets Parisian Da-daists

1922 Moves to Paris

1924 Initiation of Sur-realism through André Breton

1929 Creates his first "collage novel"

1937 Branded a "degener-ate" by the Nazis

1938 Moves to southern France

1939 Arrested after the start of hostilities

1941 Emigrates to the USA

1946 Marries the painter Dorothea Tanning

1953 Returns to France

1976 Dies in Paris

This German-born artist was one of the most innovative painters of the modern age. He is also counted among the first Surrealists in Paris, where he lived beginning in 1922. Ernst, who was self-taught, was close to the Expres-sionists in his early, prewar work. In 1919, he was one of the founders of the Dadaist group in Cologne. In his Da-daist collages, he joined seemingly incompatible things into fantastic and baffling creations. Ernst later joined the Parisian Dadaists. After the founding of Surrealism in 1924, he invented *frottage*, a technique involving placing paper col-lage over different textures; *grattage*, a painting technique that involves the scrap-ing of dry paint; and later, around 1940, the *décalcomanie* technique, which involves app-lying materials into thick layers of paint. Through layering, *décalcomanie* illus-trated the stream-of-consciousness wri-ting of Surrealist poets. His pictures, in-fluenced by Freud's dream elucidations and the unconscious, exhibit strong halluci-natory power.

■ **Moonmad**, 1956, bronze, 92.2 x 31.7 x 29 cm, Hirshhorn Sculpture Garden at the Smithsonian Insti-tute, Washington, DC

Ernst was also active as a sculptor. In contrast to his paintings, his sculptures are simply constructed and developed out of one great form. These droll beings, which in their statuesque forms often recall totem figures from archaic cultures, exude a comic spirit.

■ **The Elephant Célèbes**, 1921, oil on canvas, 125 x 107 cm, Tate Modern, London

In his Dadaist paintings, Ernst often applied the collage technique. He discovered the model for this fantastic monster in the photo of a round, industrial apparatus for preparing sugar; he transformed it into an "elephant" by adding appropriate parts, but didn't obscure the technical apparatus that forms the basis of his creation.

■ **Attirement of the Bride**, 1940, oil on canvas, 129.6 x 96.3 cm, Peggy Guggenheim Collection, Venice

With this major work, the Surrealist opened new visual horizons. Using *décalcomanie*, a spontaneous dabbing technique, Ernst created forms and structures of extraordinary variety and richness.

Other Important Works by Ernst	
Approaching Puberty, 1921, private collection	The Entire City, 1934, Tate Modern, London
Men Shall Know Nothing of This, 1923, Tate Modern, London	The Temptation of St. Anthony, 1945, Wilhelm Lehmbruck Museum, Duisburg
Forest and Dove, 1927, Tate Modern, London	The Dark Gods, 1957, Museum Folkwang, Essen
Habakuk, 1934, Max Ernst Museum, Brühl	

Max Ernst

Salvador Dalí

1904, Figueras–1989, Figueras

■ Important Spanish painter ■ Representative of Veristic Surrealism ■ Used a provocative picture language in deceptively realistic pictoral metaphors ■ Published many writings ■ Manneristic effects in his late works ■ Was also a skilled photographer, sculptor, and filmmaker

1904 Born in Figueras, Spain

1921 Studies at the art academy of Madrid

1929 Moves to Paris; joins the Surrealist group; makes the film *Un Chien Andalou* with Buñuel; meets Gala Eluard

1934 Expelled from the Surrealist group for glorifying fascism

1938 Participates in the Surrealist exhibition in Paris

1940 Moves to New York

1941 Exhibits in the Museum of Modern Art

1948 Returns to Spain, uses religious themes

1989 Dies in Figueras

This Spanish painter and drawer is considered the top representative of Veristic (truthful) Surrealism. His faithful rendition of every detail may be traced to his admiration for the French history painter Meissonier. His early work was also influenced by de Chirico's *Pittura Metafisica* and Freudian psychology. In 1929, Dalí arrived in Paris and was welcomed into the circle of Surrealists. He fulfilled their central requirements: automatism and dream interpretation. Dalí used the paranoid-critical transformation method—which created optical illusions in combination with his hyper-realistic style—which never missed a detail and which combined elements of dreams and the unconscious. He presented all of his artistic activities and actions, as well as himself and his wife and muse, Gala, together as a complete work of art in itself.

■ **The Persistence of Memory**, 1931, oil on canvas, 24.1 x 33 cm, Museum of Modern Art, New York

The paranoid-critical transformation method enabled Dalí to achieve a trancelike state, during which he had fantastic visions; he then gave form to these visions with amazing accuracy and obsessive attention to detail.

■ **The Burning Giraffe**, ca. 1936/37, oil on wood, 35 x 27 cm, Kunstmuseum, Basel

The drawer-woman is among Dalí's best known creations. He was influenced by Manneristic furniture figures. Dalí, who occupied himself intensely with Freud, wanted to create an "allegory of psychoanalysis." He wished to visualize with what pleasure "we become aware of the narcissistic smell from each of our drawers."

■ **Retrospective of the Bust of a Woman**, 1933, diverse material (reconstructed), 70 x 65 x 22 cm, Collection of Laurence Clarac-Sérou, Paris

This assemblage from 1933 featuring an old porcelain bust from a show window is one of Dalí's most charming objects. The bust demonstrates the fascination of the Surrealists with dolls, statues, and mannequins that look alive.

The high point of this fascination for models was reached during the great Surrealistic Exhibition in Paris of 1938. As always, Dalí wished to create an erotically stimulating unity. The bust was supposed to stimulate hunger and at the same time appear ready to satisfy it. Therefore, all the decorations of the bust have something to do with food.

Other Important Works by Dalí

The Lugubrious Game, 1929, private collection	Autumnal Cannibalism, 1936, Tate Modern, London
Accommodations of Desire, 1929, Metropolitan Museum of Art, New York	The Sleep, 1937, private collection
Portrait of Gala, 1935, Museum of Modern Art, New York	Crucifixion of Corpus Hypercubus, 1954, Metropolitan Museum of Art, New York

Salvador Dalí

Joan Miró

1893, Montroig—1983, Palma de Mallorca

■ One of the most important Surrealists ■ Developed a very personal and poetic picture world composed of emblematic picture signs ■ Created many sculptures, ceramics, and monumental murals ■ Opposed traditional Catalan styles ■ His later work became increasingly dreamlike and organic

This Spanish painter, graphic artist, and sculptor was one of the most original of the Surrealists, whom he joined in 1924. He is "probably the most Surrealistic of us all," commented André Breton. The artist studied in Barcelona, and his naïve-looking early work was strongly influenced by the folk art of Catalonia. In 1920 he moved to Paris where he befriended Picasso (p. 428). After a short Cubistic phase he developed a spontaneous, automatic brush script and a completely personal, poetic picture world, which was infused by abstract elements as much as by figurative. His emblematic picture signs resemble childish scribbling as well as archaic symbols. Beginning in the 1950s, he created ceramics and his first sculptures, which were made out of a variety of materials, both man-made and natural. He would later go on to paint several grandscale murals. Miró's œuvre is considerably large.

■ **A Person Throwing a Stone at a Bird**, 1926, oil on canvas, 73.7 x 92.1 cm, Museum of Modern Art, New York

Influenced by the geometric abstractions of Mondrian (p. 440) and, above all, by Klee (p. 438), Miró began to paint more simply after 1925. Instead of overcrowding his canvases he now concentrated on individual figures and introduced flat backgrounds in brilliant monochromes. The figures in this picture clearly have an archaic comic character.

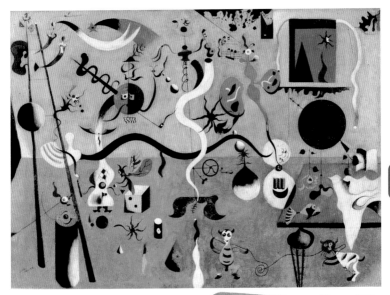

■ **The Carnival of the Harlequins**, 1924/25, oil on canvas, 66 x 93 cm, Albright-Knox Art Gallery, Buffalo, NY

Miró is rightly considered as the most playful of the Surrealists. In this painting, which is typical of this mode, he depicts a medieval wonder world with a multiplicity of forms, rising like balloons from a stage. There is a fantastic swarm of strangely joined figures bustling about: forms of cats and flying nymphs, insects with mustaches, and much more.

Other Important Works by Miró	
Vegetable Garden with Donkey, 1918, Moderna Museet, Stockholm	Women in the Night, 1946, Henie Onstad Kunstsenter, Hovi-kodden, Oslo
Dancer II, 1925, Collection of A. Rosengart, Switzerland	Blue II, 1961, Musée National d'Art Moderne, Centre Georges Pompidou, Paris
The Birth of the World, 1925, Museum of Modern Art, New York	

■ **Woman**, 1983, bronze, 206 x 103 x 70 cm, Fundació Pilar i Joan Miró, Palma de Mallorca

Already in the 1920s Miró composed a critical argument against the Neoplasticism of Mondrian. He created abstract objects out of wood and metal. In his late sculptures, Miró turned again to the fantastic and archaic creatures he had painted earlier. This sculpture, though childish in its rendering, is slightly erotic.

Joan Miró

Man Ray

Emmanuel Radnitzky
1890, Philadelphia–1976, Paris

■ American painter ■ Became famous in Paris as a Surrealistic photographer beginning in the 1920s ■ Developed a series of photographic techniques ■ Created portraits of his fellow artists and contemporaries

1890 Born Emmanuel Radnitzky in Philadelphia

1912 Studies in New York; begins signing work as "Man Ray"

1915 Meets Marcel Duchamp

1920 Freelances in fashion and portrait photography

1921 Goes to Paris and joins Dadaists and later, Surrealists

1938 Exhibits with the Surrealists in New York

1976 Dies in Paris

Man Ray became known chiefly as a Surrealist photographer. He was one of the founders of the Dada movement in New York. Influenced by Marcel Duchamp's readymades (p. 447), he created a series of Surrealist objects. In 1921 he moved to Paris, where he joined the Dadaists and later the Surrealists. He experimented tirelessly with new photographic techniques. Along with his pupil Lee Miller, he discovered solarization, a method of surrounding figures with auras. This lent photos a metaphysical quality highly valued by the Surrealists. This method of photography was well suited to the Surrealist movement because it created an ethereal, dreamlike effect. His compositions often showed alien bodies and objects that strongly exude an erotic, playful, or even depressing ambience. Man Ray also became famous for his striking portraiture, which immortalized his contemporaries.

■ **Rayography Two Hands,** serigraphy on altuglas, 42.7 x 33.7 cm, Gallery Marion Myer, Paris

About 1922, Man Ray invented a method of taking photos without cameras. These rayographies showed mostly objects with diffuse contours in white on a black background.

Other Important Works by Man Ray	
Promenade, 1915/1945, Museum of Modern Art, New York	Indestructible Object, 1922–23 original, 1966 replica, Tate Modern, London
Silhouette, 1916, Solomon R. Guggenheim Museum, New York	Le Violon d'Ingres, 1924, Centre Georges Pompidou, Paris
La Volière, 1919, Scottish National Gallery of Modern Art, Edinburgh	Nude Woman with Spider Net, ca. 1940, Collection of Lucien Treillard, Paris
Cadeau, 1921 original, 1963 replica, private collection	

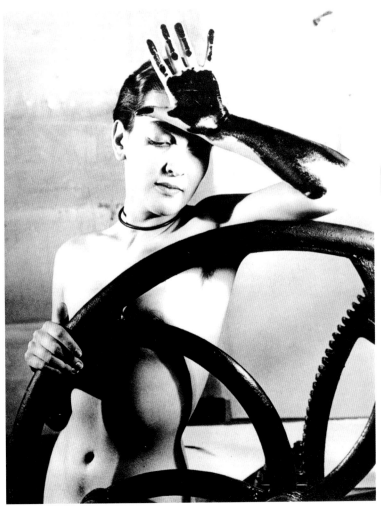

■ **Meret Oppenheim**, 1933, photo, 28.5 x 20 cm

This photo shows the Surrealist painter Meret Oppenheim as a statuesque nude. She is artfully posed behind the wheel of a printing press, and although she has a boyish body and is slightly androgynous, the photo is subtly erotic and retains a feminine allure. This is one of Man Ray's most famous works.

Man Ray

Art
after 1945

Robert Rauschenberg: Retroactive II, 1964, oil and screen-
print on canvas, 213 x 152 cm, Stefan T. Edlis Collection

Art after 1945

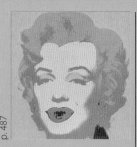
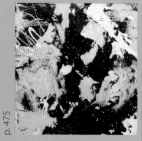
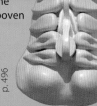
464

p. 490

1960–
Photorealism:
Video and
Photo Art

1960–
Object and
Action Art,
Conceptual Art

Joseph Beuys p. 498
Marcel Broodthaers
Edward Kienholz
George Maciunas
Wolf Vostell
On Kawara

p. 494

465

| 1970 | 1990 | 2008 |

Nam June Paik p. 492
Gerhard Richter
Richard Estes
Hannah Wilke
Bruce Nauman
Gilbert & George
Candida Höfer
Jeff Wall
Marie-Jo Lafontaine
Jenny Holzer
Bill Viola
Mona Hatoum
Nan Goldin
Cindy Sherman
Pippilotti Rist

Ilya Kabakov
Yoko Ono
Robert Barry
Hermann
Nitsch
Judy Chicago
Valie Export
Christian Bol-
tanski
Rebecca Horn
Richard Long
Joseph Kosuth
Rosemarie
Trockel

p. 473

1945–
New Figurations
in Painting and
Sculpture

Henry Moore
Alberto Giacometti p. 472
Germaine Richier
Francis Bacon p. 494
Louise Bourgeois p. 496
Maria Lassnig
Lucian Freud
Georg Baselitz
Sigmar Polke
Anselm Kiefer
Susan Rothenberg
Marlene Dumas

Modernism after 1945

A Variety of Genres, Internationality, Style, Pluralism

The development of modern art in the second half of the 20th century is characterized by the deep divisions within societies caused by World War II. At the end of the 1930s, the avant-garde found itself in a crisis. Innovations and movements were flagging, and artists had already exhausted their utopian visions. European modern art was, however, first awoken from this stagnation by the attempt of Fascism to destroy it. As a result of this persecution, modern art came to embody freedom.

The exodus of artists from Europe to America enabled the avant-garde not only to find new strength, but inspired an entire generation of young American artists. New York quickly became the staging area for developing modern art after the war.

Art after 1945

■ **Lee Krasner: Vigil**, 1960, oil on canvas, 225 x 178 cm, private collection

■ **Roy Lichtenstein: Still Life with Goldfish Bowl**, 1972, oil and magna on canvas, 132 x 106.6 cm, private collection

■ **Agnes Martin**: **Falling Blue**, 1963, oil and pencil on canvas, 182.56 x 182.88 cm, Museum of Modern Art, San Francisco

■ **Henry Moore**: **Moon Head**, 1964, bronze, 57.8 x 44.1 x 25.4 cm, Henry Moore Foundation, Leeds

European artists, with their insurrectionary style of art, provided the first creative impulse as their vigorous creative energies were once again set free. The absolute belief in progress and the optimistic hope of breaking down global borders gave way to a deep skepticism and disillusionment in light of the unprecedented inhumanity and destruction caused by the war. Artistic innovation no longer signified subversion, but modification. Modern art evolved a new artistic language from the foundations created during the first half of the century.

The artistic development after 1945 took place in two phases. The conflict with classical modernity transpired first. The second phase began in the 1970s with the development of radical new genres of expression, especially through the use of new media.

Introduction

The First Phase

For approximately three decades, America dominated the modern art scene, determining its course with its physically expressive abstractions. Inspired by Cubism and Surrealism, Abstract Expressionism developed in New York in the 1940s, where artists such as Jackson Pollock, Mark Rothko, Lee Krasner, and Barnett Newman used a spontaneous and emotional style. Abstract Expressionism inspired similar ideas in postwar Europe, especially among the Informal movement of 1951. Artists of this movement, such as Wols, Georges Mathieu, Pierre Soulages, and Maria Helena Vieira da Silva, dominated the international art scene with their amorphous style until the early 1960s. Other European artists occupied themselves during the postwar era with Figuration, which was characterized by the deformed, isolated, and violent state of man exhibited by sculptors Alberto Giacometti and Germaine Richier, and painters Francis Ba-

■ **Victor Vasarely**: **Boo**, 1978, acrylic on canvas, 200 x 200 cm, private collection

■ **Maria Lassnig**: **Frog Queen**, 2000, oil on canvas, 125 x 100 cm, private collection

Art after 1945

■ Niki de Saint Phalle: Nana Dansante, 1970, painted polyester, 63 x 44 x 26 cm, Wilhelm Hack Museum, Ludwigshafen am Rhein

■ Louise Nevelson: Sky Cathedral III, 1960, painted wood relief, 300 x 345 cm, private collection

con and Jean Dubuffet. After the late 1950s, many movements developed against the extreme individualism found in Informal art. A new style of realism developed in America that sought to bring art down to reality. Robert Rauschenberg attempted to actualize Dadaism within this movement's foundations. New Realists such as Andy Warhol, Roy Lichtenstein, and Claes Oldenburg redefined art, giving commonplace objects from consumer society artistic status. New Realism in Europe developed parallel to the Pop Art movement. Yves Klein, Arman, Niki de Saint Phalle, and Jean Tinguely helped spark off the Action movement in art and shattered the borders of artist genres.

While Bridget Riley and Victor Vasarely explored optical effects, Minimalists such as Sol LeWitt, Donald Judd, and Richard Serra promoted clarity to combat emotions by reducing sculptures to simple geometric structures.

Introduction

The Second Phase

The time of identifiable styles from autonomous directions and backlashes came to a definitive end in the 1970s. The more that artists experimented with transcending genre borders and were influenced by supposedly antagonistic foreign ideas, the more a new conception of truth emerged with a new artistic ethos. Since the 1960s, the expansion of artistic possibilities with the advent of electronic media via photography and videography has changed aesthetics at their very foundations and has promoted the integration of all forms of art. The societal conflict underwent something of a renaissance within Gerhard Richter's great political paintings and was questioned subjectively by Louise Bourgeois and by the naked bodies of Maria Lassnig. Joseph Beuys's shamanic ideas about life and the ways he expressed them through his installations, actions, and object artworks held their own against Nam June Paik's video sculp-

Gerhard Richter: Ema (Nude on the Staircase), 1966, oil on canvas, 200 x 130 cm, Museum Ludwig, Cologne

Anselm Kiefer: Poland Still Has Not Lost, 1968, lead over photograph, 170 x 240 cm, private collection

■ **Bruce Nauman**: **None Sing–Neon Sign**, 1970, neon, Castello di Rivoli Museum of Contemporary Art, Turin

■ **Wolf Vostell**: **Concrete Cadillacs in the Form of the Nude Maja**, 1987, cement sculpture, Berlin

tures, Wolf Vostell's spectacular embedded concrete objects, and the quiet, meditative pictures of Agnes Martin. Subject and object were explored once again by Anselm Kiefer, Georg Baselitz, and Kiki Smith. The conception of man experienced a new form of actualization following the exploration of video in the developing new media genres. Man finds himself in a state of disillusionment in Jeff Wall's carefully arranged photos, portrayed as the vision of violence bordering inhumanity in Bruce Nauman's video installations, or brought to an impasse in time within Bill Viola's works. Art today is characterized equally by new as well as the changing traditional genres of art. Old questions—such as *What is art?*—must be revisited.

Introduction

Alberto Giacometti

1901, Borgonovo–1966, Chur

■ A significant modern sculptor and painter ■ After 1945 developed a totally unique, personal style of sculpting based on his war experiences ■ Concentrated on the idea of man ■ The filament-thin, fragile sculptures are symbolic representations of the loneliness and isolation of modern man

1901 Born in Borgonovo, Switzerland

1919 Studies sculpture and drawing at L'École des Arts et Métiers in Geneva

1922 Moves to Paris to study under the sculptor Bourdelle

1926/27 First major work; joins the Surrealist circle

1940 Flees from Paris; stays in Geneva during the war

1945 Returns to Paris; development of the typical "Giacometti style"

1948 First exhibition after the war in New York

1966 Dies in Chur, Switzerland

The Swiss sculptor, painter, and draftsman lived several times in France and came to be regarded as one of the leading sculptors of the postwar period. His early work was closely related to the Surrealists, whom he joined in Paris from 1930 until 1935. The extreme elongation that is typical of his statues could already be seen in his work during this period. However, throughout the course of the war, his style went through a radical change and began to focus on the way man is conceived. In refocusing his work, reality was no longer limited by visible manifestations. The artist began sculpting from memory, rather than from a model, and by 1945 had created an idiosyncratic style. Giacometti was an artist in "search of the absolute," wrote Jean-Paul Sartre in 1940.

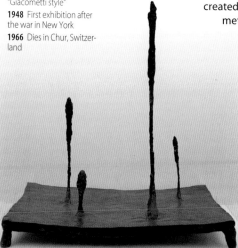

■ **City Square: Three Figures and a Head**, 1950, bronze, 57 x 53.5 x 40 cm, Smithsonian Institute, Hirshorn Sculpture Garden, Washington, DC

Isolated from each other and, at the same time, united on a common ground, the wire-thin statues balance on a pane. They are striking metaphors for individual fate, fear, and loneliness, for the fragile, lost person in the void of space. They also express his personal experience of life, which could not be separated from the immediacy of war.

■ **Three Sculptures: Slender Bust, Portrait of Diane Bataille**, undated; **Woman on a Pedestal**, 1950; **Bust of Diane Bataille**, 1947, height 43.7 cm, plaster, private collection

In 1945 Giacometti returned to Paris, moved back into his studio, and started working. Among his close circle of friends were the author George Bataille and his wife, whose portraits he modeled repeatedly in the elongated, rough style he became famous for.

Other Important Works by Giacometti

Spoon Woman, 1926, Solomon R. Guggenheim Museum, New York

The Couple, 1926, Alberto Giacometti Foundation, Kunsthaus, Zurich

The Cage, 1930–31, Moderna Museet, Stockholm

Woman with Her Throat Cut, 1932, Alberto Giacometti Foundation, Kunsthaus, Zurich

The Surrealist Table, 1933, Musée National d'Art Moderne, Centre Georges Pompidou, Paris

Invisible Object, 1934–35, National Gallery of Art, Washington, DC

The Nose, 1947, Kunstmuseum, Basel

Tall Figure III, 1949, Museum of Modern Art, New York

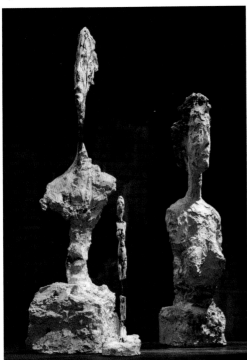

■ **Tall Woman II**, 1960, bronze, 277 x 60 x 31 cm, Fondation Maeght, Saint-Paul-de-Vence

Giacometti's tall, filament-thin statues resemble hieroglyphs—walking and standing, they refer to the idea of space. Despite only having an implied anatomy, the elongation of his emaciated figures is linked to exact proportion and gives the sculptures an impressive, intensified presence. Their fragility and brittleness is additionally emphasized though the cartilaginous, kneaded modelling of the figures' surface.

Alberto Giacometti

473

New Figurations in Sculpture

Jackson Pollock

Paul Jackson Pollock
1912, Cody—1956, East Hampton

■ Most significant American artist of the 20th century ■ Created abstract works of powerful intensity using technique known as "dripping," developed after World War II ■ Automatism is raised to the utmost extremes

● **1912** Born Paul Jackson Pollock in Wyoming

1928 Studies at an art school in Los Angeles

1930 Goes to New York to the Art Students' League

1936 Works in the Mexican muralist Siqueiros's New York workshop

1943 First exhibition at Peggy Guggenheim's gallery in New York; the collector becomes his most important sponsor

1945 Moves to Springs on Long Island

1946/47 Develops "dripping"

1955 Suffers from depression

1956 Car accident on Long Island kills Pollock and Edith Metzger

With his "drip" paintings, Pollock became one of the most famous American painters of the 20th century. His early work had an expressive style that was influenced by Mexican murals. Around 1943, he turned his attention toward the automatism of Surrealism. The pictures, painted in fluid, expressive brush strokes, suggest musical and figurative associations. In 1946, he developed the technique known as "dripping": The picture surface now became an area of experimentation for the autonomous painter's free and easy presentation. The action-oriented painter was influenced in equal measures by spontaneity, calculation, inspiration, and confident dexterity.

■ **Number 7 A**, 1948, oil and colored enamel on canvas, 91.5 x 343 cm, collection of A. Alfred Taubman

This painting is an outstanding example of Pollock's "drippings," which were constantly being adapted and expanded. The canvas was spread on the floor and color was dripped in different intensities upon it, sprinkled or flung. He often used extreme vertical or horizontal formats, as well as unusual painting utensils.

Other Works by Pollock

Enchanted Forest, 1947, Studio Esseci, Padua

Number 26 A, Black and White, 1948, Centre Georges Pompidou, Paris

Number 32, 1950, Kunstsammlung Nordrhein-Westfalen, Düsseldorf

Number 1, Lavender Mist, 1950, National Gallery of Art, Washington, DC

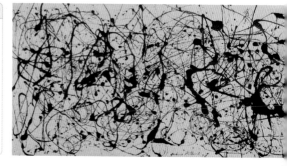

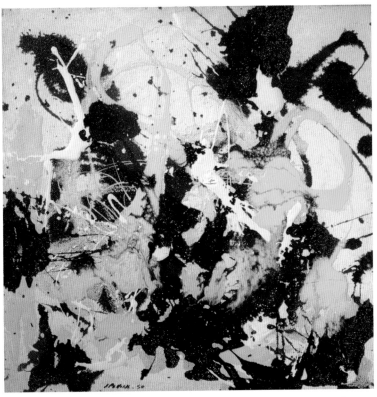

Abstract Expressionism in the USA

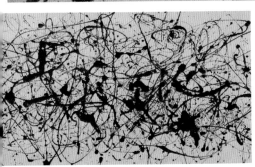

■ **Number 22**, 1950, oil on canvas, 56.4 x 56.4cm, Philadelphia Museum of Art, Philadelphia

During the act of producing the painting, the artist moved dancelike "in his picture." He circles the painting surface rhythmically and left behind trails of color, which weave and overlap, dissolve, and finally produce an abstract, expressive structure, in which forms and colors fuse into a whole.

Jackson Pollock

Mark Rothko

Marcus Rothkowitz
1903, Daugavpils–1970, New York

■ Prominent figure in the New York School of Abstract Expressionism ■ Developed the iconic style, a specific genre of Abstract Expressionism, in his large-scale pictures ■ Created murals and triptychs

1903 Born in Marcus Rothkowitz in Russia
1913 Emigrates to the USA
1924 Studies at the Art Students' League of New York
1929–52 Teaches art at a Jewish school in Brooklyn
1938 Obtains American citizenship
1945 Shows in Peggy Guggenheim's gallery in New York
1948 Develops his large-scale color style
1970 Commits suicide in his studio

This painter, of Russian origin, ranks among the most influential American artists of Abstract Expressionism. Next to Pollock (p. 474), he is counted among the main representatives of the New York School, which developed in the 1940s. He studied at Yale University and then at the Art Students' League, New York's oldest independent art school. After early work in an expressive, figurative style, Rothko, under the influence of Max Ernst (p. 454), turned to Surrealism and experimented with the automatic painting technique. His biomorphic compositions are also reminiscent of Miró's (p. 458) picture world. His first characteristic, large-size pictures emerged around 1948, the style of which forms an iconic variant in Abstract Expressionism. The distinguishable quality about these paintings is that a few large blocks of color dominate the entire picture area, suggestive of different moods and emotions.

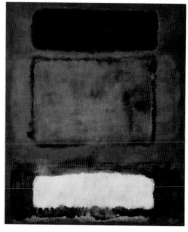

■ **Red, White, Brown**, 1957, oil on canvas, 252.5 x 207.5 cm, Kunstmuseum, Basel

Rothko's characteristic work started developing in 1948. Large rectangular blocks of two to three colors dominated his canvases. Colors run into each other and seem to float in front of monochrome backgrounds. Their diffuse, undefined structure blocks out, as the artist formulated himself, "the memory as it unburdens reflection." Colors become the main focal point; they seem to breathe in the wide space. Through subtle compositions of colors with bright white, as demonstrated by this painting, tension and silence are conveyed at the same time.

Other Works by Rothko

Orange and Yellow, 1956, Albright-Knox Art Gallery, Buffalo

White over Red, 1957, San Francisco Museum of Modern Art

No. 13 White, Red, on Yellow, 1958, Metropolitan Museum of Art, New York

Orange, Brown, 1963, Detroit Institute of Arts, Detroit

■ **Yellow and Gold**, 1956, oil on canvas, 170.5 x 159.4 cm, Philip Johnson Collection, New Canaan

Yellow and Gold represents the apex of Rothko's work and conveys the particular spiritual disposition of his iconic style in its complete orientation towards transcendence. The painting resembles a golden Russian icon in its choice of color.

Rothko's Jewish origins influenced his style, giving his compositions mystic references and a recourse to the grand traditions that dominated European painting. The golden yellow and seemingly transparent shades give this painting a lucid, floating, and immaterial character that elicits a feeling of warmth and comfort from the viewer.

Mark Rothko

Maria Helena Vieira da Silva

1908, Lisbon—1992, Paris

■ Was one of the most important female artists of informal painting in Paris after 1945 ■ With her color-stain pictures, she added a strong spatial and individual variant to abstract art ■ In the 1930s, she turned toward Surrealism and developed phantasmagoric, visionary architecture in the modern city

1908 Born in Lisbon

1919 Studies drawing, painting and sculpture at the Academia de Belas-Artes in Lisbon

1928 Studies sculpture with Bourdelle in Paris

1930 Marries the Hungarian painter Arpad Szenes

1933 First one-woman exhibition in Paris

1939 Flees from France to Portugal

1940 Moves to Rio de Janeiro

1947 Returns to Paris

1961 Wins the Grand Prix des Beaux-Arts at the Biennale in São Paulo

1966 Receives the French government's Grand Prix National des Arts

1992 Dies in Paris

Works by Vieira da Silva

Dance, 1938, Museum of Modern Art, New York

Game of Chess, 1943, Musée National d'Art Moderne, Paris

The Corridor, 1950, Tate Modern, London

Serigraphic #1, 1959, Fine Arts Museums of San Francisco

With her œuvre, created after the end of World War II, the Portuguese-born French painter Maria Helena Vieira da Silva is considered to be one of the most important representatives of the Informal art movement. She created intricate, abstract compositions and added an independent variant to the many abstract trends existing at the time. The student of Antoine Bourdelle, she started her artistic life as a sculptor. In the 1930s, under the influence of Surrealism, she began developing her characteristic confusing spatial constructions that resemble dreamlike modern architecture. She stated, "I think that everything that is real, that is static, is false." She increasingly blended spaces together in her work, focusing on linear structures.

■ **Brumes de Chaleur**, 1957, oil on canvas, 73 x 116 cm; Comité Arpad Szenes-Vieira da Silva, Paris

This abstract composition is made out of vertical lines and colored squares. They do not form rooms, but rather open structures, and they are united by a topic that forms the basis of the painting—the city or city landscape.

■ **Théâtre de Gérard Philipe**, 1975, oil on canvas, Unterlindenmuseum, Colmar

A network of lines and colored segments cross the painting, creating a strong impression of space. The lines can barely be detangled from one another, and form growing webs. The network becomes denser towards the center of the painting and more blurred at the margins. Color-stain paintings are built up from the smallest color element onward.

Maria Helena Vieira da Silva

Yves Klein

1928, Nice–1962, Paris

■ Was among the most important European postwar artists ■ Instigator of international art ■ His work focused on the id ■ Monochrome ■ Developed a his famous blue color blend, IKB ■ Painted his models' bodies, using them as "living brushes"

■ **1928** Born in Nice

1942–46 Studies at the École Nationale de la Marine Marchande and the École Nationale des Langues Orientales

1946 Begins painting and monochrome theories

1952 Travels to Japan

1955 Relocates to Paris

1956 Discovers IKB; acquaintanceship with critic Pierre Restany

1957 Exhibits in Milan

1960 Founding member of New Realism (Nouveau Réalisme)

1962 Dies in Paris of a heart attack

Other Works by Klein

Large Blue Anthropometry, ANT 105, ca. 1960, Galerie Gmurzynska, Cologne

Requiem Blue, 1960, Menil Collection, Texas

Fire Painting, Feu 88, 1961, Lenz Collection, Schönberg

Portrait Relief PR3 (Portrait of Claude Pascal), 1962, Art Gallery of New South Wales, Sydney

The French artist belongs among the leading representatives of New Realism (Nouveau Réalisme), the countermovement against American Abstract Expressionism and Tachisme, which developed in the 1960s in Europe. His complex ideas enabled him to exert great influence over the progression of art. From his earliest works, he occupied himself with the idea of the monochrome and created abstract pictures in various color tones. In search of pure pigments, he found a vibrant, deep ultramarine blue in 1956, patented as IKB, which became his trademark.

■ **Blue Venus**, 1962, bronze, painted, 53.5 x 25.5 x 8.5 cm, Musée d'Art Moderne de la Ville, Paris

Klein derived fame from his activities involving painting women's nude bodies with blue color and imprinting them on white canvas. He also translated these distinctive anthropometries into three-dimensional sculptures, such as *Blue Venus*. In other works, he further worked these pieces into what he called "cosmogonies" by incorporating the elements—using imprints from plants and traces of rain and wind.

Art after 1945

■ **RE 16, Do-Do-Do**, 1960, sponge, gravel, blue pigment, and synthetic resin on wood panel, 199 x 165 x 18 cm, Yves Klein Archives, Paris

The artist experimented relentlessly with materials and techniques. In 1956 he created International Klein Blue, a vibrant deep pigment that played an important role in his works. For him, this color was the embodiment of the cosmos, and its boundlessness was supposed to open the viewer's gaze into an endless cerebral space. Following this claim, he painted not only canvases but also items such as sponges, rocks, branches, and roots—linking tangible objects to art.

Yves Klein

Robert Rauschenberg

1925, Port Arthur

■ A leading representative of the Neo-Dada movement ■ Precursor and pivotal figure in the emerging Pop Art scene ■ His three-dimensional collages became the most important link between Abstract Expressionism and Pop Art ■ Many innovative techniques ■ Active in the world peace movement

1925 Born in Texas

1946 Studies at the Kansas City Art Institute

1948 Studies at the Académie Julian in Paris

1949 Student of Josef Albers; friends with John Cage and Merce Cunningham; moves to New York

from 1951 Begins to paint his first white, then black monochrome paintings

1953 Action of blotting out a drawing of Willem de Kooning

ca. 1955 First "combine paintings"

1969 Series *Stoned Moon* is produced after the Apollo 11 launch

present Lives and works in Florida and New York

This American painter and graphic artist was a precursor of the Pop Art movement, which developed as a reaction to the radical subjectivism of Abstract Expressionism in the 1950s. After World War II, Rauschenberg studied at different American art schools and also went to Paris to study at the Académie Julian. In his search for new artistic forms of expression, the artist became acquainted with German Dadaism. This art, especially the collages and the critical view of society, inspired him to renew the basic ideas of Dadaism and create Neo-Dadaist collages, which were directed against the predominant influence of abstract art. Duchamp's readymades (p. 447) influenced him, as did the radical music of John Cage. Although cooperation with the composer led to earlier forms of "happenings," an improvisational type of theater like a demonstration, Rauschenberg turned toward the reality of the American metropolis and paved the way for a new realism, which gave birth to Pop Art.

■ **Untitled**, 1957, collage, oil on canvas, 38 x 61 cm, Kunsthaus, Zurich

Rauschenberg's early works were inspired by the German Dadaists Kurt Schwitters (p. 444) and Hannah Höch. He also wanted to undo the gap between life and art, and inserted real fragments of the world, such as newspaper cuttings and photos, in his paintings, which were painted in the style of Abstract Expressionism.

Art after 1945

■ **Retroactive II**, 1964, oil and screenprint on canvas, 213 x 152 cm, Stefan T. Edlis Collection, Chicago

Rauschenberg came to prominence in the 1960s mostly due to his large-scale, collagelike series, in which he created a multilayered portrait of American metropolitan life. He used a variety of techniques, such as silk-screening, for the transfer of magazine photographs of current events, which he combined with other things. Among his best-known works are the paintings of the *Retroactive* series. While glorifying American idols such as John F. Kennedy, astronauts, or sports stars, he also takes a critical attitude toward contemporary trends. The composition becomes a view of the heterogeneous events superimposed on one another.

Other Works by Rauschenberg

Memorandum of Bits, 1956, combine painting, Sonnabend Collection, New York

Navigator, 1962, Museum für Moderne Kunst, Frankfurt am Main

Urban, 1962, Museum of Fine Arts, Houston

August Allegory (Anagrams), 1997, Morris Museum of Art, Augusta, Georgia

Riding Bikes, 1998, Daimler-Chrysler Collection, Berlin

■ **Magician II**, 1959, collage and mixed materials, 166 x 97 x 41 cm, Sonnabend Collection, New York

While early combine paintings such as *Magician II* were strongly reminiscent of Schwitters's collages with found objects and waste products from consumer society, this later disappeared. By means of built-in objects such as car tires or stuffed animals, the assemblages become three-dimensional, freestanding objects.

Robert Rauschenberg

Andy Warhol

Andrew Warhola
1928, Pittsburgh—1987, New York

■ One of the most famous artists of the American postwar period ■ Founded Pop, which remained the predominant international artistic style for over a decade ■ His art is still very influential

■ **1928** Born Andrew Warhola in Pittsburgh, where he later trains as a window dresser

1945–49 Studies pictorial design and art history in Pittsburgh

1949–60 Moves to New York City; changes his name; works as commercial artist and illustrator

1962 First serially produced paintings; is involved in the exhibition The New Realists; founds his studio, The Factory

1963 Begins making movies; influences the Pop Art movement

1987 Dies in New York City

The American printmaker, commercial illustrator and avant-garde filmmaker is considered a main representative of "popular art," in short called Pop Art. At first, he studied commercial art at the School of Fine Arts in Pittsburgh. After moving to New York City, he worked as a commercial illustrator. This work would later influence his entire creative activity. His early artistic career is associated with The New Realists, a group of artists who became known around 1960. Basing much of their artwork on Dadaist ideas of the 1920s, they understood their art as an ironic antithesis to Abstract Expressionism and as a search for a radical new beginning. After turning to Pop Art, everyday materialism and consumerist culture was worth being painted. Warhol's works always alternated between glorification and criticism of American mass culture, its brand-name products, and celebrities.

■ **Triple Elvis**, 1962, silk screen and aluminum paint, 40.2 x 23.4 cm, Virginia Museum of Fine Arts, Richmond

Warhol dealt widely with the entertainment industry, including movies, comic strips, rock 'n' roll music, and iconic celebrities. Through serial reproductions, Elvis Presley became even more of an icon. Warhol used silk-screening as an instrument for mass production.

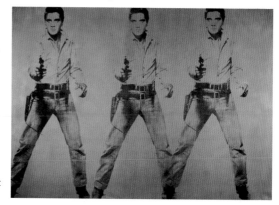

Art after 1945

■ Campbell's Soup Can on Shopping Bag, 1966, silkscreen print on a paper shopping bag, 40.2 x 23.4 cm

From 1962 onwards, Warhol created the *Campbell's Soup Cans* and *Disaster* prints. Through silk-screening, he quickly became known as the "Pope of Pop." These images changed the conventional concepts of art and aesthetics radically. No longer were artistic creativity and originality the center of attention; now the industrial products of modern consumer culture itself were even ranked as artistic œuvres. Mass reproduction and the omission of an artist's signature made a pictorial object become a portrait of its culture. In this print, on a shopping bag, Warhol creates a double relation between art and life.

485

Pop Art in the USA

Other Works by Warhol

Orange Disaster #5, 1963, Solomon R. Guggenheim Museum, New York

Ambulance Disaster, 1963, The Andy Warhol Museum, Pittsburgh

Liz, 1964–65, Ackland Art Museum, Chapel Hill, North Carolina

Brillo, 1964, National Gallery of Canada, Ottawa

Electric Chair, 1967, National Gallery of Australia, Canberra

Mao, 1973, Art Institute of Chicago

Last Self-Portrait, 1986, Metropolitan Museum of Art, New York

■ Leg and Shoe, ca. 1955, watercolor, lithographic print, and feather on paper, 66 x 50.8 cm, Jose Mugrabi Collection, New York

Trained as a window dresser, Warhol started working in New York City as a commercial artist for department stores and fashion magazines; later, until the early 1960s, he worked as an advertising illustrator and a window-display designer. His first images of the comic strip figures *Superman* and *Popeye* were originally designed for use as shop-window decorations. This early sheet belongs to the personality shoe drawings, which were collages of shoes with decorations emblematiz-

ing the characters of celebrities. Already in these pictures, Warhol's preference for striking, bright neon colors is visible.

Andy Warhol

Marilyn

In the 1960s, the United States of America had become an industrialized and consumer-oriented society. In response to this a number of young artists created works that took New York's and Los Angeles's art scenes by storm. Around 1963, the term "Pop Art" was established to designate a new art movement that reflected the contemporary attitude to life. The term "pop" was used as an abbreviation for "popular." Artists were inspired by everyday objects and icons of mass culture, and turned them into art. Andy Warhol quickly became famous as the central figure in the Pop Art movement. From the very beginning, his work was characterized by a combination of irony and a fascination with the mechanical serial production process, which had until then been considered inartistic. In his pictures and series, Warhol declared soup cans and Coca-Cola bottles superstars, just as he did with celebrities from the film industry, rock music, or politics. His prints of Elvis Presley, Jacquiline Kennedy, Elizabeth Taylor, Marilyn Monroe, and Mao became icons of the 20th century.

Warhol's famous portrait cast Marilyn Monroe as a glamorous idol of pop culture. The legend of the movie star continues to exist today, not least of all due to this rendition of her. Warhol transferred the photograph of the movie star by screen-printing onto canvases in innumerable colors, in different sizes as well as serial compositions with up to 150 single pictures. In doing so, he always worked with the same image, a still photograph taken from the movie *Niagara*. When Monroe died on August 2, 1962, Warhol expressed his grief and fascination with the star by producing more than 20 silk screen paintings of her until the end of the same year. Among his most outstanding works is *Marilyn Diptych*. The halves, one printed in bright neon colors, the other in black ink, symbolize life and death through their contrast.

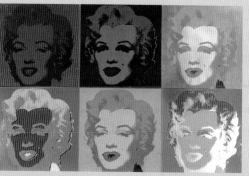

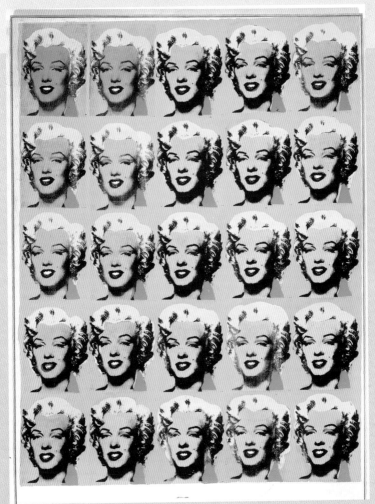

Two Marilyns, (opposite, top), silk screen and pencil on grounded canvas, 75 x 36 cm, Froehlich Collection, Stuttgart

Marilyn Monroe, 1967, silk screen print, each 91.5 x 91.5 cm, Andy Warhol Foundation for the Visual Arts, New York

Marilyn Diptych (left panel), 1962, acrylic and silk screen on canvas, 208.3 x 114.8 cm, Tate Modern, London

Andy Warhol

Richard Serra

1939, San Francisco

■ Influential and groundbreaking sculptor of the second half of the 20th century ■ Became part of the Minimalist movement with the sculptures he created after 1970 ■ Central theme of his outdoor sculptures involves the balancing of planar surfaces in relation to their environment

■ **1939** Born in San Francisco
1957–61 Studies literature at UC Berkeley and UC Santa Barbara; finances his education by working in steel mills
1961 Studies at Yale University; meets Josef Albers
1964 Educational trip to Italy; makes contact with Arte Povera
after 1964 Further travels to Italy and Paris
1968–79 Shoots several films
1983 Retrospective in Centre Georges Pompidou
since 2002 Lives and works in New York; is involved in Matthew Barney's *Cremaster 3*

This American artist is one of the most well-known sculptors of our time. He studied at the University of California and at Yale University, where the purist geometric abstractions of Josef Albers, the great practitioner of the Bauhaus, greatly influenced him. In 1964, Serra traveled to Italy, where he encountered Arte Povera. This group's ideas of using humble materials to impart energetic and poetic meaning influenced his early works. Minimalism, which developed as an art movement in the 1960s as a reaction against the radical individualism promoted by Abstract Expressionism, influenced his work the most. Since 1970, he has concentrated primarily on using steel to create planar surfaces balanced in space. His work concerns the relationship between people and their perception of space. His massive sculptures create an immediacy within the environment that shape the general experience and feeling of the surroundings.

■ **Berlin Junction**, 1987, steel, outside the Philharmonic Orchestra, Berlin

Serra's sculptures are always influenced by the conflict with gravity. The heavy, seemingly disassembled steel plates are so carefully balanced that they do not need to be anchored to the ground, despite their monumental size. Their elegant curves connote an effortless dynamism, despite the solidity of the structure.

Art after 1945

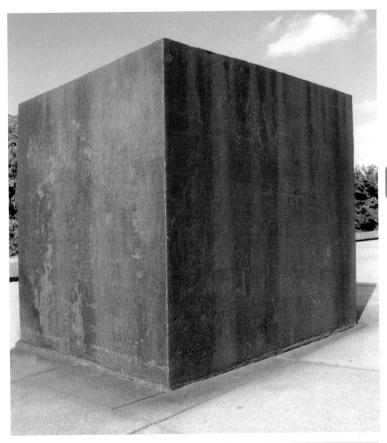

■ **Berlin Block for Charlie Chaplin**, 1978, forged iron, 200 x 200 x 200 cm, Neue Nationalgalerie, Berlin

Influenced by the principles of Minimalism, Serra's sculptures are reduced to the simplest, most basic shapes. They impart an impression of the highest clarity, yet are somehow unset-tling at the same time. This massive block establishes a relationship with the Neue Na-tionalgalerie—the cubical form consciously counteracts the rectangular construction of the building. The cube unnerves viewers, making them aware of their own unstable nature and vulnerability to gravity.

Other Works by Serra

Circle of Acceleration, 1961, Muzeum Sztuki, Lodz

Right Angle Prop, 1969, Solomon R. Guggenheim Museum, New York

Intersection, 1992, Theaterplatz, Basel

Richard Serra

Bridget Riley

1931, London

■ Is among the most significant representatives of the international Op Art movement ■ Developed a strict geometric variation of this abstract movement ■ Her interest lies in exploring optical effects and illusions through simple, only marginally varied series of patterned planes

■ **1931** Born in London

1952 Studies art at Goldsmiths College and at the Royal College of Art

1960 Teaches at the Hornsey College of Art

1962 First solo show

1968 First British painter awarded the Grand Prize at the Venice Biennale

1998 Is made a Companion of Honour in London

2003 Retrospective at the Tate Britain

The English painter numbers among the principle representatives of Op Art, the abstract art movement initiated by Victor Vasarely (p. 468) at the beginning of the 1960s. Op Art was a mathematical abstract art movement that was concerned with the way the eye perceives things. Vasarely's influence on Riley's work is palpable, but in contrast to his work, Riley occupied herself only with pure eye-baffling optics, mostly uniform planar patterns that create the impression of shimmering movement. She developed her own special variation of "optical art" through engaging with American postwar art, Futurism, and above all the geometric abstraction of Bauhaus and De Stijl.

According to her own statements, she broke into her "total self" in these paintings, her entire personality encompassing the art.

■ **Movement in Squares**, 1961, tempera on fiberboard, 123 x 121 cm, British Council, London

With the simplest of materials,as in this austere painting with planar patterns of black and white rectangles, Riley produces movement solely through the curvature of the planes, which become space and generate a virtually physical suction into the center. The artist achieved her effects through optics, referring to the entire systemic perception.

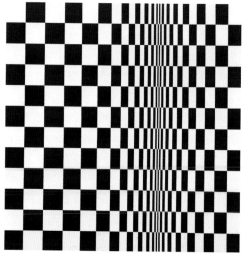

Other Works by Riley

Circle of Acceleration, 1961, Muzeum Sztuki, Lodz

Untitled, 1964, Museum of Modern Art, New York

Cataract 3, 1967, British Council, London

Winter Palace, 1981, Leeds City Art Gallery, Leeds

High Sky 2, 1992, Neues Museum, Nuremberg

■ **Crest**, 1964, emulsion on wood, 166 x 166cm, British Council, London

In most of her large-scale paintings, Riley creates an illusion of depth and of space with shimmering movement, generally through geometric light-dark contrasts. The "movement" of her compositions lies in tempo changes, as the stripes, points, wavy lines, triangular, or quadrangle patterns compress or relax, as in this work through the diagonal patterns. A tense expressiveness, a harmony of contrasts whose dramatics are always formally controlled emerges from the static and dynamic of the picture's elements. Ultimately, the artist assaults conventional optical viewing, challenging our perception of reality, space, and movement, and the expansion of the objective experience.

Bridget Riley

Nam June Paik

1932, Seoul–2006, Miami

■ The Korean musician was among the most versatile artists and pioneers of the international art scene after 1960 ■ Experimented with electronic music ■ Involved in the Fluxus movement ■ Developed and decisively influenced video art ■ Created robot sculpture and monumental video installations

■ **1932** Born in Seoul

1950 Emigrates to Japan

1953–56 Studies philosophy, music, and art history in Tokyo

1957 Studies composition in Freiburg

1958–63 Lives in Cologne; meets John Cage and creates experimental music compositions

1960 Involved with the Fluxus movement

1963 Develops, with Shuya Abe in Japan, the *Robot K 456*

1964 Relocates to New York; collaborates with Charlotte Moorman

1965 Begins video phase; installations from televisions

1979 Professor at the Düsseldorf Art Academy

2006 Dies in Miami

Art after 1945

The Korean artist, musician, and composer belonged to the pioneers of video art in the 1960s, the establishment and development of which he definitively advanced. He studied music, composition, art history, and philosophy. His acquaintance with John Cage led to involvement in the Fluxus movement and to countless happenings and concerts with the cellist Charlotte Moorman. Work with manipulated television sets and tonal objects followed. In the mid-1960s the first video installations, such as a remote-controlled robot prototype, appeared. Paik experimented relentlessly with new technology and searched for a synthesis between art, film, and music.

■ **Andy Warhol Robot**, 1994, video sculpture, Kunstmuseum, Wolfsburg

Paik's work shows his reverence for influential artists in a spectacular manner, such as here with the leading proponent of Pop Art, Andy Warhol, easily identifiable by his trademark Brillo box. To this end, Paik combined antique televisions and film reels with monitors and the newest, computerized technology available into a colossal sculpture. The first robot of this type, exhibited at documenta 8, was dedicated to the recently deceased Joseph Beuys.

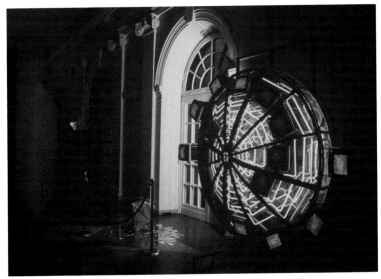

■ **Neptune**, 1993, video sculpture, metal frame, fluorescent tubes, 16 monitors, 2 picture players, and 2 picture disks, 257 x 257 x 50 cm, Galerie Weisser Raum, Hamburg

Beginning in the 1980s, countless large installations with many monitors and videotapes appeared. Shimmering colors and channel-flipping patterns, kaleidoscopic abstraction, and bewildering scrolling images resulted from the editing process. This work is understood as an aggressive response to the nature of television. Similar ideas can be seen in *Zen for TV* or *TV Buddha*.

■ **One Candle**, 1988/89, camera, candle, and 5 projectors, Museum of Modern Art, Frankfurt am Main

Time and again, there is a tranquility and intimacy in the artist's work. With simple media, such as this projection of a burning candle with its shifting colors, Paik achieves a huge impact.

Other Important Works by Paik	
TV Buddha, 1974, Stedelijk Museum, Amsterdam	Piano Piece, 1993, Albright-Knox Art Gallery, Buffalo
Beuys/Voice, 1990, TW Foundation, Hamburg	WAIS Station Tower, 1996, Art Museum of the Americas, Washington, DC

Nam June Paik

Francis Bacon

1909, Dublin—1992, Madrid

■ Most significant modern English painter after World War II ■ His central and obsessively handled theme was the depiction of loneliness, the cruelty of the individual, and the figure in interior space ■ Exercised great influence over the revival of figurative art in Europe ■ Created many portraits and triptychs

1909 Born in Dublin
1914 Relocates to London
1943 Destroys countless early pictures
1945 Sensational triptych in London
1954 Represents England at the Venice Biennale
1957 *Van Gogh* series
1963 Retrospective at the Guggenheim Museum in New York
1992 Dies in Madrid

The painter belongs among the most significant modern portraitists of the human condition in the 20th century. He designed furniture and interiors and began as a self-taught painter around 1930. At the end of World War II, he dedicated himself exclusively to painting. Deeply impressed by Surrealism, his visionary and human portraits are suspended in conflict between control and fear, aggression and pain. In his process, Bacon built his central theme equally on the apocalypses of Hieronymus Bosch (p. 188) and on William Blake, Edward Munch (p. 392), or Vincent van Gogh (p. 386), who inspired a series. Aside from the portraits, the artist continually occupied himself with many variations on the theme of the figure in interior space. The tightly structured interior spaces thereby contrast with the skewed, often almost mutilated effect of the figures, painted with intensely expressive colors and brushwork.

■ **Triptych, May-June 1973** (middle panel), 1973, oil on canvas, 3 panels, each 198 x 147.5 cm, private collection

In his later work, much like Max Beckmann, Bacon increasingly developed his lifelong theme in the monumental form of the triptych. The painter stressed ever more deeply the contrast between the clear interior spaces constructed from lines and even planes, which recall geometric Abstraction or Constructivism, and the human figure. Dark shadows additionally magnify the sinister and threatening effect, as in this piece.

Figurative Painting in England

Other Works by Bacon

Figure with Meat, 1954, Art Institute of Chicago

Studio per Una Figura VI, 1956, Palazzo Forti, Verona

Paralytic Child Walking on All Fours, 1961, Gemeente-museum, The Hague

Final Unfinished Portrait, 1991–92, Dublin City Gallery, Dublin

■ **The Screaming Pope**, 1953, oil on canvas, 152 × 118 cm, William Burden Collection, New York

Bacon's criticism of Catholicism after 1950 can be seen in multiple variations on the painting *Innocent X* by Velázquez (p. 262). This series emphatically proves that figurative art after World War II did not lose its provocative force. By showing the pope suspended in a rigid framework of lines, clutching the throne, he broke a taboo.

■ **Lying Figure in a Mirror**, 1971, oil on canvas, 198 × 147.5 cm, Museo de Bellas Artes, Bilbao

Bacon's treatment of the classic subject matter of the human figure is unique. It can only be guessed that the abstracted form is human, and the setting is left purposefully ambiguous. The rounded mass of purples and pinks has a distinctively fleshy nature, surprisingly organic when compared to the setting.

Francis Bacon

Louise Bourgeois

1911, Paris

■ Counts among the most influential artists and sculptors of the international style in the 20th century ■ Developed a polymorphic style caught between the abstract and the figurative ■ Radically subjective approach ■ First artistic breakthrough at age 70 ■ Large installations

■ **1911** Born in Paris

1932–35 Studies mathematics at the Sorbonne

1936–37 Studies at l'École des Beaux-Arts in Paris

1937–38 Studies under Fernand Léger

1938 Moves to New York with her American husband

1945 First solo show in New York

1982 Retrospective at the Museum of Modern Art, New York

1989 European retrospective and shows work at documenta 9

1993 Represents the USA at the Venice Biennale

2000 Featured at the opening of the Tate Modern, London

present Lives and works in New York

■ **Torso**, 1963/64, bronze, white patina, 62.8 x 40.6 x 20 cm, private collection, courtesy of the Galerie Karsten Greve, Cologne

Since the 1960s, the artist has experimented with increasingly un-

Art after 1945

This French artist is one of the most important sculptors of the 20th century. Using a multitude of media and forms of expression, her work defies stylistic classification. She studied in the 1930s in Paris, where she briefly joined the Surrealist movement, before emigrating to the USA in 1938. In her early sculptures she explored her domestic experiences as a wife and mother, as well as the fear and isolation of day-to-day life. In the 1970s, with her provocative experiments and the general break in the traditional representations of sexuality, she became an important role model for the feminist movement. Bourgeois didn't really achieve a major artistic breakthrough until 1982, when she had an exhibition in the Museum of Modern Art in New York. Her widespread spectrum of work reaches from the abstract to the figurative, from drawings to large installations. Most of her work draws on her Surrealist roots and is intimidating in size and subject matter.

usual materials, such as latex and rubber. The landscapes formed by the innards in works such as *Torso* have an exceptionally fleshy corporeality. The sexual forms cannot be classified as either masculine or feminine. Often, rounded "breasts" and protruding "phallic" forms combine with one another, creating a kind of hermaphroditic figure, which obviously implies sexuality.

Maman, 1999, steel and marble, 9.27 x 8.92 x 10.27 m, from the *Unilever Series* for the Turbine Hall of the Tate Modern, London

Other Important Works by Bourgeois

C.O.Y.O.T.E,
1941–48, National
Gallery of Australia,
Canberra

Dagger Child,
1947–49, Solomon R.
Guggenheim Museum,
New York

Destruction of the
Father, 1974, Museum
of Modern Art, New
York

Nature Study Eyes,
1984, Albright-Knox
Art Gallery, Buffalo, NY

Le Défi,
1991, Solomon R.
Guggenheim Museum,
New York

Three Horizontals,
1998, Daros
Exhibitions, Zurich

Autobiographical elements play a large role in Bourgeois's work. She developed a radically subjective and self-contained universe, which has its roots in her memories. In 2000 she was asked to develop an exhibit for the opening of the Tate Modern, and presented her equally monumental and fragile spider sculpture *Maman* in the Turbine Hall. Her innumerable variations of spiders encompass themes of fear, alienation, and aggressive sexuality.

Louise Bourgeois

Joseph Beuys

1921, Krefeld—1986, Düsseldorf

■ One of the most significant sculptors, illustrators, and groundbreaking object and performance artists after 1945 ■ Publicized the creativity of all people and likened his artistic function to that of a shaman ■ Initiated happenings and political and ecological performances ■ Created numerous installations

Conceptual Art in Germany

■ **1921** Born in Krefeld
1941 Seriously injured during military service
1947 Studies sculpture in Düsseldorf; master pupil of Ewald Mataré
1957 Occupies himself with the writings of Steiner and Novalis and theories of "the expanded concept of art" and "social sculpture"
1961 Appointed professor at the Art Academy in Düsseldorf
1972 Dismissed from his post for admitting rejected students
1980 Candidate for state legislature for the Greens party
1986 Dies in Düsseldorf

Other Works by Beuys

Where Would I Have Got If I Had Been Intelligent!, 1970–72, Dia Chelsea, New York

La Revoluzione Siamo Noi, 1972, Armand Hammer Museum of Art at UCLA, Los Angeles

Terremoto, 1981, Solomon R. Guggenheim Museum, New York

This German painter, illustrator, and sculptor was one of the most significant object and performance artists of the postwar era. As a teacher, he exerted great influence over the Düsseldorf Academy, and after his expulsion for accepting rejected students, he founded the Free International University for Creativity and Interdisciplinary Research. Inspired by the teachings of Rudolf Steiner, Beuys sought to produce the reunification of nature and spirit and to visualize the complexity of life through the expressive figurativeness of objects. With unconventional materials and techniques he created an œuvre that spanned all disciplinary boundaries. He staged political actions and became involved in the ecological movement.

■ **Felt Suit**, 1970, felt, ca. 170 x 60 cm, Tate Modern, London

Aside from copper, both animal fat and felt were the leading and most often utilized elements of Beuys's characteristic natural and eidetic materials. The *Felt Suit* is one of his best-known objects.

■ **The End of the 20th Century**, 1983, five basalt rocks, each ca. 190 x 60 x 60 cm, Ulbricht Collection, Düsseldorf

Beuys discussed the destruction of nature in many performances, The tree planting performance from documenta 7, in which he combined oaks with crudely hewn basalt, is recalled by this work.

■ **Lightning with Stag in Its Glare**, 1958–87, room installation, bronze, iron, and aluminium, photo from Berlin Exhibition 1988, courtesy Thomas Amman, Zurich

Archetypical and magical-religious references play a large role in Beuys' thinking. *Lightning* revolves around the question of art's function in the Industrial age. The cooperative dialogue between nature and spirit is symbolized through the shapes and materials.

Joseph Beuys

Contemporary Art— Into the 21st Century

■ Artists from every continent can address a worldwide audience ■ Styles and movements form and change quickly ■ Many artists deal with the problems of both historic events and contemporary society ■ Artists use old and new styles and media to create pieces that define their vision of the world

■ **1990s** The New Leipzig School forms in Germany

1992 BritArt, a group of British conceptual artists, develops in the UK

1992 Jeffrey Deitch's Post Human exhibit starts the Post Human movement, dealing with the loss of human touch in a techno-logy-based culture

1999 Stuckism, a move-ment promoting figurative art, develops in Britain

2000s Anime-influenced artists create Superflat Art

2003 Situationist and Psychogeographical ideas manifest in the Provflux and Psy-Geo-Conflux hap-penings

2006 Street Art show in Texas reviews top graffiti artists

The art of today draws on the styles and ideals of the past, but has also been shaped by the radical advances in technology that have paved the way for a new global community. Whereas the fin de siècle incorporation of foreign motifs and media from Asia and the Near East radically altered the direction of art, now the art world not only draws influences from afar, but artists native to these lands have entered onto the scene. With the proli-feration of globalization, the historic context that has shaped artists' creativity has grown to encompass foreign histories, techniques and legends. Contempo-rary art reflects the fast-paced world that has allowed for such diver-sity. Styles and movements are born and dis-appear at the speed of the in-formation age.

Other Important Works

Takashi Murakami: Tan Tan Bo Puking, 2002, Galerie Emman-uel Perrotin, Paris

Jonathan Meese: Sankt Ich II, 2002, Contemporary Fine Arts, Berlin

Jenny Saville: Reverse, 2003, Gagosian Gallery, New York

Raqib Shaw: The Garden of Earthly De-lights III, 2003, Victoria Miro Gallery, London

Jeff Wall: A Wall in a Former Bakery, 2003, Johnen + Schöttle, Cologne

Grayson Perry: Balloon, 2004, Victoria Miro Gallery, London

■ **Neo Rauch**: **Aufstand**, 2004, oil on paper, 199 x 275 cm, EIGEN+ART, Leipzig/Berlin

Neo Rauch belongs to the New Leipzig School. The artist was born in East Germany and many of his works deal with political themes inspired by his own life experiences. Rauch's paintings are usually monumental in scale, confronting viewers with a message and with questions about utopian societies and revolutionary ideals, particularly those of the Socialist Party.

■ **Matthew Barney: Production Still from Cremaster 3**, 2002, Barbara Gladstone Gallery, New York

Matthew Barney's video series the *Cremaster Cycle* has come to epitomize modern video art. Born in rural America, Barney draws both on Classical and contemporary mythology and culture, creating a fantastical and symbolic world of characters. He is also famed for his large installations.

■ **Zhang Xiaogang**: **The Little Red Book**, 2003, oil on canvas, 130 x 110 cm, Chinese Contemporary Art Gallery, London

Zhang is one of the best-known artists from the burgeoning Chinese art scene. His works confront viewers with the divisions created in China as the country's booming economy meets its turbulent history. Foreign investment in the Chinese art market has opened up creative avenues.

Index

Art: A World History

510